Nikon® D200 Digital Field Guide

Nikon® D200 Digital Field Guide

David D. Busch

Nikon® D200 Digital Field Guide

Published by Wiley Publishing, Inc. 111 River Street Hoboken, N.J. 07030 www.wiley.com

Copyright © 2006 by Wiley Publishing, Inc., Indianapolis, Indiana

Published simultaneously in Canada

ISBN-13: 978-0-470-03748-5

ISBN-10: 0-470-03748-2

Manufactured in the United States of America

109876543

1K/5Z/QW/QW/IN

No part of this publication may be reproduced, stored in a retrieval system or transmitted in any form or by any means, electronic, mechanical, photocopying, recording, scanning or otherwise, except as permitted under Sections 107 or 108 of the 1976 United States Copyright Act, without either the prior written permission of the Publisher, or authorization through payment of the appropriate per-copy fee to the Copyright Clearance Center, 222 Rosewood Drive, Danvers, MA 01923, (978) 750-8400, fax (978) 750-4744. Requests to the Publisher for permission should be addressed to the Legal Department, Wiley Publishing, Inc., 10475 Crosspoint Blvd., Indianapolis, IN 46256, (317) 572-3447, fax (317) 572-4355, or online at http://www.wiley.com/go/permissions.

LIMIT OF LIABILITY/DISCLAIMER OF WARRANTY: THE PUBLISHER AND THE AUTHOR MAKE NO REPRESENTATIONS OR WARRANTIES WITH RESPECT TO THE ACCURACY OR COMPLETENESS OF THE CONTENTS OF THIS WORK AND SPECIFICALLY DISCLAIM ALL WARRANTIES, INCLUDING WITHOUT LIMITATION WARRANTIES OF FITNESS FOR A PARTICULAR PURPOSE. NO WARRANTY MAY BE CREATED OR EXTENDED BY SALES OR PROMOTIONAL MATERIALS. THE ADVICE AND STRATEGIES CONTAINED HEREIN MAY NOT BE SUITABLE FOR EVERY SITUATION. THIS WORK IS SOLD WITH THE UNDERSTANDING THAT THE PUBLISHER IS NOT ENGAGED IN RENDERING LEGAL, ACCOUNTING, OR OTHER PROFESSIONAL SERVICES. IF PROFESSIONAL ASSISTANCE IS REQUIRED, THE SERVICES OF A COMPETENT PROFESSIONAL PERSON SHOULD BE SOUGHT. NEITHER THE PUBLISHER NOR THE AUTHOR SHALL BE LIABLE FOR DAMAGES ARISING HERE-FROM. THE FACT THAT AN ORGANIZATION OR WEB SITE IS REFERRED TO IN THIS WORK AS A CITATION AND/OR A POTENTIAL SOURCE OF FURTHER INFORMATION DOES NOT MEAN THAT THE AUTHOR OR THE PUBLISHER ENDORSES THE INFORMATION THE ORGANIZATION OF WEB SITE MAY PROVIDE OR RECOMMENDATIONS IT MAY MAKE. FURTHER, READERS SHOULD BE AWARE THAT INTERNET WEB SITES LISTED IN THIS WORK MAY HAVE CHANGED OR DISAP-PEARED BETWEEN WHEN THIS WORK WAS WRITTEN AND WHEN IT IS READ.

For general information on our other products and services or to obtain technical support, please contact our Customer Care Department within the U.S. at (800) 762-2974, outside the U.S. at (317) 572-3993 or fax (317) 572-4002.

Wiley also publishes its books in a variety of electronic formats. Some content that appears in print may not be available in electronic books.

Library of Congress Control Number: 2006925872

Trademarks: Wiley and the Wiley Publishing logo are trademarks or registered trademarks of John Wiley and Sons, Inc. and/or its affiliates. All other trademarks are the property of their respective owners. Wiley Publishing, Inc. is not associated with any product or vendor mentioned in this book.

About the Author

David D. Busch was a roving photojournalist for more than 20 years, and illustrated his books, magazine articles, and newspaper reports with award-winning images. He's operated his own commercial studio, suffocated in formal dress while shooting weddings-for-hire, and shot sports for a daily newspaper and an upstate New York college. His photos have been published in magazines as diverse as *Scientific American* and *Petersen's PhotoGraphic*, and his articles have appeared in *Popular Photography & Imaging, The Rangefinder, The Professional Photographer*, and hundreds of other publications. He currently reviews digital cameras for CNET.com and *Computer Shopper*.

When About.com recently named its top five books on Beginning Digital Photography, occupying the #1 and #2 slots were Busch's *Digital Photography All-In-One Desk Reference For Dummies* and *Mastering Digital Photography*. His 80-plus other books published since 1983 include best-sellers like *Nikon D70 Digital Field Guide*, *Nikon D50 Digital Field Guide*, *Digital Travel Photography Digital Field Guide*, and *Digital SLR Cameras and Photography For Dummies*.

Busch earned top category honors in the Computer Press Awards the first two years they were given (for *Sorry About the Explosion* and *Secrets of MacWrite, MacPaint and MacDraw*), and later served as Master of Ceremonies for the awards.

Credits

Acquisitions Editor Michael Roney

Project Editor Cricket Krengel

Technical Editor Michael D. Sullivan

Copy Editor Lauren Kennedy

Editorial Manager Robyn B. Siesky

Vice President & Group Executive Publisher Richard Swadley

Vice President & Publisher Barry Pruett

Business Manager Amy Knies **Project Coordinator**Jennifer Theriot

Graphics and Production Specialists Jennifer Click Denny Hager Lynsey Osborn Amanda Spagnuolo

Quality Control Technicians Laura Albert Amanda Briggs Leeann Harney Joe Niesen

Proofreading Laura Albert

Indexing Broccoli Information Management

For Cathy.

Acknowledgments

hanks to Mike Roney, who is always a joy to work with, for his valuable input as this book developed; to Cricket Krengel for keeping the project on track; and to tech editor Mike Sullivan, whose more than a decade of experience shooting Nikon-based digital cameras proved invaluable. Finally, thanks again to my agent, Carol McClendon, who once again found me a dream job at exactly the right time.

Contents at a Glance

Acknowledgments
Quick Tour
Part I: Using the Nikon D200
Chapter 1: Exploring the Nikon D200
Chapter 2: Nikon D200 Essentials
Chapter 3: Setting Up Your D200
Part II: Creating Great Photos with the Nikon D200 73
Chapter 4: Photography Essentials
Chapter 5: All About Lenses
Chapter 6: Working with Light
Chapter 7: Photo Subjects
Chapter 8: Downloading and Editing Pictures
Part III: Appendixes
Appendix A: Troubleshooting
Glossary
•
Index

Contents

Acknowledgments	ix
Introduction	xxi

Quick Tour 1

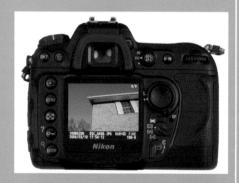

Selecting a Picture-Taking Mode Using Automatic or Manual Focus

A Few More Options	
Applying the depth-of-field	
preview	4
Using the self-timer and	
remote	5
Reviewing the Image	6
Correcting Exposure	6
Transferring Images to Your	
Computer	

Part I: Using the Nikon D200 9

Chapter 1: Exploring the Nikon D200 11

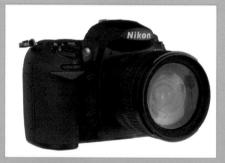

Up Front	12
On Top	16
On the Back	21
Upper left	21
Upper right	21
Lower left	22
Lower right	23
Viewfinder Display	24
LCD Display	27
Viewing and Playing Back Images	30
Activating the Onboard Flash	32
Metering Modes	32
Semiautomatic and Manual	
Exposure Modes	33

ISO Sensitivity Setting White Balance	34 34	Letting the D200 choose the focus zone automatically	51
el i a Nil Bass		Locking focus/exposure	52
Chapter 2: Nikon D200		Other Image Parameters	53
Essentials 35		Setting White Balance	54
	EWE	Creating white balance	
		presets	56
		Using white balance presets	56
		Chapter 3: Setting Up Your	
		D200 57	
		D200 31	
		A 55 de	
		当	
Will in the Prince of the Prin			
	242	一	
Metering Modes	36		
Matrix metering	36		7686
Center-weighted metering	38		
Spot metering	38	Shooting Menu Preferences	58
Adjusting Exposures with EV	39	Shooting Menu Bank	58
Using histograms	39	Menu Reset	58
Bracketing exposures and	39	Folders	58
other parameters	40	File Naming	59
Customized exposure and		Optimize Image	59
contrast tweaks	42	Color Space	59
ISO Sensitivity	42	Image Quality	59
Using Noise Reduction	44	Image Size	59
Using Automatic, Semi-Automatic,		JPEG Compression	59
and Manual Modes	45	RAW Compression	60
Programmed Auto	45	White Balance	60
Shutter Priority	47	Long Exp. NR	60
Aperture Priority	47	High ISO NR	60
Manual exposure	47	ISO Sensitivity	60
Working with Autofocus	48	Image Overlay	60
Autofocus basics	48	Multiple Exposure	60
Focus modes	49	Intvl Timer Shooting	60
Understanding the focus		Non-CPU Lens Data	61
zones	50	Playback Menu Settings	61
Choosing the focus zone		Delete	62
manually	51	Playback Folder	62
		Slide Show	62

Hide Image	62	b6: Center-Weighted Area	68
Print Set	62	b7: Fine Tune Optimal	
Display Mode	62	Exposure	68
Image Review	63	Timers/AE&AF Lock	68
After Delete	63	c1: AE Lock	68
Rotate Tall	63	c2: AE-L/AF-L	68
Setup Menu Options	63	c3: Auto Meter-Off	69
Format	64	c4: Self-Timer	69
LCD Brightness	64	c5: Monitor-Off	69
Mirror Lock-up	64	Shooting/Display	69
Video Mode	64	d1: Beep	69
World Time	64	d2: Viewfinder Grid	69
Language	64	d3: Viewfinder Warning	69
Image Comment	64	d4: CL-Mode Shooting	
Auto Image Rotation	64	Speed	69
Recent Settings	64	d5: Exposure Delay Mode	69
USB	65	d6: File Number	
Dust Off Ref Photo	65	Sequence	69
Battery Info	65	d7: Illumination	70
Firmware Version	65	d8: MB-D200 Batteries	70
Custom Settings	65	Bracketing/Flash	70
Bank Select	66	e1: Flash Sync Speed	70
Menu Reset	66	e2: Slowest Shutter Speed	
Autofocus	66	When Using Flash	70
a1: AF-C Mode Priority	66	e3: Built-In Flash	70
a2: AF-S Mode Priority	66	e4: Modeling Flash	71
a3: Focus Area Frame	66	e5: Auto BBKT Set	71
a4: Group Dynamic		e6: Auto Bracketing in	
Autofocus	66	Manual Exposure Mode	71
a5: Focus Tracking with		e7: Auto Bracket Order	71
Lock On	66	e8: Auto Bracketing	
a6: AF Activation	67	Selection Method	71
a7: AF Area Illumination	67	Controls	71
a8: Focus Area	67	f1: Center Button	71
a9: AF Assist	67	f2: Multi-Selector Press	71
a10: AF-ON for MB-D200	67	f3: Photo Info Playback	71
Metering/Exposure	67	f4: Func. Button	72
b1: ISO Auto	67	f5: Command Dials	72
b2: ISO Step Value	68	f6: Setting Method for	-
b3: EV Step	68	Buttons and Dials	72
b4: Steps for Exposure		f7: Disable Shutter If No	
Comp/Fine Tune	68	Memory Card?	72
b5: Easy Exposure			
Compensation	68		

Part II: Creating Great Photos with the Nikon D200 73

Chapter 4: Photography Essentials 75

Understanding Exposure	76
What affects exposure?	76
Exposure adjustments	77
Adjusting the light	
reaching the lens	77
Adjusting the aperture	78
Adjusting the shutter	
speed	79
Changing ISO	80
Getting the Right Exposure	81
Understanding tonal range	82
Fine-tuning	85
Understanding Depth of Field	86

Chapter 5: All About Lenses 89

Expanding Your Lens Options	89
Kit lens advantages	90
Consider a new lens	91
Choosing Between Zoom or	
Fixed-Focal-Length Lenses	93
Prime lens considerations	94
Zoom lens considerations	94
Lens Compatibility	94
Decoding Nikon's Lens Code	95
Wide-Angle Lenses	98
Telephoto Lenses	101
Normal Lenses	103
Macro Lenses	104
Reducing Vibration	105
Extending the Range of Any	
Lens with a Teleconverter	106

Chapter 6: Working with Light 107

D200 Flash Basics	107
Flash Sync Modes	109
Flash Exposure Modes	110
Flash Exposure Compensation	111
Using External Flash	112
Internal flash limitations	113
External flash advantages	113
External flash units and	
accessories	114
Triggering external flash	115
Using multiple flash units	116
Studio flash	117
Repeating flash	117
Conquering Continuous Lighting	118
Types of continuous lighting	118
Color temperature	119
Coping with white balance	120

Chapter 7: Photo Subjects 123

The Basics of Composition	124
The Rule of Thirds	125
Other compositional tips	126
Abstract Photography	127
Inspiration	127
Abstract photography	
practice	128
Abstract photography tips	130
Animal Photography	130
Inspiration	132
Animal photography	
practice	132
Animal photography tips	134
Architectural Photography	134
Inspiration	135
Architectural photography	
practice	135
Architectural photography	
tips	137
Business Photography	138
Inspiration	138
Business photography	170
practice	139 141
Business photography tips	
Event Photography	141
Inspiration	142
Event photography practice	143
Event photography tips	145
Fill Flash Photography	145
Inspiration	146
Fill flash photography	1.47
practice	147
Fill flash photography tips	149

Filter Effects Photography	149	Macro Photography	175
Inspiration	150	Inspiration	175
Filter effects photography		Macro photography	
practice	151	practice	177
Filter effects photography		Macro photography tips	178
tips	153	Night and Evening Photography	179
Fireworks and Light Trail		Inspiration	180
Photography	153	Night and evening	
Inspiration	154	photography practice	181
Fireworks and light trails		Night and evening	
photography practice	155	photography tips	183
Fireworks and light trails		Online Auction Photography	183
photography tips	156	Inspiration	184
Flower and Plant Photography	157	Online auction	
Inspiration	158	photography practice	185
Flower and plant		Online auction	
photography practice	159	photography tips	186
Flower and plant		Outdoor and Environmental	
photography tips	160	Portrait Photography	187
Holiday Lights Photography	161	Inspiration	187
Inspiration	161	Outdoor and	
Holiday lights photography		environmental portrait	
practice	162	photography practice	188
Holiday lights photography		Outdoor and environmental	
tips	164	portrait photography tips	190
Indoor Portrait Photography	164	Panoramic Photography	190
Inspiration	165	Inspiration	191
Indoor portrait photography		Panoramic photography	
practice	166	practice	192
Indoor portrait photography		Panoramic photography tips	193
tips	167	Sports and Action Photography	194
Infrared Photography	168	Inspiration	194
Inspiration	169	Sports and action	
Infrared photography		photography practice	195
practice	170	Sports and action	
Infrared photography tips	171	photography tips	197
Landscape and Nature		Still Life Photography	197
Photography	172	Inspiration	198
Inspiration	173	Still life photography	
Landscape and nature		practice	198
photography practice	173	Still life photography tips	200
Landscape and nature	175	Street Life Photography	200
photography tips	175	Inspiration	201
		Street life photography	
		practice	202
		Street life photography tips	204

Sunset and Sunrise Photography	204
Inspiration	205
Sunset and sunrise	
photography practice	206
Sunset and sunrise	
photography tips	207
Travel Photography	207
Inspiration	208
Travel photography practice	209
Travel photography tips	210
Waterfall Photography	211
Inspiration	212
Waterfall photography	
practice	212
Waterfall photography tips	214

Chapter 8: Downloading and Editing Images 215

Nikon's Offerings	215
Nikon PictureProject	216
Transferring pictures	216

Transfer options	217
Organizing and viewing	
pictures	219
Retouching pictures	220
Sharing pictures	221
Nikon Capture	222
Transfer/RAW conversion	222
Image editing	223
Camera communications	224
Other Software Options	227

Part III: Appendixes 231

Appendix A: Troubleshooting 233

Poor Battery Life	233
Flash Problems	234
Settings Vanish	235
Bad Memory Card	235

Banding
Too Much Noise
Camera Won't Function
Spots on Photos
Hot/Dead pixels

s on Photos 23 Hot/Dead pixels 23 Dust on the sensor 23

Glossary 241

Index 251

Introduction

ever has a Nikon digital camera been as eagerly anticipated as the Nikon D200! Speculation was rife in the months preceding the announcement of this camera, among those who wanted something with more resolution and more features than what was available with the Nikon D70s, but at a lower price tag than the top-of-the-line, \$5000 Nikon D2X. This camera was long overdue, too: it was seen as a replacement for the aging Nikon D100, which was effectively made obsolete when the original D70 was introduced in 2004 with the same resolution and improved performance.

Nikon didn't disappoint those of us who were awaiting its arrival. The D200 offers serious amateur photographers and value-minded professionals a sub-\$2000 dSLR alternative with much of the specifications, features, and build quality of Nikon's high-end pro cameras (like the freshened D2Hs and top-of-the-line D2X) in an aggressively-priced compact body.

Although not quite the junior version of the D2X that some had hoped for, the D200's 10.2 megapixel resolution, rugged moisture- and dust-sealed magnesium-alloy body, large viewfinder, 5fps drive mode, and bountiful fine-tuning and customization options are a significant step upward from Nikon's low-end models. Compatibility accessories including an expanded lineup of Nikon iTTL external flash units, a Wi-Fi transmitter, a burgeoning line of digital optics (such as a new 18mm to 200mm zoom with Vibration Reduction), and third-party GPS units give the D200 enough versatility to compete effectively with other pricier cameras.

I must admit I originally purchased my D200 as a backup to my Nikon D2X, but it quickly became my preferred camera for many different shooting situations. The D200 performs better at high ISO settings, so when I am shooting concerts or sporting events indoors in dim lighting, it's the D200 I use more often than not. It is lighter in weight, too, so if I am venturing out on other business with no firm intention to take any pictures, I'll tote my D200 just for fun. In the months since I bought my D200, I've probably divided my activities between it and the D2X almost equally.

The Nikon dSLR Revolution

Five years from now, you'll look back and see just how important the Nikon digital SLR cameras were in changing the face of photography, particularly since players like Kodak and Konica Minolta have abandoned their dSLR lines, and Nikon itself has announced that it will produce only a limited number of SLR film cameras in the future. It's a safe bet that this camera will be remembered warmly as a ground-breaking classic. Although Kodak led the initial charge, Nikon has been involved in digital-camera research since the mid-1980s. In

xxii Introduction

1986, it showed a prototype called the Nikon SVC, which had a 300,000-pixel sensor and saved images to a 2-inch floppy disk. The QV-1000C (with just 380,000 pixels) followed two years later. These early digital SLRs were possible thanks to the removable back panel of Nikon film SLRs, which could easily be replaced with a digital sensor.

Although Kodak offered a succession of digital SLRs based on Nikon camera bodies, Nikon didn't seriously begin competing in the digital SLR market on its own until Kodak branched out and began offering cameras based on Canon bodies, too. Partnering with Fuji in 1994/1995, Nikon created the E2/E3 series. These used a clumsy optical reduction system to allow existing Nikon lenses to produce a field of view similar to that offered by film cameras, despite the smaller sensor size.

Naturally, \$20,000 1.4-megapixel cameras didn't compete well with other models, especially because the Kodak DCS 460 offered 6-megapixel resolution as far back as 1995. The modern age of Nikon digital SLRs finally arrived in 1999 with the Nikon D1, which offered 2.74 megapixels and was enthusiastically embraced by professional photographers. A slew of pro-level D1/D2-series cameras followed, culminating in the 12.4 megapixel D2x, which first became available in early 2005.

All these \$5,000 to \$10,000 (and up) professional models just whetted the appetites of those who were weaned on sub-\$1,000 Nikon film bodies and were anxious to move into the digital realm without giving up any killer features such as autofocus, matrix metering, and tack-sharp interchangeable lenses. While the first Nikon D100 was tempting at its initial tariff of \$3,000, the price tag was still too high for anyone who couldn't justify the camera as a business expense. What photo enthusiasts really wanted were cameras in the magical \$1,000-\$1700 price bracket.

The first shot fired in the consumer dSLR revolution came from a Canon. Introduced in late 2003, the Canon EOS Digital Rebel was priced at \$899 for the body alone, or \$999 with a serviceable 18–55mm zoom lens. Nikon upped the ante a little a few months later by announcing the D70, which was priced a few hundred dollars higher and had a few features lacking in the first Digital Rebel. Both Nikon and Canon fans as well as owners of other camera lines were winners in this skirmish, as other camera vendors began to offer new and improved models in the hotly contested \$1,000 price range.

The exceptionally low-priced Nikon D50 followed, along with a slightly improved Nikon D200s, paving the way for a more sophisticated model in the D200.

The D200's Advantages

If you visit the online forums, you'll find endless debates on which digital SLR in the intermediate price range is the best. Rather than enter the debate here (if you're reading this, you've almost certainly decided in favor of the D200 camera), it makes more sense to provide a brief checklist of the Nikon D200's advantages.

Nikon lenses

The D200 is compatible with a vast number of Nikon lenses, especially since its aperture coupling ring (like the one found in the D2X) allows this camera to provide metering functions (including automatic exposure when set to Aperture Priority mode) with the huge number of manual focus AI and AI-S Nikon lenses produced after 1977.

Even older lenses can be used with the D200 if they are properly converted to Al-S compatibility (for about \$35.00 per lens). Other dSLRs may be able to use only a limited number of lenses made especially for them. Not all Canon lenses work on all Canon digital SLRs, for example.

But there are hundreds of newer lenses ("newer" being less than 25 years old), many at bargain prices, that work just fine on the D200. For example, one prized Nikon 70–300mm lens can be found used for about \$100. A Benjamin will also buy you a 50mm f1.8D AF that's probably one of the sharpest lenses you'll ever use, or a Nikon 28–100mm zoom lens. The 18mm–70mm kit lens, available separately for around \$300, is a bargain at that price. Third-party vendors such as Sigma, Tokina, and Tamron, offer a full range of attractively priced lenses with full autofocus and autoexposure functionality.

Full feature set

You don't give up anything in terms of features when it comes to the Nikon D200. Some vendors have been known to "cripple" their low-end dSLR cameras by disabling features in the camera's firmware (leading to hackers providing firmware "upgrades" that enable the features).

The D200, on the other hand, shares many of the most-used features of the Nikon D2X, and has a ton of functions not found in the D70s or D50. If you can't do it with the D200, it probably doesn't need to be done.

Fast operation

The Nikon D200 operates more quickly than many other digital SLRs. It includes a large memory buffer so you can shoot continuously for a longer period of time. It also writes images to the memory card very quickly. Many D200 users report being able to fire off shots as quickly as they can press the shutter release for as long as their index finger (or memory card) holds out.

One popular low-end dSLR takes as long as 3 seconds after power-up before it can take a shot. If you don't take a picture for a while, it goes to sleep and you have to wait another 3 seconds to activate it each time. The D200 switches on instantly and fires with virtually no shutter lag. (Actually, it uses so little juice when idle that you can leave it on for days at a time without depleting the battery much.) Performance-wise, the D200 compares favorably with digital cameras costing much more. Unless you need a burst mode capable of more than 5 frames per second, this camera is likely to be faster than you are.

Great expandability

There are tons of add-ons you can buy that work great with the D200. These include bellows and extension rings for close-up photography, and at least three different electronic flash units (including the new R1 and R1C1 wireless close-up flash units) from Nikon and third parties that cooperate with the camera's through-the-lens metering system. Because Nikon SLRs have been around for so long, there are lots of accessories available, new or used, and Nikon cameras are always among the first to be served by new gadgets as they're developed.

Digital Challenges

As you use your D200 and learn more about its capabilities, you'll want to keep in mind the challenges facing this pioneer in the dSLR arena. The Nikon D200 and other digital SLRs have advantages and disadvantages over both film cameras and non-SLR digital shooters.

Here are some of the key points to consider:

- ◆ ISO sensitivity and noise. Most non-dSLR digital cameras offer ISO settings no higher than ISO 400, and may display excessive noise in their images at settings as low as ISO 200. The larger sensor and less noise-prone larger pixels in the D200 provide good quality at ISO 800, and relatively little noise at ISO 1600, and you can boost sensitivity to ISO 3200 if you need to. The D200 also has an effective noise-reduction feature. One adjustment you'll make in learning to use this camera is how to work with higher sensitivity settings while avoiding excess noise.
- ▶ **Depth-of-field control.** As with all dSLRs, the longer lenses used provide less depth-of-field at a particular field of view, which, when you want to use depth-of-field as a creative element, is a very good thing, indeed. If you've used only non-SLR cameras before, you'll want to learn how to use selective focus and, especially, how to use the depth-of-field preview button.
- ★ The lens multiplier factor. The D200's sensor is smaller than a 35mm film frame, so the image from any lens you mount is cropped, producing a 1.5X multiplier factor. A 200mm lens is magically transformed into a 300mm telephoto, but the flip side of that is that a 28mm lens that's a wide-angle optic on a full-frame camera becomes a 42mm normal lens on the D200. To get true wide-angle coverage, you'll need a prime (non-zoom) or zoom lens that starts at 17mm to 18mm, like the kit lens. Superwide lenses, such as the \$1,000 Nikon 12-24mm zoom, are expensive and even more difficult to justify.
- ♠ Intuitive controls. Compared to non-SLR cameras, the Nikon D200 and its siblings work more like a "real" camera, which is a boon for photo enthusiasts who prefer that their shooter work more like a film SLR and less like a DVD player. Wouldn't you really rather zoom in and out by twisting a zoom ring on the lens itself, rather than pressing and rocking a button while a tiny motor does the job for you? Do you prefer navigating a multilevel menu to change the white balance, or would you rather press the WB button and spin a dial on the back of the camera?

- ▶ Dirt and dust. Small dust specks barely enter the consciousness of point-and-shoot digital owners and are usually minor annoyances in the film world, at least until it comes time to make a print from a negative or slide. But nearly invisible motes are the bane of D200 owners, because no matter how careful you are when changing lenses, sooner or later a dust spot or two will settle on the sensor. This dust is generally not difficult to remove and may not even show up except in photos taken with a small f-stop, but the mere threat drives many D200 owners crazy. Sensor dirt needn't be a major issue, but any new D200 owner should be armed with an air bulb and other tools to keep that imager clean.
- No LCD preview or composing. If you're coming to the D200 from the non-SLR digital world, one of the first things you'll notice is that the LCD on a dSLR can be used only for reviewing photos or working with menus. There is no live preview, which usually isn't a problem until you want to preview an image taken through an infrared filter (which appears totally black to visible light), or use the LCD to frame a picture when holding the camera overhead or at waist level.

Quick Tour

ou're probably eager to start using your Nikon D200, and I don't blame you. No matter what type of camera you were using before—a film single lens reflex (SLR), some other type of digital camera, or even a different digital single lens reflex (dSLR)—it's exciting to hold such a sophisticated picture-taking tool in your hands.

In this Quick Tour, I cover everything you need to know to begin using the D200's basic features immediately. And by the end of the Quick Tour, you'll already be producing good images with your D200. Once you've gotten a taste of what your camera can do, you'll be ready for later chapters that explain the more advanced controls and show you how to use them to capture even better photos in challenging situations, or to apply them creatively to create special pictures.

This Quick Tour assumes you've already unpacked your D200, mounted a lens, charged and installed the battery, and inserted a CompactFlash card; it also assumes you have a basic understanding of things like focusing, shutter speeds, and f-stops. If you've reviewed the manual furnished with the camera, so much the better. (You'll definitely need to do so to work with later chapters in this book.)

I've included only the basics in this Quick Tour. If you really want (or need) to know more right off the bat, you should just skim this section and then jump ahead to Chapter 1.

Selecting a Picture-Taking Mode

Once your D200 is powered up, you should choose a picturetaking mode for your first pictures. You change modes by pressing the Mode button on the right side of the camera near the shutter release button, and then turning the main command dial on the back of the camera until the mode you want to use appears in the status LCD on the top panel.

In This Quick Tour

Selecting a picturetaking mode

Using automatic or manual focus

A few more options

Reviewing the image

Correcting exposure

Transferring images to your computer

You can find more information on all modes in Chapter 1.

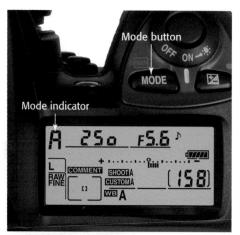

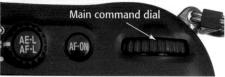

QT.1 You use the mode button and main command dial to set the picture-taking mode. The current mode appears in the status LCD on top of the camera.

The D200's main shooting modes are Program, Aperture Priority, Shutter Priority, and Manual, represented in the status LCD by the letters P, A, S, and M.

Program. When to Use: When you want your camera to make the basic settings, while still enabling you to have full control over adjustments to fine-tune your picture.

Don't Use: If you need to use a particular lens opening to control depth of field, or a certain shutter speed or shutter speed range to stop action or to use blur for creative purposes.

Aperture Priority. When to Use: When you want to use a particular lens opening, usually to control how much of your image is in sharp focus, and want the D200 to select a shutter speed for you automatically.

Don't Use: If there is insufficient light to produce a good exposure at your preferred lens opening, blurry photos can result. Conversely, Aperture Priority is not a good choice if there is too much light for your selected aperture with the available range of shutter speeds at the current ISO sensitivity setting.

Shutter Priority. When to Use: When you want to use a particular shutter speed, usually to freeze or blur moving objects, and want the D200 to select the lens opening for you automatically.

Don't Use: If there is insufficient light or too much light to produce a good exposure at the preferred shutter speed.

• Manual. When to Use: When you want full control over the shutter speed and lens opening to produce a particular tonal effect, or are using a lens that is not compatible with the D200's metering system. Manual can also be useful when you're working with external electronic flash units that aren't compatible with Nikon's i-TTL or Creative Lighting System, and you need to set the shutter speed and lens opening yourself.

Don't Use: If you are unable to measure or guess exposure properly, or you don't have time to adjust exposure after reviewing the LCD screen and histogram.

You can find more information on using histograms in Chapter 2.

Because it is a more advanced dSLR, the D200 does not have the "scene" modes you might have used with entry-level cameras from Nikon or other manufacturers. Called Digital Vari-Program (DVP) modes in the Nikon world, these settings include Auto, Portrait, Landscape, and other "canned" setups. Experienced photographers prefer to use Program, Aperture Priority, Shutter Priority, and Manual options the D200 offers because they allow a greater degree of control over exposure.

Using Automatic or Manual Focus

To use autofocus, you must be using a Nikkor autofocus lens, designated with an AF in its product name, as in AF, AF-S, AF-I, and so forth, or a Nikon-compatible autofocus lens from another manufacturer. Older Nikon lenses, as well as some current inexpensive and specialized lenses (such as those with the AI-S designation), are manual focus only.

The camera body has a lever next to the lens mount on the left side (as you hold the camera) that you can set to M (for Manual focus), S (for Single autofocus), or C (for Continuous autofocus). With the S setting, the camera locks focus when the shutter release is partially depressed, and keeps that focus point until you take a photo or release the shutter button. With the C setting, the D200 locks focus, but then it continues to refocus if the subject or camera moves until you take the picture or release the shutter button.

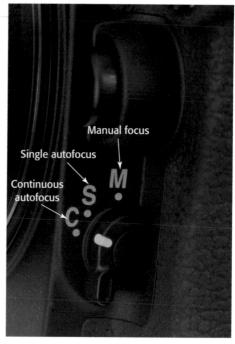

QT.2 The camera body focus-mode selector.

You learn how to choose these focus settings and set focus zones in Chapter 1.

In addition, some lenses, including the 18mm–70mm kit lens and the 18mm–200mm VR lens, have their own levers. In this case, set the camera body lever to C or S, and use the lens control to change between the automatic focus mode you've selected on the camera, and completely manual focus. The M/A designation on the lens reminds you that you can manually override the focus (by turning the outermost ring on the lens barrel) or leave it alone for the D200 to provide focus. The M position on the lens barrel means that focus will be set manually at all times.

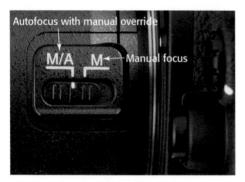

QT.3 The lens autofocus/manual lever.

To focus manually, twist the focus ring on the lens, as you would with a film SLR. To set focus automatically, partially depress the shutter-release button. If you set the D200 on automatic focus when using an AF lens, it locks into sharp focus. Brackets in the viewfinder that represent the area used to calculate focus flash red, and then a green light in the viewfinder glows, as long as the lens has a maximum aperture of f/5.6 or larger (f/5.6 to f/1.4).

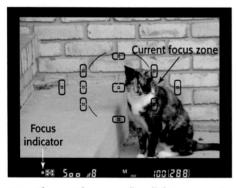

QT.4 The autofocus confirm light appears in the lower-left corner of the viewfinder, while the current focus zone is highlighted in red within the frame.

If you want the focus and exposure to be locked at the current values (so you can

change the composition or take several photographs with the same settings), hold down the AE-L/AF-L button.

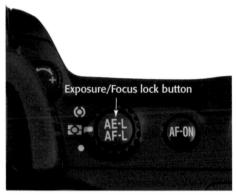

QT.5 Hold down the AE-L/AF-L button to lock exposure and focus.

Go ahead and press the shutter button all the way down. After the shutter is tripped and the mirror flips back into viewing position, the photo you just took is displayed on the LCD on the back of the camera, unless you've turned off review display.

Cross-Reference

You learn how to change the review and playback options in Chapter 1.

A Few More Options

You might want to activate a few more options for your first pictures. Here's a brief overview of the most common features you might want to use.

Applying the depth-offield preview

The D200 has a button called the depth-offield (DOF) preview that temporarily changes the lens opening to the one the Use the DOF preview to get a better idea of the range of sharp focus as it will appear in your final image. The preview image in the viewfinder is dimmer, of course, because you're viewing through a smaller aperture, but you can often get a good idea of the actual depth of field using this control because the amount of your subject matter in sharp focus more closely resembles what you get in the finished picture. Release the DOF preview button to restore the original bright view.

QT.6 Hold down the depth-of-field preview button to see roughly how much of your image will be in sharp focus at the current lens opening.

Using the self-timer and remote

Sometimes you'll want to delay taking the photo for a few seconds, or trigger the camera from a few feet away. Or, perhaps you're taking a long exposure and don't want to risk jiggling the camera when you press the shutter-release button. The self-timer provides this delay. The default camera value for the self-time is 10 seconds.

You learn how to change the self-timer's delay in Chapter 2.

To use the self-timer, follow these steps:

- Press and hold the mode dial lock button (shown in figure QT.7).
- Spin the mode dial and stop when the Self-Timer icon appears next to the indicator mark.
- 3. Compose your photo and, when you're ready, press the shutter-release button all the way down. The self-timer starts, with an accompanying blinking light on the front of the camera to warn you that a picture is about to be taken. If you've activated the Beep sound in the menus, you'll also hear a beeping noise. About two seconds before the exposure is made, the lamp stops blinking and the beeping speeds up.

Tip

Nikon recommends covering the viewfinder eyepiece with the eyepiece cap to prevent light from entering through the eyepiece, which can confuse the exposure meter. However, this extraneous light is seldom a problem unless a bright light source is coming from directly behind the camera.

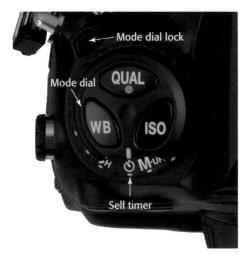

QT.7 Hold down the mode dial lock button while spinning the mode dial to choose the self-timer feature.

You can also trigger the D200 using the optional MC-20, MC-30, or MC-36 remote control cables, as well as the ML-3 infrared remote (which has a range of about 24 feet). These all plug into the 10-pin connector on the front of the camera.

Reviewing the Image

You can review the images you've taken at any time. Hold down the playback button and press the left and right buttons on the multi selector (unless you've moved this function to the up/down buttons using the menus) to move forward and backward among the stored images. The display "wraps around" so that when you have viewed the last image on your CompactFlash card, the first one appears again. The left and right buttons change the type of information about each image that's displayed on the screen.

Cross-Reference

Descriptions of all the playback and review options can be found in Chapter 2. In addition, you can perform the following functions with the other buttons shown in figure QT.8:

- Press the thumbnail button and spin the main command dial to cycle among display of a single full-sized image, four thumbnails, or nine thumbnails on the LCD.
- When viewing thumbnails, you can use the multi selector to navigate among the miniature images to highlight any of them. Then press the enter button again to enlarge the selected image to full size.
- Press the enter button when viewing an image, and then press the thumbnail button to zoom in on a selected image using the main command dial. The multi selector lets you move the zoomed area around within the full-sized image.
- Press the protect button to protect the selected image from accidental erasure.
- Press the delete button (the trashcan) twice (the second time to confirm the "Delete? Yes" message that pops up) to erase the selected image.

Correcting Exposure

Press the exposure compensation button (shown at the top in figure QT.9) and rotate the main command dial to the left (to reduce exposure) or to the right (to increase exposure). You'll see a display in the viewfinder like the one at the bottom of figure QT.9, with the plus or minus exposure highlighted on a scale.

Each increment on the scale represents either one-third or one-half of an EV (exposure value). Each EV value is equivalent to

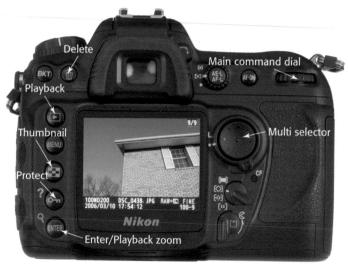

QT.8 Use the playback button and left and right keys to review the images on your CompactFlash card.

doubling or halving the size of the lens opening, or doubling or halving the length of time the shutter is open. Try adding or subtracting one increment at first, and then increase or decrease as necessary until the exposure suits you.

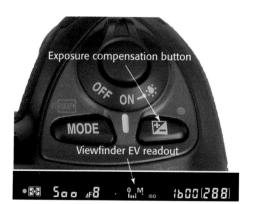

QT.9 Hold down the exposure compensation button and spin the main command dial to increase or decrease exposure.

Transferring Images to Your Computer

When you finish with a picture-taking session, you'll want to transfer the images from your CompactFlash card to your computer. You can link your D200 to your computer directly using the supplied USB cable or can remove the CompactFlash card from the camera and insert it into a card reader.

To transfer images from the camera to a computer using the USB cable:

- 1. Turn the camera off.
- Pry back the rubber cover that protects the D200's USB port, and plug the USB cable furnished with the camera into the USB port.
- Connect the other end of the USB cable to a USB port on your computer.

4. Turn the camera on. Your computer detects the camera and offers to transfer the pictures, or the camera appears on your desktop as a mass storage device, enabling you to drag and drop the files to your computer.

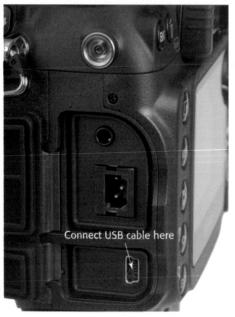

QT.10 Connect one end of the D200's USB cable to the camera and the other end into a USB port on your computer.

To transfer images from the CompactFlash card to the computer using a card reader:

- 1. Turn the camera off.
- Rotate the CompactFlash card door lever counterclockwise to release the cover and press the gray button, which ejects the card.
- 3. Insert the CompactFlash card into your memory card reader. Your installed software detects the files on the card and offers to transfer them. The card can also appear as a mass storage device on your desktop, which you can open and then drag and drop the files to your computer.

The files the D200 creates are automatically assigned names, such as DSC_439.jpg (for JPEG files) and DSC_4321.nef (for RAW files).

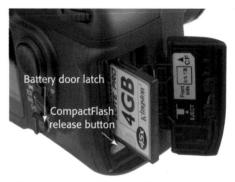

QT.11 Open the CompactFlash card door, press the gray button, and remove the card.

Using the Nikon D200

P A R T

In This Part

Chapter 1Exploring the Nikon D200

Chapter 2Nikon D200 Essentials

Chapter 3Setting Up Your D200

Exploring the Nikon D200

f you've gone through the Quick Tour and gained some basic familiarity with the layout and controls of the Nikon D200, you've probably gone out and taken some initial pictures with your camera. Even a few hours' of work with this advanced tool has probably whetted your appetite to learn more about the D200's features and how to use them.

For many of you, some of the information in this chapter will be a bit of a review. The D200 is a more sophisticated camera than Nikon's entry-level models, like the D70s and D50, so a hefty number of purchasers will be veteran photographers with extensive experience with digital single lens reflexes (dSLRs). It's likely that you've accumulated a year or two working with another Nikon digital SLR, perhaps even one of the pro models. (The D200 makes a great adjunct to the Nikon D2X!)

However, I think you'll still find the roadmap features of this chapter useful for helping you locate the key controls amidst the bewildering array of dials and buttons that cover just about every surface of the D200.

On the other hand, many new D200 owners are *not* old hands when it comes to digital SLR photography. Learning to use a D200 as a first dSLR poses a bit more of a challenge, but you won't have to upgrade in a short time as your needs outgrow the capabilities of your camera. It's likely that the D200 will serve you well for a long, long time.

For D200 owners in this category, I'm providing a bit more detail on controls and features in this chapter and those that follow. It's likely that you'll find the information in this book more accessible and easier to understand than the descriptions in the manual furnished with your camera. However, this book isn't intended to completely replace the manual—you'll still want to use it to look up seldom-used settings and options—but it will help you use your camera effectively more quickly.

CHAPTER

In This Chapter

Up front

On top

On the back

Viewfinder display

LCD display

Viewing and playing back images

Activating the onboard flash

Metering modes

Semiautomatic and Manual exposure modes

ISO sensitivity

Setting white balance

Although you may have reviewed your D200's buttons and wheels in the manual, this chapter's illustrations are designed to help you sort through the D200's features and controls quickly, especially when you're out in the field taking photos.

This chapter concentrates on the buttons, dials, and other controls that you can access directly, without visiting menus. Some of the settings discussed in this chapter, such as flash options or white balance, are duplicated in the menus or have additional options available from the menus.

This chapter does not cover the D200's menu and setup options. To learn more about the menu and setup options, see Chapter 2.

Up Front

The front panel of the Nikon D200 is shown in figure 1.1. You can't see all the buttons and controls from a straight-on perspective, so I'll show you separate, three-quartersview looks at each half of the front of the camera, which I've color-coded green (the left side of the camera when looking at it head-on) and red (the right side of the camera as seen from this angle).

1.1 The "business end" of the Nikon D200.

Most of the controls on the D200 are activated with the left hand. However, there are a few controls within the reach of your right hand's digits, as shown in figure 1.2. These controls and features include the following:

- ✦ Handgrip. The grip is the housing for the D200's battery, and also serves as a comfortable handhold for your fingers. You can hold the grip for both horizontal and vertical photos, but many D200 owners prefer using the grip on the optional vertical grip/battery pack, the Nikon MB-D200 Multi-Power Battery Pack, which enables you to use two batteries at once.
- ◆ Depth-of-field preview. This is the upper button (see figure 1.2) next to the lens mount. Press and hold the depth-of-field preview button. The lens stops down to the taking aperture, the view through the finder might dim a little (or a lot), and you can see just how much of the image is in focus.
- Func button. This is a button that you can define to provide the function of your choice. The available options (described in more detail in Chapter 3) include activating matrix, center-weighted, or spot metering; or turning the flash off. This button is also used with the FV lock to emit a preflash before locking the flash exposure.
- ◆ Sub-command dial. This is a secondary control dial used to supplement the main command dial on the back of the D200. It's used when you can apply two different, related settings, as in Manual exposure mode when you set the shutter speed using the main command dial and adjust the aperture using the sub-command dial.

Shutter release

Autofocus assist lamp
Self-timer lamp
Red-eye reduction lamp

Nikon

Nikon

Nikon

Func button

Sub-command dial Depth-of-field preview

1.2 Nikon D200 left-front side, viewed from the subject's position.

Another example of this use is when you set the white balance (which controls how the D200 reacts to illumination sources of different colors, such as daylight and incandescent light). The main command dial flips among the different light-source types, while the sub-command dial fine-tunes those settings. Although you can swap the command dials (turning the sub-command dial into the command dial, and vice versa) using the D200's menus, it's best to leave them in their default configuration to start out.

Front lamp. This front-mounted source of illumination serves three different functions: autofocus assist lamp, self-timer lamp, and red-eye reduction lamp. Under dim lighting conditions that make autofocusing difficult, you can set this light source to cast a little extra light on your subject to assist the autofocus system. If you've set your camera to self-timer mode, so that a picture is taken after a short delay, the lamp blinks in a pattern as a sort of countdown to the eventual exposure. Finally, this lamp also can send out a little blast of light

shortly before a flash exposure, which can serve to close down the pupils of your subjects' eyes, reducing the demon red-eye effect.

On/Off switch/Backlight illuminator. Rotate this switch one click to turn power on or off. Push the switch to its limit to turn on the status panel LCD backlight illumination lamp, making it easier to view the information on the panel. The lamp remains on while the exposure meter is active, or until you press the shutter release.

Note

Nikon Speedlights, as well as the Nikon SC-29 Speedlight cable, have their own lessobtrusive focus assist lights that can take over for the one built into the camera.

 Shutter Release button. Canted atop the handgrip are the Shutter Release button and power switch.

The other side of the D200 has a few more controls, as shown in figure 1.3. These include the following:

- Flash lock release. Press this button to pop up the built-in flash and begin charging it.
- ◆ Flash accessory shoe. You can slide an external flash unit, a flash connecting cable, or another accessory here. Infrared and radiocontrol units and other add-ons often use this shoe as a convenient mounting point on the D200.

- Flash sync mode/Flash exposure compensation. Nikon has kept the D200's design clean by assigning multiple functions to many buttons, and this flash control (shown in figure 1.4) is one of them. It serves two different purposes. Holding this button while spinning the command dial on the back of the camera changes flash sync modes, such as red-eye reduction, or slow sync (which combines flash and a regular exposure to lighten backgrounds). Holding this button while spinning the subcommand dial adds or subtracts from the flash exposure, making your flash picture a little lighter or darker, as you prefer.
- Lens release. Press and hold this button to unlock the lens so you can rotate the lens to remove it from the camera.
- ◆ Camera body focus mode selector. You can flip the autofocus mode lever on the camera body to set the focus mode to Continuous Autofocus (C), Single Autofocus (S), or Manual focus (M). Some lenses, as you can see in figure 1.3, also have switches that allow alternating between automatic focus/manual over-ride (M/A) and manual focus (M.)

Cross-Reference

You can find more information on choosing focus modes in Chapter 2.

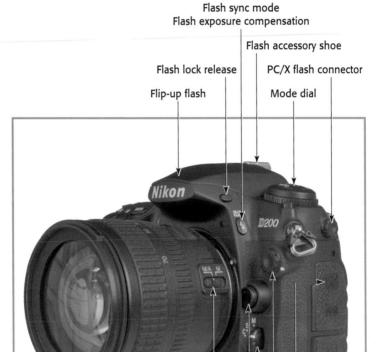

Camera body focus mode selector

10-pin remote connector

AC power/AV connector cover

Lens release

USB port cover

1.3 Nikon D200 right-front side, viewed from the subject's position.

Lens focus mode selector

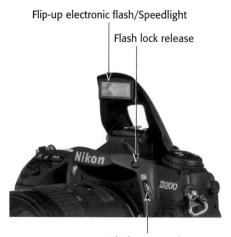

Flash sync mode Flash exposure compensation

- 1.4 Pressing the flash multi-function button (flash exposure compensation button) pops up the built-in electronic flash, ready for use.
 - PC/X flash connector. Remove the cover to access a PC/X-sync electronic flash connector for use with non-dedicated flash units, such as studio flash.
 - the protective cover to use the terminal with accessories like the Nikon MC-22, MC-30, or MC-36 remote cords (which function like the cable releases used with non-electronic film cameras), as well as other accessories, including infrared remotes, time-lapse photography devices, Global Positioning System accessories (to record latitude, longitude, and time with each still image), and cables that connect two cameras for simultaneous operation.
 - AC power/AV connector/USB port connector covers. On the side of the camera, you'll see two rubber covers that protect the D200's other external connectors.

These include the AC power connector, which can operate the camera without batteries (for, say, studio work or time-lapse photography). (The D200 uses the same EH-6 AC adapter as the D2X and D2Hs.) Just above the AC power connector is an AV plug that you can use to link the D200 to an external monitor for viewing pictures or menus. The bottom-most connector accepts the USB cable, which enables you to transfer pictures directly from the camera to your computer, and also lets you control the camera's functions using the Nikon Capture software.

On Top

The top surface of the D200 has its own set of controls, shown in figure 1.5. In addition, a bird's-eye view provides the best perspective of some of the controls on the lens. I've divided these controls into a pair of bite-sized color-coded pieces, too, with the red box assigned to the lens controls, and green box to the camera-body controls.

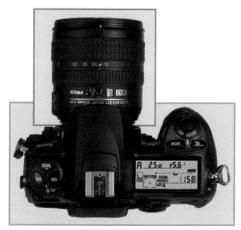

1.5 The top view of the D200 and the 18mm-70mm kit lens.

You can see the basic controls found on many zoom lenses in figure 1.6. Not all these controls are found on all lenses, however, and some of them might be in different positions on different lenses (particularly those not produced by Nikon). The key components are

- Focus ring. This is the ring you turn when you manually focus the lens. If the autofocus/manual switch (AF/M) on the lens is set to Autofocus, or the switch on the camera body is set to S or C, this ring has no effect. Some lenses, such as the kit lens, enable you to manually override the camera's autofocus setting; these ones are marked with an M/A-M switch instead. When the lens is set to M/A (and the camera body switch is set to S or C), you can use the focus ring to adjust the focus point set automatically. By convention, turning the ring toward the right (when looking down on the lens from above) increases the focused distance.
- ◆ Distance scale. This is a scale that moves in unison with the lens's focus mechanism (whether you activate it by manually focusing or the autofocus system activates it) to show approximately the distance at which the lens has been focused. It's a useful indicator for double-checking autofocus, and for roughly setting manual focus.
- ◆ Zoom ring. This is the ring you turn to change the zoom setting. With many lenses, turning this ring to the right increases the focal length, but you might find that the opposite is true with some lenses (which can be very frustrating!).

- Zoom scale. These markings on the lens show the current focal length selected.
- Lens hood bayonet/alignment guide. This is used to mount the lens hood for lenses that don't use screw-mount hoods.

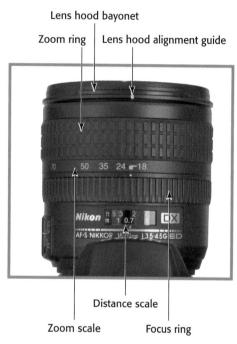

1.6 Key components of a typical zoom lens.

Figure 1.7 shows a single focal length, or prime lens—the 105mm Nikkor macro lens used for close-up photography. (This example happens to be the older, non-vibration reduction version.) This particular lens has some features that aren't available on the kit lens, but that are found on some other zoom and non-zoom lenses. Of course, because it doesn't zoom, this lens lacks the zoom ring and zoom scale. Other components include the following:

- Lens thread. Most lenses have a thread on the front for attaching filters and other add-ons. Some also use this thread for attaching a lens hood (you screw on the filter first, and then attach the hood to the screw thread on the front of the filter).
- Limit switch. Lenses with an extensive focus range (such as this macro lens) often have a switch that you can use to limit the range used by the autofocus system. For example, if you're not shooting close-up pictures, you can set the lens to seek focus only at more distant settings, which can save a bit of time.
- Aperture ring. The kit lens, as well as many other newer lenses, uses the camera's electronics exclusively to set the shooting aperture. These lenses, which include a G suffix in their name, have no aperture ring at all, and are compatible only with cameras that can set the f-stop through a control on the camera. Other lenses maintain compatibility with earlier cameras by including an aperture ring and a pair of aperture readouts (the numbers from f/32 down to f/2.8 in figure 1.7). The second, outermost readout is required by some cameras. These lenses include a D suffix in their name. Both G- and D-type lenses work fine with the Nikon D200 digital camera.
- Aperture lock. When using a Dtype lens on the D200, you'll need to set the aperture ring to the smallest f-stop, and then lock it in that position using the aperture

lock. Set it once and then forget about it, unless you need to mount the lens on an older camera or you've mounted the lens on an accessory such as a bellows or extension ring.

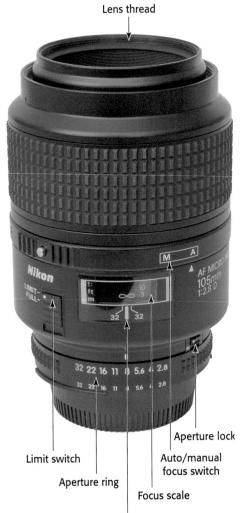

Depth-of-field indicator

1.7 Key components of a typical D-type lens.

The top panel controls include:

Mode dial. You turn this knurled wheel to change from single-shot, continuous shooting, self-timer, and mirror pre-release modes.

You can find more information about these modes in Chapter 2.

- Mode dial lock. Press this button to rotate the mode dial, which is ordinarily locked to prevent accidental changes.
- white balance. Hold down this button and rotate the main command dial to cycle among the preset white balance settings (which will be displayed on the LCD status panel). Press the button and rotate the sub-command dial to fine-tune white balance. Turn to the right to make the image more bluish (compensating for a yellow or red bias in the image) or to the left to add yellow/red (compensating for excessive blue color casts). You'll find more about setting white balance in Chapter 2.
- Image Quality/Reset #2. Hold down this button while rotating the main command dial to cycle among image quality settings (including RAW, JPEG, and the various RAW+JPEG options). Press the button and rotate the sub-command dial to change the resolution among Large (3872 \times 2592 pixels), Medium (2896 \times 1944 pixels), or Small (1936 \times 1296 pixels) sizes. (These correspond to 10.2, 5.6, and 2.5 megapixels.) Hold this button while simultaneously depressing the Exposure compensation/Reset #1 button for a few seconds to reset the camera to its default values.

- ◆ ISO. Hold down this button while rotating the main command dial to change the ISO in the range ISO 100 to ISO 1600, plus three boost settings (H0.3, H0.7, and H1.0), which take you up to the equivalent of ISO 3200.
- Flash accessory shoe. Mount an external electronic flash unit (Nikon calls them Speedlights), such as the Nikon SB-600 or SB-800, on this slide-in shoe. The multiple electrical contacts shown in the photo are used to trigger the flash and to allow the camera and flash to communicate exposure, distance, zoom setting, and other information. You can also attach other flash units made by Nikon and other vendors, but not all functions may operate.
- Monochrome LCD status panel. This LCD readout provides information about the status of your camera and its settings, including exposure mode, number of pictures remaining, battery status, and many other settings.
- Sensor focal plane. Some specialized kinds of close-up photography require knowing exactly where the plane of the camera sensor is located. This marker shows that point, although it represents the plane, not the actual location of the sensor itself, which is placed aft of the lens.
- Metering Mode/Format #1. Press this button while spinning the command dial on the back of the camera to change among Program, Aperture Priority, Shutter Priority, and Manual exposure. You can also use this button to format the memory card if you hold it down simultaneously with the

Format #2 button (described later in this chapter).

- ★ Exposure compensation/Reset #1. Hold down this button while spinning the command dial to add or subtract exposure from the basic setting calculated by the D200's auto-exposure system. Hold down simultaneously with the Image Quality/Reset #2 button to reset the D200 to its factory settings.
- Shutter Release button. Partially depress this button to lock in exposure and focus; press it all the way to take the picture. Tapping the shutter release when the
- camera has turned off the autoexposure and autofocus mechanisms reactivates both. When a review image is displayed on the backpanel color LCD, tapping this button removes the image from the display and reactivates the autoexposure and autofocus mechanisms.
- ◆ On/Off switch/LCD illuminator. Flip this switch to turn the D200 on or off. Move the switch all the way to the right to illuminate the LCD panel lamp, which remains active while the metering system is operating, or until you press the shutter release down all the way.

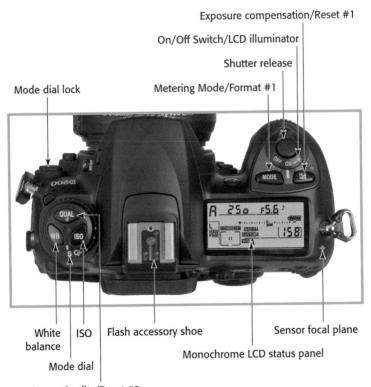

Image Quality/Reset #2

1.8. Key components on the top panel of the D200.

On the Back

The back panel of the Nikon D200 is studded with more than fifteen controls, many of which serve more than one function. Where other cameras can force you to access a menu to make many basic settings, with the D200, just press the appropriate button, turn the command dial or use the multi-selector, and make the adjustment you want. I've divided this crowded back panel into four color-coded sections.

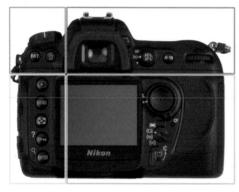

1.9 Key components on the back panel of the D200.

Upper left

The upper-left corner of the back panel includes just two buttons:

- Bracketing (BKT) button. Hold the bracketing button while spinning the main command dial (to select the bracketing function) and the sub-command dial (to choose the type of bracketing to be applied).
- Delete/Format #2. To erase the image shown on the LCD, press this button, and press a second time to respond to the "Delete. Yes?" prompt. This button also

serves as the Format #2 button to reformat a memory card when you hold it down for a few seconds simultaneously with the Mode/ Format #1 button.

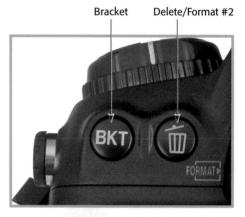

1.10 Key components on the upper-left corner of the back panel of the D200.

Upper right

A few important controls are located on the upper-right corner of the D200. They include:

- ♦ Viewfinder eyepiece. The rubber eyecup shields the viewfinder from extraneous light, much like a lens hood — a necessary component because light entering the viewfinder can affect the exposure meter. The eyecup is removable and can be replaced by a cap to block that extra light when you use the camera on a tripod.
- Diopter adjustment control.
 Rotate this knob to adjust the diopter correction for your eyesight.
- Metering mode dial. Rotate this dial to select among centerweighted, matrix, and spot metering options.

◆ AE/AF (autoexposure/autofocus) lock. Depending on settings you make in the Setup menu, pressing this button will lock exposure, focus setting, or both, either until you release the button or press it a second time.

For more on using the Setup menu, see Chapter 3.

- Activate Autofocus. Press this button to turn the autofocus system on. It serves the same function as partially depressing the shutter release, and you can use it to lock focus.
- Main command dial. This dial is spun to change settings such as shutter speed, bracketing, or shooting mode, depending on what function button you press at the same time.

Lower left

This is the D200's hot corner, because it has a collection of some of the function buttons you'll use frequently. They can each have multiple functions, so you need to keep your camera's current mode (playback/shooting, and so on) in mind when you attempt to access a specific feature. A more complete description of each button's functions appears later in this chapter. The buttons include:

- Playback. Use this button to enter the picture review (playback) mode.
- Menu. Use this button to access the D200's multilevel menu system.

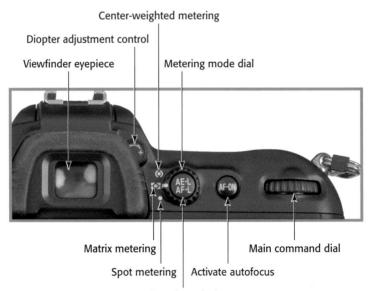

Autoexposure/Autofocus lock

1.11 Key components on the upper-right corner of the back panel of the D200.

- Thumbnails. In playback mode, use this to change the number of thumbnails displayed on the LCD, cycling among four, nine, or one full-frame image. When you press the Playback Zoom button, hold it down and rotate the main command dial to zoom in and out within an image.
- Help/Protect. When viewing the menus, press this button to view a help screen. In playback mode, press it to lock the current image from accidental erasure.
- Playback zoom/Enter. In playback mode, press this button once, and then hold down the thumbnail button while spinning the main command dial to zoom in and out of an image. When viewing menus, this button serves as an OK key.

Lower right

You'll find a second cluster of controls and components in the lower-right corner of the back panel:

- LCD. The color LCD displays your images for review and provides access to the menu system.
- Multi selector. You use this to navigate menus as well as scroll through photos you're reviewing (by pressing the left/right keys), and to change the type of image information displayed (by pressing the up/down keys), unless you've swapped these functions in the setup menus.
- Focus selector lock. This enables/disables manual focus area selection

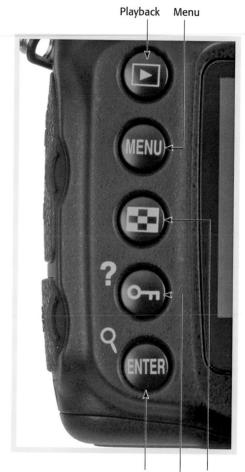

Playback zoom/Enter

Thumbnails

Help/Protect

- 1.12 Key components on the lower-left corner of the back panel of the D200.
- Autofocus area selector. Four positions enable you to change from single area autofocus, dynamic area autofocus, group dynamic autofocus, and dynamic area/closest subject autofocus.

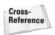

Chapter 2 contains extensive coverage of choosing focus area modes.

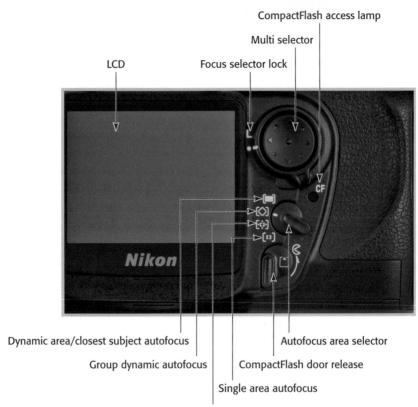

Dynamic area autofocus

- 1.13 Key components on the lower-right corner of the back panel of the D200.
- CompactFlash access lamp.
 This lamp blinks when an image is being written to the CompactFlash card.
- CompactFlash door release.
 Rotate this to open the
 CompactFlash door.

Viewfinder Display

The D200 provides a lot of status information in the viewfinder, although not all of it is visible at one time.

 Reference grid. An optional set of reference lines you can use to align images.

- Center-weighted metering reference. Shows the 8mm circle that's the default area for center-weighted meter readings. You can change the size of the circle you use in the menu system.
- ♠ Autofocus zones. Shows the areas used by the D200 to focus. Figure 1.14 shows the 11 normal-frame focus brackets that approximate the actual focus zones; you can set the display to show only the brackets that represent the 7 wide-area focus zones instead. The current active focus zone is displayed with red brackets.
- Black-and-white indicator. Appears when the D200 has been set to shoot in black-and-white mode.
- Battery indicator. Appears when battery power is low.
- No memory card warning. Alerts you that no Compact Flash card is loaded.
- Focus indicator. Illuminates when an image is focused correctly.
- Metering mode. Shows the current metering mode (centerweighted, matrix, or spot).
- Flash sync indicator. Shows the type of flash synchronization in use.
- Autoexposure lock. Shows that exposure and/or focus have been locked.
- Flash value lock. Shows when flash output has been locked at a preset level.

- Shutter speed. Selected shutter speed.
- F-stop. Selected lens opening.
- Exposure mode. Shows current exposure mode, from Program, Aperture Priority, Shutter Priority, or Manual.
- Exposure compensation. Shows the amount of over- or underexposure.
- Flash compensation indicator. Shows added or subtracted flash exposure has been applied.
- Exposure compensation indicator. Shows that exposure compensation has been applied.
- ISO auto indicator. Shows that ISO is being set automatically.
- ISO setting. Displays current ISO sensitivity.
- Remaining exposures/other functions. Multifunction display that shows the remaining exposures available, the number of shots remaining in the buffer, white balance preset status, exposure/flash compensation values, and PC/USB connection status.
- Flash ready. Lights when the Speedlight is charged for an exposure.
- Over 1,000 exposures remain.
 Shows that the number of remaining exposures indicated exceeds 1,000.

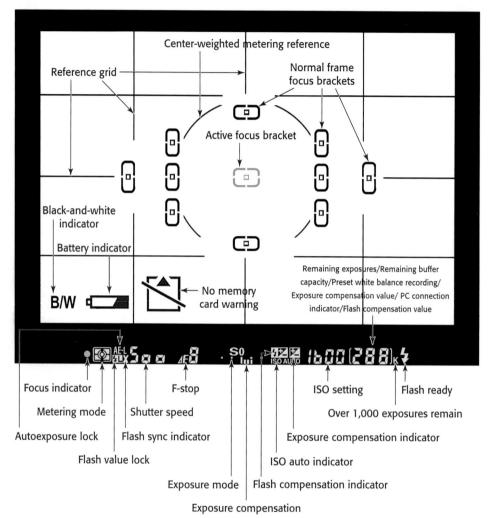

1.14 Viewfinder readouts and indicators.

LCD Display

The top-panel monochrome LCD display shows a broad range of current status information. This display is a bit much to bite off in one chunk, as you can see by the full display in figure 1.15. In practice, only a fraction of this information will be displayed at any one time, and some of the readouts (such as the GPS connection status indicator) are so specialized you might never see them at all under normal circumstances.

In figure 1.16, I've color-coded the various displays to keep them from all running together visually. They're not colored in real life, of course, but I think the coding makes them easier to keep separate here. Here's a list of what's what.

In dark blue (upper left):

 Exposure mode. Indicates whether Program, Aperture Priority, Shutter Priority, or Manual exposure mode is in use.

- Flexible program indicator. Shows that Program mode is in use and that you can change shutter speed/f-stop combinations to other equivalent exposures by
- Flash sync. Shows whether X or FP flash sync is in use (see Chapter 3 for more information on using flash sync).

rotating the main command dial.

Clock not set indicator. Shows that the date/time should be set, or that the permanent built-in clock battery must be replaced by an authorized technician.

In orange (lower left):

- Image size. Indicates the current resolution being used.
- Image quality. Shows whether image files are being saved in RAW format, Fine (JPEG), Normal (JPEG), Basic (JPEG), or RAW+Fine/Norm/Basic.

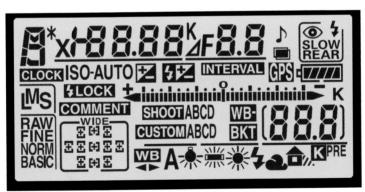

1.15 Top-panel LCD display readouts and indicators.

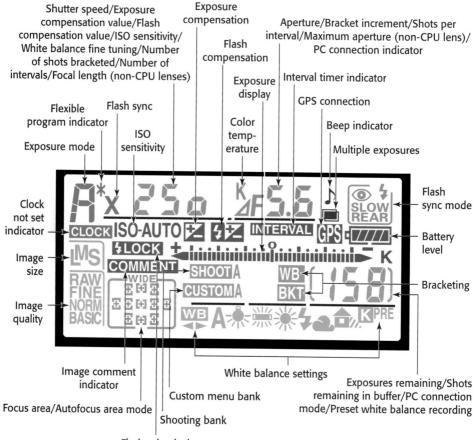

Flash value lock

1.16. Monochrome LCD readouts.

In magenta (bottom left):

Focus area/Autofocus area mode. Shows the currently selected focus area and type of autofocus operation in use. It also indicates whether Wide Frame or Normal Frame focus zones are used.

In light blue (bottom):

 White balance settings. Shows whether white balance is being set automatically, to one of the built-in settings, or to a manually preset value.

In gray (lower center):

- Shooting bank. Shows whether shooting bank A, B, C, or D is being used.
- Custom menu bank. Shows whether custom menu bank A, B, C, or D is being used.
- Bracketing: Shown when bracketing is active.
- Exposures remaining/other functions. Shows the number of exposures remaining (a K appears above the display if more than

1,000 exposures are possible); the number of shots available in the buffer; the PC connection mode; and the preset white balance recording. (There's more information on these options in Chapter 2.)

In brown (upper center):

- ISO sensitivity. Indicates that ISO sensitivity is being set automatically by the camera.
- Flash value lock. Shows that flash output has been locked at a setting.
- Image comment indicator. Shows that a comment is being applied to the images.
- Exposure display. Displays current exposure relative to exposure determined by metering system.
- Exposure compensation. Indicates that exposure compensation is being used. The amount of compensation (for example +0.7) is shown in the shutter speed readout area immediately above the indicator.
- Flash compensation. Indicates that flash compensation is being used. The amount of compensation is shown in the shutter speed readout area immediately above the indicator.
- Interval timer indicator. Shows that interval timer is being used.
- GPS connection. Appears when a GPS device is connected to the D200.

 Battery level. Shows the amount of charge left in the battery.

In green (upper right):

Flash sync mode. Shows the current flash synchronization mode: front-sync, rear-sync, slow-sync, and red-eye correction.

In purple (upper right):

- Beep indicator. Shows that the camera beep sound is activated.
- Multiple exposures. Displayed when D200 is in multiple exposure mode.

In red (top center):

- Shutter speed/other functions. Shows shutter speed; amount of EV and flash EV adjustment/ISO sensitivity/white balance finetuning/number of bracketed shots; number of intervals; and focal length of a non-CPU lens mounted on the camera. You'll find more information about these options in Chapter 2.
- Color temperature. Displayed when the color temperature is shown.
- Aperture/other functions. Shows f-stop, bracket increment; shots per interval; maximum aperture for non-CPU lenses mounted on the camera; and PC connection indicator.

Viewing and Playing Back Images

The D200's playback mode lets you review your images, delete the bad ones, and decide on exposure or compositional tweaks to improve your next shots.

Follow these steps to review your images:

- Press the playback button to display the most recently taken photo on the back panel LCD.
- Press the thumbnail button and spin the main command dial to cycle among single-picture display, or tiled views that show four or nine reduced-size thumbnails at one time

- Press the center of the multi selector button to toggle between full-frame and thumbnail display.
- In a single-picture display, the left and right keys on the multi selector move to the next or previous image. (You can change this behavior to the up/down keys in the menus if you prefer.)
- When viewing four or nine thumbnails, the multi selector keys navigate among the available images. Press the center of the multi selector button to view a selected image on the LCD in full size.

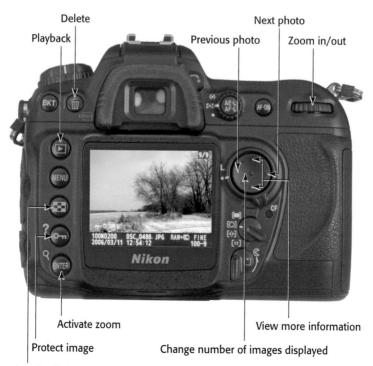

Thumbnail size/zoom in

1.17 Review your photos using the color LCD.

Press the Enter button to activate the zoom feature.

- Hold down the thumbnail button and use the main command dial to change the size of the zoomed area.
- Use the multi selector's cursor keys to move the zoomed area around within the enlarged view.

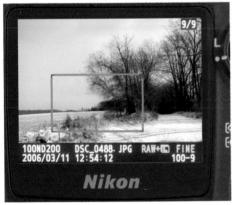

1.18 Moving the zoomed area.

- 4. Press the up and down keys on the multi selector while viewing an image to change the type of information shown with your preview. You can change the types of information available in the menu system, if you like. Your options include:
 - File Information. Shows the image and its filename, frame number, size, quality, folder name, and so on.
 - Shooting Data 1. Gives you a screen with more information, including the info in the basic File Information page, plus the

- camera name, date, time, metering and exposure methods, shutter speed, aperture, lens focal length, flash information, and any EV adjustment you've made.
- Shooting Data 2. Includes the File Information basics, plus the ISO setting, white balance, sharpening, color mode, hue, saturation, and some other data.
- GPS Data. Available if you've recorded Global Positioning System information with your D200 using a third-party GPS accessory.
- RGB Histogram. Adds a histogram graph to the basics that displays the relationship between the dark and light tones in the image, with separate histograms for red, green, blue, and grayscale (combined) data.
- Highlights. The brightest areas of an image are represented with a flashing border so you can easily see any portions that might lack detail because of overexposure.
- Histogram. This display is a larger, grayscale-only histogram superimposed on the image.
- 5. Press the protect button to keep the selected image from being accidentally erased. You can still remove the photo if you reformat the card, however.
- Press the delete button to erase the selected image. You must press a second time to confirm.

Activating the Onboard Flash

Unlike some of Nikon's other dSLR models that have the capability of activating the electronic flash (and popping it up from its retracted position automatically) when the camera detects low light levels suitable for flash photography, you must always activate the D200's flash unit manually. Pop up the flash by pressing the flash button on the left side of the camera.

Chapter 4 contains more information using flash.

If you're using Program, Shutter Priority, Aperture Priority, or Manual modes, hold down the flash button and spin the main command dial to switch among:

- ◆ Front-curtain sync. The flash fires as soon as the shutter opens. Set the shutter speed of your choice (generally up to 1/250 second) when using Manual or Shutter Priority modes. In Program and Aperture Priority modes, the D200 sets the shutter speed between 1/60 and 1/250 second.
- Red-eye reduction. Triggers the front-panel lamp (also used for focus assist) 1 second prior to exposure to reduce the red-eye effect.
- Slow sync. Uses slow shutter speeds (as long as 30 seconds) to add background illumination to the flash exposure. It is not available with Shutter Priority or Manual modes.

- Slow sync with red-eye. Adds red-eye reduction to slow sync mode.
- Rear-curtain sync. The flash is delayed until just before the shut-

1.19 Flash options.

ter closes. This records the flash image after any "ghost" images from the ambient light caused by moving objects so the ghost images seem to "trail" the flash image.

In certain modes, such as Program mode, the camera's viewfinder will signal the user with an icon when flash is suggested so that the user can press the flash button to raise the flash head.

Metering Modes

The D200 can use any of three different exposure metering methods when it's set to any of the semi-automatic or Manual exposure modes (which I discuss later in the chapter). Select the metering mode by turning the metering selector dial to the right of the viewfinder eyepiece:

Matrix. The camera examines 1,005 pixels in the frame and chooses the exposure based on that information (plus, with Type G and D lenses, distance range data).

Centerweighted.

The camera collects exposure information over the entire frame. but when making its calculations emphasizes the 8mm center circle (or other size chosen by vou, which include 6mm. 10mm. 13mm, and an averaging option) shown in the

option)
shown in the
viewfinder. You'll find more details
on these options in Chapter 2.

 Spot. Exposure is calculated entirely from a 3mm circular spot approximating the currently selected focus area.

Semiautomatic and Manual Exposure Modes

The Nikon D200 has three semiautomatic exposure modes that enable you to specify shutter speed, aperture, or combinations of the two; and a Manual exposure mode that gives you the complete freedom to set the shutter speed and aperture. You also set these four exposure modes using the mode dial. Your choices include:

- Program. In this mode, the D200 automatically chooses an appropriate shutter speed and f-stop to provide the correct exposure. However, you can override these settings in several ways. In all cases, if your attempted adjustments result in an exposure beyond the range of the system (that is, you're asking for a shutter speed or f-stop that's not available), either HI or LO appears in the viewfinder.
 - Rotate the main command dial to the left to change to a slower shutter speed and smaller f-stop combination that provides the same overall exposure.
 - Rotate the main command dial to the right to change to a higher shutter speed and larger f-stop combination that provides the same overall exposure.
 - Hold down the EV button and rotate the main command dial to the left or right to add or subtract exposure from the metered exposure reading.
- Shutter Priority. In this exposure mode, you specify the shutter speed with the main command dial, and the D200 selects an appropriate f-stop. The HI and LO warnings appear if you exceed the range of available settings.
- Aperture Priority. In this exposure mode, you specify the f-stop to be used with the sub-command dial, and the D200 selects the shutter speed for you, or displays the HI and LO indicators if this isn't possible.

Manual. You can select both the shutter speed and f-stop using the main and sub-command dials. The D200 still lets you know when proper exposure is achieved using the exposure readout in the viewfinder.

ISO Sensitivity

The D200 can choose the sensitivity setting (ISO) for you automatically, or you can manually choose a setting. Just follow these steps:

- If the LCD monitor is on, tap the shutter-release button to cancel the display.
- Hold down the ISO button on the mode dial on top of the camera.
- Rotate the main command dial to choose an ISO setting. Choose from ISO 100 to ISO 1600, or one of the boosted settings, Ho.3, Ho.7, and H1.0, which provide the equivalent of approximately ISO 2080, ISO 2720, and ISO 3200.

Cross-Reference

You can alternatively set ISO and white balance using the menu system, which is discussed in Chapters 2 and 3.

Setting White Balance

To more closely match the D200's color rendition to the color of the illumination used to expose an image, you can set the white balance. To use a preset value, follow these steps:

- If the LCD monitor is on, tap the shutter-release button to cancel the display.
- 2. Hold down the white balance button on the mode dial on top of the camera.
- 3. Rotate the main command dial to choose a white balance. Choose from among auto, incandescent, fluorescent, direct sunlight, flash, cloudy, shade, and preset. The sub-command dial can be used to fine-tune white balance settings or choose exact color temperatures.

You can also set white balance using the menu system, where you have additional options for fine-tuning or defining a preset value, which is explained in Chapter 2.

1.21 White balance options.

There is more information on ISO and white balance in Chapter 3.

Nikon D200 Essentials

nce you've learned the basic layout of the Nikon D200 and how to activate its primary controls, there are two more tasks to complete to gain total mastery over your digital SLR. First, you'll need to learn how to apply the D200's exposure, focus, white balance, and image-tweaking controls. I show you how to do that in this chapter. Then, you'll be ready to use the camera's other playback, shooting, setup, and custom menu settings to define the default values for other parameters, which you tackle in Chapter 3.

As you work through these next two chapters, you'll find that the D200 has a dazzling array of options and choices you can make. Although the large number of alternatives available might seem daunting at first, you'll soon discover that the ability to fine-tune the way your camera operates gives you the greatest possible control over your results.

There are four key components of high-quality images, and in this chapter, I explain the controls you can use to fine-tune them. The keys are:

- ▶ Exposure. The settings that impact exposure include metering modes (how the D200 collects its exposure information); exposure modes (how the camera selects the appropriate shutter speed and/or aperture); exposure adjustments (changes you can make to increase or decrease the exposure); and ISO (the relative sensitivity of the sensor). The D200 also makes it easy to customize the tonal values captured. You'll find more about exposure in Chapter 4.
- ▶ Focus. The D200 allows you to specify which areas on the screen are given priority when an image is automatically brought into sharp focus. You can also choose whether the camera refocuses continually or locks focus at some point. You'll find a good discussion on focus in Chapter 5.

C H A P T E F

In This Chapter

Metering modes

Adjusting exposure for EV

ISO sensitivity

Using noise reduction

Using automatic, semiautomatic, and manual exposure modes

Working with autofocus

Other image parameters

Setting white balance

- ◆ Color. You can adjust overall color balance by choosing a white balance setting, or allowing the D200 to set white balance for you. You can also enrich color by increasing saturation or by fine-tuning the hues applied to an image. You'll find everything you need to know about these options in this chapter and Chapter 3.
- ◆ Sharpness. The apparent sharpness of an image is an important component of image quality, too. It's dependent on a variety of factors, including the resolution you've selected, the amount of compression (which can discard some detail) if you're using JPEG or compressed RAW file formats, as well as things that I'll address in the exposure and focus sections, as sharpness can be affected by the lens opening, shutter speed, and focus accuracy.

Metering Modes

The Nikon D200 has three different metering modes selected by the metering mode dial to the right of the viewfinder

- Matrix
- + Center-weighted
- Spot

Each governs how the camera collects information about the quantity and distribution of the light passing through the lens and, then, to the sensor. Each mode has its own advantages and weaknesses. As you learned in Chapter 1, you can select any of the three modes by rotating the metering selector switch on the back of the camera, located to the immediate right of the viewfinder.

Matrix metering

When the D200 is set to matrix metering, it uses a sensor array in the viewfinder that consists of 1005 pixels that measure both the intensity and color of the measured points in the image. If you're using a Nikon D- or G-type lens, the metering system also takes into account the focus distance. When all three types of information are available, Nikon calls the result 3D Color Matrix II (because it's the second version of the technology the company has used). However, the D200 is able to use a subset of these factors if necessary, actually switching out of matrix metering into center-weighted metering if you're using an older lens and haven't entered the focal length and maximum aperture into the Non-CPU lens data entry in the Shooting menu. Table 2.1 shows the possible combinations.

The 1005 sensor cells are distributed throughout an area that covers roughly 60 percent of the image frame, ignoring a narrow strip at the top and bottom of the frame, and wider rectangles at the right and left sides. A very rough layout of the grid appears in figure 2.1. The information collected is used by a sophisticated set of algorithms that make some educated guesses about what kind of photo you're taking and, thus, what kind of exposure will be best.

Table 2.1 Matrix Metering Combinations				
Metering Mode	Lens	Parameters Used		
3D Color Matrix II	G- or D-type lens	Distance, color, intensity		
Color Matrix II	Non G- or D-type lens with CPU chip	Color, intensity		
Color Matrix	Non-CPU lens with aperture and focal length entered in Non-CPU lens data in Shooting menu	Color, intensity		
Center-weighted	Non-CPU lens, with no data entered	Intensity, center-weighted		

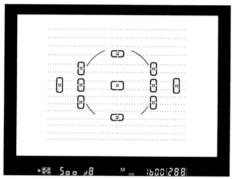

2.1 Matrix metering collects exposure information from a 1005-cell grid.

For example, the distribution of the brightness levels within the image area and their distance can often tell the camera the type of picture you're taking. Bright areas in the upper part of the frame can be assumed to be the sky. If you focus the camera at infinity, the algorithms assume you're taking a landscape photo and try to balance exposure so there will be detail in both the sky and foreground. Should you focus the camera much closer, the subjects in the foreground will be assigned greater importance and exposed properly, even if the sky ends up overexposed or underexposed.

Thanks to a database derived from information about more than 30,000 photos, the matrix metering system does a good job of pinpointing what kind of photo you intend to take. It can determine whether or not your scene is high in contrast (there are sharp differences in brightness) or low in contrast (much of the scene has pretty much the same intensity). The D200 can then make adjustments to preserve detail in the shadow areas of very contrasty scenes (chiefly by underexposing the image) or retaining detail in both shadows and highlights if the image has normal or lower contrast. The color portion of the 3D Color Matrix metering equation enables the camera to make decisions based on the quantity of light colors (such as yellows) as well as dark colors (such as dark green), rather than simply intensity alone.

Because the D200 is able to make such intelligent decisions about your image and the exposure it requires, matrix metering is usually your best all-around choice for a metering mode.

You can read more about exposure in Chapter 4.

Center-weighted metering

As you might guess from the name, center-weighted metering bases the exposure on the intensity of the entire frame, but with most of the emphasis on a circular area in the center. The central area, approximately an 8mm circle, determines about 75 percent of the exposure setting, as shown in figure 2.2. However, you can change this to a 6mm, 10mm, or 13mm circle. The rest of the frame is given a 25 percent weighting. You can also switch the D200 from center-weighted metering to a mode that averages the entire frame to calculate exposure.

For more detailed instruction on how to change the exposure setting for center-weighted metering, see Chapter 3.

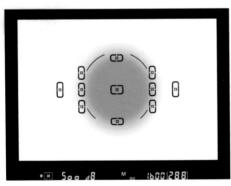

2.2 Center-weighted metering assigns a 75 percent priority to the center of the frame.

Center-weighted metering is a good choice when you know that your most important subject matter always resides in the center of the frame, but you also want to take into account the brightness of the other parts of the picture. Portraiture and some kinds of close-up photography lend themselves to center-weighted mode, which provides consistent exposures without the variation that can result from the matrix metering system.

The averaging option can work when your frame is fairly low in contrast and the entire image is equally important from an exposure standpoint.

Spot metering

Spot metering confines its data collection from a circle measuring 3mm in diameter, located at the currently active focus area. That means you can calculate exposure based on a tiny two-percent area of the frame, which can move around in response to the autofocus system, or position manually. Simply switch to spot metering mode by rotating the metering selector switch next to the viewfinder, partially depress the shutter release, and meter from the focus zone highlighted in red. If the focus zone isn't locked, press the multi selector to move to a different zone. Unlike spot metering systems of old, you aren't limited to a center spot, unless you're using a non-CPU lens or have selected dynamic area autofocus with closest subject priority (more on that later in this chapter). In either case, the center area is used for metering. Figure 2.3 shows the approximate size of the spot metering area.

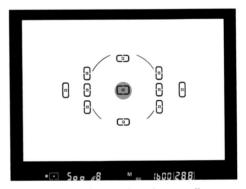

2.3 Spot metering reads only a small, moveable circle centered around an autofocus zone.

This type of exposure is a good choice if your subject isn't moving around a lot and there is a dramatic difference between the illumination falling on the subject and the rest of the frame. For example, you might find spot metering useful at a concert to measure exposure from a spot-lit performer surrounded by inky darkness.

Adjusting Exposures with EV

Exposure value (EV) settings represent additional or less exposure than that indicated by the D200's exposure meter. Each 1/3 or 1/2 EV increment (choose the step size in the Custom Settings menu) represents 1/3 or 1/2 stops' worth of exposure. To add or subtract exposure compensation, hold down the EV button on top of the camera and rotate the main command dial to the left (to add exposure) or right (to subtract exposure).

Note

To access the Custom Settings menu adjustments in this chapter, press the Menu button, choose Custom Settings Menu, and select the submenu described. Each submenu is prefaced by a letter from a to f, so CSM b3 (to change the EV increment between 1/3 and 1/2 EV) would be the third entry in the b submenu.

Chapter 3 details how to use the Custom Settings menu.

An icon appears in the LCD status panel and viewfinder to indicate that you've selected an exposure other than the metered value, and the analog exposure displays flash and show how much compensation you've applied. You can set up to +5.0 EV or -5.0 EV. Your EV adjustment doesn't change after

you've taken a photo, so be sure and change back to 0 EV when you want to return to using the actual metered value. If you don't and begin shooting a different subject, you can end up with photos that are underexposed or overexposed, because of the unnecessary EV adjustment.

You can find complete information on adjusting exposure in Chapter 4, which concentrates on the whys of fine-tuning your settings.

Using histograms

Histograms are the best way to determine whether you need to use the EV controls to tweak your exposure. *Histograms* are a kind of chart that show the relative distribution of tones in an image, using a curve that resembles a mountain with foothills at either side. Your goal is to place as many tones in the histogram's curve as possible within the dark and light limits of the graph, located at the left and right edges, respectively.

Like most dSLRs, the Nikon D200 can't display a live histogram. So, to evaluate your settings and exposure, you need to take a shot, examine the histogram that results, and make an adjustment for your next photo.

To use the histogram feature, just follow these steps:

1. First make sure histograms are displayed on your LCD. In the Playback menu, choose Display Mode, and mark the box for Histogram in the list that appears. As you gain experience with histograms, you might also want to mark the box next to RGB Histogram, which shows separate graphs for red, green, blue, and overall histograms.

- Press the Playback button to view the image you want to evaluate.
- 3. Press the multi selector's Up or Down buttons until the histogram display appears on the screen. If you've redefined the function of the multi selector buttons so the Left and Right buttons change the information display, use those keys instead.
- Evaluate the histogram, and then tap the shutter release to activate the metering system again.
- 5. Adjust EV settings. To move the tones you saw in the histogram to the right to improve detail in the highlights or to add specular highlights, hold down the EV button and rotate the main command dial to the right. To move the tones to the left and increase the detail in the shadows, hold down the EV button and rotate the main command dial to the left. An ideal histogram looks approximately like the one on figure 2.4.
- Shoot another picture and repeat steps 2 through 5, if necessary, to fine-tune your exposure further.

2.4 Moving the tones to the right to improve highlight details is a standard technique.

You'll find additional tips for using histograms in Chapter 4.

Bracketing exposures and other parameters

Auto bracketing is a fast way to apply different settings to several successive exposures, using parameters that include exposure, flash exposure, and white balance. You can bracket exposure or flash exposure only, or both of them, or white balance only.

To set up your camera for automatic bracketing, follow these steps:

 Choose which type of bracketing you want to use (for example, exposure only, or exposure plus flash exposure) in the Customs Settings Menu e5.

See Chapter 4 for details on using the Custom Settings menu.

- 2. Select the order in which you want the bracketed exposures to be applied. You can choose from Metered Exposure/Under Exposure/Over Exposure or Under Exposure/Metered Exposure/Over Exposure. There is little practical difference among these; the choice is your personal preference. The latter setting provides a natural progression from dark to lighter to lightest, and is the one I prefer.
- 3. Hold down the BKT button and rotate the main command dial to choose the number exposures in the bracketed set (either 3, 5, 7, or 9 exposures). Rotate to the right to start with overexposure, or to the left to start with underexposure.

4. Hold down the BKT button and rotate the sub command dial to select the exposure increment to be applied. The values available will be 0.3, 0.7, or 1.0 stops if you've set the D200's EV settings for 1/3 stop increments; 0.5 or 1.0 stops if you've specified 1/2 stop increments. Use Custom Settings menu b3 to change this. You can use only whole increments for bracketing if you've set b3 to 1-stop increments.

Note

Indicators will appear in the viewfinder and LCD status panel showing that auto bracketing has been activated.

5. Take your photos. Bracketing will be applied for the number of shots you've chosen. You can take the photos one at a time by pressing the shutter release, or set the D200 for Continuous shooting. To do this press the mode dial lock button and rotate to the C_L or C_H positions (continuous low speed and continuous high speed) and snap off all your bracketed exposures in a burst.

Depending on the number of shots you've requested and the EV increment, there are a total of 48 different exposure bracketing programs possible. You can find a complete list on pages 198 and 199 of the D200 manual, but it's easy to visualize what will happen based on your settings. All you need to remember is that smaller increments and larger numbers of exposures lead to more finely-tuned shots over a larger exposure range, and larger increments and smaller numbers of exposures provide changes in larger increments.

For example, if you've chosen 7 exposures using a 1/3 stop increment and selected Metered/Under Exposure/Over Exposure, the legend 7F0.3+ appears in the view-finder and status LCD, and your exposure compensation will be as follows (with the metered exposure, represented by 0 compensation, listed first):

$$0, -1.0, -0.7, -0.3, +0.3, +0.7, +1.0$$

Select 9 exposures, and a 1/2 stop increment instead, and your exposures will look like this:

Exposure bracketing is an excellent technique for experimentation. You can shoot a range of pictures with slightly different exposures and choose the one that provides the best rendition or an interesting effect.

When ISO Auto is activated (see the following section), and vou've chosen AE Only (autoexposure only) or AE & Flash bracketing, the D200 "brackets" by changing the current ISO sensitivity only. The shutter speed and f-stop remain the same for all bracketed exposures. This setup is a good choice for bracketing if you want to use the same shutter speed and aperture for all the bracketed exposures, and you don't mind the additional noise that can result if the ISO shifts stray into the high end of the ISO scale (ISO 800 or higher). If vou want all the bracketed images to be taken at the same ISO setting, turn ISO Auto off. White balance bracketing is not available when shooting with any NEF image quality option.

Customized exposure and contrast tweaks

The D200 lets you adjust the camera for more or less contrast, set a custom tonal curve, plus make other image adjustments in the Optimize Image section of the Shooting menu. Because these options don't affect the main exposure settings per se, I'll describe them later in this chapter.

However, I'm not going to cover changing the shape of tonal scales using custom curves because that ventures deeply into image editing territory, where you use an advanced tool like Photoshop. Entire chapters, and even a few books, have been written on fiddling with curves, and you really need to explore that topic as it relates to image editing. The D200 does enable you to upload special customized curves you create for your camera for specific shooting situations or to upload curves you obtain from third parties.

You create personalized curves and perform uploading using a program like Nikon Capture. Once your curve has been sent to the D200, you can apply it by choosing Optimize Image ⇔ Custom ⇔ Tone Compensation ⇔ Custom in the Shooting menu. Unless you plan on trusting the usefulness of canned curves others have prepared (your results can vary; custom curves depend a lot on personal taste), using custom curves is an advanced topic beyond the scope of this field guide.

Read more about Nikon Capture in Chapter 8.

ISO Sensitivity

ISO represents the relative sensitivity of your sensor to incoming light, and affects exposure by increasing or reducing the setting required for the shutter speed and aperture. Lower ISO settings mean that in the same situation, you'll need to use lower shutter speeds and/or larger f-stops to achieve the proper exposure, while higher ISO settings call for higher shutter speeds and/or smaller f-stops.

ISO is easy to set. Just hold down the ISO button on the mode dial, and spin the main command dial to choose any ISO setting from ISO 100 to ISO 1600, in 1/3, 1/2, or 1.0-step increments. (You can choose which increment in Custom Settings menu b2.)

In addition to the standard ISO settings, the D200 has three more boosted settings up to the equivalent of ISO 3200 that you can select using the ISO button and main command dial: ISO H0.3, ISO H0.7, and ISO H1.0 (the H stands for High Speed). You can also choose ISO settings using the ISO Sensitivity setting in the Shooting menu, as shown in figure 2.5.

	ISO Sensitivity	
	100	► ок
4	125	
(y)	160	
U	200	
	250	
	320	
	400	

2.5 You can set ISO sensitivity from the Shooting menu.

The D200 has an automatic ISO sensitivity option, which increases the ISO setting (up to a maximum of ISO 1600) whenever there isn't enough illumination at the current ISO setting to take an optimally exposed photograph. This feature is commonly found on point-and-shoot cameras, usually as the default setting. The theory is that any picture at all - even one that has a bit of extra grain caused by a higher ISO setting-is better than one that's terminally dark or blurry from using a shutter speed that's too slow to stop camera shake. It can be disconcerting to think you're shooting at ISO 400 and then see a grainier ISO 1600 shot during LCD review. The D200 provides an ISO Auto alert in the viewfinder and top panel status LCD, and this alert flashes whenever the ISO is changed from your setting, though the warning is easy to miss.

By default, when ISO Auto is activated, the D200 increases the ISO setting from 100 to as high as ISO 1600 whenever a shutter speed of 1/30 second or slower is indicated by the exposure mode in use. However, the camera doesn't know whether you're handholding the camera or have it mounted on a tripod. If the camera is solidly braced, you might find shutter speeds as slow as 1 second to be entirely acceptable at the ISO setting you've specified. Or, if you're using a longer lens, you might appreciate an automatic ISO boost when the shutter speed drops below 1/125 second. So, it's likely that ISO Auto will make a decision that's different from the one you yourself might make.

You can turn off the D200's capability to make automatic ISO adjustments entirely by disabling the setting in the Custom Settings menu option b1, shown in figure 2.6. A better choice might be to spell out to the D200 acceptable conditions to use this adjustment:

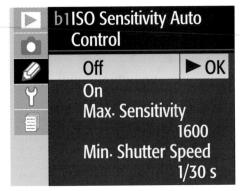

2.6 Turn off ISO Auto in the Custom Menu Settings.

Use the Max. Sensitivity option in CSM b1 to specify the maximum acceptable ISO, in the range of ISO 200 to ISO 1600. Once the ISO is set, the D200 will not raise it past that point when ISO Auto is activated. If you want to keep noise to a minimum, but are still willing to let the camera boost ISO a bit when necessary, use a relatively low value, such as ISO 200 or ISO 400. When the possibility of grain is less of a worry, set this value to a higher number, such as ISO 800 or ISO 1600 (see figure 2.7).

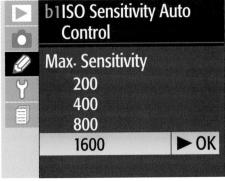

2.7 Choose the Max. Sensitivity setting.

 Specify the Min. Shutter Speed that needs to be exceeded before the ISO is increased. You can select from the range of 1/250 second to 1 second. If you're using a telephoto lens and are concerned about camera shake that might result from a shutter speed that's too low, use a higher value. such as 1/250 second, to allow the D200 to boost ISO (within the limits defined by Max. Sensitivity) when a longer shutter speed is required. If you're using a shorter lens, you might not be worried about camera shake until the shutter speed exceeds 1/30 second. and you can set this parameter to that value (see figure 2.8). You'll probably rarely use the very longest settings allowed: No one can handhold a camera at 1/2 second or 1 full second and expect to get a good shot, and, if the camera is mounted on a tripod, you probably won't care if shutter speeds are longer.

	b1ISO Sensitivi Control	ty Auto
4	Min. Shutter Sp	eed
Y	1/30 s	► OK
	1/15 s	
	1/8 s	
	1/4 s	
	1/2 s	

2.8 Specify a minimum shutter speed.

Using Noise Reduction

There are several ways to produce noise. Some is caused by increasing the ISO value, so that digital interference in an image is amplified along with the signal. Other bits of noise result from electrical interference between adjacent pixels. Noise can also result from longer exposures, as the sensor heats and produces spurious artifacts.

The D200 uses special algorithms to reduce the amount of noise in your images. The only drawbacks to this noise reduction can be a slight loss of detail when the D200 inadvertently removes non-noise, and the extra time involved with exposures longer than about 8 seconds, when a special process kicks in, and the camera takes a second, blank frame to use as a comparison between your original shot and a so-called dark frame. When this process is underway (a blinking message Job nr appears in the viewfinder and status panel), your 8-second exposures stretch into 16-second pauses while the D200 does its stuff. Each 30-second exposure ends up taking a full minute.

The D200 is equipped to deal with most kinds of noise. You can use one of two options in the Shooting menu.

High ISO NR. This setting has four options, shown in figure 2.9: three variations of On and one choice for Off. All three On settings apply noise reduction whenever you use a sensitivity of ISO 400 or higher. Choosing Low, Normal, or High applies increasing amounts of noise reduction, while slightly reducing the amount of detail as the algorithms sacrifice a little sharpness for the sake of fewer grainy speckles. Choose Off to eliminate high ISO noise reduction for all ISO

sensitivities below ISO 1600. At ISO 1600 or higher, the D200 applies only minimal noise reduction when you use the Off setting.

Long Exp. NR. This feature kicks in at exposures of about 8 seconds or longer, using Dark Frame Subtraction and increasing the total length of your recording time by up to 100 percent. You can set this option to On or Off.

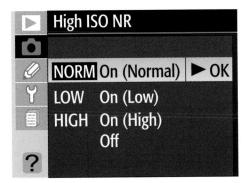

2.9 Choose the amount of noise reduction applied at high ISO settings.

If you find you don't like the wait, or want to customize the amount of noise reduction you apply, you can also perform noise reduction tasks with image editors like Adobe Photoshop; cut noise when importing RAW files using Adobe Camera RAW, Nikon Capture, and other RAW utilities; or use noise zapping programs like Noise Ninja (www. picturecode.com).

Using Automatic, Semi-Automatic, and Manual Modes

The Nikon D200 has four basic exposure modes, including one fully-automatic mode

(which, nevertheless, you can fine-tune as you work) called Programmed Auto; two semi-automatic modes (you set either shutter speed or f-stop and the camera selects the other) called Shutter Priority and Aperture Priority; as well as Manual mode, in which you set both shutter speed and aperture, but receive feedback from the camera that indicates when the nominally correct exposure has been set.

These modes work as described when you're using any Nikon-compatible lens of the modern sort-that is, one equipped with a CPU that provides the D200 with information about the lens, including its maximum f-stop, focal length, and other data. If you're using an older, non-CPU, lens, including AI and AI-S lenses produced after 1977 (or pre-1977 lenses that have been converted for AI compatibility), these modes are still used. Aperture Priority is automatically selected when a non-CPU lens is mounted, and the camera sets the shutter speed based on the f-stop you've chosen. You can also set manual mode and the camera's meter will indicate when the proper exposure has been set with the non-CPU lens.

Set exposure mode by holding down the mode button on top of the D200, and rotating the main command dial until either P, A, S, or M appear in the LCD status panel.

Programmed Auto

In Programmed Auto mode, the D200 selects both the shutter speed and aperture based on its internal exposure programs, attempting to effect an optimal compromise between using a shutter speed that neutralizes camera shake and an aperture that provides the best amount of depth of field and sharpness.

Menu Banks

The D200 has two separate sets of settings "banks" which store a complete list of various kinds of settings for your camera. One set is called the Shooting Menu Bank, and contains four different lists of preferred settings for the Shooting menu. A second, separate set of banks is located in the Custom Settings menu, and contains four different lists of preferred custom settings. Each bank is labeled A, B, C, and D, and you can select each type independently. That is, you might choose to work with Shooting Menu Bank B and Custom Settings Menu Bank D, or some other combination.

Information input for non-CPU lenses are a good example of when you might want to use one of these banks. You could, for example, enter information about a particular lens in Shooting Menu Bank A, and information about a different lens in Shooting Menu Bank B. You would then activate the bank of your choice to apply the lens information about the non-CPU lens you are currently working with. Each bank also contains other settings suitable for those types of shooting including ISO sensitivity and noise reduction, and I've assigned each of them names (Concerts and Sports, respectively) using the Rename option in the Shooting Menu Bank menu.

In addition to the Shooting Menu banks, the D200 has a second set of settings banks called the Custom Settings Banks (also initially labeled A, B, C, and D). You can set additional parameters useful in specific shooting situations, such as autofocus behavior, and switch among these banks, too, as required. I cover the Customs Settings menu in more detail in Chapter 3.

The exposure system is fairly intelligent. For example, if you're using a short telephoto lens at ISO 200, Programmed Auto elects to keep your lens wide open under low light levels until it's possible to achieve the correct exposure using a camera-shake-reducing shutter speed of 1/125 second. As light levels increase beyond that point, with camera shake blur theoretically minimized, the programming begins altering both shutter speed and aperture. With a longer telephoto lens, the lens remains wide open until a 1/1000 second shutter speed is achieved. These numbers vary depending on the ISO you select.

The settings the camera chooses are displayed in the LCD status panel and in the viewfinder. If you feel the combination shown won't provide the shutter speed or f-stop you'd prefer to use, you can use the D200's flexible program feature to adjust

the settings. Just rotate the main command dial to the right to change to a larger f-stop/shorter shutter speed or to the left to use a smaller f-stop/longer shutter speed combination that still provides the exact same metered exposure.

For example, if the D200 indicates that it's selected an exposure of 1/250 second at f/8, you can rotate the main command dial to the right to change to 1/500 second at f/5.6 or to the left to switch to 1/125 second at f/11, which are all equivalent exposures. Of course, the D200 makes these adjustments in 1/3-stop or 1/2-stop increments, depending on how you've set up the camera's EV step size. When you're using the flexible program feature, an asterisk appears next to the P in the LCD status panel (but not in the viewfinder) to show you've overridden the camera's settings.

Shutter Priority

When this mode is active, the decision about which shutter speed to use is up to you. You can use your judgment about the degree of action-stopping capability you need or, conversely, how much blur you want to apply from the subject or camera motion as a creative effect.

Oddly enough, you can also use Shutter Priority to ensure that the camera selects an f-stop in a specific range, even though lighting conditions are changing. Suppose you're shooting portraits of kids outdoors and vou expect the sun to periodically go behind a cloud. You definitely want to use a relatively fast shutter speed because your subjects are lively, and you don't want it to dip into the low range (which can happen with Aperture Priority). On the other hand, you want a relatively large f-stop so the background will be blurred slightly, even though you aren't fussy about the exact aperture used.

Set the camera to Shutter Priority, change the shutter speed so the target f-stop range is chosen, and then fire away. If lighting conditions change a bit, the D200 adjusts the f-stop slightly as required, while retaining that fast shutter speed you wanted.

Aperture Priority

Choose Aperture Priority when you want to specify the f-stop the D200 uses, and allow the exposure system to select the shutter speed. You can use this mode when you want to ensure that the camera uses a large f-stop (say, for minimal depth of field when you're using selective focus), or a small f-stop (perhaps to provide maximum depth of field for close-up photography).

As with Shutter Priority, you can use Aperture Priority in its reverse mode. For example, if you're shooting sports and want a lot of depth of field and a relatively fast shutter speed, but lighting conditions might change as you shoot. Set the aperture that provides the depth of field you want and a fast shutter speed (you might have to boost ISO to ISO 400 or faster to get both, depending on illumination.) Then, the D200 shifts the shutter speed slightly, if necessary, but won't mess with your preferred aperture. As long as the lighting doesn't change dramatically. you'll get both the aperture and shutter speed range you were hoping for.

Manual exposure

Manual exposure seems easy enough: you choose both the shutter speed and f-stop yourself. The camera provides feedback in its analog exposure display on the LCD status panel and in the viewfinder that indicates whether your settings agree with the metered exposure. What might not be obvious is why you might want to do that. Here are some good reasons for using Manual exposure:

- You want to set the exposure yourself for creative reasons, without fooling around with EV adjustments. You can set exposure directly, with no fuss and no muss.
- You're using an external flash, particularly a studio flash, and the D200's metering system and i-TTL flash exposure system are of no use to you. Just set the shutter speed you want to sync with the flash unit, and then adjust the f-stop as necessary (or, perhaps, adjust the external flash's output either automatically or manually) for proper exposure.

The iTTL flash exposure system is described in Chapter 6.

- You're using a non-CPU lens and want to use a specific shutter speed. Older lenses work automatically only in Aperture Priority mode, so if you want to specify the shutter speed, you'll need to switch to Manual exposure.
- You're using an external light meter to measure exposure.

Perhaps you're shooting in a studio situation and want to use an incident light meter, which measures light falling on the subject, from the subject position (whereas the D200 measures light reflected from the subject). The incident meter enables you to measure the illumination in the highlights and shadows separately, and you can then decide exactly how to apply that information to your exposure. Manual exposure is an excellent tool for "old school" photographers or professionals who want to have greater control over exposure.

Working with Autofocus

New Nikon D200 owners, particularly those with less experience with autofocus, often find determining the best automatic focus settings to be the most vexing part about learning how to use the camera. The autofocus system is sophisticated and accurate, but you need to have the appropriate setting for any particular shooting situation to get the best results. In the next section, I provide a quick review of the focusing features you are likely to use when you're out in the field.

Autofocus basics

To use autofocus, you must be using a Nikkor autofocus lens, designated with an AF in its product name, or a compatible lens from other vendors. Older lenses, as well as some current inexpensive and specialized lenses being sold today by Nikon (such as those with the AI-S designation), are manual focus only.

2.10 You can switch from Continuous or Single Autofocus to Manual focus using the switch on the camera body.

2.11 Some lenses have their own manual/autofocus switches.

To get the most from your D200, you'll probably use AF lenses most of the time. Therefore. you'll want to know that the camera body has a switch next to the lens mount (see figure 2.10) that you can set to C (for Continuous Autofocus), S (for Single Autofocus) or M (for Manual focus).

Some lenses, including the 18-70mm kit lens, have their own switches, as shown in figure 2.11. In this case, set the camera body switch to C or S, and use the lens control to adjust the

focus mode. The M/A designation on the lens is a reminder you that you can manually override or fine-tune (by turning the focus ring on the lens barrel) focus or leave it alone for the D200 to set. The M position on the lens barrel means that focus is set manually at all times.

Focus modes

The D200 lets you choose how autofocusing is applied:

- Single-servo. In this mode (AF-S), the D200 tries to focus the image as soon as you partially depress the shutter-release button. When focus is achieved, the in-focus indicator light illuminates, and focus is locked at that point. If you don't release the shutter button completely between shots and, instead, keep it depressed while taking continuous shots, the focus remains at the locked point for all the shots. You can also push the AE-L/AF-L button to lock focus. You can change the D200's priority when using AF-S in the Custom Settings menu CSM a1. Choose FPS (focal plane shutter) Rate (the default) and a photo is taken when you fully depress the shutter release. Select FPS Rate+AF and the D200 takes a picture, even if sharp focus has not been achieved (so-called release priority). Choose Focus and a photo will only be taken when the subject is in focus (so-called focus priority).
- Continuous-servo. In this mode (AF-C), the D200 attempts to focus the image when you partially depress the shutter-release button, and then continues to refocus until you take the picture. If you want to lock the focus at any point, you need to use the AE-L/AF-L button. Custom Settings menu choice a2 lets you choose between focus and release priority.

To focus manually, twist the focus ring on the lens. It can be the innermost or outermost ring, depending on the lens you have mounted. (With the 18-70mm kit lens, the focus ring is the innermost ring.) As you rotate the ring back and forth, you see the image pop in and out of focus. When the part of the image you're focusing on looks sharpest, the image is in focus. With AF lenses and most manual focus Nikkor lenses, a green light in the lower-left corner of the viewfinder, called the electronic rangefinder, glows to indicate focus has been achieved.

To set focus automatically, partially depress the shutter-release button. If the D200 is set on automatic focus, it locks into sharp focus. Brackets in the viewfinder that represent the area used to calculate focus flash red, and the green light in the viewfinder, shown in figure 2.12, glows, as long as the lens has a maximum aperture of f/5.6 or larger (for example, f/5.6 to f/1.4). The other elements in your viewfinder might look different from those in the illustration, depending on what picture-taking mode you've selected.

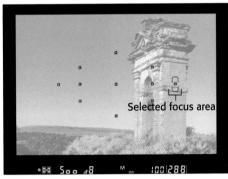

2.12 The current focus area and an in-focus LED appear in the viewfinder.

You can use a variety of options for finetuning focus, such as choosing whether the camera continuously focuses as you frame your subject after depressing the shutter release halfway (Continuous Autofocus, or AF-C), or whether the camera locks in focus as soon as you partially depress the shutter button (Single Autofocus, or AF-S). AF-S works fine for your first pictures with the D200. (AF-C can be useful for some kinds of action photography.)

Focus is best achieved when you're shooting well-lit subjects with a lot of contrast between the subject and the background. If lighting is insufficient, the D200's focus assist lamp comes on (unless you've disabled it in the setup menus) and provides additional light to help the focus system. The autofocus system can become confused if there are objects at different distances within the focus zone (say, the subject is being viewed through a chain-link fence), or the subject contains patterns or very fine details that mask the contrast between different areas.

Tip

The D200 has several other. mostly self-explanatory, Custom Setting menu adjustments that relate to autofocus. However, there's one important CSM setting you should not overlook: CSM a5, which determines how autofocus locks onto a subject. Choose Long or Normal, and the camera waits a few milliseconds if the subject appears to move before focusing somewhere else. This can be handy when your main subject is obscured by transient objects in the frame say an automobile that drives past as you're photographing a storefront across the street. Select Short to reduce this waiting time or Off to immediately focus on the new subject.

Understanding the focus zones

The first thing to understand is that the D200 bases its focus determinations on up

to 11 different focus zones, which are shown in the viewfinder as small boxes within the image frame. Figure 2.13 shows the viewfinder indicators that represent the individual zones (ordinarily, all the brackets won't be illuminated at the same time).

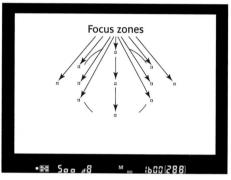

2.13 The D200 calculates focus from data gathered from 11 different focus zones.

The D200 can interpret the focus data retrieved from these zones two basic ways. It can use *normal* framing, which uses all 11 zones (great for subjects that are relatively small within the frame). Or it can use *wide* framing, which combines the 11 focus areas into 7 larger groups, which might be more suitable for larger subjects. This is particularly true if you're choosing the focus area yourself, because it's usually faster to choose from among 7 areas than 11 (unless you're particularly fleet of finger).

You can set the camera to provide highlighting, in the form of brackets around the focus areas, that reveals which of these 11 or 7 zones has been selected by the autofocus system, or by you. You can select whether the D200 uses normal or wide framing in the Custom Settings menu, under CSM a3. Figure 2.14 shows all the brackets for normal framing and wide framing.

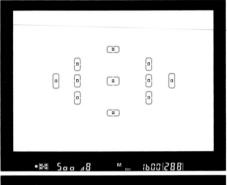

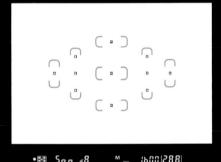

2.14 Normal framing uses all 11 focus areas individually (top), while wide framing groups some of the focus areas together.

Choosing the focus zone manually

Focus mode defaults to calculating focus based on the information from a single focus area (unless you've changed to a different preference in the Custom Settings menus). You can change the area used as the focus zone.

To choose the focus area manually:

- Make sure the focus selector lock (see figure 2.15) is not set to L (lock).
- Use the multi selector (four-way cursor pad) to move among the 11 or 7 focus zones. The selected

area is highlighted in red in the viewfinder.

If you want to use the same focus area for a succession of shots, move the focus selector lock back to the L position.

Focus mode selector

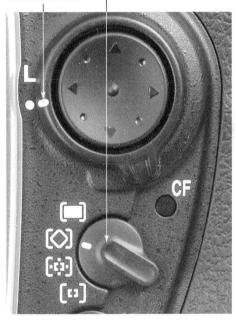

2.15 Move the focus selector lock to the unlock position and use the multi selector pad to change the focus zone.

Letting the D200 choose the focus zone automatically

The D200 can choose the focus area for you, and, as you might expect from a camera of this caliber, you have a lot of input into how the autofocus system makes its decisions. You can choose from four different modes.

Just rotate the AF-area mode selector, shown just below the focus selector lock in figure 2.15. From the top of the arc, and moving downward, these modes are:

- ▶ Dynamic area/closest subject.

 The D200 chooses the focus area containing the subject that is closest to the camera. This is a great mode to use when you know your subject will always be the closest thing to the camera, even if that subject is roaming around within the frame (think active children!). You can't override the camera's selection, which is probably a good thing when you're trying to track a subject moving erratically.
- Group dynamic. The D200 selects a focus area within a group, but uses other adjacent zones in groups of three or four zones as a backup (three when the subject is at the top or bottom edge of the frame; four at all other times). If the subject moves slightly, but not extensively, the autofocus system switches to one of the other focus zones within the group. You can select which group is used with the multi selector pad. Choose the group pattern in Custom Settings a3.
- ▶ Dynamic area autofocus. In this mode, you choose the focus area yourself (unless you've locked this option out with the focus selector lock). The D200 overrides you if the subject leaves the focus area and uses one of the other areas. The area you selected remains highlighted, however. This is a great mode to use with AF-C when shooting action: you tell the camera what your subject of interest is, and the D200 tries to follow focus if the chosen subject moves out of

- your manually chosen zone too quickly for you to compensate.
- Single area autofocus. If your subjects aren't moving much, this mode is the simplest to use. You choose the focus area using the multi selector, and that's the area the D200 uses to calculate focus. No ifs, ands, or buts. However, you can still select whether to use normal (11 zone) or wide frame (7 zone) area layouts.

Tip

The focus frame function is one of many different controls you can assign to the D200's Func button (located on the front of the camera under the depth of field preview button). Just go to Custom Setting menu CSM f4, and choose Focus Area Frame as the activity for the Func button. Thereafter, you can hold down the Func button and spin the sub-command dial to choose between normal and wide-focus frame zones.

Locking focus/exposure

When you partially depress the Shutter Release button, the automatic focus (and exposure) mechanisms are activated, and the informational display of the current settings appears at the bottom of the viewfinder screen. The viewfinder info display and exposure system remain active when you release the shutter button, but then go to sleep after a few seconds (or a longer time you can specify using the setup menus). To wake them up again, tap the Shutter Release button or depress it slightly if you want to refocus.

If you want the focus and exposure to be locked at the current values (so you can change the composition or take several photographs with the same settings) hold down the AE-L/AF-L button, shown in figure 2.16.

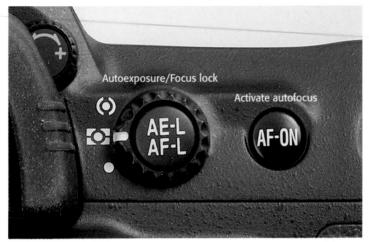

2.16 Hold down the AE-L/AF-L button to lock exposure and focus.

If you prefer, the AF-ON button shown at the right side of the figure has the same effect as pressing the Shutter Release button halfway down.

Other Image Parameters

You can fine-tune or modify many other image parameters in the Shooting menu, including the amount of sharpening, contrast, color, saturation, and hue. The D200 provides both some general, overall looks you can select, as well as customized settings for each of these.

In the Shooting menu, choose Optimize Image. The menu shown in figure 2.17 appears. You can select from Normal (the default), as well as Softer, Vivid, More vivid, Portrait, Custom, and Black-and-white. The

non-Custom settings tweak the contrast, sharpness, and saturations in ways implied by their labels—to produce generalized overall changes in your image. For example, Portrait reduces the contrast and provides a flattering color rendition for taking pictures of human subjects, particularly males. Softer might be a better choice for portraits of females or anyone who can benefit from the flattering look of an image with less sharpness and contrast. Black-and-white desaturates your image, giving you a monochrome grayscale rendition of your scene.

Select Custom in the Optimize Image menu and a new menu appears with options for Image Sharpening, Tone Compensation (contrast, plus custom curves, discussed previously in this chapter), Color Mode, Saturation, and Hue Adjustment. These are fairly self-explanatory and correspond to the equivalent settings in an image editor, with the exception of Color Mode.

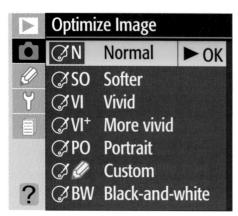

2.17 Optimize Image from the Shooting menu.

You can use Color Mode in conjunction with the Shooting menu's Color Space setting to control the color palette used to render your images. Your options include:

- In the Color Space menu, you can select Adobe RGB or sRGB for your JPEG images. You can change the color space for RAW images as you import them into your image editor. Adobe RGB allows for a wider color range, while sRGB is a subset of Adobe RGB optimized for the Web and for printing. Choose Adobe RGB if you want to retain the broadest range of colors for image editing, and sRGB if you plan to print or post your images directly and don't want to go through additional processing.
- In the Color Mode menu, you can choose Color Modes I, II, or III. Mode I, the default, is good for most types of pictures, including portraits, where basic color accuracy is important. Mode II is available only when you've selected Adobe RGB for your color space. It

has the largest color gamut, and is a good choice if you will be editing your photos extensively and don't want to lose any colors. Mode III has a vivid palette that's well-suited for nature and scenic photography. In practice, the choice of both Color Mode and Color Space is a matter of taste, and you should try out any of the five variations to see which you like best for specific kinds of photos.

Tip

Unlike some of the other models in the Nikon dSLR line, the D200 does not apply any sharpening to images. If you find your photos consistently look less sharp than you'd prefer, use the Custom Setting menu's Sharpen option to apply Medium High (+1) or High (+2) sharpening by default.

Setting White Balance

White balance is the relative color of the light source, measured in terms of color temperature. Indoor, incandescent illumination has a relatively low (warm) color temperature in the 3,000K (degrees Kelvin) range; outdoors in sunlight, the color temperature is higher (colder) from about 5,000K to 8,000K. Electronic flash units have a color temperature of about 5,400K, but this can vary with the length of the exposure (flash units provide reduced exposure by quenching the flash energy sometime during the flash itself). The flash built into the D200, and Nikon dedicated flash units like the SB-600 and SB-800, can actually report the color temperature they will use to the camera for automatic adjustment.

Your camera can make some pretty good guesses about the color temperature of its environment by measuring the color of the image using the 1,005-cell exposure sensor in the viewfinder. In addition, you can specify color temperature yourself using camera controls several ways.

- Hold down the WB button on the mode dial and use the main command dial to select a preset color balance for automatic (A), incandescent, fluorescent, direct sunlight, flash, cloudy conditions, and shade. The possible settings are shown in the bottom row of the LCD status panel in figure 2.18. (The settings show up one at a time, not all at once, as in the figure.)
- Hold down the WB button and spin the sub-command dial on the front of the handgrip to fine tune the settings for any of these preset values. Move the sub-command dial to the right to

- make the image more blue or to the left to add a yellow tinge. You can make adjustments in the range of +/-3.
- Hold down the WB button and spin the main command dial to select K, which lets you dial in a specific color temperature (measured in K). In this mode, the color temperature value appears on the top row of the LCD panel, and you dial in a specific temperature from 2,500K to 10,000K using the sub-command dial on the front of the hand grip.
- Hold down the WB button and spin the main command dial until PRE is selected and continue pressing down the WB button as you spin the subcommand dial to choose one of the user-defined white balance settings. Initially they are named d-0 through d-4, but you can rename them later to something more descriptive.

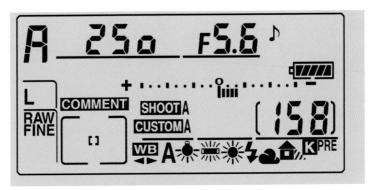

2.18 The white balance settings show up in the bottom row of the LCD status panel.

Creating white balance presets

To create white balance presets, follow these steps:

- Hold down the WB button and rotate the main command dial to select PRE.
- Hold down the WB button and rotate the sub-command dial until the name of the preset you want to define appears.
- Release the WB button, and then press it again until the PRE icon on the status LCD begins flashing.
- 4. Point the camera at the image you want to use as your white balance reference and press the shutter release as if taking a photo. The top line of the LCD status panel flashes either no Gd or Good to indicate whether or not the white balance was successfully captured.

Using white balance presets

In the Shooting menu, you can access the white balance options, which include choosing one of the factory-default white balance settings for incandescent, fluorescent, direct sunlight, flash, cloudy conditions, and shade.

You can also choose White Balance Preset to view the five user-defined preset values, shown in figure 2.19. Use the multi selector's cursor keys to navigate among the available presets, and then press the multi selector button to choose that preset for use. You can then set the D200's white balance to that value, rename the white balance setting (for example, Portage High School Gym), select an image on your memory card to use as a new preset value in one of the empty slots, or copy the value stored in preset d-0 to one of the other positions in the preset array.

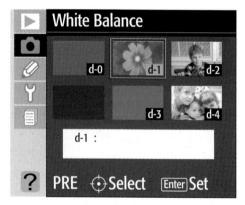

2.19 You can create and use five different user-defined white balance presets.

Setting Up Your D200

n the Quick Tour and first two chapters of this book, I cover all the basic settings you need to make most of the adjustments you'll use for everyday shooting with your Nikon D200. In this chapter, I introduce you to the rest of the options you can use to fine-tune how your camera operates. Tucked away in the menu system, these settings usually customize your camera's defaults so it uses the image size, white balance, focus modes, and other preferences you want to use most of the time. I also detail some of the most commonly changed setup parameters you can use to tailor your D200's operation.

It's important to note once again that this book is not intended to replace the manual furnished with the D200 or to provide a rehash of its contents (although you'll find there is a bit of unavoidable duplication between the official manual and this chapter). This guide has been written as a quick reference you can carry with you in your camera bag and pull out when you need some quick advice on how to take a picture, or how to set up your camera for a particular type of shot. So, in this chapter I list the key menu options to make it easy for you to find the setting that does what you want. I also explain some of the more confusing settings that require a little elaboration, or point you to a chapter in this book that provides the added information you need.

The D200 has four main menus—the Shooting menu, the Playback menu, the Setup menu, and the Custom Settings menu (often abbreviated CSM). To access any menu choice, press the menu button on the left side of the back panel, and then use the multi selector's cursor keys to select the individual menu you want, and the choices within it. Press the enter button on the left side of the back panel to activate your selection. In most cases, you can also press the multi selector's Right cursor key. Press the menu button again to exit the menu system.

C H A P T E F

In This Chapter

Shooting menu preferences

Playback menu preferences

Setup menu preferences

Custom Settings menu preferences

Shooting Menu Preferences

You'll find picture-taking preferences within the Shooting menu, shown in figure 3.1. The next sections detail what is found in each submenu.

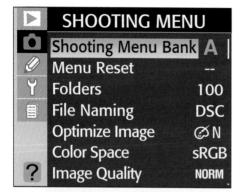

	SHOOTING MENU	
0	Image Size	
4	JPEG Compression	_
Y	RAW Compression	OFF
	White Balance	A
	Long Exp. NR	OFF
	High ISO NR	NORM
?	ISO Sensitivity	100

_		
	SHOOTING MEN	NU
Ô	Long Exp. NR	OFF
0	High ISO NR	NORM
7	ISO Sensitivity	100
	Image Overlay	
	Multiple Exposure	OFF,
	Intvl Timer Shooting	OFF
?	Non-CPU Lens Data	■.

3.1 Nikon D200 Shooting menu.

Shooting Menu Bank

As I describe in Chapter 4, the D200 has four banks, initially named A, B, C, and D, which can independently store four sets of Shooting menu settings. Simply select the bank you want to use and make any changes to the settings in that bank. The next time you load that bank again, the last-used settings for it are restored. The active bank is displayed on the monochrome status LCD on top of the D200. Choose the Rename option to assign a descriptive label to one of the four shooting banks.

Menu Reset

Choose the menu reset to set the current shooting menu bank to the factory default settings. You can also use the two-button reset (holding down the external EV button and Qual button simultaneously), which I describe in Chapter 1, to perform this task.

Folders

This option chooses the folder on the CompactFlash card in which your images are stored. By default, the D200 stores its images on your memory card in a folder named 100NCD200. Folders can accommodate only 999 shots, though, so once a folder has been used for a sufficient number of pictures, the D200 creates a new default folder, numbered one higher (for example, 101NCD200). A new folder is also created if sequential numbering is on and the picture number exceeds 9,999. It's easy to create and use other folders on the card, which gives you a lot more flexibility.

Perhaps you use the same memory card in several different cameras and want to more easily track which photos you took with which camera (different *model* cameras create their own folder names, such as 100NCD70, automatically). You might want to use a different folder for each of the cities on your vacation, so you can keep your pictures of Madrid, Toledo, and Barcelona separate.

The D200 enables you to create folders, rename existing ones, and remove ones you don't want any more, plus select which folder to use to store any new photographs you take. Switching among any existing folders you've created is fast and easy.

To create a new folder, choose Folders from the Shooting menu and scroll down to the New option. The D200's text entry screen appears, but because folder names are short, you can usually enter the name of the new folder in a minute or two. The same screen is used to rename an existing folder. Then, to switch among available folders for your current shots, access the Folders screen again, choose Select Folder, and scroll down to the folder you want to activate for subsequent images.

File Naming

The D200 prefixes the four-digit file numbers of the images it creates with DSC or _DSC. This option enables you to use a different prefix instead. It's a good idea to use this feature to create a new prefix when your sequential picture count approaches 9,999, as it lets you avoid duplicate file names. The data entry screen looks like figure 3.2.

Optimize Image

This submenu offers options for fine-tuning the color, contrast, sharpness, saturation, and hue of your photos. I described its features in detail in Chapter 2.

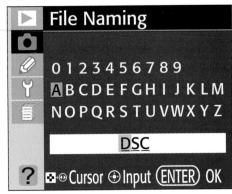

3.2 Nikon D200 data entry screen.

Color Space

You can choose from the sRBG color space, which has a reduced gamut suitable for images destined for Web display or printing, or the more comprehensive color space called Adobe RGB. I explain using this option, in conjunction with the Color Mode option found in the Optimize Image submenu, in Chapter 2.

Image Quality

This submenu duplicates the file format selection functions of the Qual button and main command dial. You can read about your options in Chapter 1.

Image Size

This submenu duplicates the resolution selection functions of the Qual button and sub-command dial, as I explain in Chapter 1.

JPEG Compression

The D200 has two methods it can use for compressing your JPEG images. Size Priority squeezes the image to a fixed size, using as much compression as required to achieve

that size. You might find that some images lose too much quality in this mode, even when you're using JPEG FINE. The Optimal Quality choice squeezes all images down by the same amount for that quality level (FINE, NORMAL, or BASIC), even if it means the file size can vary. Unless you must cram as many images as possible onto your memory card, the Optimal Quality choice should be your preference.

RAW Compression

Here you can choose whether the D200 compresses RAW files, reducing their size by up to half at the potential cost of a little quality, or whether it stores the images in uncompressed RAW format. Although the quality loss for compressed RAW files can be difficult to detect, most of the time you'll want to use the uncompressed format just to ensure you get the maximum quality possible.

White Balance

This submenu enables you to set white balance, duplicating the functions of the WB button on the Mode dial, plus choose and rename user-defined white balance presets. You'll find a complete discussion of these features in Chapter 2.

Long Exp. NR

You'll find the options for adjusting noise reduction are applied to exposures longer than about 8 seconds, as I describe in Chapter 2.

High ISO NR

You can also apply noise reduction to images taken using sensitivity settings of ISO

800 and up, using the options I explain in Chapter 2.

ISO Sensitivity

This submenu duplicates the functions of the ISO button on the Mode dial. I explain this in Chapter 2.

Image Overlay

The D200 can combine two existing RAW images to create one new one, as a sort of double exposure feature you can apply after the photos are already taken. Use this menu to select the images you want to merge. Choose Image 1 from the first screen, press the multi selector button to search among the available images on your memory card, and then press the multi selector button again to select the first picture. Then choose Image 2, and select the second image. A preview of the combined image is displayed next to the two component images. Select the preview and press the multi selector button again to save the new merged image.

Multiple Exposure

This feature lets you merge two to ten images that you haven't taken yet. Select the number of images you want to combine, and then take the specified number of shots. They'll be merged into a single picture. The Auto Gain option tells the D200 to adjust the exposure for each shot so that your merged photo isn't overexposed.

Intvl Timer Shooting

This is your D200's built-in time lapse photography feature. (You can also use Nikon Capture when your camera is tethered to a computer.) You can choose

- Starting time for the sequence (either Now, or at an exact time in the future)
- Interval (amount of time between shots)
- Number of intervals (how many times you want pictures to be taken)
- Shots per interval (the number of exposures that will be taken each time the requested interval has elapsed)
- On or Off to activate the interval feature using the current settings.

Note that interval shooting uses a lot of power, so you should have your D200 connected to an EH-6 AC adapter for time-lapse photography of periods of more than an hour or two. Figure 3.3 shows the Interval Timer menu.

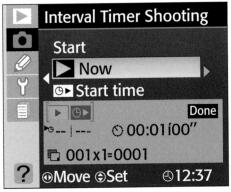

3.3 Choose interval timer options here.

Non-CPU Lens Data

You use this submenu to enter information about the maximum f-stop and focal length of older (non-CPU) lenses, so you can use them with the D200's aperture-priority and manual exposure modes. As I describe in Chapter 2, you can enter information about a different lens in each Shooting menu bank.

Playback Menu Settings

The Playback Menu offers settings that control what your D200 does during picture review. Your choices are shown in figure 3.4. Here's what you'll find in each submenu:

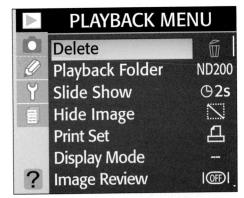

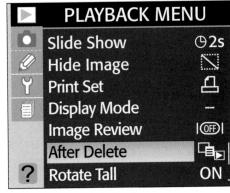

3.4 Nikon D200 Playback menu.

Delete

You can delete any images you've selected during playback, or all images on the memory card. When you choose Selected, thumbnails of the images in the folder currently being viewed appear, and you can mark any of those images for removal by pressing the multi selector button. When you're finished marking images (each will have a Delete icon superimposed), press OK to delete them.

Note that if you really want to remove all the images on a memory card, it's usually better to reformat the card, as deleting many pictures can take a very long time.

Playback Folder

If your CompactFlash card has more than one folder, you can use this option to choose which of the folders you want to use for playback. A list of available folders appears. You can also select Current to use the active folder, or All to display images in all the folders on your card. This feature is especially handy for displaying an ad-hoc slide show or favorites on your LCD screen. Just deposit the images you want to display into a separate folder, and then choose that folder alone for playback.

Slide Show

If you want an automated slide show, this option displays the images in the folder you've selected in the Playback Folder submenu one after another, pausing between them. You can adjust the amount of time each image appears.

Hide Image

To protect particular images from view, use this feature to select the images that will be made invisible. Shown in figure 3.5, it uses a Select/Set screen similar to the one used for Delete. When you're ready to unhide your photos, access this menu again and choose "Deselect All?" from the options.

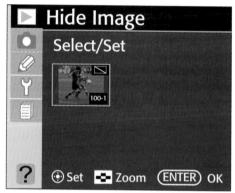

3.5 Select images to hide with this menu.

Print Set

Use this feature to mark images on your memory card for printing. You can choose specific JPEG images (but not RAW images) and request the number of copies and information to be printed along with the image. The DPOF (Digital Print Order Format) is used, so any standalone retail print kiosk, as well as digital minilabs, can interpret your memory card.

Display Mode

As I describe in Chapter 2, this is the option that specifies which items of information to display during playback. You can individually mark boxes to include/exclude picture data, histograms, RGB histograms, and the focus area used for a given photograph, as well as highlight areas that are overexposed.

Image Review

Switch this option On to have each photograph you take displayed on the LCD for review. Use Off if you're concerned about the amount of power that constant picture review consumes, if you rarely review each photo individually, or if you're shooting in a darkened environment in a public place (say, a concert), and don't want the glare of your LCD after each shot to disturb others.

After Delete

This option determines what happens after you delete an image. You can elect to have the D200 display the next photo, the previous photo, or continue scrolling through images in the order you were browsing before (forward or backward).

Rotate Tall

The D200 includes an orientation sensor, which determines whether or not you're shooting a vertical or horizontal photograph. Thanks to the sensor, the D200 is able to embed that information in the image file. The camera can provide the proper orientation when you're reviewing images on the backpanel LCD, and compatible image editing programs and digital asset management software (what used to be called albuming utilities) can orient your images correctly, too.

The sole drawback of using the orientation sensor's data during review is that vertical shots might be rotated and shown using only the short dimension of the LCD, forcing you to zoom in to see equivalent detail. If you'd rather rotate your camera during review to see your previews full size, just turn off the Rotate Tall option. If you've set Auto Image Rotation to On in the Setup menu, the orientation information will still

be embedded in the image file, but the D200 won't use that information during picture review.

Setup Menu Options

The Setup menu contains many options that you won't use very often—such as World Time or Language—but it also contains some that you'll access frequently. There are only a baker's dozen entries in this menu, shown in figure 3.6, but they're worth getting to know.

3.6 Nikon D200 Setup menu.

Format

Use this feature to format a new memory card for use, and to reformat existing cards to remove all the photos on them and return them to a fresh, clean condition.

I don't recommend using the external buttons for formatting because there is less chance of formatting unintentionally when you use a text menu.

LCD Brightness

When you select this option, a grayscale brightness chart is displayed that you can use to increase the brightness of the LCD (to make it more viewable in bright light) or decrease the brightness (which can help cut glare when you're using the D200 indoors in dim light).

Mirror Lock-up

The mirror lock-up option is not a picture-taking feature but, rather, a means of getting the mirror out of the way and the shutter open so you can clean your sensor. It can be selected only when the D200's batteries are fully charged, or the camera is connected to an AC adapter or the MB-D200 vertical grip/battery pack equipped with alkaline batteries.

Video Mode

Use this option to toggle the AV port output of the D200's still images from NTSC (used in the U.S., Japan, and some other countries) to PAL (used in much of Europe and other regions).

World Time

Set the D200's internal clock to the current date and time.

Language

Choose the language you want your D200 to talk to you in when it displays its menus and prompts.

Image Comment

If you elect to use this feature, it adds a comment to each image file. You can enter the comment using the text entry screen supplied, or type the comment on your computer using Nikon Capture and upload it to the camera when the D200 is connected to your computer.

Auto Image Rotation

This option tells the D200 to record the camera's orientation when a photo is shot within the image file. It can be used by many software programs to display the image in the proper orientation, and by the D200's Rotate Tall playback option to present images shot in a vertical format on the LCD in their proper rotation.

Recent Settings

The D200's fifth menu (see figure 3.7), displayed immediately under the Setup menu, provides a list (up to 14) of the settings you accessed most recently from the Shooting and Custom Settings menus, regardless of which menu they reside in. The Recent Settings menu is a handy way to get back to a recent menu quickly. The Recent Settings

feature in the Settings menu lets you customize the appearance of the Recent Settings menu itself.

Use Lock Menu to fix the Recent Settings menu so that no further items are added or removed. You can use this to create your own custom Recent Settings menu. Just access the menus you want to use frequently, and then lock the menu. You can return to those items at any time, retaining the ones you've selected. You can also select Delete Recent Settings to clear the Recent Settings menu of its current entries.

3.7 Use the Recent Settings menu to quickly access menus.

USB

Use this option to tell your D200 to operate in either a PTP (Picture Transfer Protocol) or Mass Storage device mode. You can use both for transferring pictures. In Mass Storage mode, the D200 behaves like a card reader and your memory card is the equivalent of a floppy disk or hard drive. In the more sophisticated PTP mode, the camera and software can communicate more completely in both directions, giving the software (such as Nikon Capture) the capability of controlling the camera.

Dust Off Ref Photo

This option enables you to take a dust reference photo that records any artifacts clinging to your sensor, so that Nikon Capture can use the information to filter out the dust from your images. If you keep your sensor clean, or are willing to retouch a few dust spots yourself, you'll never need to use this feature.

Battery Info

The D200 stores information about its battery's current condition. Information stored includes the battery level, in percentage of full charge; the number of times the shutter has been tripped since the battery was charged (the Pic. Meter); and a useful life indicator (the Charge Life scale), which tells you when the battery has reached the end of its capability to retain a charge and should be replaced.

Firmware Version

This display shows the current camera firmware versions, divided into A and B settings that can be updated separately.

Custom Settings

The Custom Settings menu is the heart and soul of the D200's customizability, with 45 different settings you can use to set your camera up exactly the way you want. Moreover, as with the Shooting menu, there are four different banks available, each of which can contain its own set of CSM tweaks. Some of the settings are a bit on the esoteric side and require a bit of practice and study to master, but I'm going to list all of them here as a quick reference.

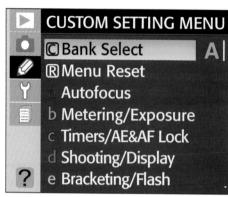

3.8 The Nikon D200 Custom Settings menu.

Bank Select

As I describe in Chapter 4, the D200 has four Custom Settings banks, initially named A, B, C, and D, which can independently store four sets of CSM settings. Simply select the bank you want to use and make any changes to the settings in that bank. The next time you load that bank again, the last-used settings for it will be restored. As with the Shooting menu banks, the active bank is displayed on the monochrome status LCD on top of the D200. Choose the Rename option to assign a descriptive label to one of the four Custom menu banks.

Menu Reset

Choose this option to set the current Custom menu bank to the factory default settings.

Autofocus

Autofocus is CSM submenu a. Its menu includes options that affect how the D200 applies its autofocus features, including whether it uses release priority (it will take a picture even if the subject is not perfectly in

focus), focus priority (the camera refuses to take a photo unless focus is achieved), and other parameters.

a1: AF-C Mode Priority

The camera sets the D200 for either release priority or focus priority whenever you're using continuous autofocus (described in Chapter 2). Choose FPS Rate to specify release priority (making it possible to take out-of-focus pictures); FPS Rate+AF (which applies release priority, but slows the frame rate when in continuous C_L or C_H modes to improve the chances of getting a well-focused picture); or Focus to make picture-taking possible *only* when the in-focus indicator (the green dot at lower left in the viewfinder) is visible.

a2: AF-S Mode Priority

This is the equivalent release/focus priority selector for single autofocus (also described in Chapter 2). Only Focus and Release options are offered.

a3: Focus Area Frame

The D200 offers you the choice of 11 focus areas (Normal Frame) or 7 larger areas (Wide Frame) when you choose single area autofocus or dynamic area autofocus as your AF Area mode using the Focus Area selector dial next to the viewfinder (see Chapter 1).

a4: Group Dynamic Autofocus

The D200 can use groups of autofocus areas to measure focus. This option lets you choose which of the available four patterns is most suitable for your particular subject.

a5: Focus Tracking with Lock On

One problem that often occurs during autofocus is the sudden intervention of a

transient subject in the image frame, or a rapid change in the distance between the subject and the camera. This option lets you specify how the camera reacts to these events. You can specify an interval that the camera will wait before changing focus from the original subject to the new subject or distance, which helps filter out transient subjects that are only in the frame for a short time. It's a good choice for subjects that are only "passing through" so to speak. Choose Long, Normal, or Short to adjust the amount of delay before refocusing occurs.

Select Off to have the D200 immediately refocus when the camera to subject distance changes drastically. You might want to use this option if you are expecting the subject to be approaching the camera rapidly and want to keep it in focus. (Remember to get out of the way!)

a6: AF Activation

Ordinarily the D200 is prompted to focus on the subject whenever you partially depress the shutter release. The AF-ON button on the back of the camera performs the same function. If you like, you can specify AF-ON only, so that pressing the shutter release partway locks exposure (as usual) but does not trigger the autofocus system.

a7: AF Area Illumination

This option enables or disables the little red light that indicates the active focus zone in the viewfinder. You can choose On, Off, or Auto, which activates the light only when needed to provide sufficient contrast in the viewfinder.

a8: Focus Area

When you're manually selecting the active focus area with the multi selector, the cursor

can wrap around to the opposite edge when you've selected Wrap, or stop at the edge when you've selected No Wrap.

a9: AF Assist

This setting enables or disables the Autofocus Assist Illuminator (see Chapter 1), which provides additional light to help the autofocus system under dim lighting conditions. The AF Assist lamp only works at distances of a few feet, and may be distracting (say, at concerts), so you might want to turn it off. This same illuminator also provides red-eye reduction and self-timer count-down functions, and these are not affected if you turn off its autofocus assist function.

a10: AF-ON for MB-D200

This option assigns a function to the AF-ON button included with the optional MB-D200 vertical grip/battery pack. You can set the button to function the same as the AF-ON button on the back of the camera, or assume a different function, such as functioning as the AE-L/AF-L button (see Chapter 1) or even doubling for the Funckey (also described in Chapter 1).

Metering/Exposure

Metering and exposure is CSM submenu b. All the settings that control metering and exposure reside in this menu. I have described many of them already in Chapter 2. The following sections go over the options within this menu.

b1: ISO Auto

This tricky option, explained fully in Chapter 2, determines whether the camera will boost ISO automatically to achieve proper exposure.

b2: ISO Step Value

This setting specifies whether ISO values can be set using 1/3, 1/2, or 1 EV increments.

b3: EV Step

This setting determines whether EV adjustments can be set using 1/3, 1/2, or 1 EV steps.

b4: Steps for Exposure Comp/Fine Tune

This setting specifies 1/3, 1/2, or 1 EV steps for exposure compensation and fine-tuning.

b5: Easy Exposure Compensation

When switched off (the default), you must press the EV button and rotate the main command dial to add or subtract EV adjustments to or from the current exposure. If you use EV tweaks a lot, you can set this feature to On, in which case you can make exposure compensation by rotating the subcommand dial in Programmed Auto or Shutter Priority modes, or by rotating the main command dial in Aperture Priority mode.

An interesting choice is the On (Auto Reset) option, which functions in the same way as On, but cancels any EV changes you've made using "easy" exposure compensation when the camera is switched off or the exposure meter is turned off. Anyone who's applied EV adjustments and then forgotten and ended up with overexposed or underexposed photos when they've changed to a different scene will appreciate this alternative.

b6: Center-Weighted Area

Use this to change from the default 8mm center-weighting circle to 6mm, 10mm, or 13mm.

b7: Fine Tune Optimal Exposure

If you discover that your D200 consistently underexposes or overexposes your photos (at least, to your taste), you can, in effect, calibrate your camera to always add or subtract a little exposure from the setting it would normally have applied. You can add or subtract up to one full EV in 1/6 EV steps. Separate calibration is available for each metering mode (matrix, center-weighted, and spot). Unlike normal EV adjustments, which cause a warning to flash in the viewfinder, there is no visible tip-off that you've recalibrated your camera's exposure system, so use this feature with care.

Timers/AE&AF Lock

Timers/AE&AF Lock is CSM submenu c. This brief submenu has five options for two unrelated sets of functions: the autoexposure/focus lock features and your camera's various auto timing functions.

c1: AE Lock

This specifies which controls you can use to lock the exposure at its current value. You can choose the AE-L/AF-L button (the default) or add the shutter release button (which normally locks the exposure only as long as you keep it partially depressed).

c2: AE-L/AF-L

Use this feature to determine the behavior of the AE-L/AF-L button. You can choose to have this button lock *both* the exposure and focus, lock *only* exposure *or* focus, or lock exposure (only) when you press the button, and keep it locked until you press the button again (to take several consecutive photos using the same exposure), or to keep it locked until you press the button again, but unlock exposure when the meter turns off.

c3: Auto Meter-Off

This controls how long the exposure meter remains active, and you can set it for 4 seconds, 8 seconds, or 16 seconds, or until you switch the camera off (No Limit). Because the exposure meter drains the battery, the default value is 4 seconds.

c4: Self-Timer

Set the self-timer delay to 2 seconds, 5 seconds, 10 seconds, or 20 seconds, depending on your needs. If you're running to get into the photo yourself, a 20-second delay might be appropriate. If you're using the self-timer as a substitute for a cable release, you might prefer a 2-second delay, just enough time for the vibration caused by pressing the shutter release to subside.

c5: Monitor-Off

The LCD monitor is another power hog, and you can use this option to specify how long it remains on when the camera is idle. Choose 10 seconds, 20 seconds, or 60 seconds, or delays as long as 5 minutes or 10 minutes if you really need to study the monitor for long periods of time.

Shooting/Display

Shooting/Display is CSM submenu d. Here you'll find many options relating to miscellaneous shooting and display options.

d1: Beep

Your D200 might make a sound from time to time, which can be useful (when the self-timer is counting down and you want to know when the picture will be taken) or annoying (when you're taking photos in quiet locations, such as libraries or lectures). You can choose High, Low, or Off.

d2: Viewfinder Grid

You use this to turn the optional viewfinder display grid lines (see Chapter 1) on or off.

d3: Viewfinder Warning

This activates viewfinder warnings whenever any of three different conditions exist: low battery, no memory card, or black-and-white shooting mode is being used. If you'd rather not see these warnings, you can switch them off entirely.

d4: CL-Mode Shooting Speed

The D200 has both low-speed and high-speed continuous shooting modes (C_L and C_H). This CMS setting determines the frame rate for the low-speed mode, and you can set it to 1 to 4 frames per second (fps). High-speed mode operates at up to 5 fps, regardless of how you set this option.

d5: Exposure Delay Mode

This helps reduce blur caused by camera shake when the D200 is mounted on a tripod, microscope, telescope, or other device by delaying the exposure for 0.4 seconds after you press the shutter release. You can use it with the mirror prerelease feature (M-Up on the Mode dial, as described in Chapter 1) to minimize camera shake from mirror bounce, too.

d6: File Number Sequence

This determines how sequential numbers are applied to your file names as the D200 creates them when storing photos on the memory card. When set to Off, the D200 starts over at 0001 each time a new folder is created, you reformat the memory card, or you use a new memory card. When the D200 is turned On, file numbering continues to increment, up to a maximum file number of 9,999. If the highest file number

in the folder is larger than the last picture taken, the D200 increments from that value instead, to avoid possible duplicate file numbers.

If you specify Reset, the file numbers start over at 0001, unless there are already images in the current folder, in which case numbering starts at the next highest number.

d7: Illumination

When this option is set to Off, the LCD status panel light comes on only when the power switch is rotated all the way; when this option is set to On, the backlight stays on as long as the exposure meters are active.

d8: MB-D200 Batteries

This allows you to specify which type of batteries are loaded into the optional MB-D200 vertical grip/battery pack, when you use ones other than the standard EN-EL3a batteries. You can choose from alkaline, nickelmetal hydride, lithium, or nickel-manganese battery types.

Bracketing/Flash

Bracketing/Flash is CSM submenu e. Nikon has lumped bracketing features and flash options into this submenu.

e1: Flash Sync Speed

Use this CSM option to set the flash sync speed at 1/250 second to 1/60 second. You can also choose 1/250 second (Auto FP) to use high-speed synchronization (shutter speeds faster than 1/250 second) with compatible Nikon flash units. Note that these Nikon strobes operate at reduced power at faster sync speeds, so the Auto FP mode is best suited for close-up photography.

e2: Slowest Shutter Speed When Using Flash

This setting determines the slowest shutter speed that you can use with flash in Programmed Auto and Aperture Priority modes. You can use it to disable the flash when shooting longer exposures in these modes, say, because you want to rely on available light for these longer exposures. The default slowest speed is 1/60 second, but you can specify slower speeds up to 60 seconds.

e3: Built-In Flash

This is a multilevel menu with a clutch of options for the D200's built-in flash unit. You can choose the following (shown in figure 3.9):

- TTL. Through the lens metering.
- Manual. Flash setting with powerlevel options from full power to 1/128th power.
- Repeating Flash. This is covered in more detail in Chapter 6.
- Commander Mode. Learn more about using these options with the D200 in Chapter 6.

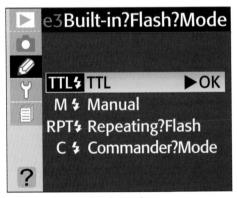

3.9 The Built-In Flash Mode menu.

Remember to set it back to TTL if you want to work quickly with the built-in flash; otherwise, you may end up with consistently overexposed images.

e4: Modeling Flash

The D200 and compatible external speedlights from Nikon have a modeling light feature that triggers a series of low-level flashes for a short period to help you judge the lighting effects you'll get. Use this option to turn the modeling flash on or off.

e5: Auto BBKT Set

You use this menu to specify whether autoexposure and flash, autoexposure only, flash only, or white balance will be bracketed when you're using autobracketing. (A complete discussion of bracketing is in Chapter 2.)

e6: Auto Bracketing in Manual Exposure Mode

This feature controls which exposure settings are varied when AE & Flash, or AE Only bracketing is selected. You can choose to vary only shutter speed/flash level, shutter speed/aperture/flash level, aperture/flash level, or flash only.

e7: Auto Bracket Order

As I describe in Chapter 2, you can use this option to specify the order in which bracketing is applied (metered exposure/underexposure/overexposure or under/metered/over).

e8: Auto Bracketing Selection Method

This specifies how the D200 selects which of the 48 different bracketing programs to apply. The default method is to hold down the BKT button while rotating the main command dial to select the number of shots, and the sub-command dial to select the bracketing increments (as I describe in Chapter 2). You can opt to use the BKT button and the main command dial to turn bracketing on and off, while using the BKT button and sub-command dial to select both number of shots and bracketing increment.

Controls

Use the options in this submenu (which is not shown in figure 3.8 because it's located after submenu e in the list) to modify how some of the common controls operate. You can tailor your D200 to your specific preferences, but should be aware that your modifications are a little like reprogramming your computer keyboard to a different alphanumeric arrangement. Altering the controls may work fine for you, but will surely perplex any other D200 user who attempts to use your camera!

f1: Center Button

Use this to program the center button of the multi selector. You can use the button to move the active focus area to the center of the viewfinder (the default value), or use it to illuminate the focus area or group. If you like, you can disable the center button entirely. Additional options are available for this button in playback mode (turning thumbnails, histogram, or zoom on/off).

f2: Multi-Selector Press

You can modify the multi selector so that, when pressed, it activates the exposure meters or initiates autofocus.

f3: Photo Info Playback

Ordinarily, the left/right buttons of the multi selector page through your images on playback, while the up/down buttons change the type of information displayed about each image. You can reverse these functions if you like.

f4: Func. Button

You can assign several different functions to the Func. button. Your options include flash value lock; Non-CPU lens data entry (using the command dials); shutter speed/aperture adjustments in 1 EV steps; AE-L/AF-L function; flash off; bracket burst; switch to matrix, center-weighted, or spot metering; or toggle between wide-area and normal focus areas with the command dials (see figure 3.10).

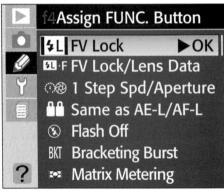

3.10 Assign a function to the Func. button.

f5: Command Dials

This option swaps the functions of the main and sub-command dials. For example, while the main command dial adjusts shutter speed in Manual and Shutter Priority modes and the sub-command dial modifies the aperture in Manual and Aperture Priority modes, you can exchange these functions. All other command/sub-command dial functions will be swapped as well. You can also reverse the rotational direction of the dials (so that turning the dial to the right produces the default effect of turning it to the left, and vice versa) and adjust the behavior of the dials during playback or menu display.

f6: Setting Method for Buttons and Dials

Normally, you must hold down the Mode, EV, BKT, ISO, Qual, and WB buttons while spinning a command dial to make an adjustment. Select Hold in this menu, and you can press the button, release it, and still make your adjustments until you press the button a second time or partially depress the shutter release.

f7: Disable Shutter If No Memory Card?

You can lock the shutter release when no CompactFlash card is inserted in the D200, or allow the camera to operate normally (except for the saving the image part). Pictures you "take" in this "play around" mode are displayed on the LCD but, of course, are not saved since no card is present.

Creating Great Photos with the Nikon D200

In This Part

Chapter 4Photography Essentials

Chapter 5All About Lenses

Chapter 6Working with Light

Chapter 7Photo Subjects

Chapter 8Downloading and Editing Images

Photography Essentials

s the proud owner of a Nikon D200, you're near the top of Nikon's digital food chain, two notches above your camera's entry-level siblings, and only a step or two below official professional models like the D2x. (Of course, the thousands of professional photographers who use the D200 to make their livings would beg to differ about professional suitability!) Because the D200 isn't considered an entry-level camera, it's likely that the D200 isn't your first dSLR and odds are good that you're well-versed in the basics of photography.

However, the aggressive price of the D200 has meant that quite a few budding photographers have made the jump to this camera directly from a point-and-shoot film or digital camera. Given the capabilities of the D200, using this camera can be daunting without a thorough grounding in photographic fundamental, so a quick introduction might be in order.

Other, more experienced photographers might have relied on their cameras' automated features so much that they're a little rusty on some of the basics. If you're in either of these camps, don't panic. In this chapter, you'll find a quick refresher on some important photography basics. Spend a minute or two boning up on exposure, depth of field, and a few other topics, and then capture that award-winning shot!

And even if you're well-versed in all this photography stuff, you still might want to skim this chapter for nostalgic purposes. Who knows? You might learn something new or something you thought you knew!

In This Chapter

Understanding exposure

Getting the right exposure

Understanding depth of field

Understanding Exposure

As a Nikon D200 user, you might have a pretty good grasp of proper exposure already. You might understand f-stops and shutter speeds, and their relationship with International Organization for Standardization (ISO) settings, and might have already used them effectively in your photography. However, the D200 does a good job of calculating exposure on its own, whether you're using programmed exposure, or even aperture- or shutter-preferred modes.

While the D200 lacks the Digital-Vari Program (scene) modes found in the Nikon D70s and D50, it still does an excellent job of figuring the correct exposure with little or no input from you. It doesn't leave you entirely on your own in manual shooting mode, either, because the indicators in the viewfinder show you when your manually selected f-stop and shutter speed are more or less correct.

Creative photography often calls for an even deeper understanding of how exposure works. Here's a quick recap to bring you up to speed.

What affects exposure?

Digital cameras, like film cameras, react to light passing through the lens, and form an image when sufficient illumination reaches the sensor. The amount of light received by the sensor varies, depending on how much light the subject reflects or transmits, and how much actually makes it through the lens. Insufficient light results in an image that's too dark; too much light gives you an

image that's too bright. You want to capture the levels in between to form your image.

Proper exposure occurs when just enough light reaches the sensor to provide detail in the darkest areas of your image, while avoiding excessive illumination in the brightest areas (which causes them to wash out). As you probably know, four things affect exposure:

- Light reaching the lens. Your subject might reflect light (say, a flower basking in the sunlight), transmit light (a backlit flower with light coming through its petals), or provide a light source on its own (as, for example, a candle flame does). To change the exposure, you simply increase or decrease the amount of illumination coming from the light source.
- ▶ Light passing through the lens. A number of factors limit the amount of light that makes it through the lens, the most important of which is the size of the lens opening. Except for a few specialized lenses (such as mirror lenses), the optics for your D200 include a diaphragm that can be adjusted, usually through an arrangement of thin panels that shift to enlarge or reduce the size of the lens opening. The relative size of the aperture is called the f-stop.
- Light passing through the shutter. The amount of light admitted by the lens is further adjusted by the duration of the exposure, as determined by the shutter. With the D200, shutter speeds can be as brief as 1/8000 second, or as long as 30 seconds, automatically, or many seconds if you manually

- keep the shutter open with a Bulb exposure.
- Sensitivity of the sensor. The sensor, like film, has an inherent response to the light that reaches it. This sensitivity is measured using ISO ratings, much like film is. When the D200 is adjusted to use a higher ISO setting, the signal produced is amplified, creating the same effect as a higher-sensitivity sensor.

All four factors work together to produce an exposure. Most important, they work together proportionately and reciprocally, so that doubling the amount of light reaching the lens, making the lens opening twice as large, leaving the shutter open for twice as long, or boosting the ISO setting 2X, all increase the exposure by the same amount.

Exposure adjustments

From an exposure standpoint, if you need more or less light falling on the sensor to produce a good exposure, it doesn't matter which of the four factors you change. In practice, however, that's seldom true, because each factor affects the picture in different ways, whether you adjust the exposure yourself or let your D200 select the settings for you.

Adjusting the light reaching the lens

The lighting of your scene affects both the artistic and technical aspects of your photograph. The quality of the light (soft, harsh), its color, and how it illuminates your subject determine the artistic characteristics of your photograph. In exposure terms, both the quantity of the light and whether your subject is illuminated evenly have a bearing on the settings. You can do one of two things:

 Increase or decrease the total amount of light in the scene.
 Move your subject to an area that is better illuminated or that has less light. Add lights or an electronic flash, or remove them.
 Bounce illumination onto your sub-

ject using a reflector.

Increase or decrease the amount of light in parts of your scene. If a great deal of contrast between the brightly lit areas and the shadows in your picture exists, your D200's sensor will have difficulty rendering the detail in both. Your best bet is usually to add light to the shadows with reflectors, fill flash, or other techniques, or move your subject to an area that has softer, more-even lighting. Figure 4.1

4.1 Light has been added to the shadow areas, making for an even exposure . . .

shows a close-up made with two lights, with the second one added to fill in inky shadows. In figure 4.2, the extra light has been switched off. The shadows are darker, but the overall image is more interesting.

4.2 ... however, letting the shadows go dark often makes a more interesting, 3-D image.

Adjusting the aperture

Changing the f-stop adjusts the exposure by allowing more or less light to reach the lens. In manual or aperture priority modes, you can change the aperture independently by spinning the sub-command dial on the front of the camera. The f-stop you choose appears in the viewfinder and on the LCD status panel on top of the camera. There are

several considerations to keep in mind when changing the lens opening:

♦ **Depth of field.** Larger openings (smaller numbers, such as f/2.8 or f/3.5) provide less depth of field at a given focal length. Smaller openings (larger numbers, such as f/16 or f/22) offer more depth of field. When you change the exposure using the aperture, you also modify the range of your image that is in sharp focus, which you can use creatively to isolate a subject (with shallow depth of field) or capture a broad subject area (with extensive depth of field).

4.3 At f/4 the depth of field is shallow.

4.4 At f/22, the depth of field is much larger.

- Sharpness. Most lenses produce their sharpest image approximately two stops less than wide open. For example, if you're using a zoom lens with an f/4 maximum aperture, the image will probably have the best resolution and least distortion at roughly f/8.
- **Diffraction.** Stopping down farther from the optimum aperture might create extra depth of field, but you'll also lose some sharpness due to a phenomenon known as diffraction, which is more pronounced the smaller the aperture becomes. You'll want to avoid f-stops like f/22 unless you must have the extra depth of field, say for macro shooting, or need the smaller stop so you can use a preferred shutter speed.
- Focal length. The effective f-stop of a zoom lens can vary depending on the focal length you use. That's why the Nikon 18-70mm zoom lens, for example, is described as an f/3.5-f/4.5 optic. At the 18mm position, the widest lens opening is equivalent to f/3.5; at 70mm, that same size opening passes one stop less light, producing an effective f-stop of 4.5. At intermediate zoom settings, an intermediate effective f-value applies. Your D200's metering system compensates for these changes automatically, and, as a practical matter, this factor affects your photography only when you need that widest opening.
- Focus distance. The effective f-stop of a lens can also vary depending on the focus distance but it's really a factor only when

you're shooting close-ups. A closefocusing macro lens can lose a full effective f-stop when you double the magnification by moving the lens twice as far from the sensor. The selected f-stop then appears to be half as large to the sensor, which accounts for the light loss. Your D200's exposure meter compensates for this, unless you're using gadgets like extension tubes, bellows, or other add-ons that preclude autoexposure.

Tip

Teleconverter lenses, which fit between your prime or zoom lens and your camera to maanify an image, also can cost you from 0.4 to 2 f-stops, too. These include the Nikon autofocus teleconverters TC-14E, TC17E, and TC20E.

Rendition. Some objects, such as points of light in night photos or backlit photographs, appear different at particular f-stops. For example, a streetlight, the setting sun, or other strong light source might take on a pointed star appearance at f/22, but will be rendered as a normal globe of light at f/8. If you're aware of this, you can avoid surprises and use the effect creatively when you want.

Adjusting the shutter speed

Adjusting the shutter speed changes the exposure by reducing the amount of time the light is allowed to fall on the sensor. In manual and shutter priority modes, you can change the shutter speed by spinning the main command dial on the back of the camera. The speed you choose appears in the viewfinder and on the LCD status panel on top of the camera. You're probably familiar with most of the considerations involving altering shutter speed, including the main advantage, action stopping. Slow shutter speeds allow moving objects to blur and steadies the camera motion when the photographer pans the camera during an exposure or fails to hold the camera steady enough to affect image sharpness. Higher shutter speeds freeze action (see figure 4.5) and offer almost the same steadying effect as a tripod.

4.5 A high shutter speed freezes all the action.

Changing ISO

You can produce the same effect as opening up one f-stop (or doubling the length of the exposure), by bumping up the ISO setting from ISO 100 to 200. However, there is at least one side effect to boosting the D200's ISO setting. *Noise artifacts* – those

multicolored speckles that are most noticeable in shadow areas but that can plague highlights, too—are more numerous and denser as you increase the ISO setting.

Fortunately, the Nikon D200 performs very well in this regard. You probably won't notice much more noise at ISO 400, and ISO 800 can produce some very good images indeed. While ISO 1600 is still quite usable, you can expect noise to be visible.

The D200 has three additional ISO steps, H0.3, H0.7, and H1.0, which increase sensitivity in one-third stop increments up to ISO 3200. I recommend using these stratospheric ISO settings only experimentally or when the very highest sensitivity available means the difference between getting a shot and not getting it at all. Expect lots of grain above ISO 1600. Experiment with the High ISO NR setting in the Shooting Menu. which can be switched off, or set to Norm. Low, or High. The High setting might minimize noise, while lengthening the time between shots as noise-reduction processing is applied following the exposure, and can introduce artifacts of its own.

You can change the ISO by holding down the ISO button on the mode dial on the upper-left end of the top panel, and spinning the main command dial. The ISO you've selected appears on the LCD status panel on top of the camera and on the right side of the viewfinder display.

4.6 At ISO 100 (left), sensor noise is almost invisible. Boost the ISO to 1600 (right), and you'll be able to detect noise, particularly in the darker areas and when the image is enlarged this much.

Getting the Right Exposure

You're no beginner to photography, so you understand that good exposure involves much more than keeping your picture from coming out too dark or too light. That's because no sensor can capture all the details possible in an image at every conceivable light level. Some details will be too dim to capture, and others will overload the photosites in the sensor and not register at all or, worse, will overflow into adjoining pixels and cause the light smearing effect known as blooming.

Like transparency film, digital sensors can't handle large variations between the darkest and lightest areas of an image, so the optimum exposure is likely to be one that preserves important detail at one end of the scale while sacrificing detail at the other. That's why you, the photographer, are often smarter than your D200's exposure meter. You know whether you want to preserve detail in the shadows at all costs, or if you're willing to let it fade into blackness in order to preserve the lightest tones.

Left to its own devices, the D200 has a tendency to allow the highlights to be clipped (blown out) slightly in order to preserve shadow detail. New users of the camera often think the D200 underexposes most pictures (until they begin making adjustments on their own), when, in fact, it's rescuing those parts of the image that are most easily corrected. You can often boost detail in areas that are underexposed, whereas you can not do much with blown highlights.

4.7 Only you can decide whether the detail in the highlights or the detail in the shadows is most important for the image you're trying to take.

Understanding tonal range

The number of light and dark shades in your image is called its *tonal range*, and the D200 provides several tools to help you manipulate that range. One of these is called *custom curves*, which you can create in Nikon Capture and upload to the D200. Unless you're using a custom curve prepared by others, this tool is beyond the scope of this field guide. However, if you understand how to use the Curves palette in Photoshop, then you can probably improve the tonal range of your images right in your camera using custom curves as the principle.

See Chapter 8 for more information on how to upload custom curves to the camera. A more accessible tool for the average D200 user is the histogram. While histograms can be shown as you are setting up a shot in the preview image of point-and-shoot cameras, they're generally an after-the-shot tool digital SLR owners use to improve the next exposure.

Tip

Find hundreds, if not thousands, of custom curves created specifically for Nikon cameras on the Web by searching for "Custom Curves" + "Nikon" with Google, Yahoo!, or your favorite search engine.

You can view the histogram for any image you've taken by pressing the review button on the back of the camera to display the image on the monitor LCD. Then press the multi selector button up or down (unless you've redefined this function to the left/right keys using Custom Settings menu entry f3) to page through the various information display options until the histogram graph appears.

A histogram is a simplified display of the numbers of pixels at each of the 256 brightness levels that produces an interesting mountain-range effect, as you can see in figure 4.8. Each vertical line in the graph represents the number of pixels in the image for each brightness value, from 0 (black) on the left to 255 (white) on the right. The vertical axis measures the number of pixels at each particular brightness level. With the D200, the histogram is superimposed over a slightly-reduced rendition of your original image so you can view your subject and the graph at the same time.

The D200 also offers a second histogram that includes an even smaller image of the original photo in the upper-left corner of the LCD, with a histogram of all color channels displayed in white immediately below it.

At the right edge of the display is a stack of red, green, and blue histograms, showing the tonal values for each color. You can switch to this type of histogram by using the multi selector's up/down (or left/right, if you've changed the default) buttons.

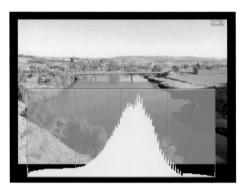

4.8 A histogram of an image with correct exposure and normal contrast shows a mountain-shaped curve of tones extending from the shadow areas (left) to the highlight areas (right).

This simplified sample histogram shows that most of the pixels are concentrated roughly in the center, with relatively few very dark pixels (on the left) or very light pixels (on the right). Even without looking at the photo itself, you can tell that the exposure is good, because no tonal information is clipped off at either end. The lighting of the image isn't perfect, however, because some of the sensor's capability to record information in the shadows and highlights is wasted. A perfect histogram would have the toes of the curve snuggle up more comfortably with both the left and right ends of the scale.

As you gain experience with histograms, you can actually determine both the contrast and exposure of an image just by examining the shape of the curve and distribution of the tones. An image with normal contrast

and good exposure looks like figure 4.8. With a lower-contrast image, like the one shown in figure 4.9, the basic shape of the histogram remains recognizable, but it's gradually compressed to cover a smaller area of the gray spectrum. The squished shape of the histogram occurs when the tones in the original image are represented by a limited number of tones in a smaller range of the scale.

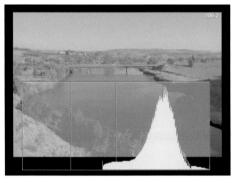

4.9 A lower-contrast histogram shows all the tones in an image compressed into a smaller range.

Instead of the darkest tones reaching into the black end of the spectrum and the lightest tones extending to the white end, the blackest areas are now represented by a light tone, and the white ones by a somewhat lighter (but not white) tone. The overall contrast of the image is reduced. Because all the darker tones are actually a middle gray or lighter, this version of the photo appears lighter as well.

Increasing the contrast of an image produces a histogram like the one shown in figure 4.10. Now, the tonal range is spread over a much larger area, and there are many tones missing, causing gaps between bars in the histogram. When you stretch the tonal scale in both directions like this, the darkest tones become darker and the lightest tones

become lighter. In fact, shades that might have had middle tone values before can change to black or white as they are moved toward either end of the scale.

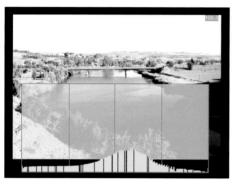

4.10 A histogram of a higher contrast image shows the tones spread over a larger area, with some tones missing.

The effect of increasing contrast might be that some tones move off either end of the scale altogether, while the remaining grays are spread over a smaller number of locations on the spectrum. That's exactly the case in the example shown in figure 4.10. The number of possible tones is smaller and the image appears harsher.

Unfortunately, short of using custom curves, there is little you can do in your D200 to compensate for low or high contrast. You should concentrate on reading the histogram so you can adjust exposure with an exposure value (EV) change. Learn to spot histograms that represent over- and underexposure, and add or subtract exposure to compensate. To change contrast while you

shoot, your best bet is to do something about the lighting itself, using reflectors, fill flash, or moving your subject to a different location if that is an option.

Exposure that is less than optimal is easy to fix. For example, figure 4.11 shows an underexposed image; some of the dark tones that appeared on the graph in the original exposure are now off the scale to the left. The highlight tones have moved toward the center of the graph, and there's a vast area of unused tones on the right side of the histogram. Adding a little exposure moves the whole set of tones to the right, returning the image to the original, prettygood exposure.

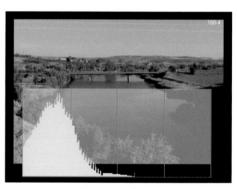

4.11 In an underexposed image, dark tones are lost at the left end of the scale.

An overexposed image is shown in figure 4.12; the highlight tones are lost at the right side of the scale. Reducing exposure can correct this problem. As you work with histograms, you can use the information they contain to fine-tune your exposures.

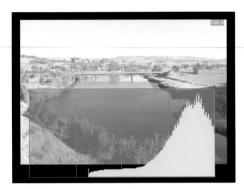

4.12 In an overexposed image, tones are lost at the right end of the scale.

Fine-tuning

You can fine-tune your exposure and the tonal range of your images several ways. Here's a quick checklist:

- Use Manual mode. Just adjust the aperture or shutter speed to add or subtract exposure.
- Use matrix, center-weighted, or spot metering. Perhaps you feel that choosing a different metering mode will let your D200 choose an appropriate exposure more easily. Turn the metering mode dial to the right of the viewfinder (it's concentric with the AE-L/AF-L button) to switch among matrix, centerweighted, or spot metering. Although matrix metering generally does a great job, sometimes you want to add emphasis to subject matter in the middle of the frame using center-weighted metering, or meter from one precise area in the frame using spot metering.

- Use tone compensation. You can actually tell the D200 what kind of image you have, so it will apply its own specialized tonal curves to the image as it's shot. Press the menu button, select the shooting menu, Custom

 □ Tone Compensation. There, you can click Auto, Normal, Less Contrast, More Contrast, or Custom (which applies a tonal curve you've uploaded to the camera using Nikon Capture).
- Apply EV settings. Hold down the EV button, and spin the main command dial to apply up to plus or minus five stops worth of exposure in 1/2- or 1/3-stop increments (depending on how you've set up your D200 in the Custom Settings menu). EV actually adds or subtracts exposure from the D200's default meter reading using aperture or shutter speed changes, depending on what the current program mode specifies. The new shutter speed or f-stop appears in the viewfinder, so you'll know what changes your EV change has made.
- Bracketing. Hold down the BKT button on the back of the camera and spin the main command dial to activate bracketing for exposure, white balance, or flash, depending on how you've set up your D200 in the Custom Settings menu (using CSM e5 through e8). Depending on which bracketing program you've selected, the D200 varies the settings for the next two or

three exposures, using your bracketing specifications. As demonstrated in figure 4.13, bracketing doesn't fine-tune an individual exposure but, rather, lets you take a series of pictures, one of which, you hope, is optimal.

Tip

When you're using Programmed mode, the D200 selects the correct exposure for you. However, if you decide you want to use a different shutter speed and f/stop combination for that exposure, you can do that by spinning the main command dial. This feature lets you switch from, say, 1/500 second at f/11 to 1/1000 second at f/8 or 1/250 second at f/16, quickly and easily.

4.13 Bracketing lets you take a series of photos at different settings.

Understanding Depth of Field

The final basic aspect of photography that you might need to review is depth of field. While DOF is a familiar topic for those of you who have been using film SLR cameras, anyone who has stepped up to the Nikon D200 from a point-and-shoot digital camera might be in brand-new territory.

That's because digital snapshot cameras have much smaller sensors that require lenses with shorter focal lengths to achieve the same image size, and DOF is determined by the focal length of the lens and the distance from the camera to the subject. So, that 7–21mm 3X zoom lens on your point-and-shoot camera might have the same field of view as a 35–105mm zoom on a full-frame film camera, but the DOF will be much greater. The telephoto position, for example, will have the same DOF as a 21mm lens on a film camera.

The larger sensor on your D200 calls for somewhat longer lenses, but the extra DOF still accrues, although to a lesser extent. The kit lens, for example, has the same field of view as a 27–105mm lens on a film camera, but the DOF at each zoom position is closer to what you'd expect from the 18–70mm lens it really is.

If DOF is important to you because you want to maximize or minimize the range of your image that's in focus, the DOF preview button is your best friend. Some lenses have DOF markers on their barrels that let you estimate DOF at a particular f-stop.

It's difficult to talk about depth of field in concrete terms because it is, for the most part, a subjective measurement. By definition, depth of field is a distance range in a photograph in which all included portions of an image are at least acceptably sharp. What's acceptable to you might not be acceptable to someone else and can even vary depending on viewing distance and the amount the image has been enlarged.

Strictly speaking, only one plane of an image is in sharp focus at one time (see figure 4.14). That's the plane your D200's autofocus mechanism or you (if you've manually focused) select. Everything else, technically, is out of focus. However, some of those out-of-focus portions of your image might still be acceptably sharp, and that's how we get DOF ranges.

4.14 When you've focused on the tack in front, the two in the back are out of focus.

As you probably know, the DOF range extends one-third in front of the plane of sharpest focus, and two-thirds behind it. So, assuming your DOF at a particular aperture, focal length, and subject distance is 3 feet, everything 1 foot in front of the focus plane and 2 feet behind it appears to be sharp.

If you plan on making a grab shot and don't want to risk losing it while your D200 autofocuses, you can switch to manual focus and set vour lens at a point known as the hyperfocal distance. This distance is a point of focus where everything from half that distance to infinity appears to be acceptably sharp. For example, if your lens has a hyperfocal distance of 4 feet at a particular focal length, everything from 2 feet to infinity is sharp. The hyperfocal distance varies by the lens focal length and the aperture in use. On the Internet, you can find charts that help you calculate hyperfocal distance. A group called Nikonians (www.nikonians. org) will even sell you a T-shirt with hyperfocal distances printed on the front, upside down so you can read the chart while wearing it!

Most of the time, DOF is described in terms of the size of the *circle of confusion* in an image. A portion of an image appears sharp to our eyes if fine details seem to be sharp points. As these sharp points are thrown out of focus, they gradually become fuzzy discs rather than points, and when that happens we deem that part of the image unacceptably blurry. The closer we are to the image and the more it has been blown up, the larger its circles of confusion appear; so DOF that looks acceptable on a computer display might be unacceptable when the same image is enlarged to poster size, hung on the wall, and examined up close.

To make things even more interesting, some of these out-of-focus circles are more noticeable than others, and can vary from lens to lens. This particular quality is called *bokeh*, after *boke*, the Japanese word for blur. (The *h* was added to help English speakers avoid rhyming the word with *broke*.) Factors such as the evenness

of a particular lens' illumination and the shape of its diaphragm determine its bokeh qualities.

Note

In some cases, the out-of-focus circles can take on the shape of the lens iris!

Lenses with good bokeh produce out-offocus discs that fade at their edges, in some cases so smoothly that they don't produce circles at all, as shown in figure 4.15. Lenses with intermediate bokeh qualities generate discs that are evenly shaded, or perhaps have some fade to darkness at their edges. The worst lenses create discs that are darker in the center and lighter on their edges.

4.15 When the out-of-focus discs blend together smoothly, they're much less distracting.

You've probably seen the donut hole bokeh that result from catadioptric or mirror lenses, which is either the most atrocious bokeh possible, or else a creative effect, as used in figure 4.16, depending on your viewpoint.

4.16 Individual discs with dark centers and bright edges call attention to out-of-focus areas of your image, but can be used for an abstract look, as in this photo.

All About Lenses

Ithough the Nikon D200 is called a single lens reflex (SLR), that doesn't mean you're limited to a single lens! In fact, the ability to swap out one set of optics for another is one of the two or three top reasons for switching from a non-SLR digital shooter to a camera like the Nikon D200. Lenses give you extra flexibility and give your picture-taking possibilities a boost. Add-on lenses are arguably the number-one expansion option available for your camera.

This chapter covers everything you need to know about choosing and using the best lens for the job.

Expanding Your Lens Options

Many photographers purchase D200 cameras without lenses, because they plan to use the cameras with sets of optics they already own. See if any of these scenarios fits you:

- If you don't already own a Nikon SLR and lenses, you might have purchased your D200 with an interchangeable lens. If so, odds are good that you bought a multipurpose lens such as the 18−70mm f/3.5−4.5G ED-IF AF-S DX Zoom-Nikkor (often called the kit lens, because it is furnished in the basic kit package offered for the Nikon D200).
- If you wanted to splurge, you might have purchased the 18–200mm f/3.5–5.6G ED-IF AF-S VR DX Zoom-Nikkor introduced at the same time as the D200, because of its attractive vibration reduction feature (VR). Some dealers supply lenses of similar zoom ranges built by a third-party lens vendor, such as Sigma. For example, Sigma makes a popular 18–125mm zoom for digital cameras that is priced

In This Chapter

Expanding your lens options

Choosing between zoom or fixed-focallength lenses

Lens compatibility

Decoding Nikon's lens code

Applying the lens multiplier factor to your pictures

Wide-angle lenses

Telephoto lenses

Normal lenses

Macro lenses

Reducing vibration

Extending the range of any lens with a teleconverter

roughly the same as the 18–70mm kit lens but offers a little more telephoto reach. Many vendors also make 18–200mm zooms without the vibration reduction capabilities of the Nikkor counterpart, at a considerably lower price. Perhaps your dealer wanted to provide an extralow kit price and packaged the D200 with Sigma's budget-priced 18–50mm zoom.

You might have some definite ideas about which lens you wanted with your D200, so you chose something else from the Nikon line or from a third-party vendor. The 17-55mm f/2.8G ED-IF AF-S DX Zoom-Nikkor is extremely popular among owners of upper-crust Nikon cameras because it's solidly built, extremely sharp, and has an f/2.8 maximum aperture that doesn't change as you zoom. However, it costs almost as much as the D200 itself, so vou'll need deep pockets or a lot of usage to justify this beast.

In any of these cases, if you have the D200 and just one lens, you're ripe for an add-on.

Kit lens advantages

If you bought your D200 with the 18–70mm kit lens, you have a lens that's extremely versatile and suitable for a wide variety of picture-taking situations. Here are some of the advantages of the kit lens:

- Low cost. For about \$300, this lens is a very good value and is solidly constructed.
- Nice 3.8X zoom range. When you factor in the 1.5X lens multiplier factor (more on that later), this lens corresponds to a 27–105mm zoom

- on a full-frame film camera. At the wide end, that 27mm provides a moderately wide field of view, certainly enough for everyday shooting. The 105mm telephoto position falls smack into the range considered excellent for portraits and some types of close-in sports activities.
- Adequate aperture speed. The f/3.5 maximum aperture at the wide-angle position and f/4.5 at the telephoto end are about one-half to a full f-stop slower than what you'd expect from a prime (nonzoom) lens at the equivalent focal length. However, faster lenses cost a lot more, and the kit lens's speed is, at least, adequate.
- ◆ Good image quality. Even at its low price, the kit lens includes extra-low dispersion glass and aspherical elements that minimize distortion and chromatic aberration; it's sharp enough for most applications. If you read the user evaluations in the online photography forums, you know that owners of the kit lens have been very pleased with its image quality.
- Compact size. At less than 14 ounces and roughly 3 inches in diameter and length, this compact optic makes a good "walking around" lens you can take with you when you plan to leave all your other gear at home.
- ★ Fast, relatively close focusing. The autofocus mechanism of the 18-70mm lens is fast and quiet, and gets you down as close as 14 inches, so you can use it as a semimacro lens in a pinch.

If you can afford only one lens for your D200, this is one to consider. If you have a bit more money, the 18–200mm VR lens,

which offers vibration reduction to counteract the effects of camera shake, is an excellent alternative. Unless you shoot many ultra-wide-angle photos, or you need to reach out with a longer telephoto, the kit lens or VR lens can handle most of the picture-taking situations you're likely to encounter. You generally won't need both, because the VR lens's focal length duplicates that of the kit lens.

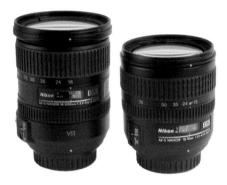

5.1 The 18–200mm f/3.5–5.6 G ED-IF AF-S VR DX Zoom-Nikkor (left) and 18–70mm f3.5–4.5G ED-IF AF-S DX Zoom Nikkor kit lens (right).

Consider a new lens

After you've used your D200 for awhile, you'll certainly discover that there are at least a few pictures you can't take with your existing set of lenses. It's time to consider buying an additional lens. Here are some of the key reasons for expanding your lens collection:

★ Wider view. When your back is against a wall — literally — you need a lens with a wider perspective. A lens with a shorter focal length lets you take interior photos without going outside to shoot through a window, or asking the owner of a 21st-century vegetable cart to move so you can photograph that 16th-century cathedral. You can emphasize the foreground in a landscape picture while embracing a much wider field of view. And you can move in close with a wide-angle lens to use the perspective distortion that results as a creative element. For the D200, wide-angle lenses generally fall into the 10–24mm range, and include both fish-eye (distorted, curved view) and rectilinear (non-distorted, mostly) perspectives.

Longer view. A longer telephoto lens can do several things for you that a shorter lens cannot. A tele reaches out and brings distant objects closer to the camera; it's especially valuable when "sneaker zoom" won't work. A long lens has less depth of field, so you can throw a distracting background or foreground out of focus for a creative effect more easily. Telephoto lenses have the opposite perspective distortion than what is found in wide-angle lenses: Subjects, such as faces, appear to be broader and flattened. So, you might improve the appearance of a narrow face simply by using a longer zoom setting. That same distortion is great when you want to reduce the apparent distance between distant objects - the same effect is used in Hollywood to make it appear that the hero is darting between oncoming cars that are actually separated by 30 feet or more. With the D200, a 50mm lens has something of a telephoto effect because of the 1.5X crop factor, and longer lenses extend out to 600mm or much more.

5.2 Get a broader view with a wide-angle lens.

5.3 Telephoto lenses bring you up close.

Macro focusing. Macro lenses let you focus as close as an inch or two from the front of the lens, offering a different perspective on familiar objects. You'll find these lenses available both as prime lenses (such as the popular 60mm and 105mm Micro-Nikkors), and as macro-zoom lenses. The available range of focal lengths is important, because sometimes you want to get as close as possible to capture a particular viewpoint (say, to emphasize the stamens in a delicate flower petal) or back off a few feet to avoid intimidating your subject (perhaps a hyperactive hummingbird).

5.4 Macro lenses provide extra magnification, as is shown in this shot of a domestic cat.

- Sharper image. Some lenses, such as fixed-focal-length prime lenses, are sharper, overall, than others. Inexpensive zoom lenses are often noticeably less sharp than the discriminating photographer might prefer. In addition, lenses rarely have the same sharpness at all apertures and zoom settings. A wide-angle lens, for example, might have barrel distortion and fuzzy corners at its widest setting, and if you shoot many photos at that focal length you might be better served with a different optic. Lenses also fall down in sharpness when they're asked to do things they weren't designed for, such as taking macro photos with a zoom that's best-suited for sports photography, or shooting at maximum aperture under low-light conditions.
- Faster aperture. Your 300mm f/4.5 lens might be sharp enough and have the perfect focal length for the sports photography you're planning to do. But, you find that it's not fast enough to let you use a high enough shutter speed. What you might really need is a 300mm f/2.8 lens, optimized for shooting wide open. The difference between a shot grabbed at 1/500 second at f/2.8 and the same image captured at 1/180 second at f/4.5 can be significant in terms of actionstopping. In addition, your f/2.8 lens might be sharpest when stopped down to f/5.6. You might have to use f/8 to get similar sharpness with the f/4.5 optic.
- Special features. Another reason to choose an add-on lens is to gain special features. Although the

close-up capabilities of a macro lens are certainly a special feature, you have more exotic capabilities at your disposal. These include lenses with shifting elements that provide a certain amount of perspective control; and optics like the Nikon DC (defocus control) series let you adjust how the out-of-focus portions of an image appear (especially useful in portraiture). Other special lenses include fish-eve lenses for ultrawide views, ultraviolet lenses for scientific applications, and vibration reduction lenses that compensate for camera shake and give you sharper results at slower shutter speeds. When you need or want an unusual feature, you'll be glad your D200 has interchangeable lenses and the capability to use older Nikon mount optics.

Choosing Between Zoom or Fixed-Focal-Length Lenses

It wasn't that long ago that serious photographers worked almost exclusively with fixed-focal-length/prime lenses rather than zoom lenses. Many zoom lenses were big, heavy, and not very sharp. The most expensive zooms were sharp, but still cumbersome. For example, the Zoom-Nikkor 50–300mm f/4.5 optic, which set the standard for such lenses, weighed 5 pounds and was almost a foot long! Today, you can buy a 28–300mm lens for the D200 that's about 3 inches long and weighs less than a pound.

Some of these early zoom lenses had a nasty habit of shifting focus as you zoomed in or out. They were used primarily for applications where it wasn't always practical to change lenses rapidly (such as sports or spot news), or when the zoom capability itself was needed for a special look, such as the ever-popular zoom during exposure effect.

Today, optical science has made great strides, and there are plenty of zoom lenses available that even the most snobbish photographer can endorse. They're smaller, lighter, faster, and sharper. For example, Nikon's 28–200mm f/3.5–5.6G ED-IF AF Zoom-Nikkor is a little gem that measures 2.7 by 2.8 inches, weighs just 13 ounces, and focuses down to 1.2 feet. Many D200 users favor this lens as a "walking around" optic when they expect that longer telephoto reach will be more valuable than extra-wide-angle perspective. The chief drawback of this lens is that it's slow (f/5.6) at the telephoto position.

Prime lens considerations

You use a prime lens when you must have the ultimate in sharpness or speed at a particular focal length. For example, Nikon offers f/1.4 lenses in fixed 28mm, 50mm, and 85mm focal lengths that are unmatched for speed and resolution. You can buy 300mm and 400mm Nikkors with f/2.8 maximum apertures, and 500mm or 600mm f/4 super-telephotos. In contrast, even wide-angle and short telephoto zoom lenses from Nikon with f/2.8 maximum apertures tend to be very expensive.

Prime lenses are a good choice when you have freedom of movement and can get closer to your subject, or can back up a little to fill the frame appropriately.

Zoom lens considerations

Size, speed, and sharpness tend to be the chief drawbacks of zoom lenses. Because of the additional elements required to zoom, these lenses are quite a bit larger than their fixed-focal-length counterparts. The disparity can be huge if you take most of your photos at the short end of the zoom range; a 50mm f/1.8 prime lens, at 5 ounces, might be only 20 percent of the size and weight of a slower zoom lens that covers the same focal length.

The most affordable zoom lenses tend to change their maximum aperture as the focal length increases. An f/3.5 lens might become an f/5.6 lens when you crank it all the way out. A smaller maximum f-stop brings with it a penalty in exposure flexibility, viewfinder brightness, and autofocus capabilities. (The D200's autofocus system won't function if the f-stop is smaller than f/5.6, which might be the case with a zoom mounted on a teleconverter or that has a maximum aperture of f/6.3 or smaller.) Lenses that don't change their maximum aperture as they zoom (called constant aperture lenses) are more costly and, typically, much heavier. For example, Nikon's professional-quality 17-55mm f/2.8G ED-IF AF-S DX Zoom-Nikkor, with a constant f/2.8 aperture, weighs 26.6 ounces; while Nikon's "consumer" equivalent, the 18-55mm f/3.5-5.6G ED AF-S DX Zoom-Nikkor weighs a mere 6.8 ounces (thanks to its rugged, but plastic, mount and other parts).

Lens Compatibility

Among all digital cameras, Nikon lenses are, without a doubt, the most compatible. Indeed, most of the lenses produced for the first Nikon F in 1959 can be used (perhaps with some small modifications) on the latest

digital single lens reflex (SLRs) cameras offered by Nikon, Fuji, and many models in the professional camera line discontinued in 2005 by Eastman Kodak Company. That's not the case with other brands. (Some recent Canon digital SLRs can't use a few of the company's newest lenses.)

Of course, a few Nikkors, such as the earliest fish-eye lenses, extend too far into the camera to be used, or have parts that might intersect with components of the camera body. All Nikon lenses made prior to 1977 must have some simple machining done to remove those portions of the lens mount that interfere with tabs and levers added to later models, including the D200, for functions such as autofocus.

Tip Technician John White can perform conversions for you for as little as \$25 to \$35 (www.aiconversions.com).

Older lenses can't provide all the features built into the latest optics. The automatic diaphragm works, but features such as autofocus and autoexposure might not function in all respects. For example, with the D200, if you want automatic exposure, you need to use the lens in Aperture Priority mode, and then tell the camera the focal length and maximum aperture of the lens you're using in the shooting menu's Non-CPU Lens Data option. The D200 then sets the correct shutter speed for the aperture you've selected. You can also use the D200's exposure meter in Manual mode if you've set the non-CPU lens data. In either A or M modes, you must still set the aperture manually.

Many D200 users feel that the ability to recycle older lenses is worth the inconvenience of using manual focusing and having to calculate and set exposure (just as in the old days).

5.5 Older lenses (bottom) don't have the electronic and mechanical linkages found on newer optics (top).

Decoding Nikon's Lens Code

Choosing the right lens from among the vast universe of new and used lenses that fit the Nikon D200 can be confusing, partially because of Nikon's system of letter codes that indicate a lens's features. Here's a brief checklist that will clear up most of that confusion:

★ AI, AI-S. Nikkor lenses produced after 1977 include an automatic indexing feature that eliminated the need to align the aperture ring manually when the lens was mounted. The first lenses to include this feature had the AI or AI-S designation. However, all Nikon optics introduced after 1977 have automatic indexing (except for G Series lenses, because they

have no aperture ring), whether that's included in the lens code or not.

- ★ E. Nikon's Series E lenses are bargain-priced optics with great image quality, but they have less rugged mechanical innards suitable for nonprofessional use. They frequently include aluminum or plastic parts instead of the brass that the most costly Nikkors use. However, E lens mounts are all metal, so the series is more rugged than you might think.
- D. When a D is included in the lens name, the lens is capable of communicating focus distance information to the camera, which supposedly helps with 3-D matrix metering and flash photography.
- G. Lenses with this marking have no aperture ring. You use the camera to set the aperture, either automatically or by spinning the sub-command dial (on the D200). The only caveat you should know is that you cannot use these lenses on older cameras that require an aperture ring.
- ♠ AF, AF-D, AF-I, AF-S. Various AF designations show that the lens is an autofocus lens. The secondary code letter provides additional information: D (it's a D-type lens), I (focus is through an internal motor), or S (you can focus or finetune focus manually even with AF engaged).
- DX. All DX lenses are designed exclusively for use with digital cameras having the 1.5X crop factor.

- Their coverage circle isn't large enough to fill up a full 35mm frame. The digital-only design means that these lenses can be smaller and lighter than their full-frame counterparts.
- VR. These lenses have Nikon's vibration-reduction technology, which shifts lens elements to counteract camera shake or movement, and allows you to take photos without a tripod at slower shutter speeds.
- ◆ ED. The ED designation indicates that the lens has elements made of extra-low dispersion glass, which tends to reduce chromatic aberration (color fringing) and other defects. Some lenses use a LD (low dispersion) or UD (ultralow dispersion) marking.
- Micro. The term micro is Nikon's designation for a macro lens.
- IF. This code means that the lens has internal focusing, so the length of the lens doesn't increase or decrease as the lens is focused.
- ★ IX. These lenses were produced for Nikon's Pronea APS film cameras. Although you can use many standard Nikkor lenses on the Pronea 6i and Pronea S, the reverse is not true. You cannot use these IX lenses on the D200 or any other D-series Nikon digital SLR.
- DC: The DC stands for defocus control, which is a way of changing the appearance of the out-of-focus portions of an image; this is especially useful for portraits or close-ups.

Applying the Lens Crop Factor to Your Pictures

You know that because your D200's sensor is smaller than the 24mm-by-36mm standard film frame, lenses at a particular focal length produce what appears to be a magnified image, but that is, in fact, just a cropped version of the original image. The D200 provides a 1.5X crop factor (often erroneously called a *multiplier factor* even though nothing is being multiplied).

It's important to recognize that the cropping factor is not a focal-length multiplier, because the true focal length of the lens (along with its DOF) remains the same. Your 200mm f/3.5 lens isn't really converted to a 300mm f/3.5 optic. It's still a 200mm lens, but you're cropping out the center portion of the image in the camera rather than in Photoshop or another image editor.

As you've seen, although this multiplier factor can be very cool for those who need fast, cheap telephoto lenses, it makes getting a true wide-angle view that much more difficult.

Of course, because a smaller portion of the lens coverage area is used, the smaller sensor crops out the edges and corners of the image, which, with some lens designs, is where aberrations and other defects reside. On the other hand, stretching an extremely short wide-angle lens (10–15mm) to fill the D200's sensor can reintroduce those very distortions that are reduced by the crop factor in longer lenses.

Wide-Angle Lenses

A wide-angle lens or wide-angle zoom setting is useful for several picture-taking situations, as mentioned earlier in this chapter. Here's a concise listing of the top reasons for using a wide-angle lens:

- ♣ To get the whole scene in close quarters. Frequently, you won't have much room to maneuver indoors if you want to shoot an entire room. Architectural photographers might find that the perfect position to photograph a building is unfortunately inside the lobby of the building across the street. Perhaps you want to photograph a celebrity surrounded by a crowd, and backing up an extra 5 feet means you'll have a wall of bodies between your camera and your subject.
- To increase the field of view for distant shots. You're looking at a stunning panorama and want to capture as much of it as possible. Shoot with a wide-angle lens to grab the broadest possible view.
- ★ To increase depth of field (DOF). Wide-angle lenses offer more DOF at a given aperture than a telephoto lens. Of course, the fields of view and perspective differs sharply, but if a lot of DOF is your goal, a wide-angle lens is your best bet.
- ◆ To emphasize the foreground. Using a wide angle on landscapes tends to emphasize the foreground details while moving the distant scenery farther back from the camera. You can crop out the

foreground, or use it as a picture element. For example if you're photographing a vista that includes a lake, you might want to use the wide angle to emphasize the broad, unbroken expanse of water nearest the camera. Or, in the following photograph, the wide angle was used to emphasize the country road that ran in front of the old-time service station.

5.6 Wide-angle lenses emphasize the foreground.

- To provide an interesting angle. Get down low and shoot up. Get up high and shoot down. Wideangle lenses can emphasize the unusual perspective of either angle, providing additional creative opportunities.
- ◆ To distort the foreground. Wideangle lenses provide a special kind of perspective distortion to objects that are closest to the camera, and you can use this look to create unique photos, as I did when I moved in closer to the old service station to isolate one of the antique pumps in this photo.

5.7 Wide-angle perspective distortion can provide an interesting effect.

When you are working with a wide-angle lens, there are a couple things to keep in mind:

Watch your horizontal and vertical lines. Because things such as the horizon or the lines of buildings in your photograph are emphasized, you'll want to keep the plane of the camera parallel to the plane of your subject, and avoid tilting or rotating the camera if you want those lines to appear straight in your photo. Architecture can be especially problematic,

because tilting the camera back to take in the top of a building invariably produces that peculiar "tipping over" look. Your Nikon D200's optional viewfinder reference grid (custom setting CSM d2) can help you keep your lines straight.

- Avoid unwanted perspective distortion. Wide-angle lenses exaggerate the relative size of objects that are close to the camera. Although you might want to use this effect for creative purposes, you might also want to avoid it when shooting subjects, such as people, that don't benefit from the distortion.
- Be aware of lens defects. Many lenses produce barrel or pincushion distortion, and might have other problems, such as chromatic aberration or even vignetting, at the edges. You'll want to keep this in mind when you compose your photos so that important picture information doesn't reside in areas that will have problems.
- Watch flash coverage. Electronic flash units might not cover the full wide-angle frame in their default modes. You might need to use a diffuser or wide-angle accessory over your flash, or set the flash unit for its wide-angle mode to avoid dark corners. The lens hoods on some lenses might cause shadows in flash pictures when you use them with the D200's built-in speedlight at the wide-angle positions of the kit lens and other lenses. Sometimes, simply removing the lens hood or zooming in slightly solves the problem.

5.8 If you tilt the camera back, the structure appears to be tipping over.

- ◆ Don't forget sneaker zoom. If the widest zoom setting isn't wide enough, look behind you. Unless you're standing at the edge of a cliff, you just might be able to back up a few steps and take in the entire view. Zoom lenses are so common these days, it's easy to forget that you can bring your feet into play.
- ▶ Slower shutter speeds are possible. You know that telephoto lenses require higher shutter speeds because their longer focal lengths tend to magnify camera shake. You'll find wide-angle lenses more forgiving, because of their wider field of view. You might be able to handhold your D200 at 1/30 second or slower when

shooting with a wide-angle lens. That can be a special boon when you are taking photos in low-light conditions indoors.

Tip

To put a double whammy on camera shake, use a Nikkor vibration reduction lens, such as the 24–120mm or 18–200mm VR lenses, at the wide-angle setting with anti-shake turned on.

Telephoto Lenses

Many D200 shooters fall into one of two camps: the wide-angle people and the telephoto folks. Although these photographers are smart enough to use a full range of focal lengths creatively, they tend to favor the odd viewpoints that wide-angle lenses produce, or treasure the up-close, in-your-face perspective of telephoto lenses. If you're an innate telephoto shooter, you'll especially want to explore one of these creative avenues:

- ◆ To isolate your subject. Telephoto lenses reduce the amount of DOF and make it easy to apply selective focus to isolate your subjects.
- ★ To get closer to the game. Except for a few indoor sports like basketball, it's often difficult to get close to the action in other kinds of contests. A tele brings you right into the huddle, into the middle of the action around the goal, or up to the edge of the scrum.

To get closer to the wildlife. Whether you're photographing a hummingbird hovering 12 feet from your camera, or trying to capture a timid fawn 50 yards away, a telephoto lens can bring you closer without scaring off your photographic prey.

5.9 Get close without alarming your wild subject.

- Portraits. Human beings tend to photograph in a more flattering way with a telephoto lens. A wideangle might make noses look huge and ears tiny when you fill the frame with a face, but that same magnification looks more natural with a 50–85mm lens or zoom setting on a D200.
- ♦ Macro photography. An ordinary 60mm macro lens gets you up close to that tiny object you want to photograph perhaps even too close, so that the camera or lens itself casts a shadow on your subject. A longer telephoto macro lens, such as the 105mm f/2.8 or 200mm f/4 Micro-Nikkors, lets you back up and still shoot close-ups.

102 Part II → Creating Great Photos with the Nikon D200

5.10 A telephoto macro lens throws the background out of focus, turning a white wall into a seamless background so your kitchen table becomes a close-up photography studio.

◆ Decrease distance. Sometimes you simply can't get any closer. That erupting volcano makes a tempting target, but you'd rather stay where you are. Perhaps you want to capture craters on the moon, or photograph a house on the other side of the river. Slip a long lens on your D200, and you're in business.

Telephoto lenses involve some special considerations of their own; some of them are the flip side of the concerns pertinent to using wide-angle lenses. Here's a summary:

* Shutter speeds. Longer lenses tend to magnify camera/photographer shakiness. The rule of thumb of using the reciprocal of the focal length (for example, 1/500 second with a 500mm lens) is a good starting point, but it doesn't take into account the actual steadiness of the photographer, the weight distribution of the camera/lens combination, and how much the image will be enlarged. When sharpness is very important, use a higher shutter speed, a tripod, or a monopod.

- Depth of field (DOF). Telephoto and telezoom lenses have less DOF at a given aperture as you increase focal length. (Some photographers consider this a myth, because when you enlarge a wide-angle shot and crop it so the subject is the same size as in the telephoto picture, the DOF is actually the same. But who does such a crazy thing?) The reduced DOF of telephoto lenses can be a good thing or a bad thing, depending on whether you're using selective focus as a creative element in your photo. Use your DOF preview button, if necessary, and be prepared to use a smaller f-stop to provide the DOF you need.
- ✦ Haze/fog. When you're photographing distant objects, a long lens shoots through a lot more atmosphere, which generally is muddied up with extra haze and fog. That dirt or moisture in the atmosphere can reduce contrast and mute colors, so you should be prepared to boost contrast and color saturation if necessary.
- Flare. Both wide-angle and telephoto lenses are furnished with lens hoods for a good reason: to reduce flare from bright light sources at the periphery of the picture area, or completely outside it. Because telephoto lenses often create images that are lower in contrast in the first place, you'll want to be especially careful to use a lens hood to prevent further effects on your image (or shade the front of the lens with your hand.)
- Flash coverage. Edge-to-edge flash coverage isn't the problem with telephoto lenses; distance is. A long lens might make a subject that's 50 feet away look as if it's right next to you, but your camera's

flash isn't fooled. You'll need extra power of distant flash shots — probably more than your D200's built-in flash provides. Sports photography, in particular, often calls for a more muscular flash unit such as the Nikon SB-800.

♦ Compression. Telephoto lenses have their own kind of perspective distortion. They tend to compress the apparent distance between objects. Fence posts that extend down the west side of your spread's lower 40 might look as if they're only a few feet apart through a 1000mm lens. Similarly, human faces can look flatter (but not flattered) when they're photographed with a very long lens. You can use this effect creatively if you like, but you should always be aware of it when using a tele.

5.11 Posts separated by six feet appear to be right next to each other in a telephoto shot.

Normal Lenses

So-called normal lenses (about a 32mm zoom setting or 35mm prime lens on a D200) are disdained by many because they are too . . . well . . . normal. Not wide enough to provide a wide-angle perspective, and not long enough to pull in distant details or serve as a portrait lens, the normal lens is seen as bland and not very creative.

Of course, if you're using a zoom lens that includes the normal position in its range, it's unlikely you'll give this much thought. The normal lens setting is just another position on the zoom scale, one that you choose because it provides the framing and look you prefer.

If you're working with prime lenses, however, there's a lot to be said for fixed-focallength lenses in this range. Here are a few things to think about:

- ▶ **Speed.** Prime lenses in the normal range can be quite a bit faster than zoom lenses at the same setting. Nikon offers a 28mm f/1.4 lens and a 35mm f/2 lens that are perfect for indoor available-light photography. If you stretch the definition slightly to include 50mm lenses, Nikon's 50mm f/1.4 and 50mm f/1.8 lenses are other speed demons to consider.
- ♣ Low cost. Okay, Nikon's 28mm f/1.4 costs more than \$1,000. But you can purchase the vendor's 35mm f/2 and 50mm f/1.4 lenses for less than \$300, and the 50mm f/1.8 is a positive steal at less than \$100. A low-cost "normal" lens might be a great way to add to your lens arsenal without emptying your wallet.

- ♦ Sharpness. Prime lenses tend to be simpler in design and much sharper than zoom lenses in the same coverage and price range.

 Millimeter for millimeter, the Nikon 50mm f/1.8 has to be the sharpest lenses on the market, and the other lenses in the Nikon "normal" range aren't slouches in terms of resolution, either.
- Size. If you want to travel light, a normal prime lens is compact and light in weight. Use one as a walking-around lens, and you might even learn more about photography as you work with and around the lens's advantages and limitations.

- by vendors other than Nikon. You'll want a lens that provides at least a half-life-size image (1:2 magnification), and preferably one with life size (1:1) magnification.
- Minimum aperture and depth of field. DOF is at a premium in macro photography, especially as you get closer to your subject. You want to stop down as far as possible (at least to f/32) to avoid a focused area that's too shallow. Of course, at such small apertures, you'll certainly be losing sharpness to diffraction effects, but that's often an acceptable tradeoff.

Macro Lenses

Macro lenses—"micro" lenses in Nikon's nomenclature—are used to take what are called *close-ups*, although the term might be a misnomer. What you're really looking for when you shoot with a macro lens is not to get close, but to magnify the apparent size of the subject in the final image. The distance doesn't matter as much as the magnification.

When using a macro lens, keep these two things in mind:

Magnification offered. With conventional lenses, the specification touted is the close-focusing distance; that is, can you get down to 12 inches, 6 inches, or 2 inches from the subject. With macro lenses, the magnification is more important, because these optics are offered in a variety of focal lengths and, even as zoom lenses

5.12 Depth of field is at a premium in macro photographs, so you'll need to use a small aperture, such as the f/22 lens opening used for this photo.

Reducing Vibration

Nikon has introduced an expanding line of lenses that include a vibration-reduction/image-stabilization feature. This capability uses lens elements that are shifted internally in response to the motion of the lens during handheld photography, countering the shakiness the camera and photographer produce and telephoto lenses magnify. However, VR is not limited to long lenses; the feature works like a champ at the 18mm zoom position of Nikon's 18–200mm VR lens. The older 24–120mm VR lens does a great job at its widest position, too.

VR provides you with camera steadiness that's the equivalent of at least two stops, which can be invaluable when you are shooting under dim lighting conditions, or hand-holding a long lens for, say, wildlife photography. Perhaps that shot of an elusive polka-dotted field snipe calls for a shutter speed of 1/1000 second at f/5.6 with your 80–400mm zoom lens. If you're using the 80–400mm f/4.5–5.6D ED VR AF Zoom-Nikkor, you can go ahead and use 1/250 second at f/11 and get virtually the same results.

Or, maybe you're shooting a high-school play without a tripod or monopod, and you'd really, really like to use 1/15 second at f/4. Assuming the actors aren't flitting around the stage at high speed, your 18–200mm f/3.5–5.6 G ED-IF AF-S VR DX Zoom-Nikkor or 24–120mm f/3.5–5.6G ED-IF AF-S VR Zoom-Nikkor just might do the job.

Here are some things to keep in mind when using a VR lens:

 VR doesn't stop action.
 Unfortunately, no VR lens is a panacea to replace the actionstopping capabilities of a higher shutter speed. Vibration reduction applies only to camera shake. You still need a fast shutter speed to freeze action. VR works great in low light, when you're using long lenses, and for macro photography. It's not so great for action photography.

- Ignore the shaking behind the curtain. The view through your finder might be jittery as the VR elements adjust to control camera movement, but you can relax: that means the lens is doing its job.
- ◆ Choose your battles. Some VR lenses produce worse results if you use them while you're panning. The lens might confuse the motion with camera shake and overcompensate. Optical designers are working to fix this problem by designing two different anti-shake systems into the same lens. However, you might want to switch off VR when panning to be on the safe side. VR also might not work the way it's supposed to when you mount the camera on a tripod.
- ◆ VR slows you down. The process of adjusting the lens elements takes time, just as autofocus does, so you might find that VR adds to the lag between when you press the shutter and when the picture is actually taken. That's one reason why vibration reduction might not be a good choice for sports.
- ◆ Save your money. Remember that an inexpensive monopod might be able to provide the same additional steadiness as a VR lens, at much lower cost. If you're out in the field shooting wild animals or flowers and think a tripod isn't practical, try a monopod first.

Extending the Range of Any Lens with a Teleconverter

Nikon, as well as third parties such as Kenko and Tamron, offer teleconverter attachments that fit between your prime or zoom lens and your D200's camera body, and provide additional magnification to boost the lens's effective focal length. These are generally available in 1.4X, 1.7X, and 2X (from Nikon), as well as those magnifications plus 3X from the third-party vendors.

For about \$100 to \$400, you can transform your 200mm lens into a 280mm telephoto (with a 1.4X converter) or into a 600mm monster (with a 3X module). However, there is no free lunch.

Remember that with the D200's 1.5 crop factor, your 280mm lens has an actual field of view equivalent of a 420mm lens on a 35mm camera, and the 600mm is the equivalent of a 900mm lens.

Here are some things to consider:

You lose an f-stop − or three. Teleconverters all cost you some light as they work their magic. It might be as little as half an f-stop with Nikon's 1.4X converter, to three full stops with a 3X converter. Transforming your 400mm f/6.3 lens into a 1200mm f/18 optic might not seem like such a great idea when you view the dim image

in your finder and realize that you

can use this lens only outdoors at

ISO 1600. This light loss is one reason why the more moderate 1.4X and 1.7X converters are the most popular.

- You might lose autofocus capabilities. The D200's autofocus system functions only when there is an f/5.6's worth of light, or better. Most teleconverter vendors call this to your attention by recommending you use their higher magnification converters (especially the 3X models) for autofocus use only with lenses having a maximum aperture of at least f/2.8. That requirement excludes a lot of zoom lenses, unless you're willing to focus manually. In addition, some teleconverters don't provide autofocus or autoexposure, or don't give you access to special features such as VR at all.
- You lose sharpness. In the best of circumstances, you lose a little sharpness when working with a teleconverter. Part of that loss of sharpness comes from the additional optics in the light path, and part of it might be due to the tendency to use a larger, less-sharp f-stop to compensate for the light loss. In the worst case, you might find that simply shooting with no converter at all and enlarging the resulting image might provide results that are equal or better. A converter with moderate magnification, especially one of the pricey Nikon models, produces the best results. The latest Nikon 1.4X converter, for example, has five lens elements in five groups and special coatings to reduce flare.

Working with Light

s a photographer, light is one of your basic tools. The quantity and quality of the light you work with has an effect on every other aspect of your photography. The amount of light available controls whether you can make an exposure at all, how well you can stop action, whether you can slow down a shutter enough to use movement blur creatively, and how you apply selective focus. The distribution of light affects the tonal values and contrast of your photo. The color of the light determines the hues you see.

In many ways, photography (*light writing* in ancient Greek) depends as much on how you use light as it does on your selection of a composition or a lens. Great books have been written on working with lighting; for this field guide, I concentrate on some of the nuts and bolts of using the lighting tools available for the Nikon D200 digital SLR.

Light falls into two categories: continuous light sources, such as daylight, incandescent and fluorescent light; and electronic flash. Both forms are important.

D200 Flash Basics

Electronic flash illumination is produced by accumulating an electrical charge in a device such as a capacitor, and then directing that charge through a glass flash tube containing a gas that absorbs the electricity and emits a bright flash of photons. If the full charge is sent through the flash tube, the process takes about 1/1,000th second and produces enough light (with the D200's built-in flash in manual flash mode) to properly illuminate a subject 10 feet away at f5.6 with an ISO 200 sensitivity setting. Exposure is calculated in this way because light diminishes with the distance (actually, the square of the distance). An object that is 4 feet from the flash

In This Chapter

D200 flash basics

Flash sync modes

Flash exposure modes

Flash exposure compensation

Using external flash

Conquering available light

receives four times as much illumination as one that is twice as far, or 8 feet away. Photographers call this the *inverse square* law.

Through its exposure sensing system, the D200 can determine, via an almost unnoticeable preflash, whether sufficient light is reflected from the subject and changes the exposure accordingly. If the subject is more than 10 feet away, the camera may use a larger f-stop, such as f/4. Closer subjects require a smaller f-stop, such as f/8.

The D200's Speedlight varies the *amount* of flash tube light to reduce the illumination reaching subjects that are closer to the camera. The Speedlight dumps some of the electrical energy before it reaches the flash tube, in effect making the duration of the flash shorter. The basic intensity is the same; the flash is just briefer (roughly 1/50,000 second when squelched the equivalent of seven f-stops, or 1/128 full power).

No matter what the duration of the flash, it generally occurs only when the D200's shutter is fully open. As with most single lens reflex (SLR) cameras, the D200's mechanical focal plane shutter consists of two curtains that follow each other across the sensor frame. First, the *front curtain* opens, exposing the leading edge of the sensor. When the front curtain reaches the other side of the sensor, the *rear curtain* begins its travel to begin covering up the sensor. The full sensor is exposed when the flash is tripped. If the flash goes off sooner or later, you'll see the shadow of the front or rear curtains as they moved across the frame.

With the Nikon D200, the sensor is completely exposed for all shutter speeds from 30 seconds (or longer) to 1/250 second. The maximum top shutter speed that you

can use with electronic flash is called the camera's *sync speed*. Under some circumstances, you can use flash at higher than the nominal sync speed, using electronic trickery to make it last longer than the shortest interval when the shutter is completely open. Such techniques reduce the effective power of the flash and are useful chiefly for close-up photography.

What does all this mean in the field? These basics produce some corollaries that affect your shooting:

- ♦ Shutter speed and flash actionstopping. Because the flash occurs during the brief time the shutter is completely open, the actual shutter speed has no effect on the flash's action-stopping power. A 1/1,000 second flash will freeze action at 1/2 second in exactly the same manner it does at 1/250 second.
- ★ Two exposures. If the shutter is open long enough to produce an image from the nonflash (available) light in a scene, you get a second exposure in addition to the flash exposure. If your subject is moving, this second exposure appears as a blurry ghost image adjacent to the sharp flash image. You must always remember that you're taking two exposures, not one, when shooting with flash.
- ▶ Fast action shooting. Photos taken with the automatic flash squelching in operation have an effective exposure speed that's much shorter than 1/1,000 second as brief as about 1/50,000 second at the lowest power used for very close subjects. You can use this quality to stop very fast action.

- **6.1** The brief duration of an electronic flash can virtually freeze the quickest action, such as the droplets emerging from this sprayer.
 - Flash recharge. After you make an exposure, it takes a short time for the flash to recharge to full power, usually 1 to 2 seconds. If your photo didn't require the full capacity of the flash, you might be able to take another picture more quickly.
 - Under/over exposure. Because of the effects of the inverse square law, electronic flash produces a correct exposure only at one distance. Objects that are farther away or closer to the flash are under- or overexposed. For example, if you're shooting a person standing 8 feet away, someone positioned 4 feet behind your main subject will receive about one f-stop less exposure; a bystander 8 feet farther will receive two fewer f-stops' worth of light. Someone in the foreground 4 feet from the camera will be overexposed by two full stops. You can think of this phenomenon as depth of light, although the distribution is the opposite of depth of field (DOF): on a foot-by-foot basis, there's more depth of illumination behind the main subject than in front of it.

Flash Sync Modes

Flash exposure calculation works with any of the D200's *sync modes*, which control how and when the electronic flash is triggered. These include:

Front sync. In this mode, which is the default, the flash fires at the beginning of the exposure when the first curtain reaches the opposite side of the sensor and the sensor is completely exposed. The sharp flash exposure is fixed at that instant. Then, if the shutter speed's exposure is long enough to allow an image to register by existing light as well

as the flash, and if your subject is moving, you end up with a streak ahead of the subject, in the direction of the movement. This is the default mode and provides the best exposures. It should be used except when you are photographing moving subjects in high ambient light levels (see rear sync).

6.2 A falling rock is captured by the flash in front sync mode, but its movement continues to register on the sensor, producing a ghost ahead of the direction of motion.

 Rear sync. In this optional mode, available only in S and M modes, the flash doesn't fire until the end of the exposure. A ghost of the image registers first and terminates with a sharp image produced by the flash at your subject's end position. This

creates a ghost streak behind the subject, similar to the streaks vou see in comic books and movies about superheroes. If you must have ghosts (or want them for creative effect), rearcurtain sync is more realistic. You can't use this mode with studio strobe units, which won't sync properly.

6.3 With rear sync mode, the ghost image of the falling rock is registered first, and the sharp flash image is captured at the end of the exposure.

 Slow sync. This mode, available only when the D200 is set to P or A shooting modes, combines slow shutter speeds with flash to produce two different images (one from the flash; the other from the ambient light) so that your flash pictures have a background that isn't completely black. Using a tripod and avoiding moving subjects when using slow sync is best, because the D200 can program exposures up to 30 seconds long, and you're likely to get ghost images otherwise. (Use slow rearcurtain sync instead, to place the ghosts behind the subject.)

Multimodes. Red-eye reduction uses a preflash of the focus-assist lamp to decrease the chances of red-eye effects. Supposedly, the preflash causes your subjects' pupils to contract and stifle some of the reflection. Red-eye reduction is available as an optional mode both for front-sync and slow-sync settings. In addition, in P and A modes, you can choose to combine slow sync with rear-curtain sync.

Flash Exposure Modes

Your D200 determines the correct exposure by emitting a series of preflashes just prior to the actual exposure (called monitor preflashes), and then measures the amount of light reflected from the subject using the matrix metering system. The preflash occurs almost simultaneously with the main flash, so you probably won't even notice it.

Several different flash exposure modes are available. You can set them using the menus on the camera, or, in the case of three optional modes with the SB-600 and SB-800 flash, on the flash itself.

i-TTL. Nikon calls its basic throughthe-lens (TTL) flash exposure system i-TTL. Only the Nikon D200's internal electronic flash, plus Nikon dedicated external flash units, such as the Nikon SB-30, SB-600, and SB-800 flash units, support full i-TTL features. The system has an autofocus feature that determines the focal length of the lens and the distance of the main subject. The system uses the autofocus information supplied by D or G-series lenses with the measured light reflected during the preflash, and attempts to balance the flash illumination with the ambient light to produce the best exposure. This mode does not operate when using spot metering or manual metering modes.

★ TTL. A second mode, called simply TTL, is used when you select spot metering or Manual exposure. This mode calculates only the exposure needed to properly expose the subject. The D200 does not try to balance the flash with ambient light.

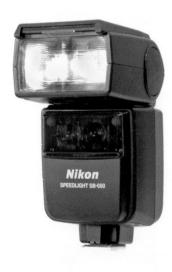

6.4 The Nikon SB-600 Speedlight supports all i-TTL features.

- AA (Auto Aperture). This mode, available with the latest external flash (and a few older Nikon flash units), takes some of the control from the camera and calculates exposure in the flash itself. The camera tells the flash the ISO and aperture settings, and a sensor on the front of the flash measures the light the subject reflects.
- ♠ A (Automatic). This mode, similar to AA mode, might be all you have available with some non-Nikon flash units. You must enter the aperture and ISO setting into the flash manually, and the flash measures the amount of light the subject reflects and shuts off at the appropriate time.
- Manual. You can set the power of the internal D200 flash manually using the menus, or set the power output of an external flash on the Speedlight itself. This mode is useful when you have a handheld electronic flash meter or want to set the flash level yourself for other reasons.

Flash Exposure Compensation

If you want to tweak the exposure set for you by your flash, you can use the D200's flash exposure compensation system. To make this adjustment, hold down the flash exposure compensation button, and turn the sub-command dial until the setting

you want (+ or -3 EV) appears in the status LCD on top of the camera. This feature is especially useful when you're trying to use fill flash to brighten up shadows and your D200 provides either too much or too little fill.

There are some key settings you can make in the Custom Settings menu's Bracketing/ Flash submenu (submenu e). Here's a quick summary:

- CSM e1 (flash sync speed setting). Use this setting to control the shutter speed used to synchronize with the flash. You set the Sync speed depending on your situation:
 - 1/250 s. Eliminates most of the ambient light and reduces ghost images.
 - 1/60 s-1/250 s. Allows you to capture different amounts of ambient light. If you are using the internal flash or a unit compatible with Nikon's Creative Lighting System, you can choose 1/250s (Auto FP), which automatically sets the shutter speed to 1/250 second when using P or A modes, even if the speed you select happens to be faster than the top 1/250 second synch speed. This can prevent accidentally taking photos at too high a shutter speed for proper flash synchronization.
- CSM e2 (slowest speed when using flash). This setting limits the slowest shutter speed allowed for flash when you're using P or A modes, to prevent you from

accidentally using a speed low enough to promote ghost images from ambient light. The default value is 1/60 s, but you can choose a slower speed (say, you know there will not be much ambient light, or you will be using a tripod and want ambient light to be captured), up to 30 seconds. In M or S modes, this setting has no effect; you can use flash at any shutter speed from 1/250 second down to 30 seconds.

- ◆ CSM e3 (built-in flash mode). Use this to choose between various i-TTL modes, manual flash (select an output level from full power down to 1/128 power, depending on how close you'll be to your subject), repeating flash, or Commander mode (both discussed later in this chapter).
- ◆ CSM e4 (Modeling flash). This turns the internal flash's modeling feature on or off. Modeling lights are discussed in the next section on external flash, because add-on flash units are more likely to have this feature (which is a bit uncommon in built-in flash. Bravo Nikon!).

Using External Flash

As you work with your D200, you might find yourself constrained by the limitations of the built-in flash. There's a lot to like about the internal flash because it's always there when you need it, requires no extra batteries, and is well-integrated with the D200's exposure system.

Internal flash limitations

Unfortunately, the internal flash is relatively limited:

- Decreased output. Your effective range might be 10 to 12 feet at ISO 100.
- Red-eye problems. Because the internal flash is so close to the lens, it tends to exacerbate red-eye problems, even with the ineffectual red-eye preflash in use.
- ◆ Casts shadows on your subject. The flash's position also means it's not very useful when you're shooting close-up photos or some wideangle shots. The lens or its lens hood can cast a visible shadow on your subject. There's no way to re-aim the D200's internal flash to bounce it off the ceiling, walls, or reflectors.
- Energy concerns. The internal flash wastes a lot of light, which keeps the same coverage area whether you're using a wide-angle or telephoto lens.

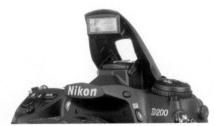

6.5 Although the Nikon D200's built-in Speedlight is handy and easy to use, it has its limitations.

External flash advantages

An external flash unit, particularly one designed especially for the D200, solves many of these problems.

- Increased output. The maximum output of the SB-800 Speedlight, for example, allows an exposure of about f/14 at 10 feet with an ISO setting of 100 – roughly three stops more light than the D200's built-in flash.
- Decreased red-eye. Even mounted in the camera's hot shoe, an external flash is much farther away from the lens, reducing redeye problems.
- Adjustable coverage. You can swivel the external light up or down or from side to side to change its coverage while mounted on the hot shoe.
- * Shadow reduction. You can remove the flash from the camera (if you use a connecting cable or set it for wireless Commander mode) and point it any way you like for bounce flash or close-ups. You can adjust the flash coverage narrower or wider to better suit the focal length of the lens you're using. Your D200 can even tell the flash unit the focal-length setting so this adjustment is automatic.
- Energy efficiency. Because Nikon external flash units change their coverage angle to match the setting of zoom lenses, they use the available illumination more efficiently.

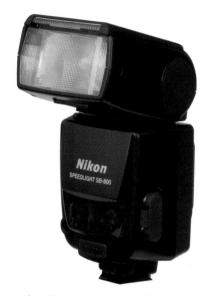

6.6 The Nikon SB-800 Speedlight is a powerful external flash unit.

Many of the electronic flash's automated functions are available with non-Nikon external flash units, as well. A few even support the Nikon i-TTL exposure system. However, not all Nikon flashes support all the features of the SB-600 and SB-800 flash units, described next.

External flash units and accessories

Nikon currently offers a useful range of external flash units and accessories that are compatible with the D200. These include:

♦ SB-600/SB-800. These are relatively high-powered hot-shoemounted flash units. The flagship SB-800 has the highest output and can serve as a commander for

- other external Nikon flash units. The SB-600 has a guide number of 98 at ISO 100, while the SB-800's guide number at ISO 100 is 125 when its zoom setting approximates a 35mm lens's field of view. For a subject 10 feet away from the camera, the SB-600 requires an exposure of f/9.8, and the SB-800 requires an exposure of f/12.5 when sensitivity is set to ISO 100.
- SB-30. This is an ultra-compact. 3.2-ounce flash unit that can serve as a wireless speedlight for multiple flash photography up to 131 feet from the main flash. It can also function as an infrared remote commander for other Nikon flash units. You can fit it with a 17mm wide-angle adapter that broadens its field of view to 104 degrees. It has a guide number of 58 at ISO 100 when the wide-angle adapter is not fitted, so, when it's used alone, you'll need an exposure of about f/5.6 for a subject 10 feet awav.
- R1/R1C1 wireless close-up flash. These close-up flash systems include a pair of speedlights mounted on a ring on opposite sides of the lens. The R1 system uses the D200's built-in flash as the master, while the R1C1 system includes a Nikon SU-800 wireless commander that makes it compatible with strobeless Nikon cameras, such as the D2x. The close-up flash units have a guide number of 10, which is quite enough for close-up work; a typical exposure would be f/10 at ISO 100 at distances of about one foot.

Triggering external flash

You can connect an external flash by sliding it into the hot shoe. Dedicated Nikon flash units can communicate with the camera using the special contact points built into the camera's flash shoe. Nondedicated units from other vendors, or older Nikon flash units, can connect to the camera for the flash triggering function only; you must set exposure manually or by using the nondedicated flash's internal autoexposure system.

You can also connect external flash offcamera by using a cord plugged into a Nikon AS-15 Sync Terminal Adapter or Wein Safe Sync adapter (both mounted on the hot shoe), or by using an external cable, such as the Nikon SC-28 or SC-29. The chief difference between the two Nikon cables is that the SC-29 has a focus-assist light built into the portion of it that slides into the hot shoe. That light supplants the light built into the flash unit, on the theory that a focus assist lamp on the camera is better positioned than one on a flash that's not mounted on the camera. Both the SC-28. and SC-29 include all the conductors needed for communication between the flash and camera, just as if the flash were plugged into the hot shoe.

You can also plug external Nikon flash units into the 10-pin connector on the front of the D200, enabling full communication between flash and camera, or into the PC/X connector on the left edge of the camera. The PC/X connector is used only for triggering the flash at the moment of exposure

(the flash and camera don't exchange other information), which makes it useful for connecting older non-dedicated flash units, or studio flash.

You can also trigger an external flash by equipping that flash with a light-sensing slave unit (some have them built-in) and using the D200's internal flash to trigger the external unit. Use the menus (Custom Settings menu e3) to set the internal flash to Manual mode and 1/128th power. The reduced power minimizes the effects of the internal flash in your photo but is still enough to trigger the remote unit.

6.7 The Wein Safe Sync isolates your strobe's triggering voltage, which is a good idea for studio flash and some non-Nikon flash units.

If you're using a Nikon SB-600 or SB-800 flash unit (or multiple units), there's an even better way to achieve wireless operation. Use CSM e3 to set Built-In Flash to Commander mode. Within this same menu setting, you can set the camera to Group A or Group B, and choose the "channel" your Flash resides on. Choose Group A and Channel 3 to start. Then, press the Sel button on your external flash, change the flash's mode to Remote, and select Channel 3. Assign this setting to Group A, and you're ready to go. (Your flash's manual covers these options in more detail; explaining all the external flash functions is beyond the scope of this Field Guide, which provides just enough on the basic settings to get you started.) You can actually use several different external flashes in this way, as described in the next section.

Using multiple flash units

You'll find that using several flash units gives you great flexibility in lighting your subjects. The only tricks to using several flash units involve triggering them and visualizing how the illumination from the flash will look when it's applied to your subject.

Your D200 in Commander mode (the camera's wireless triggering mode) can control several specific external Nikon flashes, including the Nikon SB-30, SB-600, or SB-800. You can also use a flash equipped with slave sensors, or attach add-on slave sensors to your flash. The light from one flash automatically triggers the others.

Typically, you visualize the effects of your flash using modeling lights. Studio flash units generally have incandescent lamps located concentrically with the flash tube so their light provides a very good approximation of the actual light you'll get from the flash. These modeling lamps can be set to act proportionately; that is, they get brighter or dimmer as you adjust the output level of the studio flash.

The D200, as well as some of the latest Nikon external flash units, can simulate a modeling lamp by firing repeatedly at a low power, creating an almost continuous light for a few seconds. You can use this light to judge how your flash will appear. This is a make-do approach at best; true modeling lights, such as those found in studio flash, can remain on for hours at a time without consuming much power or overheating. Still, it's nice to have this capability available in your camera as well as in a small battery-powered external flash unit.

To turn on the D200's modeling light feature, access the Custom Settings menu, select CSM e4 (Modeling flash) and change the setting to ON. Thereafter, you'll see (and hear: there is a slight crackling noise) a longish preflash that lets you preview your lighting effect. If you happen to shoot 10 or 12 pictures in quick succession, the internal flash overheats and refuses to fire. After a second or two, it comes to life again.

When using multiple flash units, you'll especially want to take advantage of options such as the snap-on diffuser dome that comes with the SB-800, the built-in bouncelight cards, and wide-angle lenses that spread the illumination of your flash over a broad area. You can also add colored gels to change the hue of each individual flash.

6.8 Some Nikon Speedlights come with slide-out wide-angle diffusers and bouncelight cards.

Studio flash

You can connect the D200 to studio flash units if you want the ultimate amount of control and access to accessories such as soft boxes, umbrellas, radio controls, and other add-ons that are available in a more limited variety for Nikon's own Speedlights. Such lights are available in inexpensive versions costing as little as \$200 per light. The least expensive units, called *monolights*, have built-in power supplies so you don't have to fuss with bulky external power packs.

Studio lights generally attach to the camera using the X/PC connection. You can also

purchase the Nikon AS-15 Sync Terminal adapter, which fits in the hot shoe and enables you to connect any flash using a PC cord. However, the triggering voltage of the external flash should be limited to 24 volts or less. Older flash units might have higher voltages. In that case, use a component such as the Wein Safe Sync, which performs the same function as the AS-15 adapter, but isolates your camera from the flash's voltage, eliminating the chance of frying your D200's internal circuitry.

Repeating flash

Repeating flash is a very cool feature that's usually found in external flash units such as the Nikon SB-800, but is now found in sophisticated cameras such as the D200. This feature fires off a series of brief flashes over a period of time to provide a succession of images in a single photo. For example, you might want to analyze your golf stroke. Set up the camera on a tripod in a dark room with a dark background, take a 1-second exposure, and execute your stroke during that span. The D200, or more powerful SB-800, set for repeating flash, will capture a sequence of shots of your stroke.

You can adjust the flash power output, and choose the number of shots per second, depending on the power level you select. Because you use reduced power to allow for multiple shots, this capability is most useful for close-up shots of things such as water-drop splashes. Your golf-stroke shot would probably require you to use a higher ISO setting to provide enough light for a decent number of shots during your stroke.

To use the D200's repeating flash, go to the Custom Settings menu and choose CSM e3 built-in flash and scroll down to select RPT (Repeat). In the sub menu, choose Flash output from about 1/4 to 1/128th power, then select the number of flashes you want in your set, from 2 to 35. Finally choose the frequency, from 1 to 50 shots per second. The range of each of these settings can vary, depending on how you've set up the other parameters. For example, with Output set to 1/4 power, you can only specify two flashes, triggered no more quickly than eight times per second. At 1/128th power, you can choose the maximum values for the other two parameters. Remember to use Commander Mode for external flash units.

Conquering Continuous Lighting

The other form of light you'll work with is continuous lighting, either in the form of available light that's already on the scene (including daylight and outdoor lighting), or add-on lamps, lighting fixtures, or reflectors that you supply expressly for photographic purposes.

Continuous lighting has some advantages over electronic flash:

You always know what lighting effect you're going to get. Daylight and lamps of all types are their own modeling lights. Any such light automatically shows how it affects your scene and how it interacts with other continuous lighting in use.

- It's easier to measure exposure with daylight/incandescent/ fluorescent-style lighting.
- Daylight tends to fill a scene completely, but artificial lights suffer from the same light fall-off due to the inverse square law characteristics as flash (as described earlier in this chapter) but it's usually easier to increase your depth of light by providing broader, more diffuse lighting from multiple sources. Continuous lighting syncs with any shutter speed for any exposure.

On the other hand, continuous lighting doesn't have the built-in action-stopping capabilities of electronic flash, nor is it always as intense. In the studio, you might have to mount your D200 on a tripod to get sufficient exposure, where you're able to handhold the camera with an electronic flash under the same conditions—usually a better option when shooting people or pets, as long as the ambient light in the scene is not strong enough to record an image on the sensor.

Types of continuous lighting

Fortunately for photographers, continuous lighting is much less complicated and confusing than flash. The main thing you'll want to be concerned about is the color of the light, which is referred to by the terms color temperature and white balance. Both refer to the same thing: the tendency of various types of illumination to change the apparent overall color of the light used to make the exposure.

As I mentioned at the beginning of this section, there are three types of continuous lighting: daylight, incandescent/tungsten light, and fluorescent light. There are also some oddball light sources, such as sodium vapor illumination, that share some of the unusual lighting renditions of fluorescent lighting, even though the process used to generate the light is different.

- ▶ Daylight. This is the light the sun produces, even on cloudy days when it isn't visible. Sunlight can be harsh when it's direct, and softer when it's diffused by the clouds, filtered by shade, or illuminates a subject indirectly as it bounces off walls, other objects, or even reflectors you might use. Strictly speaking, moonlight is sunlight (reflected), too, but it's rarely intense enough for photographing anything other than the moon.
- Incandescent/tungsten light.

 This kind of continuous light is produced by a heated filament inside (usually) a glass bulb that contains a vacuum. The tungsten filament is, in a sense, burning, like the sun itself. Unlike the sun, the filament tends to burn out during our lifetimes and you must replace the bulb. Incandescent illumination is often called tungsten light because tungsten filaments are used in the most common variety of bulb.
- Fluorescent light. Fluorescent light is produced through an electro-chemical, rather than burning, process in a tube full of gas (which is why the bulbs don't get as hot). The type of light produced

varies depending on the phosphor coatings and type of gas in the tube. So, the illumination fluorescent bulbs produce can vary widely in its characteristics, as you'll learn later in this section.

Color temperature

Continuous light sources that use heat, such as daylight or incandescent/tungsten illumination, produce illumination of a particular color, which you characterize by its color temperature (or, in digital camera terminology, white balance). Electronic flash, another type of light that is produced by a burst of heat, also has a characteristic color temperature. Fluorescent light doesn't have a true color temperature, but its "white balance" can be accounted for nonetheless.

The term color temperature comes from the way it is defined. Scientists derive color temperature from a mythical object called a black body, which is a substance that absorbs all the radiant energy that strikes it, and reflects none at all. A black body not only absorbs light perfectly, but it emits it perfectly when heated. At a particular physical temperature, this mythical body always emits light of the same wavelength or color. That makes it possible to define color temperature in terms of actual temperature in degrees on the Kelvin scale that scientists use. Incandescent light, for example, typically has a color temperature of 3200K to 3400K ("degrees" is not used). For example, daylight might be 5500K to 6000K.

Photographers refer to these color temperatures using terms such as "warm/reddish" or "cold/bluish," but the actual physical

temperatures being described are just the reverse. As the black body is heated, it first glows with a dull reddish light, as you might see in an iron ingot that is being heated. As the temperature increases, the light becomes yellowish, and then blue. Humans associate reddish hues with warmth and blue with cold, so that's why you'll see indoor illumination called warm, and bright daylight cold, even though the color temperature of incandescent light (3400K) is lower than that of daylight (5500K). If you can remember that "cold" lighting is called that because it reminds us of ice and snow, and not because of its actual temperature, you can keep the concept straight.

Coping with white balance

In the digital camera world, you compensate for the different color temperatures of light using white balance adjustments. As I mentioned, all light sources, including electronic flash, can vary in the color balance of their illumination. Each individual source has its own particular color, popularly (but inaccurately) called *white balance*. This color can be partially—but only partially—specified using the scale called *color temperature* that was described in the previous section.

Digital camera sensors can't automatically adjust to the different colors of light the way our eyes do automatically. So, we must "tell" the sensor what type of lighting it's looking at by specifying a color temperature. The D200's electronics can make some pretty good guesses at the type of lighting being used, and its color temperature, simply by examining and measuring the light in the

scene. But when the camera's white balance setting is on Auto, you might not always get the results you want. That's why the D200 has an array of manual white balance settings, and the capability to measure and set white balance from a neutral area of your scene (as explained in Chapter 1). You can select from daylight, incandescent light, and so forth as described in that chapter. You can also fine-tune the white balance so it's a little warmer or cooler, as needed for particular situations.

Things get a little complicated when you introduce fluorescent lights into the mix, because they don't produce illumination from heat but, rather, from a chemical/electrical reaction. So, fluorescent light can't be pegged precisely to the color temperature scale. Nor does it necessarily produce proportionate amounts of all the colors of light in the spectrum; and the color balance of fluorescents varies among different types and vendors.

That's why fluorescents and other alternative technologies such as sodium-vapor illumination can produce ghastly-looking human skin tones. Their spectra can lack the reddish tones we associate with healthy skin and emphasize the blues and greens popular in horror movies and TV procedural investigation crime shows.

These light sources can also be graded using a system called *color rendering index*, or CRI, which measures, using a scale from 0 (really bad) to 100 (perfect), how well a particular light source represents standard colors compared to another light source. For example, daylight and incandescent lights are assigned a CRI of 100. Daylight fluorescents might have a CRI of about 79—not

great, but acceptable compared to other sources such as white deluxe mercury vapor lights (CRI 45) or low pressure sodium lamps (CRI 0-18). You won't generally use CRI in photography, except when you're checking, say, a fluorescent lamp you intend to use to see how close its CRI is to ideal. (Warm white fluorescents might have a CRI of 55; a deluxe cool white fluorescent, a CRI of 86.)

Tip

If you are not sure of the CRI of a light source, use Google, Yahoo!, or another search engine to find the CRI of a particular lamp you happen to be using.

The D200 does a fairly good job of compensating for the most common types of fluorescent tubes, but when colors are critical, it's best to use incandescent light, flash, or daylight.

If you shoot RAW, you can adjust the white balance when the image is imported into your image editor. If you're an old-school photographer, you can use color-correction filters on your lenses, including the special filters such as the FL-D created for particular types of fluorescent lights. Although electronic flash color balance can vary, depending on the flash exposure, advanced units such as the Nikon SB-800 can report their current color balance to the D200 for automatic compensation.

If you're not satisfied with the automatic white balance settings you're getting, you can select a manual setting.

Cross-Reference

See Chapter 2 for instructions on setting a manual white balance.

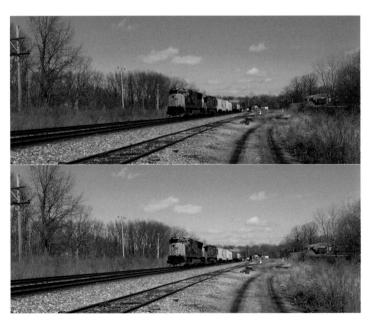

6.9 A subject under daylight with the white balance set to Tungsten appears too cool (top); with the proper white balance, the colors are shown realistically.

Photo Subjects

ew kinds of photography can be intimidating and exciting at the same time. You're daunted because you haven't compiled the depth of experience you have with other photo subjects, but energized by the challenge of finding new ways to apply your creativity. All you really need is a little encouragement and, perhaps, a few tips on how to arm yourself and approach a new photographic arena. This chapter explores a broad selection of the most common shooting situations, and provides a consistent formula for exploring each type. There are tips for choosing the right lens, selecting the most appropriate ISO setting, and composing the picture. You can flip through the pages to any photo subject listed and follow the guidelines to get good pictures right from the start.

Of course, if you're an experienced photographer, you may have explored some of these photo subjects already. This chapter is a great resource to help you with the subjects that are still new to you, in addition to providing a few ideas on how you can approach a familiar subject in a new way.

The Basics of Composition

The very best photos are carefully planned and executed. Good execution means more than proper exposure and sharp images, especially because some very good pictures are deliberately underexposed or overexposed or intentionally include an element of blur. Beyond the technical aspects, good images have good composition (that is, the selection and arrangement of the photo's subject matter within the frame).

CHAPTER

In This Chapter

The basics of composition Abstract photography Animal photography Architectural photography Business photography Event photography Fill flash photography Filter effects photography Fireworks and light trail photography Flower and plant photography Holiday lights photography Indoor portrait photography Infrared photography Landscape and Nature photography Macro photography Night and evening photography Online auction photography Outdoor and environmental portrait photography Panoramic photography Sports and action photography Still life photography

Street life photography Sunset and sunrise photography Travel photography Waterfall photography Here are some questions to ask yourself as you compose your picture:

- What do I want to say? Will this photo make a statement? Should it tell something about the subject? Is the intent to create a mood? Know what kind of message you want to convey and who your audience is.
- What's my main subject? A picture of six cute puppies might not be as effective as one that focuses on a single puppy surrounded by its littermates. Even if the picture is packed with interesting things, select one as the subject of the photo.
- Where's the center of interest? Find one place in the picture that naturally draws the eye and becomes a starting place for the exploration of the rest of the image. Da Vinci's The Last Supper included several groupings of diners, but viewers always look first at the gentleman seated in the center.

7.1 There's no mistake about who's the center of interest in this photograph.

Would this picture look better with a vertical or horizontal orientation? Trees might look best in vertical compositions; landscapes often lend themselves to horizontal layouts. Choose the right orientation now and avoid having to waste pixels when you crop later on.

7.2 Choose a vertical or horizontal orientation that is appropriate for your subject matter.

What's the right shooting distance and angle? Where you stand and your perspective might form an important element of your composition. For example, getting down on the floor with a crawling baby provides a much more interesting viewpoint than a shot taken 10 feet away from eye level.

- Where will my subject be when I take the picture? Action photography, especially, might force you to think quickly. Your composition can be affected not just by where your main subject is when you decide to take a picture, but also by where it will be by the time you actually take the photo.
- How will the background affect the photo? Objects in the background might become part of the composition – even if you don't want them to. Play close attention to what's visible behind your subjects.

7.3 While this is an interesting fountain, the background, even out of focus, is too distracting.

✦ How should the subjects in the photo be arranged? This is the essence of composition: arranging the elements of the photograph in a pleasing way. Sometimes you can move picture elements, or ask them to relocate. Other times you'll need to change position to arrive at the best composition.

within the composition? Viewers don't stare at a photograph; their eyes wander around the frame to explore other objects in the picture. You can use lines and curves to draw the eye from one part of the picture to another, and can balance the number and size of elements to lead the viewer on an interesting visual journey.

The Rule of Thirds

Photographers often, consciously or unconsciously, follow a guideline called the *Rule of Thirds*, which is a way of dividing a picture horizontally and vertically into thirds, as shown in figure 7.4. The best place to position important subject matter is often at one of the points located one-third of the way from the top, bottom, and sides of the frame.

Other times, you'll want to break the Rule of Thirds, which, despite its name, is actually just a guideline. For example, you can ignore it when your main subject matter is too large to fit comfortably at one of the imaginary intersection points. Or you might decide that centering the subject would help illustrate a concept, such as being "surrounded"; or that placing the subject at one side of the picture implies motion, either into or out of the frame. Perhaps you want to show symmetry in a photograph that uses the subject matter in a geometric pattern. Following the Rule of Thirds usually places emphasis on one intersection over another; breaking the rule can create a more neutral (although static!) composition.

7.4 The "horizon" formed by the top of the hill is located one-third of the way down from the top of the image, while the center of interest — the building — is placed one third of the way from left side of the frame.

Other compositional tips

Here are some more compositional rules of thumb you can use to improve your pictures:

- If subjects aren't facing the camera, try to arrange it so they're looking into the frame rather than out of it. This rule doesn't apply only to people or animals. An automobile, a tree swaying in the wind, or a bouncing ball all look more natural if they're oriented toward the frame.
- ◆ Use curves, lines, and shapes to guide the viewer. Fences, a gracefully curving seashore, meandering roads, railroad tracks, a receding line of trees, or the architectural curves of a tall building all can lead the eye through the composition. Curved lines are gentle; straight lines and rigid geometric shapes are more forceful.

7.5 Lines and curves lead the eye through the composition.

- Look for patterns that add interest. A group portrait of three people is more interesting if the subjects are posed in a triangular or diamond shape, rather than in a straight line.
- Balance your compositions. Place something of interest on each half (left and right, top and bottom). For example, if you have a group of people on one side of the frame, you'll need a tree, a

- building, or some other balancing subject matter on the other to keep the picture from looking lopsided.
- Frame your images. Use doorways, windows, arches, the space between buildings, or the enveloping branches of trees as a "border" for your compositions. Usually, these frames will be in the
- foreground, which creates a feeling of depth, but if you're creative you can find ways to use background objects to frame a composition.
- Avoid mergers. Mergers are those unintentional combinations of unrelated portions of an image, such as the classic tree-growingout-of-the-top-of-the-subject'shead shot.

Abstract Photography

Abstract photography is your chance to make—rather than take—a picture. When shooting abstract images, your goal is not to present a realistic representation of a person or object but, rather, to find interest in shapes, colors, and textures. One definition of abstract art says that the artistic

7.6 A series of falling water droplets (actually three separate exposures made with red, blue, and green gels over a Nikon SB-800 flash), create an abstract composition frozen in time.

content of such images depends on the internal form rather than the pictorial representation. That's another way of saying that the subject of the photo is no longer the subject!

You can let your imagination run wild when you're experimenting with abstract photography. An image doesn't have to "look" like anything familiar. Some people will tell you that if it's possible to tell what an abstract subject really is then the image isn't abstract enough. A droplet of splashing water can become an oddly malleable shape; a cluster of clouds in the sky can represent fantasy creatures as easily as random patterns. When you choose to photograph an abstract shape, you're giving your vision a tangible form.

Inspiration

French photographer Arnaud Claass once said, "In painting, the curve is a hill; in photography, the hill is a curve." In other words, while painters attempt to use abstraction to create an imaginative image of a subject, photographers use abstract techniques to deconstruct an existing image down to its components. Both approaches create art that doesn't look precisely like the original subject, but that evokes feelings related to the subject matter in some way.

128 Part II ◆ Creating Great Photos with the Nikon D200

You can find abstract images in nature by isolating or enhancing parts of natural objects such as plants, clouds, rocks, and bodies of water. Many wonderful abstracts have been created by photographing the interiors of minerals that have been sliced open, or capturing the surfaces of rocks polished over eons by ocean waves.

You can also create abstract compositions by arranging objects in interesting ways, and then photographing them in nonrepresentational ways. A collection of seashells that you've stacked, lit from behind, and then photographed from a few inches away can be the basis for interesting abstract images that resemble the original shells only superficially and on close examination

of the picture. Familiar objects photographed in unfamiliar ways can become high art.

7.7 Abstract images can be found in nature, as in this shot of a flower photographed against a mirror to create a kaleidoscope effect.

Abstract photography practice

7.8 Unusual lighting turns this pile of paper clips into an abstract image.

Table 7.1 Taking Abstract Pictures

Setup

Practice Picture: For figure 7.8, I took a pile of paper clips and set them on a tabletop with a high-intensity desk lamp on either side. I mounted the D200 on a sturdy tripod, and captured the clips from above.

On Your Own: You can obtain some of the best abstract images from close-up views of everyday objects. A tripod lets you experiment with different angles, then "lock down" the camera when you find a view you like. Desk lamps make it simple to play with various lighting effects that can add to the abstract quality of your image.

Lighting

Practice Picture: I placed a red gel over the lamp on the right side, but kept the lamp on the left unfiltered. Then, I moved the lamps to manipulate the specular highlights until I had a neon-glow effect.

On Your Own: While hard light accentuates texture, you can also bounce light from reflectors to diffuse it and create a softer look. Experiment with colored reflectors or colored pieces of plastic held in front of the light source to add interesting color casts.

Lens

Practice Picture: I used a 60mm f/2.8D AF Micro-Nikkor. A macro lens is essential for getting close enough to capture detail without distortion. You can also use a macro-zoom lens that focuses close enough or even the 50mm f/1.8D AF Nikkor with an extension tube or close-up lens attachment that lets you focus closer than that lens's minimum 18-inch focus distance.

On Your Own: Although close-focusing is a must for this kind of picture, a focal length of 50–60mm or perhaps a little wider is just as important. A longer lens, such as the 105mm f/2.8D AF Micro-Nikkor, even if it can produce the same magnification, tends to flatten the image, reducing the three-dimensional quality.

Camera Settings

Practice Picture: I used a RAW format, which I processed using Adobe Camera RAW to adjust white balance (tungsten), increase saturation of the paper clips, and boost both sharpness and contrast. I also used Aperture Priority AE mode.

On Your Own: Aperture Priority AE mode lets you choose a small aperture and let the camera select a slow shutter speed. Extra saturation, sharpness, and contrast increase the abstract appearance at the expense of realism. You can also boost these values when converting the RAW image and processing it in your image editor.

Continued

Table 7.1 (continued) Exposure Practice Picture: ISO 100, f/32, 1/2 second. On Your Own: A small lens aperture increases the depth of field so that the entire image is sharp. The long exposure means that the D200's ISO 200 sensitivity is sufficient. If you're patient, you can go as low as ISO 100 to improve quality slightly. A tripod lets you lock down the camera after you've found an angle you like; it also makes it possible to stop down to a small f-stop without worrying that the long shutter speeds that result will cause image blur. A Nikon MC-30 wired remote control for the D200's 10-pin socket is faster for releasing the shutter without jiggling the tripod, but you can also use the self-timer. A wireless remote control, the Nikon ML-3, is also available, but it costs about three

times as much as the MC-30 (more than \$150).

Abstract photography tips

- Go abstract in post-processing. Many mundane conventional photographs can be transformed into abstract prize-winners by skillful manipulation in an image editor. Filter plug-ins can enhance edges, add textures, change color values, and perform other magic after the fact.
- ◆ Freezing and blending time. A high shutter speed can freeze a moment that isn't ordinarily easy to view, such as when a rock strikes the surface of a pond to produce concentric waves. Slow shutter speeds can merge a series of moments into one abstract image.
- ◆ Use color and form to create abstract looks. Exaggerated colors and shapes produce a nonrealistic look that has an abstract quality. Colored gels over your light sources can create an otherworldly look. An unusual angle can change a familiar shape into an abstract one.
- Crop and rotate. Try flipping an image vertically to create an unfamiliar look. When the light source seems to come from below, rather than above as we expect, our eyes see a subject in a new way. Or rotate the image to produce a new perspective. Then crop tightly to zoom in on a particular part of the image that has abstract qualities of its own.

Animal Photography

It's an apparent contradiction: Everybody likes interesting pictures of animals, but *nobody* likes photographs of caged animals. Photo safaris to exotic locations to capture charging rhinos and prowling lions, may not be realistic for most people, but you find

interesting wildlife at zoos. And, zoo animals are less mangy than the in-the-wild variety, and zoos go to great lengths to duplicate the animals' natural habitats, so you'll find a minimum of bars and other barriers that inhibit your photography.

Zoo animals aren't the only animals of interest to photograph. Your own pets, or those

7.9 Catching animals doing human-like things adds a touch of personality to your photos.

of friends and family, are perfect models. You can also visit parks and grab photos of that Frisbee-catching dog, or that frog lurking in the pond.

Finally, capturing real, live wild animals in their actual habitat is the most challenging kind of creature photography. Depending on where you live, you may have deer, exotic birds, moose, wild boars, coyotes, prairie dogs, or even beautiful wild horses to photograph. You must have patience, and know where to find these animals, but you'll be rewarded with photos that your zoogoing compatriots will find difficult to equal.

Tips for Zoos

Veteran visitors to zoos know that their photo safaris will be more successful if they plan ahead of time.

- ◆ Go early. The animals are more active early in the morning. By the time the sun is high in the sky and the real crowds arrive, many of the animals will be ready for a nap. Phone ahead to find out when feeding times are, so you can capture the big cats gobbling up their lunch.
- ◆ Use a tripod. That long lens calls for either a high shutter speed or the steadiness a tripod can provide. A monopod can serve as a substitute, but you'll find that a lightweight tripod won't be that difficult to carry around, even in the largest zoos for the few hours you'll be there.
- Open wide. If you must shoot through bars or a fence, use a longer lens and open your aperture all the way to throw the obstruction out of focus. Selective focus will also let you disguise the walls or fake rocks in the background that advertise that your animal is not in the wild. Use the D200's depth-of-field preview button to confirm that your depth-of-field trick is working.
- Get down to their level, or below. Think like the prey or predator. Animals don't spend a lot of time looking at what's above them, and overhead is not a great angle for photographing wildlife, either. If you have a choice of angles, get low.
- ◆ Avoid the shooting-through-glass problem entirely. If you wait awhile or come back when it's cooler, most zoo animals will leave their glass cages and venture outdoors. If you're forced to shoot through glass (some zoos are using glass "bars" even for outdoor exhibits), focus manually and throw the background out of focus, shoot at an angle, and, if you can get away with it, use a monopod to allow slightly longer exposures at low ISO settings (in the ISO 100−200 range if there is sufficient illumination).

Inspiration

Modern zoos give you the widest variety of animals to photograph in the most realistic settings. You can visit an Amazon rain forest, African jungle, mountains of the Himalayas, and Australian outback all in an afternoon, with plenty of time for a stop in Antarctica to photograph frolicking penguins.

Take your camera with you on your next hike or trip to any space where wild animals may be spotted. Finding a herd of deer grazing in a clearing or an owl at sunset will be well worth having it along. Just remember to be quiet so you are not detected, and you are likely to get a great picture of the creature in its natural environment.

7.10 Photograph animals in glass cages from one side to avoid reflections, eschew electronic flash, and throw the back of the cage out of focus to help the creature's environment look more natural.

Animal photography practice

7.11 A long lens brought these simians up close.

Table 7.2

Taking Pictures at Zoos

Setup

Practice Picture: A rock wall and steep moat separated me from the "monkey island" where the primates shown in figure 7.11 resided. I set up my camera on a tripod and waited for them to do something interesting. Eventually, one of them looked me in the eye as if I were spying on him, and that's when I took the picture.

On Your Own: Patience is its own reward at zoos. Plan on spending the morning there shooting animals, then wander around photographing flowers and plant life during the hottest hours of the day. Then return to shooting the animals in the late afternoon and evening when they become active again. Find a creature you like, spend enough time to learn its habits, and the payoff will be a picture that far surpasses the snapshots the other zoo visitors get.

Lighting

Practice Picture: The monkeys' compound had a lot of trees, so I took most of my pictures when they climbed to a branch in a sunny spot.

On Your Own: You'll be working with the available light most of the time. Unless you can get closer than about 15 feet to the animal, fill flash won't do you much good.

Lens

Practice Picture: I used a Sigma 170–500mm f/5–7.3 APO Aspherical Autofocus Telephoto Zoom Lens at 400mm.

On Your Own: A long lens lets you shoot close-up photographs of animals that are 40 to 50 feet away. You probably won't need a wide-angle lens much at zoos, so pack your longest lens. A long prime lens (at least 200mm) with a large maximum aperture (f/4–f/2.8) is preferable to a slower zoom lens.

Camera Settings

Practice Picture: I used RAW capture and Shutter Priority AE; and enhanced the saturation in post-processing with Adobe Camera RAW.

On Your Own: Even with a tripod, you'll want to use a relatively high shutter speed. I've found that 400–500mm lenses are almost impossible to handhold on a D200, even with 1/1000- or 1/2000-second shutter speeds.

Exposure

Practice Picture: ISO 400, f/8, 1/1000 second.

On Your Own: You'll want to use selective focus to eliminate elements of the cage or enclosure, so an aperture like f/8 is a good choice. Use a high shutter speed to freeze any movement of the animal, and to eliminate residual camera shake.

Accessories

Bring along a tripod or monopod.

Animal photography tips

- ◆ Frame animals in a natural setting. For example, when in a zoo setting, try to photograph animals as if you were on a safari and they were in their natural habitat. Or, if photographing birds at your backyard feeder, choose an angle that won't include the neighbor's garage in the background.
- Get close. You'll probably have to use a telephoto lens to get close to most animals, but a headshot of a yawning tiger is a lot more interesting than a long shot of the beast pacing around in his enclosure.
- ◆ Don't annoy the animals. Chimps won't say "cheese!" and smile, nor will tigers turn your way just because you jump up and down and yell. If monkeys are about, you probably don't want to attract their attention (don't ask why). Instead, just watch patiently until your animal poses in an interesting way on its own.
- Favor outdoor locations. Many zoo exhibits of larger animals have both an indoor and outdoor component. The animals might come inside to feed or at night, and choose to spend other time outdoors in good weather. You want photographs of them outdoors, not inside.

Architectural Photography

Whether you're taking some snapshots of existing homes you'd like to offer as suggestions to your architect, or looking to capture historic structures, taking photos of interior and exterior architecture is fun and easy.

Architectural photos can be used for documentation, too, to provide a record of construction progress, or show how a building has changed through the years. Some of the most dramatic architectural photos are taken at night, using long time exposures or techniques such as painting with light (using a light source such as a flash to illuminate a subject multiple times during a long exposure).

Of course, even informal architectural photography requires a wide-angle lens with a minimum of the barrel distortion that causes straight lines near the edges of the image to bend outward. You'll find prime lenses in the 14–35mm range most useful. Thanks to the D200's 1.5x crop factor, those fixed focal length lenses provide the equivalent at the short end of the scale of the 20–21mm wide angle lenses you might have used if you migrated from a full frame/film camera. The 28–35mm focal lengths offer a more or less normal lens field of view when cropped by the camera's sensor. Zoom lenses, including the 12–24mm f/4G

7.12 A bit of uncorrected barrel distortion, most easily seen in the vertical wall at right, often results from using wide-angle lenses.

ED-IF AF-S DX Zoom-Nikkor can be useful for less critical work. The 12–24mm lens has quite a bit of distortion in the 12mm focal length range, as you can see in figure 7.12.

Inspiration

The best architectural photographs involve a bit of planning, even if that's nothing more than walking around the site to choose the best location for the shot. Or you might want to take some test shots and come back at a specific time, say, to photograph an urban building on Sunday morning when automobile and foot traffic is light. A particular structure might look best at sunset.

However, the biggest challenge you'll need to plan for is illumination. The existing lighting can be dim, uneven, or harsh. You might encounter mixed illumination with daylight streaming in windows to blend with incandescent room illumination, or lighting that's tinted. You can counter some of these

7.13 Night-time exteriors make challenging subjects because the available illumination can be less than perfect.

problems by mounting your D200 on a tripod and using a long exposure. Perhaps you can add lighting, supplementing existing light with reflectors or lights mounted on stands. Painting with light by manually tripping an electronic flash aimed at different areas of an outdoor structure several times during a long exposure can work, too.

Architectural photography practice

7.14 Photography of architecture after dark lends itself to *painting* with light techniques.

Table 7.3 Taking Architectural Exteriors

Setup

Practice Picture: Although this government building was fairly well lit, the left and right sides of the structure were cloaked in murky shadows. To get the photo shown in figure 7.14, I set my camera on a tripod and used *painting with light* techniques. I was fortunate that it was a calm night, without any breezes that would cause the flags on the poles topping the building to unfurl and blur during the long exposure.

On Your Own: Find a shooting spot that shows a building at its best, with a clean background and uncluttered foreground. Look for surrounding trees or other structures that can serve as a frame. You can look at articles in "home" magazines for ideas for the most flattering way to shoot a particular type of building. If you plan to shoot at night using painting with light techniques, study the existing illumination before you set up.

Lighting

Practice Picture: During a two-minute exposure, I had an assistant equipped with an external flash walk around the front of the building, pressing the open flash button on the electronic flash at intervals to illuminate the dark areas, pointing the flash from an angle to avoid having the flash reflect off windows into the camera lens. He kept his body between the camera and the flash and kept moving so he wouldn't show up in my photo. Orange gel over the flash gave the unit the same color balance as the existing lighting.

On Your Own: At night, time-exposures can yield good pictures of many exteriors with existing light. During the day, the lighting varies more. To avoid harsh shadows that can obscure important details, you might want to wait for slight cloud cover to soften the harsh daylight. If you've found a particular spot that's ideal and you have the luxury of time, you can choose the time of day that provides the best lighting.

Lens

Practice Picture: I used a 28–200mm f/3.5–5.6G ED-IF AF Zoom-Nikkor set to 28mm. In tighter quarters, a lens with more wide-angle reach, such as the 18–70mm f/3.5–4.5G ED-IF AF-S DX Zoom Nikkor kit lens might be more suitable.

On Your Own: Your lens choice depends on whether you can get far enough away to avoid tilting the camera to take in the top of the structure. In extreme cases, a wide-angle prime lens like the 14mm f/2.8D ED AF Nikkor or wide zoom like the 12–24mm f/4G ED-IF AF-S DX Zoom-Nikkor might be necessary. As a last resort, you can use a semi-fisheye lens like the 10.5mm f/2.8G ED AF DX Fisheye-Nikkor and straighten out the curves in Nikon Capture.

Camera Settings

Practice Picture: I used RAW capture, set the white balance to tungsten, used Manual exposure with a custom curve, and added saturation enhancement and sharpening in post-processing with Nikon Capture.

On Your Own: When not shooting time exposures, you can usually use Shutter Priority to specify a speed that will nullify camera shake, and let the camera choose the appropriate aperture.

Exposure

Practice Picture: ISO 100, f/22, 120 seconds.

On Your Own: Time exposures are more or less a trial-and-error process, but in daylight your camera's auto-exposure system works well. Use center-weighted or spot metering to ensure that the exposure is made for the building itself and not any bright surroundings such as sky or snow. Using the D200's automatic bracketing feature lets you take several consecutive pictures at slightly different exposures, so you can choose the one that most accurately portrays the building.

Accessories

A tripod was a must for this time exposure; but it can also be helpful to allow a repeatable perspective, in case you'll be returning from time to time to take additional shots from the sample angle. Record where you placed the tripod legs by removing the camera after the shot and taking a picture of the tripod and its position. Flash can sometimes be used in daylight to fill in shadows — but be careful of reflections off windows. That applies double for painting-with-light exposures.

Architectural photography tips

- ♦ Shoot wide. Exterior architecture often requires a wide-angle lens, while interiors almost always call for a wide setting to capture most rooms or spaces. Unless you're shooting inside a domed stadium, cathedral or other large open space, you'll find yourself with your back to the wall sooner or later. Wide angles also help you include foreground details, such as landscaping, that are frequently an important part of an architectural shot.
- Watch out for lens distortion. Some lenses produce lines that are slightly curved when they're

- supposed to be straight. Although you might not notice this distortion most of the time, architectural design often depends on straight lines and any warps introduced by your lens become readily apparent.
- Avoid perspective distortion. To avoid that "tipping over" look that results when the camera is tilted back, locate a viewpoint that's about half the height of the structure you want to photograph. It might be a neighboring building or a bluff overlooking the site, or some other elevation. Shoot the picture from that position, using the widest lens setting you have available, keeping the back of the camera parallel with the structure.

Ask permission. The laws of most states don't require getting permission to shoot and use photographs of buildings that are clearly visible from public areas. However, many property owners become nervous as soon as you set up a tripod and start shooting, so it's always a good idea to ask first, and, perhaps, offer them a free print if they seem reluctant.

Business Photography

Good photographs can spice up PowerPoint presentations overladen with bullet points and graphs. Pictures can help sell a viewpoint in reports, document progress in an ongoing project, illustrate business e-mail messages, and add credibility to correspondence. In today's visually-oriented world, the ability to communicate with photographs is a definite business advantage. Your Nikon D200 gives you the tools you need to create these photos, whether for personal use in your own business activities, or as goodlooking professional-quality illustrations for your company or organization.

Of course, your business will probably hire professional photographers to craft the high-stakes illustrations needed for advertising, annual reports, and most brochures. But you can become involved with other kinds of business communication that benefits from well-crafted photographic images.

7.15 Photos can enhance letterheads, newsletters, and other printed pieces.

Inspiration

There are dozens of formal and informal opportunities for business-oriented photos. More-formal photos include most communications intended for customers, including external newsletters, new business proposals, training manuals, Web sites, and sales promotions. A more informal approach can be taken for internal communications, such as employee anniversaries or retirements, internal newsletters, and corporate communications.

7.16 Instructional PowerPoint presentations work best when there are a lot of images.

Both kinds of pictures call for wellorganized and cleanly composed images that highlight the main subject, whether it's a person or a product. If an image is intended for sales, training, or promotional use, it should accurately represent the subject matter and not mislead in any way. Backgrounds should never detract from the message. Photograph people and larger products against a plain background, such as a neutral-colored wall located at least a half-dozen feet behind the subject to minimize shadows from available light or the D200's built-in flash. Or, better yet, use Nikon SB-600 or SB-800 flash, moved off camera and bounced off reflectors or umbrellas to create better lighting. The D200 can trigger either of these strobes wirelessly.

You can photograph smaller objects on a seamless paper roll (available at any photo store) or a piece of poster board.

7.17 Plain backgrounds put the emphasis on the product being showcased in your photo.

Business photography practice

7.18 Even mundane products can be made more attractive with simple photographic techniques.

Table 7.4 **Taking Business Pictures**

Setup

Practice Picture: The image shown in figure 7.18 was intended for a trade magazine story on aging fire hydrants (some more than 100 years old) still in use in American cities. A low angle showed how this particular hydrant had been painted and repainted.

On Your Own: Fancy backgrounds and complex arrangements of objects make business images confusing. Outdoors, the sky can make a perfect uncluttered background. Indoors, you can press white, black, or gray poster boards and seamless paper into service for product shots, head shots, and other types of photography. Remember, you can make a medium-toned background look lighter or darker (or even change its color) simply by adjusting the lighting. Mount the camera on a tripod to allow for a long exposure.

Lighting

Practice Picture: I wanted to photograph the hydrant from a dramatic angle, so I chose the side that had the sun casting vivid shadows that highlighted its texture.

On Your Own: If you plan to do a lot of business photography, you might want a set of umbrellas to bounce light off (they can be used indoors with artificial light, or outdoors to bounce sunlight). For product and head shots, you can use photoflood lights or external, off-camera electronic flash units to give you the most control over your illumination. You'll need a light for the background, one or two for your subject, and some reflectors to cast light into the shadows.

Lens

Practice Picture: The 18–70mm f/3.5–4.5G ED-IF AF-S DX Zoom Nikkor set at 28mm was perfect for this low-angle close-up.

On Your Own: You don't need a special wide angle or macro lens if you take photos of larger products (or people) and don't need to shoot extreme close-ups. A normal lens or zoom set to the normal range (about 30–40mm) works well for small objects. A longer lens or zoom setting enables you to blur the background. For group photos, you'll need a medium wide-angle lens, but head-and-shoulder portraits call for a short telephoto in the 60–90mm range.

Camera Settings

Practice Picture: I used RAW capture and Aperture Priority AE.

On Your Own: RAW gives you the best sharpness, while using Aperture Priority makes it possible to choose an f-stop that provides the amount of depth of field you need. While you can set white balance manually to tungsten, you can fine-tune the setting when converting from RAW.

Exposure

Practice Picture: ISO 100, f/11, 1/200 second.

On Your Own: A moderately-small aperture, between f/8 and f/16, provides the depth of field required. Use a wider f-stop, such as f/5.6, to throw the background out of focus. An ISO setting of 100 gives you the best image quality. You don't need higher sensitivity because mounting the camera on a tripod enables a sufficiently long exposure time.

Accessories

Use white cardboard sheets to soften the light. White umbrellas provide more control. For slightly more contrasty lighting to emphasize details in a subject, you can use silver umbrellas or reflectors to provide an indirect, but still vivid, light source. A tripod is an essential accessory for exposure times longer than about 1/125 second.

Business photography tips

- Avoid direct flash in business headshots. If you can't shoot with existing light, bounce the light off the ceiling. You can swivel an SB-600 or SB-800 flash mounted on the hot shoe at an angle to reflect from the ceiling. With portraits, use a silver reflector to cast light into the shadows that will form under the eyes, nose, and chin. With product shots, use white cardboard reflectors to illuminate those shadows.
- Keep backgrounds simple. If you're not using a poster board or wall as a background, pay attention to what's behind your subject to make sure it doesn't interfere.
- Use consistent lighting and setups for photographs that will

- be used as a series. If you're photographing a number of products, or creating a series of portraits, either take as many of the pictures as you can in a single session, or use the same lighting, background, shooting angle, exposure, and other setup details each time you take that sort of picture. Then you'll be able to use all the photos in a single print layout, presentation, or Web site while retaining a professional, consistent look.
- Look at the colors as a group. As you set up a photo, consider all the colors in the image. If they don't work well together, change backgrounds or locations to find a better background color scheme for the subject, or, failing that, use a neutral-color background such as a white wall or a poster board.

Event Photography

Concerts, theater plays, and musicals are the kind of events that beg to be captured for posterity with creative photography. The excitement of a concert, the unfolding storyline of a play, and the melodic excitement of a musical all provide many opportunities for images.

But there are other kinds of events—any special activity of limited duration—that

lend themselves to photography. These include county fairs, parades, festivals such as Mardi Gras, as well as weddings and other celebrations. They can last a few hours like a concert, a full day, or as much as a week. Your company's annual picnic at a local amusement park, a traveling art exhibit, a building dedication, or a tailgate party before a big football game all qualify as interesting events.

You can find a lot of photo opportunities at these events, usually with a lot of color, and

all involving the musicians or players on the stage, as well as other groups and individuals having fun. If you want your creativity sparked by a variety of situations, attending a concert, play, or other event as a spectator or participant is a good place to start.

It sometimes helps to think of a concert or other event as an unfolding story that you can capture in photographs. For example, concerts usually start off with a rousing tune or two, seque into quieter pieces or acoustic numbers, then wind up with crowd-pleasing finales. You'll want to take photos that embody the theme of the event, including overall photographs that show the venue and its setting. Grab shots of the broad scope, the number of people in attendance. and the environment where the event takes place. Then zero in on little details, such as individuals enjoying moments of action or repose. At some events, you'll find booths, a dignitary giving a speech, or an awards ceremony. Tell a story that transports the viewer to the event itself.

7.19 Concert photos taken from as close to the stage as possible offer lots of challenges, such as how to frame the performer amidst a clutch of microphones.

Planning can help you get the best shots. You can scout parade routes in advance, or recall what sort of lighting was used at the last rock concert you attended at a particular site. Events such as Renaissance Faires, festivals, or Civil War re-enactments usually have a schedule of events you can work from (although you might need to request one in advance or visit the organizer's Web site). A program lets you spot scheduling conflicts, and separate the must-see events from those you'll catch if you have time.

Inspiration

Public events not only serve as photo opportunities but they also give you a chance to document your life and time in a way that will be interesting in years to come. For example, popular-music concerts today are quite different from those staged during the late 1960s. Customs at weddings change over the years. Clothing, such as the outfits that were common in discos 25 years ago, can seem exotic or retro today. You'll want to give some consideration to photos that will be interesting today, as well as those you'll take for posterity.

Pack light to increase your mobility, but be sure to take along a wide-angle lens to capture overall scenes and medium shots in close quarters, and at least a short telephoto for more-intimate photos. At concerts, you'll want a longer telephoto to shoot the action onstage and probably a monopod to steady your hand for longer exposures in low light. If flash is permitted, you might want a higher powered unit like the Nikon SB-600 or SB-800 to extend your shooting range.

7.20 Look for a pivotal scene in a play or when the main characters are all present.

Event photography practice

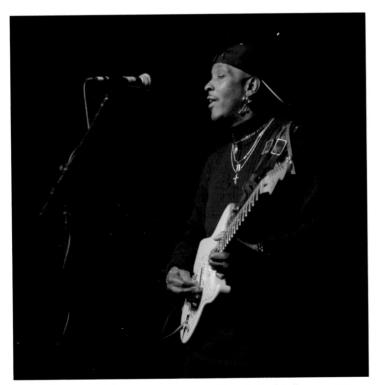

7.21 A blues musician concentrates on his solo in this live concert shot.

Table 7.5 Taking Event Pictures

Setup

Practice Picture: The concert shown in figure 7.21 was in a club that held about 400 people, all tightly packed around the stage or boogying on the dance floor. I got permission to climb past the barriers at the front of the stage so I could shoot the band, including this blues guitarist, from about 10 feet away.

On Your Own: Shooting low at a concert provides an interesting perspective and usually gives you a plain background so you can isolate one musician. However, up front and below the band at a concert is not always the best place to shoot, especially if you want to include more than one band member in the shot. See if you can't get onstage in the wings or shoot from a few rows back where the angle won't be quite so drastic.

Lighting

Practice Picture: I took this picture using only the stage lighting provided at the concert — in this case a spotlight with a blueish cast. Usually, the existing light provides illumination that suits the mood of the performance. However, it's likely to be very contrasty with not much fill-in illumination in the murky shadows. I actually brightened the guitar player's head and frizzy hair in an image-editing program.

On Your Own: Lighting at concerts can vary dramatically during the course of the performance. You can use big, bright lights for energetic portions, and for more subdued illumination, often with a blue or other hue color cast. If flash is allowed and dozens of delirious fans are snapping away, you can use the D200's built-in Speedlight at a low power setting to fill in some shadows. Using the flash at the full setting will overpower the existing light and give your photo a harsh, snapshot-like look.

Lens

Practice Picture: I used an 85mm f/1.8D AF Nikkor at f/5.6.

On Your Own: Although zoom lenses are great for events with bright lighting so you can change the focal length quickly, at concerts you'll want to use fast prime lenses for their low-light capabilities. Vibration-reduction lenses like the 18-200mm f/3.5–5.6G IF-EDAF-S DX VR Zoom-Nikkor are also a good choice.

Camera Settings

Practice Picture: I used Aperture Priority AE mode. I set the white balance to tungsten. By controlling the aperture, I was able to control the depth of field so that the guitarist's face was in sharp focus.

On Your Own: You'll want to control the depth of field, so switch to Aperture Priority AE mode and set the white balance to the type of light in the scene. If the light is low, switch to Shutter Priority AE mode.

Exposure	Practice Picture: ISO 800, f/5.6, 1/160 second.
	On Your Own: Concerts usually call for higher ISO ratings, and the D200 provides decent results at ISO 800. You might need ISO 1600 in very low light or when you're using a longer lens and want a higher shutter speed. Don't fear using lower shutter speeds to allow musicians' hands to blur slightly. Experiment with different shutter speeds to get different looks. For other kinds of events, particularly those taking place outdoors in bright sunlight, choose ISO 100 for the best results.
Accessories	A monopod is almost a must to steady your camera for exposures that are longer than 1/200 second — or even for faster shutter speeds with longer lenses.

Event photography tips

- ◆ Get there early. Although security is tight at major rock concerts (even if you have a backstage pass), shows at smaller venues with less-well-known bands can be more photographer friendly, particularly if you arrive early and are able to chat as equipment is unloaded and set up. (Don't get in the way!) At other kinds of events, getting there early lets you scout the area and capture some interesting photos of floats or exhibits as they're prepped.
- Concerts and other events look best photographed from a variety of angles. Don't spend the whole concert performance planted in front of the stage, right at street-level for a parade, or around the barbeque grill at a

- tailgate party. Roam around. Shoot from highvantage points and from down low. Use both wide-angle and telephoto lenses.
- Ask for permission before photographing adults or children who aren't performing. Sometimes a gesture or a nod will be all you need to do to gain the confidence of an adult. It's always best to explicitly ask for permission from a parent or guardian before photographing a child.
- For outdoor events, plan for changing light conditions. Bright sunlight at high noon calls for positioning yourself to avoid glare and squinting visitors. Late afternoon through sunset is a great time for more-dramatic photos. Night pictures can be interesting, too, if you've brought along a tripod or monopod, or if you can use a flash.

Fill Flash Photography

Using electronic flash to fill in dark shadows is an easy way to improve the lighting of scenes with excessive contrast. Even photographs taken in broad daylight often benefit from an extra squirt of light that balances the highlights with the darker portions of the image. Indoors, in studio environments, fill flash lets you control the balance of light, or, in lighting parlance, the lighting ratio. Figure 7.22 shows a series of

7.22 Fill flash brightens the shadows to reduce the harshness of the lighting.

images in which fill flash was applied to create lighting ratios of 4:1, 3:1, and 1:1 (left to right).

It's easy to forget to use flash as a source of shadow-filling light. Although the electronic flash built into your Nikon D200 can provide the main illumination for a photograph, you probably know that direct flash isn't the best way to light a scene in a natural and attractive way. Using the existing light or, perhaps some off-camera flash, is usually the way to go if you want the best rendition of your subject.

However, your D200's flash can be throttled down to a fraction of its default power output to provide just a touch of illumination that fills in the shadows without that washed-out flash photo look. You can also apply some fill-in light with an off-camera flash unit such as the Nikon SB-600 or SB-800.

Inspiration

One cause of blown highlights (overexposed light areas in photographs that have no detail) is the camera's valiant attempt to preserve information in the darkest shadows, even when the dynamic range of the image is beyond the capabilities of the sensor. If the correct exposure for the shadows is 1/250 second at f/4, and the highlights are calling for 1/250 second at f/16, something has to give. Depending on the exposure mode your Nikon D200 is set for and which matrix metering zones are used to calculate exposure, you can end up with properly exposed highlights and dingy dark shadows, or full, open shadows and blown highlights.

Fiddling with metering modes and zones or applying custom tonal curves can help, but it is time consuming. Your best bet might be to simply alter the balance of the light in your photo. Use fill flash to brighten those shadows, and allow the camera to expose for the highlights.

The simplest way to do this is to set your D200 to AE shutter priority mode, set the shutter speed to 1/250 second (the highest speed usable with electronic flash), flip up the camera's built-in flash, and let the i-TTL balanced fill flash automatically calculate the right amount of electronic flash to apply. You can also get the same effect with Nikon dedicated Speedlights. Or, you can manually reduce the amount of power from the camera or flash menus.

7.23 Flash can fill *any* shadow, not just those found in harsh, direct sunlight. Here, an off-camera flash provided a spotlight effect on a flamingo that was lurking in the shade of some foliage.

Fill flash photography practice

7.24 Without fill flash (left), shadows are harsh. A bit of electronic flash fill-in softens them dramatically.

Table 7.6 Using Fill Flash

Setup

Practice Picture: My seat next to the dugout at a minor league baseball game provided an excellent vantage point to photograph the team's mascot, but the bright sunlight cast dark shadows as seen on the left of figure 7.24. Flipping up the D200's built-in flash provided a small burst of light that brightened the mascot's jersey as shown on the right of figure 7.24.

On Your Own: When shooting in harsh daylight, first try to change your position so that dark shadows aren't a prominent part of your photo. Then, don't hesitate to add some flash to reduce the contrast of the scene.

Lighting

Practice Picture: I used the D200's built-in flash.

On Your Own: An external flash might be a better choice, because you can aim the flash more easily, use a diffuser, and more easily cut the power level appropriately using the controls on the back of the flash.

Lens

Practice Picture: I used a 12mm–24mm f/4G ED-IF AF-S DX Zoom-Nikkor set to 24mm.

On Your Own: Choose a lens suitable for your shot, but remember that longer focal lengths move you farther away from your subject, reducing the effectiveness of the flash in filling in the shadows.

Camera Settings

Practice Picture: I used RAW capture and Manual exposure, and set both the shutter speed and aperture by hand.

On Your Own: Even though your camera can handle daylight/ fill flash exposure calculation, don't be afraid to make your settings manually after reviewing a couple of pictures. That lets you zero in on the best fill flash/available light balance.

Exposure

Practice Picture: ISO 100, f/11, 1/250 second.

On Your Own: Don't forget that even though you are shooting outdoors, your flash syncs at no more than 1/250 second. You might have to use a low ISO setting to allow shooting with such a slow shutter speed outdoors.

Accessories

If your electronic flash has a diffuser, consider using it to soften the fill light even more. Or, have a handkerchief handy to drape over your camera's built-in flash, diffusing the light and cutting its intensity at the same time.

Fill flash photography tips

- If you own a flash meter, use it to calculate the precise exposure needed to fill in your shadows. This gives you the capability to adjust your fill flash lighting ratio more accurately. For example, if the flash meter tells you that the fill flash is providing only one quarter the light that's illuminating the highlights, you can boost the fill to soften the shadows more.
- ◆ Experiment with colored gels. Try gels, such as those in the accessory set available with the Nikon SB-600 and SB-800, to fill in shadows with color. As shadows outdoors are often illuminated by light reflected from the blue sky, a yellowish gel can warm up the shadows for more flattering people shots.
- ◆ Try different lighting ratios. Set your flash to different power levels to provide more or less illumination in the shadows. You may find you prefer a more dramatic effect with less fill flash.

Filter Effects Photography

Filters aren't just for Photoshop anymore. If you're an experienced photographer, that statement might verge on the ridiculous, as filter attachments that can be added to lenses (front, back, or inside the lens itself) have been around for decades. Yet, it's true: many digital picture-takers have never known anything other than the plug-in filters found in their image editors. That's a shame, because even though Photoshop filters can mimic some of the effects of actual filters, there are many effects you can apply more effectively using a glass add-on attached to your favorite optics, and more that can be achieved only with a physical filter.

Some split up your image in interesting ways, like the Hoya Multi-vision series,

available in three-face (three segment), five-face, and six-face versions. You can find similar filters from other vendors if you want to create effects like the one shown in figure 7.25.

7.25 A multi-image filter produced this effect.

There are image-splitting filters available with each face colored differently, say, red, green, and blue, and those that rotate so you can manipulate how your image is divided. You might prefer a star filter to add twinkles to the specular highlights in your images, or attach a polarizer to reduce reflections and darken the sky.

Inspiration

Filters let you visualize your photo as its taken, so you can apply your creativity to an image at the moment of capture, rather than at some later time. Indeed, one key advantage of applying filters in your camera rather than in an image editor is that you can see the effect as you're taking the photo, and make adjustments then to your exposure, focus, or even shooting position to get the exact effect you want. For example, one popular kind of filter blurs the outer edges of an image using various techniques. A clear spot filter has a physical hole in the glass so that the center is sharp, while the rest of the image is affected by the blurring filter itself. Another way of achieving a similar look is with the use of a plain glass, UV, or skylight filter that has been smeared with petroleum jelly with a clean spot left in the center. The effects you get with such filters are variable and can vary within the image frame, making them much more organic and less artificial-looking than if you'd used a Photoshop blur filter.

Filters help you from a technical standpoint, too. There's no easy way to remove glare in an image editor, but a polarizer can perform the chore efficiently—and you can see the effect right in your viewfinder as you rotate the filter mounted to the front of your lens. One frequent problem in landscape photos is trying to balance an excessively bright sky with the less brightly-lit foreground. There are split neutral density filters that can darken only the upper half of your image while allowing a normal exposure in the lower half (or vice versa).

7.26 Clear spot and blur filters can focus attention on the subject matter in the center of your image.

Filter effects photography practice

7.27 A split neutral density filter balanced the sky with the foreground in this sunset image.

Table 7.7 Taking Filter Effects Pictures

Setup

Practice Picture: It was dusk, and I wanted to photograph the flock of sea birds on the shore, but exposing for them would wash out the sky, while properly exposing the sunset would render the birds as dark silhouettes. I broke out my split neutral density filter and captured the image shown in figure 7.27.

On Your Own: Often, you can forget that you're carrying a filter that can solve a problem or add a special effect. If you train yourself to think about using these useful add-ons, you'll discover applications for them everywhere you look.

Lighting

Practice Picture: The sunlight alone provided the illumination for this photo. I resisted the temptation to use the D200's built-in flash as fill, because the bluish flash would have given an artificial look to the warm hues in this scene.

On Your Own: Some kinds of filters work best with particular kinds of light. For example, a polarizer works best in sunlight coming from specific angles, which can vary depending on how high in the sky the sun is.

Lens

Practice Picture: I used a 12-24mm f/4G ED-IF AF-S DX 700m-Nikkor set to 24mm

On Your Own: You can use a variety of lenses for filter effects, but some kinds of filters aren't suited for extreme wide angles, because their added thickness can cause vignetting, or darkening of the corners.

Camera Settings

Practice Picture: RAW format processed using Adobe Camera RAW to adjust white balance, increase saturation, and boost both sharpness and contrast. Aperture Priority AE mode.

On Your Own: While automatic exposure is best, you may have to switch to manual if your D200 is unable to properly compensate for the effects of your filter.

Exposure

Practice Picture: ISO 400, f/16, 1/200 second.

On Your Own: You might need to increase the ISO setting of your camera if the filter removes a significant amount of light, producing a longer than normal exposure.

Accessories

If you want to use many different filters economically, consider an investment in the Cokin Filter System, available from any photo retailer.

Filter effects photography tips

- * Step-up/step down. It's unlikely that all your lenses will use the same size filter. You can use the same filter on several lenses if you purchase an appropriate step up ring, which allows you to mount a larger filter on a lens with a smaller diameter thread; or step down ring, which adapts a smaller filter to a lens with a larger thread diameter (this works best with telephoto lenses stepping down can cause vignetting with lenses that have normal or wide angle focal lengths).
- Get with the system. The Cokin Filter System consists of a mount adapter that can be attached to several different lenses with appropriate adapters, and which accept any of dozens of available square

- filters. Because you're not paying for a mounting system with each filter you buy, Cokin can save you money in the long run.
- Cover all the angles with polarizers. Polarizing filters work best when the camera is pointed 90 degrees away from the direction of the light source. The polarizing effect is reduced with a lesser angle is involved. So, with the sun relatively near the horizon, you'd want it located at your left or right. If the sun is directly overhead, you'll find maximum polarization in front of you, at the horizon. Wide angle lenses can be problematic, because their field of view is so large that some of the image may be 90 degrees from the direction of the sunlight, while other portions are almost facing the sun, producing an uneven polarizing effect.

Fireworks and Light Trail Photography

Every type of photography requires light to make an exposure, but did you know that it's easy to make light itself your subject? You probably know that if your camera moves during a long exposure (which can range from 1/30 second to several seconds or minutes), everything in the photo will become streaky—especially any light sources within the frame.

If the points of light are the only thing bright enough to register, what you end up with is a photo that captures light trails. These trails show the path the light takes as the camera shakes or, in the case of nonstationary illumination, the movement of the light itself. Figure 7.28 shows an example of a fixed light source and a moving camera.

Alternatively, you can lock down the camera on a tripod and leave the shutter open long

7.28 I pointed the camera at an interesting neon sign, and then panned the camera during a 2-second exposure to produce these abstract light trails, plus a final sharp image when the camera stopped.

enough to capture moving lights at night, such as the headlights or taillights of moving automobiles, a rotating Ferris wheel, or fireworks displays. You'll find out more about time exposures later in this chapter.

Inspiration

Use your imagination to come up with different ways of recording light trails. Here are a few ideas to get you started:

◆ Outdoors on a very dark night, set up the camera on a tripod and open the shutter for a 30-second time exposure. A helper positioned within the camera's field of view can use a penlight pointed at the camera to write or draw an image with light. As long as no light spills over onto the person wielding the penlight, only the light trail will show up in the picture. Place a transparent piece of colored plastic in front of the penlight to change the color of the light trail, even during the exposure.

If your confederate wants to inscribe actual words in midair, remember to use script letters and write backward! However, you can also flip your shot in an image editor.

- ◆ Tie the penlight on a piece of long cord, suspend it from an overhead tree branch, and place the D200 on the ground, pointing upward. Start the penlight swinging back and forth, pendulum-fashion in a figure eight or other pattern. Then open the shutter for a few seconds. You'll record a regular pattern. Carefully pass pieces of colored plastic in front of the lens to create multicolored streaks.
- Mount the camera on a tripod, point it at a busy street, and shoot long exposures to capture the streaking headlights and taillights of the automobiles. Experiment with various exposures, starting with about 1 second to 20 seconds to create different effects.

7.29 A 1-minute exposure captured the streaking lights of passing cars, and a traffic signal with all three colors showing at once.

Fireworks and light trails photography practice

7.30 A long exposure captured the multi-bursts that erupted during the finale of a Fourth of July fireworks extravaganza.

Table 7.8 **Taking Pictures of Fireworks**

Setup

Practice Picture: To get the image in figure 7.30, I got to the fireworks show early. I was able to pick out a prime location on a small hill slightly elevated above the crowd and at the edge of a stand of trees where I could set up a tripod without obstructing the view of the crowds seated in the vicinity.

On Your Own: A position close to where the fireworks are set off lets you point the camera up at the sky's canopy and capture all the streaks and flares with ease. On the other hand, a more distant location lets you photograph fireworks against a city's skyline. Both positions are excellent, but you won't have time to use both for one fireworks show. Choose one for a particular display, and then try out the other strategy at the next show.

	Table 7.8 (continued)
Lighting	Practice Picture: The fireworks provide all the light you need.
	On Your Own: This is one type of photography that doesn't require you to make many lighting decisions.
Lens	Practice Picture: I used a 28–200mm f/3.5–5.6G ED-IF AF Zoom-Nikkor set to 28mm.
	On Your Own: A wide-angle lens is usually required to catch the area of the sky that's exploding with light and color. You can even use a fish-eye lens to interesting effect. If you're farther away from the display, you might need a telephoto lens to capture only the fireworks.
Camera Settings	Practice Picture: I used RAW capture and Manual exposure, setting both the shutter speed and aperture by hand. I set the saturation to Enhanced.
	On Your Own: Depth of field and action stopping are not considerations. Don't be tempted to use noise reduction to decrease noise in the long exposures; the extra time the reduction step takes causes you to miss some shots.
Exposure	Practice Picture: ISO 200, f/11, 30 seconds.
	On Your Own: Don't rely on any autoexposure mode. Your best bet is to try a few manual-exposure settings and adjust as necessary.
Accessories	A steady tripod is a must. You also should have a penlight, so you can locate the control buttons in the dark! Carry an umbrella so your camera won't be drenched if it rains unexpectedly. You can use the D200's MC-30 or ML-3 wired or infrared remote control/shutter release devices to trip the shutter or to produce a bulb-type exposure that continues until you press the remote-control button a second time.

Fireworks and light trails photography tips

- Use a tripod. Fireworks and light trails usually require a second or two of exposure, and it's impossible to handhold a camera completely still for that long.
- Don't use a tripod. Break the rules! You can get some interesting light trails by handholding the camera and deliberately moving it during the exposure.
- Don't worry about digital noise. It's almost unavoidable at longer exposures and won't be evident in

- your light trails or fireworks shots after you start playing with the brightness and contrast of your shots in your image editor.
- Review the first couple fireworks shots you take on your LCD to see if the bursts are being captured as you like. Decrease the f-stop if the colored streaks appear too washed out, or increase the exposure if the display appears too dark. Experiment with different exposure times to
- capture more or fewer streaks in one picture.
- Track the skyrockets in flight.
 You can time the start of your exposure for the moment just before the fireworks reach the top of their arc and explode, and then trip the shutter. An exposure of 1 to 4 seconds will capture single displays. You can use longer exposures if you want to image a series of bursts in one shot.

Flower and Plant Photography

For many people, flowers and plant life are the only living things that are as much fun to photograph as people. Like people, each blossom has its own personality. Flowers come in endless varieties, and you can photograph their infinite variety of textures and shapes from any number of angles. If you like colors, flowers and fruits provide hues that are so unique that many of our colors—from rose to lilac to peach to orange—are named for them.

Best of all, flowers and plants are the most patient subjects imaginable. They'll sit for hours without flinching or moving, other than to follow the track of the sun across the sky. You can adjust them into "poses," change their backgrounds, and even trim off a few stray fronds without hearing a single complaint. You can photograph them in any season, including indoors in the dead of winter. Floral photographs are universal, too, as flowers are loved in every country of the world.

Flower photography is a good opportunity to show off your macro photography skills. You can get close to the blooms, or *very* close, as was the case in figure 7.31, which I took with the D200 on a tripod using a 60mm macro lens mounted on a reversing ring to increase the magnification.

Because of their popularity, you won't have to look far for subject matter. Your own garden can provide fodder, but if you're looking for more-exotic plants, there are bound to be public gardens, greenhouses, and herbariums you can visit for your photo shoots.

7.31 The translucent petals of flowers seem to glow with their own light when backlit.

Photography is so likely to be part of the experience at some venues that you'll find maps leading you to the most popular exhibits, along with tips on the best vantage points for taking pictures. Take a few overall photos to show the garden's environment, and then get closer for floral "portraits" of your favorites.

Inspiration

Flower photography is an excellent opportunity to apply your creative and compositional skills. Use color, shape, lines, and texture to create both abstract and concrete images. Experiment with selective focus and lighting (just move to another angle, and the lighting changes!). It's always fun to find plants and flowers that look like people or other objects when you want to add a little mystery or humor to your photographs.

When shooting flowers, you can capture individual blossoms, or photograph groups of them together. As every professional or

amateur flower arranger knows, floral groups of different types of plant life can be put together creatively in bouquets to form one-of-a-kind compositions.

If you have a macro lens, you can isolate an individual part of a flower to explore the mysteries of how these small-scale miracles are constructed. It's possible to spend an entire career doing nothing but photographing flowers, and many photographers do. Surely, you'll find many hours of enjoyment tackling this most interesting subject on your own.

7.32 The almost monochromatic light purple color scheme gives this photo a delicate look.

Flower and plant photography practice

7.33 Break a few rules — shoot from the side and allow the blooms in the foreground to go out of focus — to create an unusual image.

Table 7.9 **Taking Flower and Plant Pictures**

Setup

Practice Picture: I wanted to show a bug's-eye view of some flowers, rather than the usual human viewpoint from above. So, I moved the camera down and placed a piece of black velvet behind the blooms to get the photo shown in figure 7.33.

On Your Own: It's tempting to shoot down on flowers from a lofty perch above them, to better capture those sumptuous blooms. That's why you might enjoy the unusual results you'll get from looking at the plant's world from its own level. Or shoot up to include the contrasting blue sky in the photo. You can photograph single blossoms, bouquets, or an entire field full of wildflowers.

Continued

Table 7.9 (continued)

Lighting

Practice Picture: I took this shot in full midday bright sunlight, producing vivid colors and high contrast.

On Your Own: Although overcast conditions can be suitable for floral photos, this soft lighting tends to mask the color and texture of flowers. Full sunlight brings out the brightest colors and most detail, but it also leads to dark shadows. Use reflectors or fill flash to more brightly illuminate individual blossoms and make the color pop out.

Lens

Practice Picture: I used a 105mm f/2.8D AF Micro-Nikkor.

On Your Own: Macro lenses are ideal for flower photography. Shorter macros like the 60mm f/2.8D AF Micro-Nikkor exaggerate the proportions of parts of the flower that are closest to the lens. A longer macro, like the 105mm Micro-Nikkor (or the new upscale version with built-in Vibration Reduction), lets you step back from the blossoms and helps throw the background or (in this case) the foreground out of focus. If you don't own a macro lens, a close-focusing telephoto in the 100mm range also works. To photograph large groups of plants or an entire field of blossoms, use a 24mm–25mm lens or zoom setting.

Camera Settings

Practice Picture: I used Aperture Priority AE. I set the white balance to Auto, and used the manual focus to prevent the camera from locking in on foreground flowers. I boosted saturation in post-processing using Nikon Capture.

On Your Own: Usually you want to control the aperture yourself, either to limit depth of field for selective focus effects, or to increase the depth of field to allow several flowers to remain in sharp focus.

Exposure

Practice Picture: ISO 400, f/22, 1/800 second.

On Your Own: An ISO 100 setting is ideal for outdoor lighting conditions when you want to use a large aperture to use selective focus. For more generous depth of field, use an f/8 or f/11 aperture as I did, and boost the ISO setting to ISO 200 to 400 if necessary.

Accessories

It's often best to take contemplative shots such as macro photos of flowers with a tripod; it lets you position the camera precisely and fine-tune focus manually if you need to.

Flower and plant photography tips

- Try natural backlighting. Get behind the flower with the sun shining through to capture details of the back-illuminated blossom. The translucent petals and leaves
- will seem to glow with a life of their own.
- Use manual focus. Play with manual focus and large apertures to throw various parts of the flower in and out of focus, creating a dramatic and romantic look.

- Boost saturation. Pump up the richness of the colors by boosting saturation in post-processing. You can use a polarizing filter to create even greater saturation in the flowers and sky.
- Experiment with time-lapse photography. The Nikon D200 has a built-in time-lapse feature (found in the Shooting menu

under Interval Timer Shooting) or, if you have Nikon Capture software, you can connect the D200 to a computer and instruct the software to snap off a photograph automatically at intervals. You can grab shots of the flower turning to face the sun, or shoot a sequence that shows a bud opening to its full floral glory.

Holiday Lights Photography

Although the traditional festive season from Thanksgiving through New Year's is the best time for photographing holiday lights, you'll find a lot of opportunities for capturing the spirit of celebration with lights at other times of the year. Many communities use spooky lighting to add drama to Halloween, strings of lights as decoration for Fourth of July bashes, and a lot of lighting effects brightening the night during county fairs, local festivals, and other activities. These lights make great photographs because they punctuate night-time shots with decorative pin-points of illumination or with broad effects.

7.34 You can find holiday lights in some form during celebrations at many times of the year.

Inspiration

In planning your holiday lights photos, you'll want to think about using the mood of after-dark activities to express the spirit of the holiday. Lights always show up best at night or, at the very least, at dusk when there is sufficient contrast between the lights themselves and their surroundings.

So, plan on applying your night photography skills to your shots. In many cases, that means you'll be working with a tripod to allow the long exposures needed. Figure 7.35 was taken at dusk using the 18–200mm f/3.5–5.6 G ED-IF AF-S VR DX Zoom-Nikkor introduced at the same time as the D200 itself. Thanks to the vibration

7.35 The Vibration Reduction (VR) feature of the zoom lens allowed shooting this wreath of lights at 1/4 second without a tripod.

reduction feature of this lens, when I zoomed in to the 35mm (equivalent) position, I was able to photograph the wreath

hanging from the lamp-post at 1/4 second at f/11 at ISO 400.

Holiday lights photography practice

7.36 Camera movement during exposure produced interesting light trails with these holiday lights.

Table 7.10

Taking Holiday Lights Photos

Setup

Practice Picture: The holiday season was nearly over and these lights were due to come down – but there was no snow! I decided to put the emphasis on the lights themselves, using long exposure that let camera movement create a pattern with the lights as shown in figure 7.36. I got down low to minimize the amount of snowless ground in the photo.

On Your Own: You'll also find yourself in photo situations that are long on lights, but short on seasonal snowfalls if you live in warmer climes. You can choose an angle that doesn't emphasize the ground or other areas where snow would be expected, or can simply underexpose the photo so that only the lights themselves are shown.

Lighting

Practice Picture: It was about 30 minutes after dusk and there was sleet falling when this shot was taken. I didn't want to hang around for full darkness, so I used the low angle to let the sky provide a partial silhouette effect for the clock tower. The lighting was a combination of the remaining daylight, plus the illumination from the lights on the tower and evergreen tree.

On Your Own: If there are a lot of lights in your photo, you'll find that they often provide sufficient illumination all by themselves.

Lens

Practice Picture: I used an 18–200mm f/3.5–5.6 G ED-IF AF-S VR DX Zoom-Nikkor at the 30mm zoom setting, with the vibration reduction feature turned off.

On Your Own: Most of the time a wide-angle prime lens or zoom setting is best for holiday lights, allowing you to capture a broad view that incorporates many lights in your shot.

Camera Settings

Practice Picture: I used RAW capture and Manual exposure, which I determined by taking a few practice shots and reviewing the results.

On Your Own: Using RAW lets you play with the exposure and color when the image is imported into your image editor.

Exposure

Practice Picture: ISO 200, f/4, 1/2 second.

On Your Own: If you mount your camera on a tripod, you can use longer exposures. A 1/2 second exposure for hand-held shots lets you produce light trails while keeping your original subject recognizable.

Accessories

A tripod is a must if you want a sharp image of your holiday lights. Experiment with star filters to add some sparkle to the individual lights.

Holiday lights photography tips

- Use a tripod. To capture both the lights and their surroundings (which requires a longer exposure) use a tripod to steady your camera. At night, you may need an exposure of several seconds, and it's impossible to handhold a camera that long.
- Don't use a tripod. Go ahead and let the lights streak, adding some interesting light trails to your photo.

- Use a VR lens. Holiday lights are a perfect application for a vibration reduction lens, as you'll be able to handhold your camera at low shutter speeds and still get a sharp photo.
- ♣ Try using filters. Add some extra color to your holiday lights photos by using colored filters. If you're taking a long time exposure, you can hold the filter in your hand and move in front of the lens for part of the exposure, or swap several different filters in and out during the exposure.

Indoor Portrait Photography

Indoor portraits are often what we think of as slightly more formal photos of individuals or small groups with carefully-crafted lighting, posing, and backgrounds. However, portraits taken indoors can also be candid photos, like the one shown in

Figure 7.37. Today, most people have a definite preference for relaxed, comfortable portraits, whether they're taken indoors or out.

You'll find that indoor portraits are a perfect opportunity to experiment with lighting, because you'll usually have complete command of the illumination and can, if you like, set up lights or electronic flash units

Lighting Tips

Lighting should present your subject in a flattering way and you can even use it to improve faces that are less than perfect. You can use a few techniques to achieve this goal:

- ♦ Work with two or three (or more) lights. A main light provides the principal illumination for the scene. The fill light, usually placed near the camera on the side opposite the main light, brightens shadows. Increasing or decreasing the intensity of the fill makes the shadows less or more dramatic. If necessary, you can use a third, background light to provide separation between your subject and a similarly-toned background. Many photographers add a hair light to add sparkle to the hair and create additional separation from the background.
- Broad lighting places the main light so it illuminates the side of the face turned toward the camera. This type of lighting tends to widen narrow faces.

- Short lighting moves the main light behind the subject so it illuminates the side of the face turned away from the camera. This type of lighting narrows wide faces.
- Side lighting is used to illuminate profiles.
- * Back lighting produces silhouette-type photos.

under more controlled conditions. A mini studio set up at home lets you adjust poses, backgrounds, and lighting in dozens of ways, all in the space of a few minutes.

Inspiration

You can use several off-camera electronic flash or incandescent lights to create professional-looking indoor portraits.

7.37 Window lighting, augmented by light reflected from the window in the rest of the room, can be the basis for soft, flattering portrait lighting indoors.

7.38 Two lights — one on the background and one bouncing off a reflector to the left of the camera — were all I needed for this teen portrait.

Indoor portrait photography practice

7.39 Four lights and a stool helped produce this semiformal portrait.

Table 7.11 Taking Indoor Portraits

Setup

Practice Picture: I set up a seamless paper backdrop as a background, set up three off-camera electronic flash units, and posed my model on a stool to bring her up to camera-eye-level for the photo in figure 7.39.

On Your Own: You'll find that fabric, at a few dollars a yard, makes a great background for indoor portraits, too. Purchase two or three yards of solid or textured fabrics in blues, neutral browns, or grays. A transparent piece of plastic placed over your background line can turn a gray background into any color of the rainbow.

Lighting

Practice Picture: I placed a low-power electronic flash with built-in slave unit on the ground behind the model and pointed up at the background. I positioned an off-camera Nikon SB-800 Speedlight, linked to the D200 through a Nikon SC-28 cable, to the right of the camera position and bounced off a 40-inch white umbrella to serve as a fill light. A second SB-800 flash, triggered by the camera-linked unit, was bounced off a white reflector positioned to the left of the camera and slightly behind the model to provide the main light for this portrait. An SB-800 mounted on a light stand above and to the left and set to 1/128th power provided a kick of light in the subject's hair.

On Your Own: It's common to add a low-powered hair light, placed above and behind the model to illuminate the top of the head/hair and provide additional separation from the background. Be careful that the hair light does not spill over onto the face!

Practice Picture: I used a 50mm f/1.8D AF Nikkor.

On Your Own: At less than \$100, Nikon's 50mm f/1.8 lens is likely to be one of the sharpest optics in your bag of tricks, and it makes a great portrait lens. It's sharp wide open, so you can opt for really shallow depth of field if you like, and it focuses as close as 1.5 feet — much closer than you'll want to get for most portraits. However, you can choose any lens or zoom setting in the 50mm–70mm range for most individual portraits.

Camera Settings Practice Picture: I used RAW capture and Aperture Priority AE.

On Your Own: If you're using flash, the shutter speed isn't crucial, so you'll want to use Aperture Priority AE mode to let you specify the f/stop and control the amount of depth of field.

Exposure Practice Picture: ISO 200, f/11, 1/500 second.

the best pose or expression.

On Your Own: For most portraits, you'll want enough depth of field to ensure your model's entire face is in sharp focus (especially the eyes!), but is shallow enough to throw the background partially out of focus. So, f/11 is a good place to start, but you can use f/8 or

f/5.6 if you want more selective focus.

White or silver reflectors or umbrellas are essential for providing indirect lighting that is softer and more flattering. Use soft white for women and teenagers who want their skin to look creamy-soft. Silver might be a better choice for men or older folks who are proud of their character lines. Gold reflectors add a warmer look that is beneficial for glamour shots. You'll want to eschew a tripod if you're using flash, because people pictures work best when the photographer is free to move around and change angles to capture

Indoor portrait photography tips

- Alter your shot angle. Although a bald head has become a fashion statement these days, if your subject is sensitive about a bare pate, elevate your victim's chin and lower your camera slightly to minimize the top of the head. And don't use a hair light!
- Know when to shoot head on and when to shoot in profile. If your subject has a long, large, or angular nose, have him face directly into the camera. To minimize prominent ears, shoot your model in profile, or use short lighting so the ear nearest the camera is in shadow.
- Change the lighting for best results. You can narrow wide faces

Lens

.....

Accessories

by using short lighting; you can widen narrow faces using broad lighting. To minimize wrinkles or facial defects such as scars or a bad complexion, use softer, more diffuse lighting using a white umbrella or an even more flattering add-on light modifier called a *soft box*. (You can search online, with a search engine such as Google, for vendors of these products.) Make sure the

- main light is at eye level to avoid wrinkle-emphasizing shadows.
- Beware of reflections. People wearing glasses are a perennial problem for portrait photographers. Watch for reflections and ask your model to raise or lower her chin slightly so the light will bounce off the lenses at an angle, rather than right back at the camera.

Infrared Photography

Infrared photography is a great way to explore new ways of looking at familiar subjects, by using only illumination in the *near infrared* portion of the spectrum to make exposures. In this mode, the D200 records subjects in a range of tones that represent how much infrared light they reflect. Plant life and foliage reflect infrared light well, so trees and grass appear almost white in photos, as you can see in figure 7.40. The sky itself doesn't reflect much infrared light to the camera, but the water vapor in clouds does, so you end up with fluffy white clouds on an eerie dark sky.

Infrared photography looks best when it provides a black-and-white view of the world, too. Your shots will initially have a reddish cast to them, which you can vanquish by converting the image to grayscale, or by isolating the red channel in your image editor.

There's not a lot of extra equipment involved in infrared photography. All you really need is an infrared filter, such as a Hoya R72 or Wratten #89B, and a tripod for the long exposures that are required. You'll be shooting blind, by the way, because an IR filter is virtually opaque to visible light – so that tripod is *really* a good idea to help you use a fixed viewpoint.

Can the D200 Cut It with Infrared?

You'll need to use long exposures in the several second range, because the Nikon D200 isn't especially sensitive to infrared illumination, like its upscale cousin the D2X and unlike the company's entry-level cameras, the D70s and D50. In one respect, that's a good thing. Too much infrared light can degrade your image, so camera vendors tend to be more rigorous in filtering it out in their higher-end cameras. While a D70s can often shoot infrared photos in bright daylight at 1/4 second or even 1/8 second at mid-range ISO settings, the D200 calls for 8X or 16X as much exposure. A tripod is mandatory.

7.40 In infrared photos, foliage and clouds appear white, but objects that don't reflect infrared well, such as the sky, are darker than they normally appear.

Inspiration

When looking for subjects for infrared photography, you'll want to start with traditional landscapes. Scenery is kind enough to hold still for the long exposures that infrared photography requires with the D200. You can set your camera up on a tripod, focus and frame the image, and *then* attach your IR (infrared) filter.

But don't avoid exploring other types of subjects. Infrared portraits can be interesting, if a little weird, because of the ghostly white rendition of human skin. (Teenagers with complexion problems might find the look especially cool!) Indoor pictures by firelight can also be interesting. You're not capturing the image by the heat of the fire, of course: that's far infrared illumination. But hot subjects like fires emit enough near infrared to provide some interesting photos by firelight or candle light.

7.41 Infrared photos don't have to be limited to landscapes. You can create portraits with a grainy, ethereal look.

Infrared photography can be interesting as a photojournalism tool. A grainy look, black-and-white tones, and motion blur can all add an arty look to an otherwise mundane photograph. Because objects often reflect more or less infrared light than we anticipate

based on our perceptions of the visible light that reaches our eyes, everyday objects take on strange tonal values, with some things darker than we would expect and others lighter.

Infrared photography practice

7.42 This dry stream bed surrounded by trees made a great setting for an infrared landscape.

Table 7.12 Taking Infrared Pictures

Setup

Practice Picture: The high vantage point above a dry stream bed shown in figure 7.42 offered a good mix of foliage and sky for this infrared photo.

On Your Own: Outdoors, look for scenic locations with a lot of greenery to provide a dramatic look to the foliage.

Lighting

Practice Picture: Daylight was all the illumination I needed for this shot.

On Your Own: Brightly lit days are best for outdoor infrared photography, but you'll find that the infrared illumination does cut through haze quite well, giving you some surprising results on foggy days, too.

Lens

Practice Picture: I used an 18–200mm f/3.5–5.6 G ED-IF AF-S VR DX Zoom-Nikkor at the 18mm zoom setting, with the vibration reduction feature turned off.

On Your Own: Use a wide-angle lens to take in a broad view, especially if you want to take several photos in different directions without bothering to remove the IR filter. I've found that simply pointing the camera in the direction you want and snapping off a shot works a surprisingly high percentage of the time.

Camera Settings

Practice Picture: I used RAW capture and Manual exposure. I set white balance manually using the D200's Preset capability. Instead of pointing the camera at a neutral gray or white subject to capture the white balance, use the grass or trees to let the camera measure the white balance from your high-IR-reflecting subjects.

On Your Own: Manual exposure lets you tweak the shutter speed and f-stop after reviewing a few (dim, but viewable) preliminary shots on your LCD. Store the white balance settings you measure for reuse the next time you shoot infrared under similar conditions.

Exposure

Practice Picture: ISO 400, f/5.6, 8 seconds.

On Your Own: Use a high enough ISO setting to let you keep shutter speeds within the range of a few seconds — unless you want to use longer exposures and see what blur from cloud movement looks like.

Accessories

A tripod is essential. If you want a "color" infrared photo, you'll also need an image editor to fine-tune the photo.

Infrared photography tips

- ♦ Swap your channels. To get a color infrared shot, use Photoshop's Channel Mixer to set the Red Channel's Red value to 0 percent and its Blue value slider to 100 percent. Then switch to the Blue channel and set the Red slider to 100 percent and the Blue slider to 0 percent. It's that simple.
- Bracket exposures. Infrared photo can look quite different when you bracket one-half to one full stop.
- ★ Take advantage of the long exposures. Select subjects that have movement, such as rivers, streams and waterfalls, or moving cars and people. The intentional blur can become an interesting picture element.

Landscape and Nature Photography

Like floral photography, landscape and nature photography provides you with a universe of photo subjects, there for the taking, courtesy of Mother Nature. This kind of photography provides a dual joy: the thrill of the hunt as you track down suitable scenic locations to shoot—whether remote or close to home—and then the challenge of using your creativity to capture the scene in a new and interesting way.

Landscapes are an ever-changing subject, too. You can photograph the same scene in summer, winter, fall, or spring, and it looks different each time. Indeed, a series of these photos of a favorite vista in different seasons makes an interesting and rewarding project.

7.43 This peaceful woodsy path shows how humans and nature can co-exist.

Scouting Locations

As you enjoy landscape and nature photography, you'll discover some tricks for finding good scenes to shoot.

- If you're in an unfamiliar area, check with the staff of a camping or sporting goods store or a fishing tackle shop. Stop in and buy a map or make another small purchase, and then quiz these local experts to discover where the best hiking trails or fishing spots are. You'll find a lot of wildlife and great scenic views along these trails.
- Buy a local newspaper and find out what time the sun or moon rises or sets, and when to expect high or low tide. Each time of day offers its own landscape and nature photographic charm. Dusk or dawn make particularly good times for landscape and nature photography because the light is warm and the lower angle of the sun brings out the texture of the scenery.
- ◆ Don't get lost. Carry a compass so you'll always know where you are when scouting locations. Plus, you can use the compass with subposition tables you can find locally to determine exactly where the sun or moon will be at sunset or sunrise. If the sun will set behind a particular mountain, you can use that information to choose your position.
- ◆ Include weather in your plans. Rainy or cloudy weather can put a damper on your photography, or it can form the basis for some interesting, moody shots. Some kinds of creatures can be more easily tracked when the weather is moist or there is snow on the ground. The National Weather Service or local weather forecasters let you know in advance whether to expect clear skies, clouds, wind, or other conditions.

Inspiration

Nature photography can take many forms. You can photograph a landscape as it really is, capturing a view exactly as you saw it in a moment in time. Or you can look for an unusual view or perspective that adds a fantasy-world quality. The three basic styles of landscape photography actually have names: representational (realistic scenery with no manipulation), impressionistic (using photographic techniques such as filters or special exposures that provide a less realistic impression of the landscape), and abstract (the landscape is reduced to its essential components so the photo might not resemble the original scene at all).

Animals are a part of nature photography, too. You can photograph creatures like tree frogs or insects up close, or grab shots of more timid animals from a distance with a

7.44 You can approach lakes and rivers from many different angles, which enables you to carefully construct your compositions.

telephoto lens. Look for wildlife to populate your landscape, too, or shoot a scene with only the trees, plants, rocks, sky, and bodies of water to fill the view. Choose the time of day or season of the year. You may be working with the raw materials nature provides you, but your options are almost endless.

Landscape and nature photography practice

7.45 This snowy scene was only a few yards from the road.

Table 7.13 Taking Landscape and Nature Pictures

Setup

Practice Picture: I hate being cooped up all winter, but don't enjoy slogging through snow, so I was pleased to discover the picturesque scene in figure 7.45 only a few yards from a rural road I was exploring.

On Your Own: You don't need to find a remote location to find unspoiled wilderness. Even sites close to home can make attractive scenic photos if you're careful to crop out the signs of civilization.

Lighting

Practice Picture: My trek began as a search for wildlife in late afternoon, so the shadows when I took this landscape were long and the contrast quite dramatic. Even so, the sun was still high enough in the sky that the snow kept its cool, blue-white cast.

On Your Own: You won't have much control over the available illumination when shooting scenic photos. Your best bet is to choose your time and place, and take your shots when the light is best for the kind of photographs you want to take.

Lens

Practice Picture: I used an 18–200mm f/3.5–5.6 G ED-IF AF-S VR DX Zoom-Nikkor at the 18mm zoom setting, with the vibration reduction feature turned off.

On Your Own: Use a wide-angle lens to take in a broader view for landscapes, but keep in mind that the foreground will be emphasized. If you're far enough from your chosen scene, a telephoto lens captures more of the distant landscape, and less of the foreground.

Camera Settings

Practice Picture: I used RAW capture and Shutter Priority AE, with saturation set to Enhanced. Although I could have boosted saturation during conversion from RAW, it's easier to make your basic settings at the time you shoot.

On Your Own: Shutter Priority mode lets you set a high-enough shutter speed to freeze your landscape and counteract any camera or photographer shake if you're not using a tripod.

Exposure

Practice Picture: ISO 400, f/11, 1/250 second.

On Your Own: This late in the day, an ISO setting of 400 allowed the 1/250 second shutter speed. Any extra noise caused by the ISO boost shows up only in the distant trees and in shadow areas.

Accessories

If you're not shooting from a car, a tripod can help you steady the camera and make it easy to fine-tune your composition. Use a quick-release plate so you can experiment with various angles and views and then lock down the camera on the tripod only when you've decided on a basic composition. A circular polarizer and an umbrella and raincoat can be handy, too when weather is severe.

Landscape and nature photography tips

- Long telephotos capture distant subjects. If far-away objects are your photo prey, a long telephoto lens is your best friend.
- ◆ Use a circular polarizer with caution. A polarizer can remove reflections from water, cut through haze when you're photographing distant scenes, and boost color saturation. However, a polarizer can cause vignetting with extrawide-angle lenses, will reduce the amount of light reaching your sensor (increasing exposure times), and might be unpredictable when applied to images with a great deal of sky area.
- Bracket your exposures. The same scene can look dramatically different when photographed with a half-stop to a full-stop (or more) extra exposure, or with a similar amount of underexposure. An ordinary dusk scene can turn into a dramatic silhouette.
- ★ Take along protective gear for inclement weather. A sudden shower can drench you and your D200. An unexpected gust of wind can spoil an exposure, or even tip over a tripod-mounted camera. An umbrella can protect you from precipitation or shield your camera from a stiff wind.

Macro Photography

Close-up, or *macro*, photography is another chance for you to cut loose and let your imagination run free. This type of picture taking is closely related to floral photography and still-life photography, which also can involve shooting up close and personal. However, the emphasis here is on getting really, *really* close.

Although you can have a lot of fun shooting close-ups out in the field, macro photography is one of those rainy-day activities that you can do at home. You don't need to travel by plane to find something out of the ordinary to shoot. That weird crystal salt shaker you unearthed at a garage sale might be the perfect fodder for an imaginative close-up that captures its brilliance and texture. Grains of sand, spider webs, the

interior workings of a finely crafted Swiss watch, and many other objects can make fascinating macro subjects. Or you can photograph something important to you, such as your coin or stamp collection.

Inspiration

Explore the world around you by discovering interesting subjects in common objects. When you've found subject matter that gives your imagination a workout, the next step is to make it big.

Indeed, the name of the game in macro photography is magnification, not focusing distance. If you want to fill the frame with a postage stamp, it matters little whether you're using a 60mm or 105mm macro prime lens, or a close-focusing zoom lens. Any of these should be able to fill that

176 Part II → Creating Great Photos with the Nikon D200

frame with the stamp, and for a relatively flat object of that sort, you probably won't be able to tell which lens or focal length was used to take the picture.

Your choice of lens, then, depends on how far away you want to be when you fill that frame. To shoot a postage stamp, you might like a 60mm lens; a 105mm lens might be better when you're photographing a flower and want enough room to play with some lighting effects, as was the case for figure 7.47. If your passion is photographing poisonous spiders or skittish critters, perhaps a 200mm macro lens is more suitable.

7.46 You'll find a lot of macro opportunities in natural phenomena, such as dripping icicles.

7.47 A close-up photo can help you discover new worlds in everyday objects, such as this rose.

You don't have to purchase an expensive macro lens to enjoy close-up photography, although Nikon's new 105mm macro lens with built-in vibration reduction is especially tempting! If you're not ready to spring for an exotic lens, a lens you already own might focus close enough for some kinds of macro work. If you own Nikon's excellent 50mm f/1.8 AF lens (or are willing to spend less than \$100 for one), you can couple that optic with an inexpensive extension tube to extend its focus range down to a few inches from your subject.

Automatic extension tubes that preserve your D200's autofocus and exposure features can be purchased individually for as little as \$50, in sizes ranging from about 12mm to 36mm in length, or in sets of three. You can combine tubes to get longer extensions. A good, sharp lens and some extension tubes can get you in the macro game quickly.

Less ideal are close-up attachments that screw onto the front of a lens similarly to a filter, and provide additional magnification. Unless you buy one of the more expensive models (\$50 or more, depending on the filter size your lens requires), you'll lose a little sharpness. You can use several close-up

attachments at once to produce additional magnification at the cost of a little more resolution.

Macro photography practice

7.48 Chess pieces and a glass chessboard made this atmospheric macro shot easy to achieve.

Table 7.14 Taking Macro Photos

Setup

Practice Picture: One of my long-term projects is finding new ways to photograph a glass chessboard and matching glass chess pieces, shown in figure 7.48. I placed the chess board on a piece of white poster board, all of which was supported by water bottles which allowed illumination from beneath the board.

On Your Own: Use poster board, fabric, or other backgrounds to isolate your macro subjects, and pose them on a tabletop or other flat surface.

Lighting

Practice Picture: I used a pair of high-intensity desk lamps located on either side of the chessboard, with a little light spilling underneath the board.

On Your Own: You can use desk lamps to light small setups, with reflectors to fill in the shadows.

Table 7.14 (continued)

Lens

Practice Picture: I used a 105mm f/2.8D AF Micro-Nikkor.

On Your Own: Use a macro lens or close-focusing prime or zoom lens to provide the magnification you need. Or fit a 50mm f/1.8 or other prime lens with extension tubes to get you in close.

Camera Settings

Practice Picture: I used RAW capture and Manual exposure. RAW capture allowed me to tweak the white balance when the image was imported into an image editor, so I could change the white balance to a much bluer rendition that added an icy cool mood to this shot.

On Your Own: Unless you're going for a special effect, you'll want to control the depth of field, so choose Aperture Priority AE mode and set the white balance to the type of light in the scene.

Exposure

Practice Picture: ISO 100, f/18, 8 seconds. To blur the background, while still allowing good focus on chessmen arranged two-deep, I used a relatively small f-stop. But I focused slightly in front of the king, so the pieces would be in focus even if the background was not.

On Your Own: The D200's depth-of-field preview button is your friend for visualizing how much is in focus before you take the shot. For maximum front-to-back sharpness, set a narrow aperture such as f/16 to f/22. To blur the background, choose a wider aperture such as f/8 to f/11. Use ISO 200 for maximum sharpness and the least amount of noise. You won't need higher ISOs when your camera is mounted on a tripod.

Accessories

Use a tripod for macro photography. Use the self-timer to trip the shutter without vibrating the camera. You can use the D200's M-Up feature to raise the mirror before the shot and eliminate vibration from mirror travel.

Macro photography tips

- Use the focus-lock control to freeze focus. You can also set your camera/lens to manual focus and zero in on the exact plane you want to appear sharpest.
- Remember that long exposures take some time. Just because you heard a click doesn't mean the picture is finished. Wait until the shutter closes again, or you can see the

- review image on the LCD before touching the camera.
- Use the D200's LCD to review your close-up photos. Do this immediately so you can doublecheck for bad reflections or other defects. It takes a long time to set up a close-up photo, so you want to get it right now, rather than have to set up everything again later.

Night and Evening Photography

Photography during the evening and after dusk is a challenge because, after the sun goes down, there is much less light available to take the photo. You can use add-on light sources, such as electronic flash, as a last resort because as soon as you add an auxiliary light, the scene immediately loses its nighttime charm. Unless you're looking for a retro-Speed Graphic look reminiscent of the 1930s to 1950s photojournalist Weegee (Arthur Fellig), flash at night is a less-than-perfect solution.

Instead, the goal of most night and evening photography is to reproduce a scene much as it appears to the unaided eye, or, alternatively, to add blur, streaking lights, or other effects that enhance the mood or create an effect.

Because night photography is so challenging technically, you'll find it an excellent test of your skills, and an opportunity to create some arresting images.

Correct exposure at night means boosting the amount of light that reaches your sensor. You can accomplish this several different ways, often in combinations. Here are some guidelines:

Use the widest possible aperture. A fast prime lens, with a maximum aperture of f1.8 to f1.4, lets you shoot some brightly lit night scenes handheld using reasonably short shutter speeds. Nikon makes such autofocus lenses in 28mm, 50mm, and 85mm focal lengths. Older-style (Al-S) manual focus lenses are available in 35mm f1.4, 50mm f1.2, and 85mm f1.4 configurations.

7.49 The half-hour after sunset is a perfect time to capture moody nature photos.

180 Part II → Creating Great Photos with the Nikon D200

- ♦ Use the longest exposure time you can handhold. For most people, 1/30 second is about the longest exposure they can use without a tripod with a wide-angle or normal lens. Short telephotos require 1/60th to 1/125 second, making them less suitable for night photography without a tripod. However, you can handhold lenses with vibration reduction built in, such as the 24mm−120mm f/3.5−f/5.6 VR Zoom-Nikkor, for exposures of 1/15 second or longer.
- Use a tripod, monopod, or other handy support. Brace your camera or fix it tight and you can take shake-free photos of several seconds to 30 seconds or longer.
- ❖ Boost the ISO. Increase the sensor's sensitivity to magnify the available light. Unfortunately, raising the ISO setting above 400 also magnifies the grainy effect known as noise. If you're not in a hurry, the D200's noise-reduction option

takes a second, blank frame for the same interval as your original exposure, and then subtracts the noise found in this dark frame from the equivalent pixels in your original shot. This step effectively doubles the time needed to take a picture, meaning you'll have a 30-second wait following a 30-second exposure before you can take the next picture.

Inspiration

Night and evening photography is always a challenge because there is rarely enough light for handheld exposures. That means you need to find ways to steady the camera, especially if you spot a low-light photo you'd like to take but don't happen to have your tripod with you. Use your creativity to come up with alternate ways of steadying your camera. Rest the camera on a solid surface and use the self-timer to trip the D200's shutter. Find a handy fence or (if you're in a city), a flat-topped trash receptacle.

7.50 This military academy looks foreboding at night when the exterior is illuminated with light from the surrounding streetlamps.

Alternatively, your creativity may inspire you to incorporate some degree of blur in your night and evening photographs. Allowing

blur to occur naturally or even deliberately shaking the camera as you shoot can lead to some interesting effects.

Night and evening photography practice

7.51 With the camera on a tripod, I was able to capture this carnival scene and the moon in a single shot.

Table 7.15 Taking Night and Evening Pictures

Setup

Practice Picture: As the moon rose above the carnival booth, I decided I wanted to capture both in one shot, so I set up my tripod and shot this time-exposure (see figure 7.51).

On Your Own: If you carry your camera with you at all times, you can constantly be on the lookout for grab shots. You don't necessarily need a tripod for night scenes. Rest your camera on an available object to steady it. If your scene is relatively unmoving, use the self-timer to trigger the shot and avoid shaking the camera with your trigger finger.

Lighting

Practice Picture: Part of the illumination comes from the carnival lights, but the moon provides its own light. I had to cover up the top half of the frame with my hand for 90 percent of the time exposure to keep the moon from washing out during the long exposure needed to capture the neon lights.

On Your Own: Try to work with the light that is available. If you must use supplementary light, bounce it off reflectors or other objects and don't let it become strong enough to overpower the existing light. At most, you'd just want to fill in some of the darker shadows, especially when the available light is overhead and high in contrast.

Lens

Practice Picture: I used an 28–200mm f/3.5–5.6G ED-IF AF Zoom-Nikkor set to 28mm.

On Your Own: Unless you need to reach out to photograph something at a distance, fast wide-angle prime lenses or zoom lenses at a wide-angle setting are your best choice for night photography. Longer lenses usually have a smaller maximum aperture, and require more careful bracing to avoid blur from camera/photographer shake.

Camera Settings

Practice Picture: I used RAW capture and Shutter Priority AE with optimize image set to Vivid.

On Your Own: Using Shutter Priority mode, set your camera to the slowest shutter speed you find acceptable (based on whether you're handholding or using the camera on a tripod), and the metering system will select an f-stop. For wide-angle scenes extending to infinity, the depth of field is usually not important. Unless the foreground is very close to the camera, everything will be acceptably sharp, even wide open.

Exposure	Practice Picture: ISO 800, f/11, 2 seconds (for the neon lights).
	On Your Own: Although your D200's matrix metering system does a good job with most night scenes, you might want to bracket exposures to get different looks, and you will certainly need to use Manual exposure and experimentation for pictures that image the moon and the surrounding scene in one picture.
Accessories	A tripod, a <i>monopod</i> (a clamp with camera tripod mount attached), or even a beanbag can serve as a support for your camera during long nighttime exposures.

Night and evening photography tips

- If you absolutely must use flash, use slow-sync mode. This allows for longer shutter speeds with flash so that existing light in a scene can supplement the flash illumination. With any luck, you'll get a good balance and reduce the direct flash look in your final image.
- Shoot in twilight. This enables you to get a nighttime look that takes advantage of the remaining illumination from the setting sun.
- When blur is unavoidable due to long exposure times, use it as a picture element. Streaking light

- trails can enhance an otherwise staid night-scene photo.
- If you have a choice, shoot on nights with a full moon. The extra light from the moon can provide more detail without spoiling the night-scene look of your photo.
- ♣ Bracket exposures. Precise exposure at night is iffy under the best circumstances, so it's difficult to determine the "ideal" exposure. Instead of fretting over the perfect settings, try bracketing. A photo that's half a stop or more under- or overexposed can have a completely different look and can be of higher quality than if you produced the same result in an image editor.

Online Auction Photography

Online auction sites such as eBay are great venues for those who want to clear out their attics, sell their older Nikon gear so they can buy new lenses and accessories, or locate a rare or an unusual item. The first thing sellers discover is that good photos lead to higher bids and more profit, because online buyers are more likely to purchase something if they can see exactly what they're getting.

You can sell just about any product on eBay, with some notable exceptions for firearms, human body parts, and other excluded

items. In addition to photo gear, you'll find computers and accessories, clothing, videogames, books, automobiles, and other goodies for sale. Because shipping large items can be expensive, the vast majority of the items sold on eBay are roughly the size of a proverbial breadbox or two. That means you can apply much of what you've learned about close-up or flower photography, or even indoor portraiture, to online auction photos. The goals are the same: to capture a clear, well-lit image of a subject.

You'll probably recall that when the Nikon D200 was introduced, they were initially in short supply. When I purchased my own, I ended up buying the camera in a kit that included the 18 – 70mm zoom lens – because no camera bodies were available from my dealer separately. As I already owned this lens, I turned around and sold it on eBay in less than a week, for about what I paid for it. The key to the swift sale was the image, like the one shown in figure 7.52, that showed potential buyers everything they were getting, including the lens itself, hood, pouch, and documentation furnished with the original lens.

7.52 I used this photo on eBay to sell an extra lens set.

The chief difference between online-auction photography and other sorts of close-up or product photography is that your end product must be Web-friendly, and probably will be resized to no more than about 600 x 400 pixels. However, by starting out with the tools available to Nikon D200 owners, you can be sure that your final photo will be superior to most of the efforts of the point-and-shoot crowd

Inspiration

Unlike other photography you might produce, online-auction pictures take on a mass-production aspect. Where you might spend half an hour setting up a conventional close-up photo to get it exactly right, when you have 15 or 20 different items to photograph for this week's auctions, you'll want to be able to crank out good pictures very quickly. The key is to have a setup you

7.53 There's a separate eBay Motors auction site for motor vehicles, but the photo rules remain the same: Picture the product you're selling in an attractive setting, so buyers want to own what you're offering.

can use over and over, much in the way catalog photographers do. After you have set up the background and lights, you can drop one product into the setting, take a photo or two, and then replace it with a different product. Instead of spending 30 minutes per photo, you might want to be able to shoot 10 or 20 pictures in 30 minutes.

If you want to work very fast, use a piece of fabric as a background and find a location

that has good natural lighting that will let you dispense with flash or lamps altogether. Mount your camera on a tripod so you can keep the same subject distance and angle for a series of similar-sized items, and consider using an infrared remote control so you don't even have to take more than a glance through the viewfinder between shots. With some practice, you'll be cranking out auction photos as quickly as an experienced catalog photographer.

Online auction photography practice

7.54 Lladró porcelain sells well in online auctions, but the piece must be presented attractively. Here, the specular highlights on the glossy finish bring this figurine of a clown to life.

	Table 7.16 Taking Auction Photos
Setup	Practice Picture: I draped a black velour cloth over a living room couch and used a pair of electronic flashes to provide the illumination for the shot in figure 7.54.
	On Your Own: If you shoot many auction photos, you might want to set aside a corner as your permanent auction "studio" with background and lighting already in place. You'll find that a single setup can work with objects in a broad range of sizes.
Lighting	Practice Picture: The flash bounced off umbrellas provided relatively soft illumination, but was still bright enough to provide specular highlights on the shiny surfaces of the figurine. Lladró sells both glazed and matte porcelain, so the glossy surface texture was an important part of the image.
	On Your Own: Direct flash won't give you good results for this kind of photography. It is too harsh and you might even find that the camera's lens or lens hood casts a shadow on the item being photographed. Use desk lamps or off-camera flash with umbrellas.
Lens	Practice Picture: I used a 105mm f/2.8D AF Micro-Nikkor.
	On Your Own: Use a macro lens or close-focusing prime or zoom lens to provide the magnification you need. You can also use a 50mm f/1.8 or other prime lens with extension tubes to photograpl objects from a few inches to a few feet from the camera.
Camera Settings	Practice Picture: I used RAW capture with Aperture Priority AE with saturation set to Enhanced.
	On Your Own: As with other close-up photos, you'll want to contro the depth of field, so choose Aperture Priority AE mode and set the white balance to the type of light in the scene.
Exposure	Practice Picture: ISO 100, f/22, 1/250 second.
	On Your Own: Usually, you'll want to use an f-stop between f/11 and f/22 to maximize front-to-back sharpness. If the camera is mounted on a tripod, you can use longer shutter speeds as required

and stick with an ISO setting of 200 for maximum quality.

Use reflectors to fill in the shadows.

Online auction photography tips

Accessories

 Crop tightly. If you're trying to fill a 600-pixel-wide image with information, crop tightly so you don't waste any space. You can crop in the camera, or later in your image editor. Fortunately, your D200 has pixels to spare – about 25 times more than you really need for an auction photo.

- Use a plain background.
 - Although plain backgrounds are important for most kinds of close-up photography, they're even more important for online auction photos, which must present the product being sold with no distractions.
- Use higher-contrast lighting. Soft lighting obscures details, and snappier lighting shows off the details in the product you're trying to sell.

- Save the diffused illumination for your glamour photography.
- ♣ Boost saturation within limits. For some kinds of products, it's a good idea to dial in some extra saturation to make your image more vivid and appealing. However, if the true colors of your item are an important selling point (as with clothing or dinnerware), go for a more realistic rendition that doesn't mislead your buyers.

Outdoor and Environmental Portrait Photography

Before the 1960s, most formal portraits were taken in the studio or, if outdoors, under rigidly controlled conditions. The renewed love for the environment and nature made outdoor portraits a favorite type for both professional photographers and serious amateurs. The goal is to produce an image that looks like a portrait, rather than a snapshot, but which includes the more casual and informal elements of the great outdoors.

Strictly speaking, environmental portraits don't have to be outdoors. A painter in a studio, a horticulturalist in a greenhouse, or a basketball player at the foul line all show these portrait subjects in their respective environments. However, most environmental portraits are taken outdoors, using the same basic concepts of portraiture as their more formal counterparts.

Inspiration

Environmental portraits present a wonderful opportunity to work the creative muscles. You might not always be able to choose your portrait models, but you certainly can choose your environment! Just about any attractive outdoor setting is fodder for your shots. You can choose public parks, nearby woods, a scenic overlook, or a handy urban location.

7.55 Fill flash helped balance the light in this gazebo with the background scene.

Some professional photographers have suitable environmental setups right next to their studios. They solve the bad-weather problem by using large backdrops with pictures of leafy trees, along with foreground props like logs or fence posts to get an environmental look indoors.

You'll want to scout appropriate locations in advance, or simply pack up your camera

and portrait subject in a car and drive around looking for good sites. Find spots with attractive natural features and enough shady areas that you won't be shooting in direct sunlight all the time.

Outdoor and environmental portrait photography practice

7.56 Soldiers in Civil War re-enactments love to have their portraits taken in their authentic uniforms.

Table 7.17 Taking Environmental Portraits

Setup Practice Picture: Civil War re-enactors, which included soldiers, their spouses, and children, all dressed up in period costumes and uniforms, offering an opportunity for this digital photographer to play Matthew Brady for an afternoon. For the shot shown in figure 7.56, I elected to use the D200's black and white mode to photograph this Union calding is fount of his total.

black-and-white mode to photograph this Union soldier in front of his tent, and then tinted the resulting picture for a more authentic appearance.

On Your Own: While using a tent as a background adds an historic flavor, you'll probably want to choose a background that is simple and not distracting, such as trees, flowers, or a scenic vista. It helps if the background colors aren't gaudy and are, preferably, darker than your portrait subjects. If you need ideas for locations, check the online tourist Web sites for your area. You might unearth some local scenic gems that you'd forgotten about!

Lighting

Practice Picture: Outdoors, simple lighting is best. It was a cloudy day, so the overcast sky provided the perfect soft lighting for this shot. No reflectors or fill flash were required.

On Your Own: Look for shady areas with a lot of illumination bouncing off the surroundings, so your images will be well-lit with soft light and not murky. Reflectors can help fill the shadows.

Lens

Practice Picture: I used a 18mm–70mm f/3.5–4.5G ED-IF AF-S DX Zoom Nikkor at 50mm.

On Your Own: Less-than-full-length portraits of people always look better if you get in close and frame with a short telephoto lens in the 50mm–70mm range. Longer lenses tend to "flatten" the features of your subjects a bit, widening faces almost imperceptibly.

Camera Settings

Practice Picture: I used black-and-white mode and Aperture Priority AE.

On Your Own: Aperture Priority should always be your choice for portraits when controlling the depth of field is important. Use RAW capture so you can adjust the white balance later if the camera doesn't pick up on the shady light, which can tend to be bluish when much of the illumination comes from sky light bouncing into the scene. RAW is a better choice than the D200's shade white balance, which might not be spot-on in all cases.

Exposure

Practice Picture: ISO 200, f/5.6, 1/200 second.

On Your Own: To blur the background, use a wider aperture such as f/5.6 or f/4.5. To really throw the background out of focus, use a prime lens with an f/1.4 or f/1.8 aperture. If you want to show more of the background in sharp focus, use f/11 or f/17. Set the ISO to 200 or 320, depending on the amount of light available.

Accessories

Keep some reflectors around whenever you shoot portraits. A tripod will hold your camera steady and let you get in the photo, too, if you activate the self-timer.

Outdoor and environmental portrait photography tips

- A little environment goes a long way. Unless you want the subject's surroundings to become a major part of the composition, frame tightly and let only enough of the environment show that's required to make the setting obvious.
- Try late-afternoon and dusk shoots. Humans look their best in the warm light of late afternoon, compared to the stark, bluish tones found at midday. As sunset approaches, you might find the color of the light too reddish for your tastes, but if you go with the flow you can get romantic images with an almost candle-lit quality. You'll find early-evening sunlight much different from what you'd get simply applying a warming tone using your camera's or image editor's controls.

- Indoor rules apply, too. Check out the posing tips in the groupportraits and indoor-portraits sections of this chapter. You can use the same guidelines to arrange pleasing portraits in environmental settings.
- Watch that background! What photographers sometimes forget is that the background in an environmental portrait outdoors can change dramatically while they're shooting. A cable-TV service truck might suddenly park in front of that nice stand of trees you were using as a background. Lighting can change behind your subject, even if the illumination where you're set up in the shade remains fairly constant. That nice cloudfilled sky can change into a stark. overexposed sky. Monitor your backgrounds as you shoot to make sure they're still as suitable as they were when you started.

Panoramic Photography

No scenic photo is quite as breathtaking as a sweeping panorama. Horizons look more impressive, mountain ranges more majestic, and vistas more alluring when presented in extra-wide views. If you shoot scenic photography—from landscapes to seascapes—you'll want to experiment with panoramas. You can create them in your camera, or assemble them from multiple shots in your image editor.

Some of the charm of panoramas comes from the refreshing departure from the typical 3:2 aspect ratio that originated with 35mm still-photo film frames, and which lives on in the $3872-\times2592$ -pixel resolution of the Nikon D200. Even common print sizes, such as 5×7 , 8×10 , or 11×14 inches provide a staid, squat, rectangular format. You can go far beyond that with your Nikon D200, producing panoramas that stretch across your screen or print in just about any ultra-wide view you choose.

7.57 This panorama was produced by taking an ordinary shot and cropping off the top and bottom to eliminate excess sky and foreground areas.

Inspiration

You can create panoramas several different ways. The easiest method is to take a wide-angle photo of your vista, and then crop off the top and bottom portions of the image to create a view that's much wider than it is tall. If you go this route, you'll want to start with the sharpest possible original image. Mount your camera on a tripod, set sensitivity to ISO 100, and work with the sharpest suitable lens in your collection, set to its sharpest f-stop.

Another method for creating a panorama is to take several photos and merge them in your image editor. (Photoshop and Photoshop Elements have special tools for stitching photos together.) For the best results, mount your camera on a tripod and pan from one side to the other as you take several overlapping photos. (The term *pan* comes from panorama, by the way.) Ideally, the pivot point should be the center of the lens (there are special mounts with adjustments for this purpose), but for casual panoramas, mounting the camera using the D200's tripod socket works fine.

7.58 Panoramic photos are a creative way to express wide open spaces, as in this photo of a dairy farm.

192 Part II ← Creating Great Photos with the Nikon D200

7.59 Sports photos make great panoramas.

When you choose your panorama subjects, remember that you're not limited to scenic photographs. Almost any subject that can be captured with a wide-angle lens can be

turned into fodder for a panorama. A superwide panorama can show both the infield and action around the plate in a single photograph.

Panoramic photography practice

7.60 Photographing a lakeside amusement park from the other side of the water at dusk yielded this panoramic vista.

Table 7.18 Taking Panorama Pictures

Setup

Practice Picture: A traditional wide-angle shot of this amusement park from the other side of the lake would have wasted a lot of space on the sky and water, so I decided to shoot with a wide-angle lens, and then trim the excess to arrive at the photo shown in figure 7.60.

On Your Own: Look for scenes that can be cropped to produce images that are much wider than they are tall. Mountains and other kinds of landscapes and skylines are especially appropriate.

Lighting	Practice Picture: The existing light provided by the setting sun was
Ligiting	just fine for this silhouetted panorama.
	On Your Own: As with conventional landscape photography, your control over lighting is generally limited to choosing the best time of day or night to take the photo. Unless you're taking a picture on the spur of the moment, think about planning ahead and showing up at your site when the lighting is dramatic.
Lens	Practice Picture: I used a 12–24mm f/4G ED-IF AF-S DX Zoom-Nikkor at 18mm.
	On Your Own: Choose a good moderate wide-angle lens to capture your vista for panoramas created by cropping a single photo. If you're stitching pictures together, you might want to try a slightly wider zoom setting to reduce the number of images you need to collect. Avoid very-wide-angle lenses and the distortion they can produce. Nikon's 12mm-24mm zoom has very little barrel distortion at the 18mm setting.
Camera Settings	Practice Picture: I used RAW capture and Shutter Priority AE.
	On Your Own: Use Shutter Priority AE and select a high shutter speed to produce the sharpest possible image.
Exposure	Practice Picture: ISO 200, f/8, 1/200 second, with the camera's selected f/stop reduced by two stops using the EV setting.
	On Your Own: Unless you're including foreground objects for framing, you can select a high shutter speed and let the camera go ahead and open the lens fairly wide, with no worries about the shallower depth of field.
Accessories	For dawn or dusk shots, a tripod can help steady the camera during longer exposures.

Panoramic photography tips

- Use a tripod. If you're shooting several photos to be stitched together later, use a tripod to help you keep all the shots in the same horizontal plane.
- Overlap. Each photo in a series should overlap its neighbor by at least 10 percent to make it easier to stitch the images together smoothly.
- Watch the exposure. You'll make your life simpler if you use the

- same exposure for each photograph in a panorama series. Use the D200's exposure-lock feature, or else your camera will calculate a new exposure for each shot.
- ◆ Save time with software. If you don't have Photoshop or Photoshop Elements, do a Google search to find the latest photostitching software for your particular computer platform (Windows or Mac). Although you can stitch images together manually, the right software can save you a lot of time.

Sports and Action Photography

The Nikon D200's fast response and rapidfire five frames-per-second continuous shooting mode capabilities make it a popular tool for capturing football, baseball, basketball, or hockey games and getting great shots at soccer and tennis matches. But action photography isn't limited to sports, of course. You'll encounter fast-moving action at amusement parks, while swimming at the beach, or while struggling to climb a mountain. Everything from skydiving to golf to spelunking all lend themselves to action photography.

7.61 The brief duration of electronic flash can freeze action effectively.

You can take action pictures during the daytime, using fast shutter speeds to freeze action, or slower speeds to allow a little blur to provide a feeling of motion in your images. Or, you can shoot at night and let the action-stopping capabilities of electronic flash freeze your subjects in their tracks.

The dual challenges facing action photographers are knowing the right subject and knowing the right time. The other aspects are just technical details that are easy to master. However, you'll always need to understand enough about what is going on to anticipate where the most exciting action will take place and be ready to photograph that subject. Then you need to have the instincts to pull the trigger at exactly the right instant to capture that decisive moment.

Inspiration

Action photography is exciting because it captures a moment in time. The goal is to find exactly the right moment to take the photo. Your Nikon D200 simplifies the process in several ways. You can leave it switched on and ready to go at all times, so you'll never lose a shot waiting for your camera to "warm up." Moreover, after the camera is up to your eye and you see a picture you want to take, the autofocus and autoexposure systems work so quickly that you can depress the Shutter Release button and take a picture in an instant, without the interminable shutter lag that plagues so many point-and-shoot digital cameras. Finally, the D200's continuous shooting mode can fire off bursts of shots as quickly as five frames per second, so even if your timing is slightly off, you can still improve your chances of grabbing the precise instant.

7.62 I panned the camera in the same direction as the riders, creating a feeling of motion in the finished picture.

When deciding how to shoot action, don't worry about freezing all motion with a fast shutter speed. Sometimes the right amount of blur can enhance your photo by imparting a sense of movement. One way to do this is to *pan* the camera, or move it in the direction of the motion. When you pan, the apparent speed of your subject seems to the sensor to be less, which causes a given

shutter speed to offer more action-stopping capability. Figure 7.62 shows a picture of an amusement park ride taken at 1/4 second, with the camera panning in the same direction the riders were moving. While the riders are still blurry enough to show motion, the structure of the ride is *very* blurry, creating a feeling of excitement.

Sports and action photography practice

7.63 The combination of a long lens, a good choice of location, perfect timing, and a little help from the D200's continuous shooting mode produced this shot of a runner being picked off at first base.

Table 7.19 **Taking Sports and Action Pictures**

Setup

Practice Picture: My seat next to the home dugout for the professional baseball game shown in figure 7.63 provided the perfect vantage point for coverage of both the pitcher's mound and first base.

On Your Own: Know where to stand or sit for the best action-shooting opportunities. At football games, that might be on the sidelines 10 yards in front of or behind the line of scrimmage. You can shoot soccer games from behind or next to the net. Basketball games look best from near the bench or behind the backboard. You might not have easy access to these positions at pro or college contests, but you'll find high school games considerably more photographer friendly. Until you find a favorite location or two, roam around and scout out the best shooting sites.

Table 7.19 (continued)

Lighting

Practice Picture: Daylight was just fine at this mid-afternoon baseball game.

On Your Own: Even outdoors, you might find the illumination is less than perfect, particularly on gloomy days or at dusk. When the outdoor light is really scarce, you can't do a lot except use a flash to fill in murky areas. Indoors, the light might be okay as is if you boost the ISO setting to ISO 800 or ISO 1600. More-ambitious sports photographers might want to experiment with multiple flash units to provide broad illumination over larger areas.

Lens

Practice Picture: I used a Sigma 170–500mm F5–7.3 APO Aspherical AutoFocus Telephoto Zoom Lens at 500mm. When you're far from the action, the longer the focal length you can muster, the better.

On Your Own: Your lens choice depends on the type of action you're shooting. Indoor sports can call for wide-angle or normal focal lengths. Outdoors, if you can get close to the action, a 70mm–200mm zoom lens might cover all the bases. If you're up in the stands or you want to capture an outfielder snaring a fly ball, a prime lens or zoom in the 300mm to 500mm range might be required. You'll need a lens that's fairly fast if you want the D200's autofocus features to focus for you. A wide aperture also makes it easier to focus manually. However, most of your shots will be taken with the lens stopped down to produce sufficient depth of field.

Camera Settings

Practice Picture: I used JPEG Fine with Shutter Priority AE and continuous shooting mode.

On Your Own: The D200 can usually store JPEG Fine images more quickly than RAW format, so when you're shooting quickly and continuously, you'll gain some speed with very little quality loss by choosing Fine. Select Shutter Priority mode so you can choose the highest appropriate shutter speed when you want to stop action. Under reduced light levels, you'll want to drop down to a slower shutter speed or boost the ISO setting.

Exposure

Practice Picture: ISO 800, f/11, 1/2,000 second.

On Your Own: At 500mm, the f/11 aperture allowed the people in the stands to blur slightly, and 1/2,000 second was plenty fast enough to freeze all the action except for the ball and the end of the bat. Image noise isn't a serious problem with the D200 at ISO 800, but good results are possible at ISO 1600 if you need a smaller aperture or faster shutter speed.

Accessories

Even with high shutter speeds, a tripod or monopod can help steady a long lens and produce sharper results. Compact tripods and monopods made of carbon fiber or magnesium are light in weight and easy to tote to sports events. Indoors, a flash can be useful.

Sports and action photography tips

- Anticipate action. Become sensitive to the rhythm of a sport and learn exactly when to be ready to press the Shutter Release button to capture the peak moment.
- ◆ Be ready to use manual focus or focus lock. Autofocus works great, particularly the D200's predictive-autofocus feature that tries to anticipate where your subject will be at the time the picture is taken. However, don't be afraid to turn off the autofocus feature, manually focus, or lock focus on a position where you think the action will take place, and then snap the picture when your subjects are in position. You might be able to get more accurate focus this way.

Take advantage of peak action.

Many sports involve action peaks that coincide with the most decisive moment. A pole-vaulter pauses at the top of a leap for a fraction of a second before tumbling over to the other side. A quarterback might pump-fake a pass, and then hesitate before unleashing the ball. A tennis player poised at the net for a smash is another moment of peak action. These moments all make great pictures.

Shoot oncoming action.

Movement that's headed directly toward the camera can be frozen at a slower shutter speed than movement that's across the field of view. If you don't have enough light to use the D200's highest 1/8,000 second shutter speed, try photographing oncoming action to freeze the motion.

Still Life Photography

Still-life pictures have long been a favorite of artists and photographers looking for infinitely patient models that can become the basis for images that explore form and light to its fullest. The best thing about still-life photography is that, after you're finished, you don't need to buy your model lunch—your model can be lunch!

You'll find shooting still-life photos a perfect rainy-day activity. A quick visit to your collection of porcelain figurines, pewter soldiers, or artificial flowers can yield enough subject matter to keep you busy for hours. Or you might find the subject matter you need in the refrigerator.

The most labor-intensive part of photographing a still life is coming up with pleasing arrangements that lend themselves to creative compositions. Count on spending time positioning your objects, perhaps adding something here, or removing an item that doesn't quite work. Setting up a still-life arrangement is the closest a photographer can come to sculpting or painting.

You might be attempting to create photographic art or illustrate a cookbook, but still-life photography is challenging under any circumstances. Although still-life images have traditionally involved settings on a table, with bowls of flowers or fruit, cornucopias, and perhaps a sprinkling of leaves, don't feel that you're limited to that kind of approach. You can skip the accoutrements, get in close, and concentrate on shape, texture, and color.

7.64 Get in close to emphasize the texture and color of your subjects.

Inspiration

Still-life photography is like macro photography but a step or two farther from your subject. Your subject matter is likely to be a bit larger, sometimes covering an entire table. You probably won't need a macro lens to focus close enough. Yet the same principles of lighting and composition apply. You'll want to use auxiliary lighting such as flash or incandescent lights, maintain control with umbrellas or reflectors, and, after you've selected the best composition, lock your camera down on a tripod.

In fact, you can light many still-life setups as you would a portrait sitting:

- Use a main light to create shadows that provide your subject with shape and form.
- Illuminate the shadows with reflectors or fill lights.
- Consider lighting the background on its own to provide separation between your subject and its surroundings.
- Consider applying techniques like short lighting or broad lighting to create a more flattering rendition.

7.65 A spritz of water makes these peppers look good enough to eat.

Still life photography practice

7.66. Simple setups, such as this one, are easy and quick to create.

Table 7.20 Taking Still-Life Pictures

Setup

Practice Picture: There was a sale of various hot peppers, including several habañero chilies I wasn't brave enough to taste myself. I couldn't resist collecting a group of them on a piece of poster board that had been curved to form a seamless background, as you can see in figure 7.66.

On Your Own: Some of the best still-life photos are the simplest. Use the natural beauty of food or a handcrafted object, and don't clutter up the picture with other props.

Lighting

Practice Picture: I used a pair of white umbrellas placed to the left and right of the camera, and turned them around to shoot *through* the fabric to create extra-soft lighting for the peppers.

On Your Own: Many umbrellas are backed with black fabric (often removable) to reduce light loss. If your electronic flash is powerful enough, you can use the extra diffusion from shooting through the umbrellas to produce an even softer lighting arrangement. You'll find add-ons called *soft boxes* produce even smoother, broader lighting.

Lens

Practice Picture: I used a 60mm f/2.8D AF Micro-Nikkor.

On Your Own: A close-up macro lens has the advantage of extra sharpness and the capability to focus close, but you don't necessarily need such a lens for your still-life photography. Any zoom lens that focuses down to a foot or two is suitable for all but the tightest compositions.

Camera Settings

Practice Picture: I used RAW capture and Aperture Priority AE with a custom white balance. I set saturation to Enhanced.

On Your Own: You'll want to control the depth of field, so choose Aperture Priority AE mode and set the white balance to the type of light in the scene, either tungsten or flash.

Exposure

Practice Picture: ISO 100, f/22, 1/250 second.

On Your Own: Close-up photos call for smaller f-stops and extra depth of field, and most still-life pictures are in that distance range.

Accessories

Umbrellas with external flash units are your best choice, but you can also use desk lamps and reflectors. A tripod is handy for locking down a composition and holding the camera steady if the exposure time is longer than 1/125 second.

Still life photography tips

- ◆ Use your imagination. Seek out still-life subjects and backgrounds that you might not think of immediately. For example, an end table carefully arranged with lamp, television remote control, newspaper folded open to the crossword puzzle, and pencil could become an interesting still life, rather than a picture of some cluttered furniture.
- ★ Inject the element of surprise. A little bit of the unexpected or a humorous touch can spice up a mundane still life. An arrangement of green peppers with one yellow pepper in the middle will attract attention. A cluster of stainless-steel nuts making a nest for a single walnut is a visual pun that can tickle the funny bone — especially if

- you can work a confused stuffed toy squirrel into the picture.
- ★ Small touches mean a lot. Spritzing a little water on food can make it seem more appetizing. The difference between a suitable background and the perfect background can be significant. For example, a layout of a picnic basket and its contents on a checkered tablecloth can be interesting, but a background of an old slab of wood from a weathered picnic table resting on a few tufts of grass might be better.
- ♣ Try different angles. Even if you've meticulously set up your still life, you might find that another angle you hadn't considered looks even better. Don't ignore the possibility of happy accidents.

Street Life Photography

Urban areas have a charm of their own. The pace is more hurried, the ambience a little grittier, and the variety of photo subjects almost infinite. You can easily spend a year photographing everything within a one-block area and still not exhaust all the possibilities.

The focus of street-life photography is often on the people, but there's a lot more to explore. Old buildings, monuments, storefront windows, or kiosks packed with things for sale all present interesting photographic fodder. Or you can concentrate on the streets themselves, the bustle of traffic and pedestrians, or the derring-do of whistle-blowing bicycle messengers. The animals that populate the streets, including stray dogs, voracious pigeons, and darting squirrels are worthy of photographic study. Take refuge in the peace of an urban park and capture the contradictions of an island of natural beauty hemmed in by tall buildings.

Photography of street life has been a cornucopia of photographic opportunities for as long as cameras have been used in cities. Hang around long enough in one spot in a city or village and sooner or later you'll encounter characters and situations that are perfect for a lively photograph.

7.67 There's more to street photography than the people you encounter. Any big city's skyline is part of its personality.

Inspiration

Photographing people on the streets has become more complex in the 21st century. Security concerns have tightened restrictions on photography around certain buildings, including most government installations. Paparazzi have given impromptu people-photography something of a sour reputation as an intrusive invasion of privacy. In parts of some cities, a few denizens might be engaging in activities that they don't want captured on film. If you want to be successful on the streets, you'll need to follow a few rules:

Ask permission to shoot people on the street. You don't need to walk up to every photo subject and say, "Hi, I'm a photographer. May I take your picture?" A simple quizzical nod and a gesture with your camera will alert your subject that you'd like to snap a photo. If you're met with a smile or ignored, go right ahead and shoot. Should your victim turn away from you, glare, or flash a finger salute, that's your signal to back off.

7.68 Watching groups of people in a city interact as they stroll around provides fodder for interesting photos that show urban life in action.

- Never photograph children without asking the adult they're with. If the child is unaccompanied, look for another subject. Granted, you'll miss some cute kid shots, but the chance of being mistaken for a bad person is too much to risk. The only possible exception to this rule might be if you're a female photographer, preferably accompanied by children of your own.
- Leverage your personality.
 Recognize that photographers, including yourself, fall into one of several different personality types.
 Some folks have an outgoing way
- that lets them photograph people aggressively without offending or alarming their subjects. Other people approach street photography more tentatively, or tend to blend into the background. If you know which style is more suitable for you, work with your personality rather than against it.
- Don't act in a suspicious way. Photographing with a long lens from a parked car is a good way to attract unwanted attention. In fact, any kind of furtive photography is likely to ensure that your street shooting session is a short one.

Street life photography practice

7.69 Every city is populated with interesting characters who find their own ways to relax and amuse themselves, or, maybe, raise a little cash. You can capture their personalities on film if you're careful not to intrude.

Table 7.21

Taking Pictures of Street Life

Setup

Practice Picture: This big city was a lot more hectic than I am used to, but I found lots of photo opportunities in capturing folks as they went about their business, as you can see in figure 7.69.

On Your Own: In seeking your street subject matter, look for simple arrangements of people or objects that make an interesting composition. You'll rarely be able to rearrange your subjects to suit your needs, so explore all the angles to get the best perspective.

Lighting

Practice Picture: It was a bright day, but slightly overcast, so the lighting was not harsh.

On Your Own: Using reflectors, flash, or other extra lighting quickly destroys the mood of your street scene, so try to work with the lighting that is already there. City streets can often be fairly shady because of the shadows cast by tall buildings, so you'll often find that exactly the sort of diffuse lighting you need is already available.

Lens

Practice Picture: I used a 28mm–200mm f/3.5–5.6G ED-IF AF Zoom-Nikkor set to 120mm.

On Your Own: Crowded streets often call for wide-angle views, but you'll also need to be able to zoom in for an impromptu portrait. The D200 with a medium-to-long telephoto zoom provides the perfect range. You might need a wider optic for photos that include buildings, and a faster lens can come in handy in lower light levels and at night. The Nikon 50mm f/1.8 is an excellent lens for urban photography when light isn't abundant.

Camera Settings

Practice Picture: I used RAW capture and Shutter Priority AE, with saturation set to Enhanced because of the muted colors in this overcast day.

On Your Own: You might need shutter priority or Manual exposure for time exposures, but Aperture Priority AE mode gives you greater control over the depth of field. If light levels are low, you might want to switch to Shutter Priority to make sure that your shutter speed is high enough to counter camera shake.

Exposure

Practice Picture: ISO 400, f/11, 1/200 second.

On Your Own: To ensure front-to-back sharpness, set a narrow aperture such as f/8 or f/16. If the background is distracting, use a wider aperture such as f/5.6 or f/4.0. Set the ISO to 200 or 400, depending on the amount of light available.

Accessories

A monopod for steadying the camera is more practical than a tripod in urban situations, but it won't be steady enough for exposures (especially time exposures) longer than 1/30 second. But, in most other situations, you'll find that a monopod is easier to set up, requires less room, and won't bog you down with unnecessary weight.

Street life photography tips

- Tell a story. Some of the best photos of street life are photojournalist-style images that tell a story about the people and their activities in an urban area.
- ◆ Travel light. When working in cities, you'll be on foot much of the time, scooting between locations by bus or taxi. You won't want to be lugging every lens and accessory around with you. Decide in advance what sort of pictures you're looking for, and take only your D200 and a few suitable lenses and accessories.
- Cities are busy places; incorporate that into your pictures. Don't be afraid to use blur to emphasize the frenetic pace of urban life. Slower shutter speeds and a camera mounted on a monopod can yield interesting photos in which the buildings are

sharp, but pedestrians and traffic

all have an element of movement.

Learn to use wide-angle lenses. The tight confines of crowded streets probably mean you'll be using wide-angle lenses a lot. Experiment with ways to avoid perspective distortion, such as shooting from eye-level, or exaggerate it by using low or high angles.

Sunset and Sunrise Photography

Sunsets and sunrises are classic photo subjects that are difficult to mess up. Their crisp compositions tolerate a wide range of exposures and tend to provide vivid colors in infinite variety; a picture taken from one position on one day might look entirely different from one taken at the same place the next day. Sunrises and sunsets are so beautiful they make even average photographers look brilliant.

You can shoot unadorned sunrises and sunsets with nothing but the sky and horizon showing, or incorporate foreground subjects into the picture. Place the emphasis on the sky itself with a wide-angle lens, or zero

7.70 About 20 minutes after sunrise, the sun had moved up behind the clouds, creating interesting patterns of color for this shot.

in on the grandeur of the setting sun with a telephoto.

Your choice of shooting a sunrise or a sunset depends primarily on whether you're willing to get up early and where the sun will be at the time you take the picture. For example, on the East Coast of the United States, the sun peeping over the ocean's edge must be captured in the early-morning hours. On the West Coast, sunsets over the Pacific Ocean are the norm. However, you can shoot the setting or rising sun with a lake, mountain range, or city skyline, too, simply by choosing your position.

Don't ignore the twilight hours just before sunset, and the moments just after sunrise. The skies are colorful and worth capturing at those times, too.

Inspiration

Because sunrises and sunsets, by definition, are backlit, they're the perfect opportunity to shoot silhouettes. You can outline things at the horizon, or create silhouettes from closer subjects, such as people or buildings. Here are some things to consider:

- Make underexposure work for you. Silhouettes are black outlines against a bright background, so you'll usually have to underexpose from what the D200 considers the "ideal" exposure. Use the exposure value compensation to reduce exposure by two stops.
- Shoot sharp. Silhouettes usually look best when the outlined subject is sharp. Watch your focus, using the focus lock button or manual focus if necessary to ensure sharp focus.
- ◆ Use imaginative compositions. It's too easy to just find an interesting shape and shoot it at sundown in silhouette mode. Use the dramatic lighting to enhance your composition. For example, one favorite wedding shot is the bride and groom in profile facing each other, jointly holding a half-filled wine glass. Shot at sunset as a silhouette, the shapes of their faces contrasts beautifully with the non-silhouetted image of the transparent wine glass.

7.71 Shapes along the horizon can be transformed into interesting and mysterious objects when silhouetted against a sunrise or sunset.

Use colored filters or enhanced saturation to make the sunset more brilliant, while retaining

the dramatically dark outline of the silhouette.

Sunset and sunrise photography practice

7.72 Although the sun was low in the moments just before sunset on this crisp fall day, I underexposed this photo to create a darker, more dramatic look

	Taking Sunset and Sunrise Pictures
Setup	Practice Picture: I spotted the scene in figure 7.72 while strolling around a lake one fall afternoon and liked the curve of the shore and

the trees along the horizon. I decided the composition would work better as a sunset silhouette, so that's how I shot it. On Your Own: As with other kinds of landscape photography, the

key to finding a good composition is to scout the area beforehand and then come back, if necessary, when lighting is ideal.

Practice Picture: I maneuvered to find a spot where the sun would set behind the silhouetted trees in an interesting way.

On Your Own: Sometimes taking a few steps to the left or right can dramatically change the relationship and lighting provided by the setting and rising sun and objects in the foreground.

Lighting

Lens	Practice Picture: I used an 18–70mm f/3.5–4.5G ED-IF AF-S DX		
	Zoom Nikkor at 30mm.		
	On Your Own: Wide-angle lenses are fine if you want to take in a large area of sky. A telephoto setting is a better choice to emphasize the sun and exclude more of the foreground.		
Camera Settings	Practice Picture: I used RAW capture and Shutter Priority AE.		
	On Your Own: Use a high shutter speed to minimize camera shake and a small f/stop to underexpose the foreground in a silhouette.		
Exposure	Practice Picture: ISO 200, f/16, 1/800 second.		
	On Your Own: Underexpose by one or two f-stops to create your silhouette effect.		
Accessories	A star filter can add an interesting effect to the sun, but a small f-stop tends to produce a starlike effect anyway.		

Sunset and sunrise photography tips

- Keep in mind that sunrises and sunsets aren't created equal. There are some subtle differences between sunrises and sunsets, which are accentuated depending on the time of year. For example, with a sunrise after a cold night,
- you might encounter a lot of fog that forms in the cool air above a warmer ground. In some parts of the country, sunsets can be plagued by smog or haze that clears up by morning.
- Experiment with filters. Try splitgradients, star filters, colors, diffraction gratings, and other add-ons for some interesting variations.

Travel Photography

Travel, whether foreign or domestic, provides a perfect opportunity to cut loose and experiment with your digital camera. You can capture new and exotic locales, interesting people, and historic buildings or monuments—all while having the time of your life.

Unless you're traveling on business and your business isn't photography, you'll have a lot of free time to photograph the places and events you're enjoying. And, while memories fade, your images will still be there to remind you of a special time.

7.73 This 1820s-era log cabin may or may not have been the birthplace of someone famous.

What to Take When You Travel

Experienced travelers pack light, taking only the minimal amount of clothing and other gear. Experienced photographers make certain that their short list of equipment and accessories includes everything they'll absolutely need for the trip. Some things you might forget include:

- ◆ A cleaning kit. Make sure you have a cleaning cloth and lens tissue for keeping your lens and camera spotless. You'll also want to have a blower brush for dusting off your sensor, and perhaps a few silica packets to absorb moisture. Be sure and use only your manufacturer's recommended procedures for cleaning your sensor!
- A roll-up plastic rain poncho. You'll want to keep you and your camera dry when unexpected weather strikes.
- ◆ Plenty of memory cards. You'll want enough to record an entire vacation, unless you also have a laptop or a portable hard drive/CD-burner with you to offload pictures from the flash memory. If you shoot a meager three rolls of film a day in your film-shooting period, you'll need at least a 512 MB card each day if you shoot RAW files, or 256 MB of memory space if you're shooting JPEG Fine.

Inspiration

In many ways, foreign-travel photography shares a lot of the attributes of the architecture, event, landscape, seascape, night, and street-life situations I already covered in this chapter. What makes it most exciting is the cultural differences you'll find. Clothing and jewelry can differ sharply; common items such as soda cans, candy bars, or electric outlets might be interestingly odd. Even plant and animal life might not be what you're accustomed to.

Be sensitive to cultural differences. Some cultures frown upon photographic images of other human beings, and women wear clothing designed to hide their appearance. In some of these countries, photographing people can be a serious offense.

Although you'll want any people you photograph to appear natural, it's still a good idea to ask their permission first. In poor countries, they might want a few coins in exchange. Emphasize that you want the picture to be natural, and that they should

7.74 Travel provides the opportunity to photograph truly historical artifacts and ruins.

return to what they were doing before. Don't forget to provide feedback, and indicate that you're glad they granted you the favor of their photograph. You might want to let them review the pictures you took on your camera's LCD.

Travel photography practice

7.75 This narrow alleyway evokes a medieval mood.

Table 7.23 Taking Travel Pictures

Setup

Practice Picture: I'm always fascinated by the narrow streets in European towns, but this one was even narrower than usual, so I decided to capture it on silicon, trying to exclude "anachronistic" features of modern life from the shot shown in figure 7.75.

On Your Own: Monuments and ancient structures have a timeless quality. If you can compose your photo so that modern buildings and artifacts are hidden, the scene can look much as it did 400 to 500 years ago. Hunting for unspoiled treasures can be an enjoyable pastime on its own, and recording your find in pixels is just the culmination of the hunt.

Table 7.23 (continued)

Lighting

Practice Picture: The early-afternoon sun was diffused in the alley itself, but illuminated the alleyway at the end. I used the murky light to add to the mysterious mood.

On Your Own: When traveling through an area, you'll rarely be able to wait for the lighting to change, so you'll have to make do with what you've got. In bright sunlight, go for vivid; at dusk, try to use the dramatic lighting; on overcast days, try for a moody look. In dark alleyways, use the diffuse light that is available.

Lens

Practice Picture: I used a 12–24mm f/4G ED-IF AF-S DX Zoom-Nikkor set to 18mm.

On Your Own: Wide-angle lenses work well with travel photos involving castles, cathedrals, and landscapes, providing you can get far enough back to avoid tilting the camera. If quarters are tight, crop your view and emphasize interesting details rather than the big picture.

Camera Settings

Practice Picture: I used RAW capture and Shutter Priority AE.

On Your Own: Shutter Priority AE mode lets you select a shutter speed to eliminate camera shake, and you can set the white balance to the type of light in the scene.

Exposure

Practice Picture: ISO 400, f/5.6, 1/125 second.

On Your Own: Consider bracketing a stop or two on either side of the exposure recommended by your camera, because a slightly darker or lighter version can look quite different.

Accessories

You might not want to carry a tripod on a trip (but consider doing so anyway), though even a monopod might be overkill unless you're shooting a lot of interior photos (say, inside cathedrals or museums). If neither a tripod or monopod appeal to you, consider taking along a beanbag you can use as a camera support just about anywhere you can find a solid surface.

Travel photography tips

- Capture the cultural environment. Look for things that are unusual back home, and shoot a lot of photos. Show people playing, relaxing, and working, because these behaviors might be different in foreign countries — or even in different parts of your own country.
- Move in close. You might be tempted to shoot the vistas, but close-up details provide a lot of

- interest and add intimacy to your portrayal of a strange land and its people. You'll find that even a person's hands can tell you a lot about that person and what he's done, whether it's repairing computers or watches or manual labor.
- Mix it up. Shoot both horizontal and vertical photos of people, buildings, and landscapes. You'll avoid getting locked into one mindset and having all your travel photos look exactly the same.

Waterfall Photography

Waterfalls are a type of outdoor or nature photography that fall into a category all their own. One reason for their popularity is that once a fledgling photographer becomes comfortable with his or her camera, the one trick that is most often attempted is the time-honored blurry-waterfall effect. It's a challenge to create a new look to what threatens to become a photographic cliché, using a time exposure to allow the cascading water to blend into a laminar flow while the surrounding trees, rocks, and other objects in the photo remain tack sharp.

7.76 A high angle captures this waterfall and its cascade as it flows behind an old flour mill.

7.77 A fast shutter speed freezes the droplets of this waterfall in mid-descent, offering a sparkling view.

One challenge facing the prospective waterfall photographer is finding a suitable subject. Truly impressive waterfalls aren't all that common, and many of them are inaccessible, or located far from the road (which helps preserve their natural beauty, but makes enjoying them somewhat of an adventure). It's also necessary to hope that the view hasn't been marred by the encroachment of humans; nothing is more alarming to a nature photographer than finding a wonderful woodsy scene marked with graffiti carved into the trees next to a waterfall cascading into a pool filled with soda cans.

But the challenges only make photographing these natural wonders all that much more rewarding.

Inspiration

Of course, there's a lot more to photographing waterfalls than blurry streams of water. You can photograph them from above, below, or even shoot from behind the sheet of falling water. Waterfalls can be captured in mid-summer, look gorgeous in the fall when surrounded by trees in changing colors, and make interesting subjects in winter (as long as the falls isn't completely frozen over).

You'll find opportunities in tiny waterfalls that trickle only a driblet of water, and interesting pictures in mammoth displays like Niagara Falls. Your goal is to find a new way of photographing a very popular subject.

Unusual angles are often the best approach. Lazy photographers park themselves in front of the falls and fire away, not realizing that clambering down the gully and taking a few shots from the side will yield a much more interesting picture. If you are able to get behind the falls without risk of getting your camera damp (sometimes a gallon-sized plastic zipper-lock bag with a hole for the lens is all the protection you need) you'll get some great pictures of the falls itself as well as the sunlight filtering through the water.

Waterfall photography practice

7.78 A long time exposure with three colored filters alternated in front of the lens gave this waterfall a multi-hued look.

Table 7.24 Taking Waterfall Pictures

Setup

Practice Picture: I wanted to enhance the customary blurred water effect with a spot of color, so I used a variation of technique first developed by Kodak whiz Bob Harris many decades ago in figure 7.78. I set up my D200 on a tripod, took a long time exposure, and passed a strip containing red, green, and blue filters in front of the lens during the exposure. The non-moving rocks, which received a regular red/green/blue exposure are colored normally, but the moving water has multi-colored highlights, depending on which filter was in front of the lens as the water moved.

On Your Own: If you search the Internet for the "Harris shutter," you'll find instructions for building a frame that holds the red/green/blue strip as it passes in front of the lens. But you can just move the strip manually if you move quickly and are careful not to jar the camera.

Lighting

Practice Picture: Direct sunlight provided the illumination for this shot.

On Your Own: If you're using a time exposure, cloudy days with diffuse lighting is even better, because the reduced illumination makes it easier to leave the shutter open for a longer period of time.

Lens

Practice Picture: I used a 18–70mm f/3.5–4.5G ED-IF AF-S DX Zoom Nikkor at 30mm. Mounted on the front of the lens were a pair of 8X neutral density filters, which reduced the available illumination by three stops each, or six stops total.

On Your Own: The lens you use will depend on how close you can get to the waterfall. In most cases, you'll be using a medium wide angle or wide angle zoom setting.

Camera Settings

Practice Picture: RAW format processed using Adobe Camera RAW to adjust white balance (tungsten), increase saturation, and boost both sharpness and contrast. Manual exposure mode.

On Your Own: If you're using heavy neutral density filters, it's likely that your D200's autofocus system won't work, and exposure metering will be inaccurate. Both manual focus and exposure are your best bet for this kind of photograph

Exposure

Practice Picture: ISO 100, f/22, 4 seconds.

On Your Own: Use your D200's lowest ISO sensitivity, your lens's smallest f/stop, and the longest exposure you can manage to blur the falling water.

Accessories

A tripod lets you lock down the camera and use long exposure without image blur. You can release the shutter using the D200's self-timer (set it to 2 seconds or 5 seconds to reduce your waiting time). A Nikon MC-30 wired remote control for the D200's 10-pin socket is faster for releasing the shutter without jiggling the tripod. A wireless remote control, the Nikon ML-3, is also available, but costs about three times as much as the MC-30 (more than \$150.00).

Waterfall photography tips

- ★ Time after time. If a particular waterfall is located near your home base, consider visiting at all four seasons of the year to show how one of these natural wonders change with the weather. After you've taken the first in a planned series of photographs, remove your D200 from the tripod and photograph the tripod itself so you can reproduce the positioning of your tripod the next time you visit.
- Freezing time. So many photographers are trying to reproduce a blurry waterfall effect that using a high shutter speed can give you an unusual picture without much effort on your part. Visit a falls after a dry spell when the water is dribbling, rather than gushing over, to

- improve your chances of freezing individual droplets.
- Waterfalls make great backdrops. Get some people in a few of the shots. Waterfalls make good backgrounds for environmental portraits. Shoot from an angle so the falls and surrounding rocks add interest to your portrait.
- Add some wildlife. The large pools that form at the base of some waterfalls can attract wildlife, such as deer, looking for liquid refreshment. Help yourself along by placing a block of salt near the edge of the pool, then hiding out of sight. (Photographers who are also hunters who have used blinds have an advantage here.) If you're patient, you may be able to capture a woodland creature as an accent to your waterfall image.

Downloading and Editing Images

our work isn't finished after you've pressed the shutter release. Each photo you take must be downloaded to your computer, organized for display or printing, and, if you want to crop, tweak, or manipulate your image in some way, process the picture in an image editing program. You perform most of those functions using the software included with your D200, but if you want to go beyond the basics, other applications and utilities exist that you'll find useful. In this chapter, I explain some of the things you may want to do, and the software available to do them. Because this is a *field guide*, I won't go into extensive detail on how to use any of these programs. After all, unless you take a laptop with you out into the field, you probably won't be using one of these applications until you're back at your home or office, safely nestled in front of your computer.

Nikon's Offerings

Nikon includes two software programs on CDs, packed right in the box, with the D200. They are the full version of Nikon PictureProject and Nikon Capture, which is offered as a try-out version. PictureProject is a simple application for downloading, viewing, and organizing your photos, and includes some features for cropping and making minor retouching modifications. You can also print photos from within PictureProject, burn them onto a CD or DVD, or send pictures by e-mail.

Nikon Capture is a more extensive program that gives you greater control over your images (especially RAW files), and includes some nifty features, such as the capability to control your camera remotely using the USB cable.

In This Chapter

Nikon PictureProject

Nikon Capture

Other software options

While Nikon View is still available for download, PictureProject and Capture are the programs of choice.

Nikon PictureProject

If you're new to digital cameras and/or image editing, PictureProject gives you a quick way to perform many of the basic functions involved in importing, touching up, and organizing your photos. Because the D200 is not an entry-level camera, I expect that those of you who are new owners of this camera won't be satisfied with the PictureProject features. You'll probably be happier if you use Nikon Capture in conjunction with a full-fledged image editor. either an application such as Adobe Photoshop Elements or a mega-featured program like Photoshop. The following section, which outlines PictureProject's basic features, is intended for those brave souls who have jumped into the dSLR realm directly via the D200; for those who want a simple program to make simple adjustments: and for those who make it their business to understand all the options available for their camera, even if they do not intend to use them.

If you want to learn even more about PictureProject, you'll find a manual on the CD furnished with the camera.

Transferring pictures

Once you install PictureProject, you can specify it as the default photo import facility, or continue to use another importer. For example, Adobe Photoshop Elements and Microsoft Windows XP also include pop-up utilities that recognize when a digital camera is connected to the computer through a USB

cable, or when a memory card is inserted in a card reader attached to the computer. Even if you use one of these other options most of the time, you can still transfer images using PictureProject by clicking Transfer on the PictureProject Tools menu, or by clicking the Transfer button at the left end of the toolbar. (A Macintosh running OS X will also detect your camera and card, and offer to download the photos using iPhoto.)

In either case, the transfer wizard appears when a connected camera or card reader has new photos available. The PictureProject Transfer dialog box includes several options.

If you've clicked the Show Thumbnails button, a series of miniature views of each picture is displayed at the bottom of the dialog box. To select the photos to be transferred, you can do the following:

- Click an individual photo.
- Ctrl/%+click additional photos to add them to the selection.
- Click the first in a contiguous series of photos, then hold down the Shift key and click the last in the series to select all the photos between them.
- Ctrl/%+click a selected photo to remove it from the selection.
- Click the Select All button to choose all the thumbnails.
- Click the Select All or Select
 Protected buttons to choose all the pictures that have been marked or protected in the camera.
- Click the Deselect button to unselect all the thumbnails.

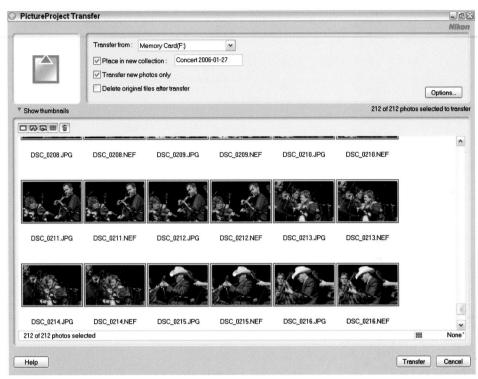

8.1 The PictureProject Transfer dialog box

You can also choose to import the transferred photos into your current PictureProject collection, delete the files from your memory card once they've been transferred, and upload the files to the NikonNet online display service after they've been transferred.

To transfer the selected photos, click the Transfer button.

Transfer options

If you prefer to use a different transfer popup, you can disable PictureProject Transfer by choosing Tools \circlearrowleft Options to open the PictureProject Options dialog box. Uncheck the AutoLaunch button on the General tab to disable automatic transfer.

Click the Options button in the PictureProject Transfer dialog box to access these three tabs of options in the Transfer Options dialog box:

• General. Here you find options for synchronizing your camera to the computer's clock (only when the camera is connected via the USB cable); copying hidden files; including the color profile information in the file; adding a preview to RAW Nikon Electronic File (NEF) images; and rotating images shot in vertical orientation (if you've selected that option in the camera).

218 Part II → Creating Great Photos with the Nikon D200

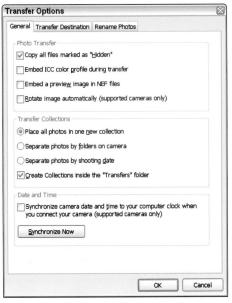

8.2 The General parameters tab

- Transfer Destination. Here you specify the folders used to store the transferred pictures on your computer. You can tell PictureProject Transfer to create a new folder each time photos are transferred, which can make it simpler to organize the fruits of your various shooting sessions.
- Rename Photos. Here you tell PictureProject Transfer whether to use the file name the camera created, or to rename each photo using a name you specify.

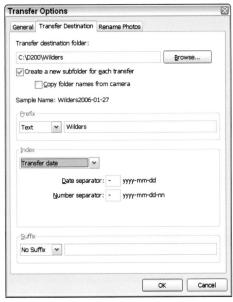

8.3 Specify the file destination

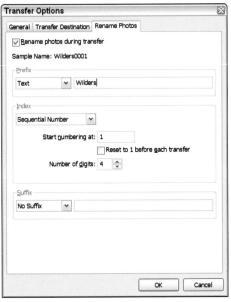

8.4 Specify the file name

Organizing and viewing pictures

PictureProject lets you examine individual images, organize them into collections, or view a series of photos in a slide show:

- Picture collections. The left side of the PictureProject window shows a list of picture collections. Just click on a collection name to view all the images in that collection in a scrolling thumbnail panel in the center of the PictureProject window.
- Thumbnail area. A zoom slider lets you change the size of the thumbnails, and you can choose whether to view thumbnails only, or view a larger preview of a

- selected image below the thumbnails in addition.
- ♣ Information area. At the right side of the screen are panels that show more information about a selected photo, and a search box for finding specific images using the file name, a keyword you've previously entered, or the date when the image was taken. Click the Information bar to see additional data about a selected image.
- Slide Show button. Select a collection or folder of images and click the Slide Show button in the PictureProject toolbar to view a series of images one after another.

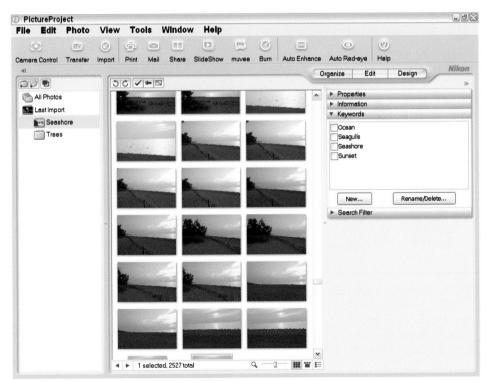

8.5 Organize your photos into collections.

Import button. Although PictureProject automatically loads the pictures it transfers into collections, you can also add photos already residing on your hard drive by clicking the Import button in the top tool bar.

Retouching pictures

PictureProject has some limited picture retouching features that you might find handy if you're in a hurry, or aren't inclined to become heavily involved in image editing. For more serious editing, you'll probably be happier with programs such as Adobe Photoshop Elements, Photoshop (for both Mac and Windows), or PaintShop Pro (Windows only). PictureProject locates your other editing programs when it is installed, and places links to them in the File Menu under Edit Using Other Programs.

To edit in PictureProject, double-click any photo in a collection, or select a photo and click the Edit button. You can choose from the following functions:

Auto Enhance button.

PictureProject makes its best effort to automatically fix the brightness, color saturation, and sharpening for the image.

- Auto Red-Eye button.
 Automatically removes demon red eyes from pictures of humans.
- Photo Enhance section. Mark the Brightness, D-Lighting HS (shadow brightener), Color Booster (saturation), Photo Effects, Sharpening, or Straighten boxes, then use the slider and/or options offered for each to make the adjustments manually.

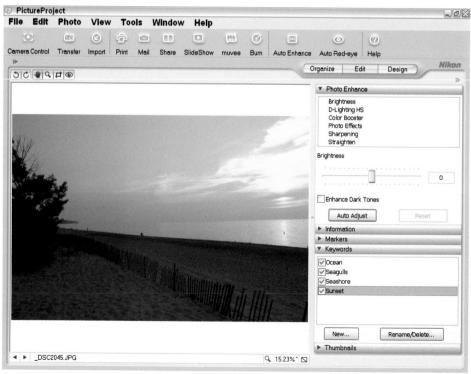

8.6 PictureProject offers basic editing features.

Tool buttons. These are immediately above the editing preview window. They allow you to rotate the image, move it around, zoom in or out, crop, or remove red eye manually.

Sharing pictures

PictureProject also includes functions you can use to share your photos through PictureProject InTouch. You'll need to create an account with NikonNet, but it's free and you can set it up the first time you use PictureProject InTouch. To use the feature, click the Share button in the toolbar and wait for the program to launch. PictureProject InTouch enables you to do the following:

 Print one photo, or a selection of them, from a collection.

- Send one or more photos by e-mail using Outlook, Outlook Express, Eudora (Windows); or Entourage X, Mail, or Eudora (Macintosh).
- Arrange photos into a layout to print or e-mail.
- Upload pictures to NikonNet so friends, family, and colleagues can view them. Membership is free, and you get 50MB of free online storage space. You'll be able to add titles, keywords, basic information about the images you've uploaded, and choose the JPEG compression level (to find a balance between quality and download times to your liking).
- Copy pictures to a PDA that supports photo display.

8.7 You can use PictureProject InTouch to share your best images.

Nikon Capture

Although Nikon Capture is a not an essential tool for owners of Nikon's entry-level dSLRs, it is a considerably more sophisticated application than Picture Project. Anyone who owns a D200 or one of Nikon's professional cameras should bite the bullet and pay the \$99 fee, because the extra features that Capture provides, not found in PictureProject, are well worth the price.

You might wonder why you should pay for it. After all, you can perform two of Capture's three main functions - image transfer/conversion and image editing - with equal facility using other programs. PictureProject transfers, Photoshop and Bibble Pro do RAW conversions, and Photoshop edits. However, Capture communicates directly with the D200 in advanced ways. For example, you can control the camera for automatic timelapse photography or upload custom tonal compensation curves from your computer to the camera. Best of all, Capture, like some other programs such as Bibble or Adobe Bridge, can operate on batches of files, so you can apply many types of changes to groups of pictures automatically. That's especially handy when you need to convert an entire group of NEF files to TIFF format, for example.

Although I hate buying anything I can get for free, in many ways I'm glad Nikon charges a fee for Capture for the following reasons:

Nikon is a digital camera company, not a software developer. Levying a tariff keeps the company on its toes and ensures that Capture will have the kinds of features that make it worth the price. The hope is that Nikon's profits on Capture will fund further development of new and enhanced features. I've only had to purchase Nikon Capture once, with my first Nikon digital SLR. When I purchased additional Nikon cameras, I could continue using Capture at no additional cost. Would you really want Nikon to bury its development costs for this application in each and every camera they sell? The company might have to increase the price of the camera only \$25 or so, but you'd end up paying for it, over and over, whether you needed the program or not.

The following sections offer an overview of Nikon Capture's key features.

Transfer/RAW conversion

Nikon Capture can import RAW/NEF images and save them in a standard format such as TIFF, either using the original settings from the camera file or fine-tuned settings for things such as sharpening, tonal compensation, color mode, color saturation, white balance, or noise reduction. One advantage Capture has over Adobe Camera RAW or Corel RAW Essentials is that it tends to be ahead of the curve in supporting new features in Nikon image file formats. When I purchased my D200, Capture supported the camera's RAW format on Day One. I had to wait more than a month for Adobe to catch up.

Capture has a useful "image dust off" feature for subtracting dust spots caused by artifacts that settle on the sensor. Just take a dust reference photo (it's in the Set Up Menu under Dust Off Ref Photo)—a blank exposure that Capture uses for reference—and the application subtracts the dust in the exact same location in subsequent images you import.

Image editing

Once you get past the fine-tuning controls for things such as White Balance, Noise Reduction, tonal controls, and so forth (all available when converting and manipulating RAW files), Nikon Capture isn't much more sophisticated than PictureProject in its pixel-pushing capabilities. You can rotate, crop, zoom, and give an automatic brightness or color saturation adjustment to photos. The biggest improvement is the LCH Editor, which, as the acronym implies, gives you access to correction curves for lightness, chroma, and hue components of an image. It also lets you transfer a selected image to another program, such as Photoshop.

Where this editor really shines, however, is in its facilities for "correcting" certain lens defects, such as vignetting and fish-eye distortion. For example, some lenses are known to produce images that are darker in the corners; Nikon Capture can correct for this tendency, or add darkness or lightness if you want them as a special effect.

Nikkor 10.5mm fish-eye lens owners absolutely love Nikon Capture's capability for "defishing" these images, creating a rectangular, rectilinear photo from the original round fish-eye rendition.

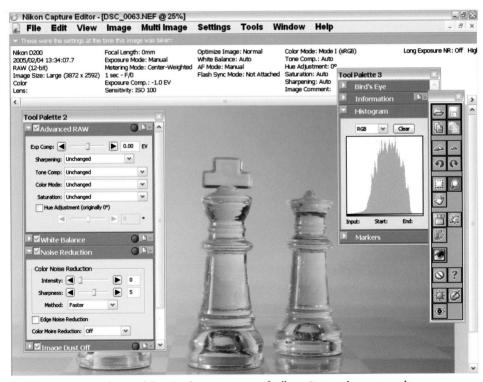

8.8 Image conversion and fine-tuning are some of Nikon Capture's strong suits.

Camera communications

Nikon Capture's Camera Control Module lets you communicate with your D200 in powerful ways. For example, you can control the camera remotely when it's connected to your computer using a USB cable. Perhaps you've set up a hummingbird feeder outside your home office window and want to mount your D200 on a tripod near the feeder and trip the shutter from your computer as you keep one eye on the feeder as you work. You can't preview the image before you take it, of course (no digital SLR enables you to do that), but you can control virtually every camera feature right from your workstation. (Notice the viewfinder LED readout at the bottom of figure 8.9.)

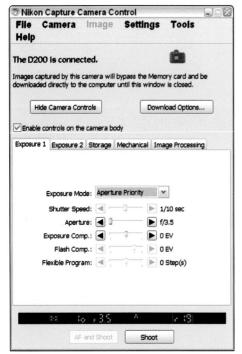

8.9 Control your camera from your computer!

The Nikon Capture Camera Control dialog box (use Tools ⇔ Show Nikon Capture Camera Control) has the following tabs:

- ♠ Exposure 1 tab. Figure 8.9 shows this tab, which lets you choose the exposure mode (Aperture Priority, Shutter Priority, or Manual), and then adjust the aperture itself (with lenses that set the f-stop electronically) or shutter speed (in Shutter Priority or Manual mode), plus add any exposure compensation (EV) adjustments you want.
- ♠ Exposure 2 tab. Lets you shift around the focus zone, and even includes a thumbnail of the focus zones as they appear in your viewfinder. You can also choose Metering Mode, Flash Synch Mode, change ISO settings or White Balance (including making fineadjustments to white balance), and add a custom comment to the image file.

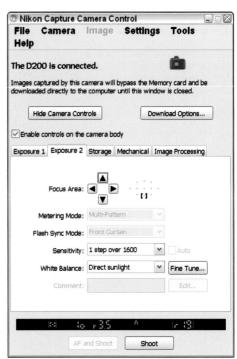

8.10 Select the Focus Area, White Balance, or ISO settings here.

Storage tab. Gives you access to the file format, JPEG compression level, and resolution settings of the camera, so you can choose RAW, RAW+FINE, and so forth, plus specify whether JPEG compression should optimize for image quality or storage efficiency.

	mera C	Setting	10	Tools
<u>F</u> ile <u>C</u> amera <u>H</u> elp	iiiage	Aarrini	,•	79019
he D200 is connecte	ed.			â
mages captured by this ca ownloaded directly to the				
Hide Camera Contr	ols	D	ownlo	ad Options
Enable controls on the o	tamera bo	ody		
Exposure 1 Exposure 2	Storage	Mechanical	Imag	e Processina
Data Form	at: RAW	/ (12-bit) + JP	EG (8-	bit) 🗸
Data Form JPEG qual			EG (8-	bit) Y
	ity: Fine		EG (8-	
JPEG qual	ity: Fine			~
JPEG qual	ity: Fine on: Optionize: Larg	mal quality)	[v]
JPEG qual	ity: Fine on: Optionize: Larg	mal quality e (3872x2592)	[v]
JPEG qual	ity: Fine on: Optionize: Larg	mal quality e (3872x2592)	[v]
JPEG qual	ity: Fine on: Optio	mal quality e (3872x2592)	[v]
JPEG qual JPEG compression Image Si	ity: Fine on: Optio	mal quality je (3872x2592 aw compressi) on	<u>*</u>

8.11 Choose file format and JPEG options here.

Mechanical tab. Enables you to access single and continuous shooting modes, set up bracketing options, choose the focus mode (AF-C, AF-S, or Manual), and even get a glimpse of the current battery level.

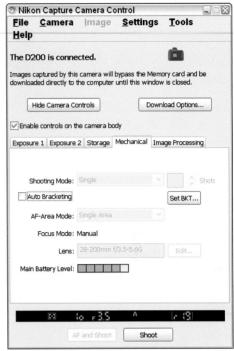

8.12 Fiddle with the mechanical controls of your camera, including focus options, here.

♣ Image Processing tab. You can edit the amount of fine-tuning your camera performs on the images you shoot in the Image Processing tab. Choose Vivid or one of the other custom looks the D200 offers, and change sharpening, tonal compensation, color mode, saturation, hue, or even the color space used.

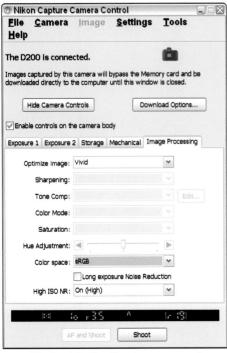

8.13 Manipulate the fine-tune processing your camera performs.

Once you've set everything the way you want, you can take a photo by clicking the Shoot button. Of course, there is no way to preview the image in Capture Controls prior to taking the picture (the sensor receives no image until the mirror flips up and the shutter opens), but your shot is immediately displayed for your review.

The Camera Control Module also lets you change settings, including those that are clumsy to enter using the camera controls alone, such as the image comment appended to every photo. You can also upload custom exposure curves to change the tonal rendition the camera uses (in the Shooting menu, click Optimize Image Custom choice).

Perhaps the most interesting capability is the Time Lapse facility (choose Camera □ Time Lapse Photography), which enables you to take a series of pictures at intervals that range from seconds to days. Replace that hummingbird feeder with a flower bud just about to blossom, and you can capture every fleeting moment. Choose from two to 9,999 shots (luckily, each photo is stored directly to your hard drive, and not to the

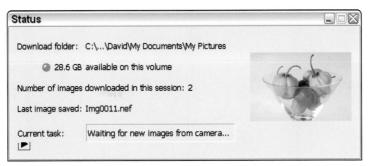

8.14 A thumbnail of the most recent image appears with a status report after you click the Shoot button.

Nikon Capture NX

Nikon Capture NX, announced in February, 2006 but with availability delayed past the middle of the year, is an enhanced version of Nikon Capture. Incorporating technologies from Nikon partner Nik Software, it features a host of new capabilities, including selection tools and advanced layering features. Brush, Lasso, and four kinds of Marquee selection tools allow isolating individual elements of an image. In Capture NX, parts of images can be adjusted through "control points" so that color, dynamic range, and other parameters can be modified only in selected areas.

Capture NX has improved tools for correcting aberrations such as barrel distortion, vignetting, and fisheye distortions found in Nikkor lenses. A new Edit List provides better control over image processing workflow by listing each manipulation as it is applied, and allowing individual steps to be undone in any order. There's even a new Capture NX Browser that facilitates labeling and sorting images, and applying settings to batches of photos.

camera's memory card), and a delay from one second to 99 hours, 59 minutes, and 59 seconds between shots. You can even bracket exposure or white balance between pictures. If you're shooting a very long time-lapse sequence, it's a good idea to use the D200's optional AC power supply; direct connection through the USB cable uses more juice than untethered shooting anyway, so your battery may poop out before you finish your sequence.

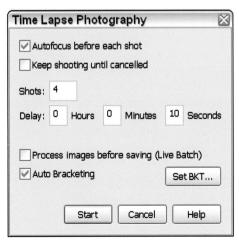

8.15. Shoot time-lapse sequences using your D200.

Other Software Options

Image editors and RAW file utilities are available from a wide range of suppliers and can cost you nothing (in the case of IrfanView) or be included in the cost of other software (which is the case with Photoshop). Alternatively, you can pay \$129 for a sophisticated utility such as Bibble Professional, or as much as \$500 for a top-of-the-line program such as Phase One's Capture One Pro (C1 Pro).

Software to consider includes:

◆ IrfanView. You can download this freeware Windows-only program at www.infanview.com. It can read many common RAW photo formats, including Nikon's, and give you a quick way to view RAW files, just by dragging and dropping to the application's window. You can crop, rotate, or correct your image, and do cool things such as swapping the colors around (red for blue, blue for green, and so forth) to create false color pictures.

- Phase One Capture One Pro (C1 Pro). This premium-priced RAW converter program does everything. but reduced-function versions, Capture One dSLR, and Capture One dSLR SE, exist for those of you who don't need such a flexible application. Available for both Windows and Mac OS X, C1 Pro offers special noise reduction controls, a quick develop option that provides speedy conversion from RAW to TIFF or JPEG formats, dualimage side-by-side views for comparison purposes, and helpful grids and guides that can be superimposed over an image. Learn more at www.phaseone.com.
- ➡ Bibble Pro. This utility offers instantaneous previews and realtime feedback as changes occur. That's important when you have to convert many images in a short time using Bibble's batch processing capabilities to process large numbers of files using custom settings with no user intervention. You can even create a Web gallery from within Bibble. Learn more at www.bibblelabs.com.
- Photoshop CS/Photoshop Elements. Photoshop CS is the serious photographer's number one choice for image editing, and Elements is an excellent option for those who need most of Photoshop's power, but not all of its professional-level features. Both

- use the latest version of Adobe's Camera RAW plug-in, which makes it easy to adjust things such as color space profiles, color depth (either 8 bits or 16 bits per color channel), image resolution, white balance, exposure, shadows, brightness, sharpness, luminance, and noise reduction. Learn more at www.adobe.com.
- Corel PhotoPaint. This imageediting program is included in the popular CorelDRAW Graphics suite. Various versions of the program are available for both PCs and the Mac. It's a full-featured photo retouching and image-editing program that includes selection, retouching, and painting tools for manual image manipulations as well as convenient automated commands for a few common tasks, such as red-eye removal. PhotoPaint accepts Photoshop plug-ins to expand its assortment of filters and special effects. Learn more at www.corel.com.
- ◆ Corel Paint Shop Pro. This is a general-purpose image editor that has gained a reputation as the "poor man's Photoshop" because it provides a substantial portion of Photoshop's capabilities at a fraction of the cost. It includes a nifty set of wizard-like commands that automate common tasks, such as removing red eye and scratches, as well as filters and effects that can be expanded with other Photoshop plug-ins. Learn more at
- Macromedia Fireworks. This image-editing program (formerly from Macromedia, and now owned by Adobe) specializes in Web development and animation

software like Dreamweaver and Flash. If you're using your D200—images on Web pages, you'll like this program's capabilities in the Web graphics arena, such as banners, image maps, and rollover buttons. Learn more at www.adobe.com/products/.

- Corel Painter. Another image editing program from Corel, Corel Painter's strength is in mimicking natural media, such as charcoal, pastels, and various kinds of paint. Painter includes a basic assortment of tools that you can use to edit existing images, but the program is really designed for artists to use when they create original illustrations. As a photographer, you might prefer another image editor, but if you like to paint on top of your photographic images, nothing else really does the job of Painter. Learn more at www.corel.com.
- Ulead PhotoImpact. This generalpurpose photo editing program provides a huge assortment of brushes for painting, retouching, and cloning in addition to the usual selection of cropping and fill tools. If you find you frequently perform the same

- image manipulations on a number of files, you'll appreciate PhotoImpact's batch operations. Using this feature, you can select multiple image files and then apply any one of a long list of filters, enhancements, or auto-process commands to all the selected files. Learn more at www.ulead.com.
- PictureCode Noise Ninja. This program is among the best of a group of utilities that can process your Nikon D200's images to reduce the noise that results from shooting at high ISO ratings and long exposures. It uses a sophisticated approach that can identify and recognize noise that presents itself at different frequencies, in various parts of your image, and in varying color channels. Unlike the D200's built-in noise reduction feature, Noise Ninja gives you control over how its algorithms are applied, using easy-to-operate sliders with real-time previews for feedback. There's also a "noise brush" you can apply to selectively modify the noise in those parts of the image where it's particularly troublesome. Learn more at www.picturecode.com.

Appendixes

P A R T

In This Part

Appendix ATroubleshooting

Glossary

Troubleshooting

on't panic. If your D200 is not performing exactly as you expect it should, is doing something weird, or, worst of all, seems to have given up the ghost entirely, a quick fix might be at hand. If one isn't, and you do have to send your camera in for servicing, Nikon is ordinarily very speedy when it comes to fixing a camera and returning it to its rightful owner. However, the tips and suggestions I cover in this appendix might help you avoid this step or calling tech support, altogether.

Poor Battery Life

When the D200 first came out, many of the early adopters complained about poor battery life, with some reporting that they could take only a few hundred pictures before their power pooped out. So, the first thing I did when my D200 arrived was to test out the battery. I found I could easily get more than 1,000 shots per charge (even if I took as many as 300 flash photos), and once, when I carefully turned off all the power-hungry features (such as LCD picture review and vibration reduction) I got more than 2,000 full-resolution pictures in a single session. So, what's the complaint about then? There are several factors at work.

- ▶ RAW drainage. The D200 seems to use a lot more power when saving files in RAW mode. For my 2,000-picture burst, I used JPEG Fine for every exposure. When using RAW during other tests, I often got fewer exposures per charge. If you want to shoot RAW exclusively (and who doesn't?), plan on having an extra battery or two for times where you expect to shoot in the neighborhood of 1,000 pictures or more.
- Excessive LCD use. Early users of the D200 were trying out all the features and doing a lot of picture review. The LCD alone uses up quite a bit of power, and if you're exploring all the menus, experimenting with autofocus, and putting the camera through its

paces, you'll find that the battery doesn't last very long. Once you've familiarized yourself with the D200's operation and settle in to reviewing photos only briefly after every few shots, you'll get much better battery life.

- Unseasoned battery. A new battery takes several charge/discharge cycles to achieve its optimum capacity. However, the difference really shouldn't be more than 10 to 20 percent once the battery has been seasoned. You can't expect it to suddenly last twice as long after you've recharged it a few times.
- The built-in flash uses a lot of power. The D200's built-in flash is quite powerful, and it includes an optional modeling light feature that really sucks up the current. Indeed, when I tested the modeling light I found I couldn't shoot more than 10-12 pictures before the flash overheated and became (thanks to the D200's infinitely wise designers) temporarily unavailable. If you want to optimize the life of the D200's internal battery, minimize vour flash use, or switch to an external flash such as the SB-600 or SB-800. A quartet of rechargeable 2400mAh AA batteries can power your flash a lot longer than the D200's internal cell.
- Add-on battery. Consider the MB-D200 grip/battery pack if you really need long battery life and don't want to carry a few extras in your pocket. This vertical grip has a space for a second EN-EL3e battery and helps provide proportionately longer battery life.

Remember, you can recharge the D200's battery at any time, even after just a few shots, with no danger of the battery building a memory, as some types of rechargeable batteries can do, and losing capacity. So, go ahead and recharge just before heading out for a new shooting session.

Flash Problems

The flip-up flash is reliable, but it has some features that you might not be used to. Most flash problems are actually caused by incorrect settings. Here are a few symptoms, diagnoses, and cures:

- Flash stops working after a few shots. You may have switched the modeling light mode on (CSM e4) and forgotten, mistaking that extra long flash for a red-eye preflash. The flash overheats and disables itself until it cools down. Unless you need the modeling lamp feature, turn it off.
- ◆ Flash exposure is always wrong. Check out whether you might have accidentally switched to Manual (CSM e3) and reduced the power output inadvertently. It is also possible that you have set flash compensation and forgotten. For automatic exposure, use the TTL mode.
- Flash casts a shadow. The flip-up flash isn't really high enough to prevent casting a shadow of the lens hood, or even the lens itself, in your subject area when you use 18–200mm, 18–70mm, 18–55mm, 17–55mm, or similar zooms at their widest settings. You can try removing the lens hood or zooming in slightly.

AA.1 A dark shadow at the bottom of the frame appears because a wide angle lens's hood blocked the flash.

Settings Vanish

It's possible you've changed to a different shooting bank (see the Shooting menu) and the settings in the bank you're using aren't what you expected. Removing the battery for recharging or leaving it out of the camera for long periods won't cause you to lose settings because the clock battery powers the memory that retains the settings. It's possible that your clock battery is dead, which causes your D200 to lose your custom settings. Usually, the flashing Clock icon on the status LCD will alert you, but it's possible you've overlooked the warning.

Bad Memory Card

Your D200 suddenly suggests that you format your memory card, even though it's full of pictures (or so you think). I once had this happen to me while shooting a concert. The FOR (format) warning popped up, and it wasn't blinking. I'd only shot a few pictures on that card, so I went ahead and reformatted it. Although the format was apparently successful, the FOR warning didn't go away. I swapped out cards and continued shooting.

My other Nikon dSLRs were unable to successfully reformat this card, too. I had to insert it in a card reader, do a format from Windows, then re-insert it in my D200 and format it again to restore the card to life.

Sometimes bad things happen to good memory cards. If you format the card in your computer, sometimes your camera fails to recognize it. Occasionally, I've found that a memory card I've used in one camera fails when I use it in a different camera (until I reformat it in Windows, and then again in the camera). Every once in awhile, a card goes completely bad and can't be salvaged.

If this happens to you and the photos are important, you might be able to retrieve them using a picture recovery utility. If not, you might be forced to reformat the card or, in the worst case, discard it (literally). The media you use with your D200—even the relatively fragile mini-hard disk drives—are quite reliable, so it is unlikely you will run into this problem.

Banding

Some early models of the D200 displayed a problem called banding, much to the consternation of those who'd eagerly awaited this camera. *Banding*, an electrical problem with the sensor, occurs under certain conditions, and appears as alternating bands of dark and light pixels, especially at the boundaries of very dark (underexposed) and very light (overexposed) areas at certain ISO settings. (ISO 400 seems to be particularly bad.) If you shoot, say, a bright, isolated light source, such as a streetlamp at night at ISO 400, you can probably detect banding if your camera is susceptible to it.

This problem is not limited to the Nikon D200; many other dSLRs exhibit the phenomenon

under appropriate conditions. Some D200 cameras are more susceptible than others, and Nikon has been prompt in fixing the problem (reportedly by recalibrating how the sensor responds under such conditions), when annoyed owners send their cameras in. Only a small, but vocal, number of D200 owners actually noticed this malady (I've never been able to reproduce it in either of the two D200's I've used), but I've seen enough sample photos from others to know it exists.

If your camera suffers from banding and it bothers you, have Nikon fix it.

Too Much Noise

Although the D200 does a much better job of controlling noise than many other dSLRs, both inside and outside the Nikon lineup, you may find that your pictures are filled with those multicolored speckles called noise. Remember that using your camera's noise reduction features can slow down your shooting speed (while each image is processed to remove noise) and can cost you some sharpness as a bit of image detail is removed along with the noise. Here are some steps to take:

Turn custom setting CSM b1 off. When this setting is turned on, your D200 will adjust the ISO for you automatically, and, if necessary, increase the ISO setting to provide the proper exposure. You might decide that the noise you get at ISO 800 is the most you can tolerate, but the camera goes ahead and moves it up to ISO 1600 anyway. If you fail to notice this change, you can end up with more noise than you want. It's usually a better idea to turn CMS b1 off, and change ISO yourself only when you really want to.

- Adjust custom setting CSM b1 to limit the boost. If you decide you do want your D200 to adjust ISO sensitivity for you, it's possible to limit the increase to an upper limit you specify. Within the CSM b1 menu, adjust the Max. Sensitivity setting to a lower ISO, such as ISO 800 or ISO 400. Then, when it's changing the ISO, the D200 will not exceed your upper-limit value.
- Turn Long Exposure Noise Reduction on. You'll find this option in the Shooting menu. When the option is activated, the D200 applies noise reduction for photos taken at shutter speeds of about 8 seconds or longer.
- Turn High ISO Noise Reduction on. This option is also in the Shooting menu. Even when it's turned off, the D200 applies minimum noise reduction to images taken at ISO 800 or above. When this feature is turned on, you have your choice of Normal noise reduction (applied to images when ISO settings of ISO 400 or higher are used), Low noise reduction (a diminished amount of noise reduction is applied), or High noise reduction (a maximum amount of noise reduction is applied).
- ◆ Use Noise Reduction for RAW files available in Nikon Capture, Adobe Camera RAW, Photoshop, and other software applications, such as Noise Ninja. You can also remove noise reduction while your image is being converted for editing in your imaging program. Photoshop also has a less-effective noise reduction feature you can apply to JPEG images or to RAW images after conversion.

AA.2 Your noise problems won't be this bad (left version), but your D200 or your image editor can reduce the multicolored speckles significantly (right).

Camera Won't Function

If your camera goes completely dead or won't allow you to take photos, it can be really annoying! However, there are several possible causes:

No CompactFlash card. If you've set CSM f7 to Lock, the shutter will be locked when a memory card isn't inserted. You'll get a helpful -E- error message on the status LCD. Change CSM f7 to Enable Release only if you want to use the D200 in play mode, perhaps to enable friends to see how it feels to shoot photos without actually storing any of them. Most of the time, you'll want to lock the shutter when the card is absent, because there is nothing worse than shooting a once-in-a-lifetime image that's lost forever because you didn't have a CompactFlash card inserted.

- No battery. Perhaps you took the battery out for charging and forgot to re-insert it. One tip-off that the battery is missing is that the viewfinder will look very dim. D'oh!
- Battery fell out. This seems to be a quirk of the D200. On several occasions I have managed to accidentally press the battery compartment latch while shooting, causing the battery door to open. Nikon appears to be aware of this possibility, because there is a catch that stops the battery from sliding all the way out and falling onto the ground. If your camera locks up and the viewfinder goes dim while you're shooting, check the battery compartment door - it might have fallen open. If you're careful to double-check the latch when inserting a battery after recharging it (listen for a positive click as it engages), you won't have to worry about this problem.
- Focus difficulty. If you've set the D200 for Single Autofocus (AF-S) and the camera is unable to zero in on perfect focus (moving subiects or subjects with plain, featureless, no-contrast backgrounds, like the sky cause this), it will refuse to shoot a picture. Switch from AF-S (often called focus priority) to AF-C (referred to as Shutter Priority focus) to allow the D200 to shoot a picture even if precise focus isn't achieved. You should keep in mind, however, that the D200 allows you to specify whether AF-S or AF-C actually function in focus priority or release priority modes, using CSM a1 and a2.
- Lens not mounted correctly.
 Sometimes lenses can appear to be seated correctly when they are

not. This happens most often with lenses having an aperture ring (non-G series lenses) and the ring is not locked at the maximum aperture. You'll get an f E E error message. Try removing the lens and remounting it.

Spots on Photos

An alert D200 user might notice spots on some images. These can come from several sources, and you can usually remove them in your favorite image editor with a clone brush or other spotting tool. Some spots are intermittent, and sometimes result from the superb sharpness of your D200 camera and its lenses. I've enlarged odd-looking spots at times to discover that they were actually just birds in flight, captured by the sensor.

Hot/Dead pixels

If the spots appear in the same position in a series of photos at a variety of f-stops, the problem is likely a dead/live pixel (sometimes called a *stuck* pixel, because it is stuck in the off or on mode) in your sensor. If the problem is a pixel that's permanently switched on (hot) or off (dead), you'll see a black or a white pixel in your image, surrounded by a halo of other pixels. These pixels aren't defective themselves but the result of your camera's interpolation/demo-

AA.3 A pixel that is permanently live looks like this when highly magnified.

saicing algorithm, which applies information from each pixel to the surrounding photosites to assign each pixel to its red, green, or blue value in the final RGB image.

Dead/live pixels can be corrected by a process called pixel mapping, which programs the D200 to ignore the defective pixels. Unfortunately, you'll have to send your camera back to Nikon for this remedy.

Dust on the sensor

If the artifact disappears when you're using larger f/stops, and reappears when you stop down, you're looking at dust on the sensor. You can fix this using one of the following methods, which you should try in the order listed. In all cases, the first step is to remove the lens and lock up the mirror out of the way, exposing the sensor to your ministrations. You'll find Mirror Lock-up in the Set Up menu. When it's activated, just press the shutter release to raise the mirror and open the shutter. Turn the D200 off to reverse the process.

Always clean your sensor with a fully charged battery to avoid having the shutter close unexpectedly.

AA.4 Sensor dust spots frequently show up first in areas of solid color, such as the sky, and might be out of focus at intermediate f/stops.

 Blow it off. Use a bulb blower, such as an ear or a nasal aspirator, or a tool designed for the job, such as a Giotto Rocket. Don't touch the sensor with the blower, but, instead, direct a few gusts at the sensor surface, with the lens mount pointed downwards so the dust can fall out of the mirror chamber.

Do not use canned air, which can coat your sensor with an unhealthy layer of propellant.

Brush it off. If blowing off the sensor doesn't work, use one of the special brushes designed for swiping sensors, available from a variety of sources, including VisibleDust (www.visibledust. com). Such brushes can be expensive. You can use a new nylon-fiber cosmetic brush that has been thoroughly cleaned and then rinsed in distilled water to remove sizing and contaminants present even in brand-new brushes. Blow some air through the brush to electrically charge it, and then pass it over the sensor so it can pick up the dust that resides on the sensor's surface.

Swab it off. If the first two methods fail, you'll need to wet-clean your sensor, using extra-pure methanol. Eclipse solution from Photographic Solutions (www. photosol.com) works best. You'll need a soft, lint-free swab, too, which you can purchase from VisibleDust, Photographic Solutions, or Copper Hill (www.copperhillimages.com). You can also make your own swabs using a cut-off rubber spatula wrapped in Pec*Pad cloths (also from Photographic Solutions). Put a drop or two of Eclipse on the swab, and gently wipe in one direction, flip the swab over, and wipe in the other direction.

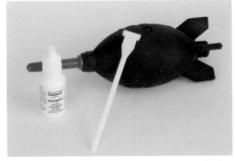

AA.5 A variety of tools are available to help you clean your D200's sensor.

Glossary

additive primary colors The red, green, and blue hues that are used alone or in combination to create all other colors that you capture with a digital camera, view on a computer monitor, or work with in an image-editing program, such as Photoshop. See also *CMYK color model*.

AE/AF lock A control on the D200 that lets you lock the current autoexposure and/or autofocus settings prior to taking a picture, freeing you from having to hold the shutter release partially depressed, although you must depress and hold the shutter release partially to apply the feature.

ambient lighting Diffuse, non-directional lighting that doesn't appear to come from a specific source but, rather, bounces off walls, ceilings, and other objects in the scene when a picture is taken.

analog/digital converter The electronics built into a camera that convert the analog information captured by the sensor into digital bits that can be stored as an image bitmap.

angle of view The area of a scene that a lens can capture, determined by the focal length of the lens. Lenses with a shorter focal length have a wider angle of view than lenses with a longer focal length.

anti-alias A process that smoothes the look of rough edges in images (called *jaggies* or *staircasing*) by adding partially transparent pixels along the boundaries of diagonal lines that are merged into a smoother line by our eyes. See also *jaggies*.

Aperture Priority A camera setting that enables you to specify the lens opening or f-stop that you want to use, with the camera selecting the required shutter speed automatically based on its light-meter reading. See also *Shutter Priority*.

artifact A type of noise in an image, or an unintentional image component produced in error by a digital camera during processing, usually caused by the JPEG compression process in digital cameras.

aspect ratio The proportions of an image as printed, displayed on a monitor, or captured by a digital camera.

autofocus A camera setting that enables the D200 to choose the correct focus distance for you, usually based on the contrast of an image (the image will be at maximum contrast when it is in sharp focus) or a mechanism such as an infrared sensor that measures the actual distance to the subject. Cameras can be set for *Single Autofocus* (the lens is not focused until the shutter release is partially depressed) or *Continuous Autofocus* (the lens refocuses constantly as you frame and reframe the image).

autofocus assist lamp A light source built into a digital camera that provides extra illumination that the autofocus system can use to focus dimly lit subjects.

averaging meter A light-measuring device that calculates exposure based on the overall brightness of the entire image area. Averaging tends to produce the best exposure when a scene is evenly lit or contains equal amounts of bright and dark areas that contain detail. The D200 uses much more sophisticated exposure measuring systems, which are based on center-weighting, spotreading, or calculating exposure from a matrix of many different picture areas. See also center-weighted meter and spot meter.

backlighting A lighting effect produced when the main light source is located behind the subject. Backlighting can be used to create a silhouette effect, or to illuminate translucent objects. See also *front-lighting* and *sidelighting*.

barrel distortion A lens defect, usually found at wide angle focal lengths, that causes straight lines at the top or side edges

of an image to bow outward into a barrel shape. See also *pincushion distortion*.

blooming An image distortion caused when a photosite in an image sensor has absorbed all the photons it can handle, so that additional photons reaching that pixel overflow to affect surrounding pixels, producing unwanted brightness and overexposure around the edges of objects.

blur To soften an image or part of an image by throwing it out of focus, or by allowing it to become soft due to subject or camera motion. Blur can also be applied in an image-editing program.

bokeh A buzzword used to describe the aesthetic qualities of the out-of-focus parts of an image, with some lenses producing "good" bokeh and others offering "bad" bokeh. Boke is a Japanese word for "blur." and the h was added to keep English speakers from rhyming it with broke. Out-of-focus points of light become discs, called the circle of confusion. Some lenses produce a uniformly illuminated disc. Others, most notably mirror or catadioptic lenses, produce a disc that has a bright edge and a dark center, producing a "doughnut" effect, which is the worst from a bokeh standpoint. Lenses that generate a bright center that fades to a darker edge are favored, because their bokeh allows the circle of confusion to blend more smoothly with the surroundings. The bokeh characteristics of a lens are most important when you're using selective focus (say, when shooting a portrait) to deemphasize the background, or when shallow depth-of-field is a given because you're working with a macro lens, with a long telephoto, or with a wide-open aperture. See also circle of confusion.

bounce lighting The light bounced off a reflector, including ceiling and walls, to provide a soft, natural-looking light.

bracketing Taking a series of photographs of the same subject at different settings, including exposure, color, and white balance, to help ensure that one setting will be the correct one. The D200 enables you to choose the order in which bracketed settings are applied.

buffer The digital camera's internal memory where an image is stored immediately after it is taken until it can be written to the camera's nonvolatile (semi-permanent) memory or a memory card.

burst mode The digital camera's equivalent of the film camera's motor drive, the burst mode is used to take multiple shots within a short period of time.

calibration A process used to correct for the differences in the output of a printer or monitor when the output is compared to the original image. Once you've calibrated your scanner, monitor, and/or your image editor, the images you see on the screen more closely represent what you'll get from your printer, even though calibration is never perfect.

Camera RAW A plug-in included with Photoshop and Photoshop Elements that can manipulate the unprocessed images captured by digital cameras, such as the D200's NEF files.

camera shake The movement of the camera, aggravated by slower shutter speeds, which produces a blurred image. Nikon offers several vibration reduction lenses that shift lens elements to counter this movement, including a new 18200mm VR lens introduced at the same time as the D200.

CCD See charge-coupled device (CCD).

center-weighted meter A light-measuring device that emphasizes the area in the middle of the frame when you're calculating the correct exposure for an image. See also averaging meter and spot meter.

charge-coupled device (CCD) A type of solid-state sensor that captures the image. It is used in scanners and digital cameras, including the Nikon D200, but not its pro camera sibling, the D2X, which uses a CMOS sensor.

chromatic aberration An image defect, often seen as green or purple fringing around the edges of an object, caused by a lens failing to focus all colors of a light source at the same point. See also *fringing*.

circle of confusion A term applied to the fuzzy discs produced when a point of light is out of focus. The circle of confusion is not a fixed size. The viewing distance and amount of enlargement of the image determine whether we see a particular spot on the image as a point or as a disc. See also bokeh.

close-up lens A lens add-on that enables you to take pictures at a distance that is less than the closest-focusing distance of the lens alone.

CMOS See complementary metal-oxide semiconductor (CMOS).

CMYK color model A way of defining all possible colors in percentages of cyan, magenta, yellow, and frequently, black. (K represents black, to differentiate it from blue in the RGB color model.) Black is added to improve renditions of shadow detail. CMYK is commonly used for printing (both on press and with your inkjet or laser color printer).

color correction Changing the relative amounts of color in an image to produce a desired effect, typically a more accurate representation of those colors. Color correction can fix faulty color balance in the original image, or compensate for the deficiencies of the inks used to reproduce the image.

complementary metal-oxide semicon- ductor (CMOS) A method for manufacturing a type of solid-state sensor that captures the image that is used in scanners and digital cameras such as the Nikon D2X.

compression Reducing the size of a file by encoding, using fewer bits of information to represent the original. Some compression schemes, such as JPEG, operate by discarding some image information, while others, such as TIF, preserve all the detail in the original, discarding only redundant data.

Continuous Autofocus An automatic focusing setting (AF-C) in which the camera constantly refocuses the image as you frame the picture. This setting is often the best choice for moving subjects. See also *Single Autofocus*.

contrast The range between the lightest and darkest tones in an image. A high-contrast image is one in which the shades fall at the extremes of the range between white and black. In a low-contrast image, the tones are closer together.

dedicated flash An electronic flash unit, such as the Nikon SB-600 or SB-800, designed to work with the automatic exposure features of a specific camera.

depth of field (DOF) A distance range in a photograph in which all included portions of an image are at least acceptably sharp. With the Nikon D200, you can see the available depth of field at the taking aperture by pressing the depth-of-field preview button,

or estimate the range by viewing the depthof-field scale found on many lenses.

diaphragm An adjustable component, similar to the iris in the human eye, which can open and close to provide specific-sized lens openings, or f-stops.

diffuse lighting Soft, low-contrast lighting.

digital processing chip A solid-state device found in digital cameras that's in charge of applying the image algorithms to the raw picture data prior to storage on the memory card.

diopter A value used to represent the magnification power of a lens, calculated as the reciprocal of a lens's focal length (in meters). Diopters are most often used to represent the optical correction used in a viewfinder to adjust for limitations of the photographer's eyesight, and to describe the magnification of a close-up lens attachment.

equivalent focal length A digital camera's focal length which must be translated into the corresponding values for a 35mm film camera if the sensor is smaller than 24mm x 36mm. This value can be calculated for lenses used with the Nikon D200 by multiplying by 1.5.

exchangeable image file format (Exif) A format that was developed to standardize the exchange of image data between hardware devices and software. A variation on JPEG, Exif is used by most digital cameras, and includes information such as the date and time a photo was taken, the camera settings, the resolution, the amount of compression, and other data.

Exif See exchangeable image file format (Exif).

exposure The amount of light allowed to reach the film or sensor, determined by the intensity of the light, the amount admitted by the iris of the lens, and the length of time determined by the shutter speed.

exposure values (EV) EV settings are a way of adding or decreasing exposure without the need to reference f-stops or shutter speeds. For example, if you tell your camera to add +1EV, it will provide twice as much exposure, either by using a larger f-stop, a slower shutter speed, or both.

fill lighting In photography, it is the lighting used to illuminate shadows. Reflectors or additional incandescent lighting or electronic flash can be used to brighten shadows. One common technique outdoors is to use the camera's flash as a fill.

filter In photography, it is a device that fits over the lens, changing the light in some way. In image editing, it is a feature that changes the pixels in an image to produce blurring, sharpening, and other special effects. Photoshop includes several interesting filter effects, including Lens Blur and Photo Filters.

flash sync The timing mechanism that ensures that an internal or external electronic flash fires at the correct time during the exposure cycle. A digital SLR's flash sync speed is the highest shutter speed that can be used with flash, ordinarily 1/250th of a second with the Nikon D200. See also *frontcurtain sync* and *rear-curtain sync*.

focal length The distance between the film and the optical center of the lens when the lens is focused on infinity, usually measured in millimeters.

focal plane An imaginary line, perpendicular to the optical access, which passes through the focal point forming a plane of

sharp focus when the lens is set at infinity. A focal plane indicator is etched into the Nikon D200 at the lower-right corner of the top panel.

focus lock A camera feature that lets you freeze the automatic focus of the lens at a certain point, when the subject you want to capture is in sharp focus.

focus servo A digital camera's mechanism that adjusts the focus distance automatically. The focus servo can be set to Single Autofocus (AF-S), which focuses the lens only when the shutter release is partially depressed, and Continuous Autofocus (AF-C), which adjusts focus constantly as the camera is used.

focus tracking The capability of the automatic focus feature of a camera to change focus as the distance between the subject and the camera changes. One type of focus tracking is *predictive*, in which the mechanism anticipates the motion of the object being focused on, and adjusts the focus to suit.

fringing A chromatic aberration that produces fringes of color around the edges of subjects, caused by a lens's inability to focus the various wavelengths of light onto the same spot. Purple fringing is especially troublesome with backlit images. See also *chromatic aberration*.

front-curtain sync The default kind of electronic flash synchronization technique, originally associated with focal plane shutters, which consist of a traveling set of curtains, including a *front curtain* (which opens to reveal the film or sensor) and a *rear curtain* (which follows at a distance determined by shutter speed to conceal the film or sensor at the conclusion of the exposure). For a flash picture to be taken, the entire sensor

must be exposed at one time to the brief flash exposure, so the image is exposed after the front curtain has reached the other side of the focal plane, but before the rear curtain begins to move. Front-curtain sync causes the flash to fire at the beginning of this period when the shutter is completely open, in the instant that the first curtain of the focal plane shutter finishes its movement across the film or sensor plane. With slow shutter speeds, this feature can create a blur effect from the ambient light, showing as patterns that follow a moving subject with the subject shown sharply frozen at the beginning of the blur trail. See also *rear-curtain sync*.

frontlighting The illumination that comes from the direction of the camera. See also *backlighting* and *sidelighting*.

f-stop The relative size of the lens aperture, which helps determine both exposure and depth of field. The larger the f-stop number, the smaller the aperture itself.

graduated filter A lens attachment with variable density or color from one edge to another. A graduated neutral density filter, for example, can be oriented so the neutral density portion is concentrated at the top of the lens's view with the less dense or clear portion at the bottom, thus reducing the amount of light from a very bright sky while not interfering with the exposure of the landscape in the foreground. Graduated filters can also be split into several color sections to provide a color gradient between portions of the image.

gray card A piece of cardboard or other material with a standardized 18-percent reflectance. Gray cards can be used as a reference for determining correct exposure or for setting white balance.

high contrast A wide range of density in a print, a negative, or another image.

highlights The brightest parts of an image containing detail.

histogram A kind of chart showing the relationship of tones in an image using a series of 256 vertical bars, one for each brightness level. A histogram chart, such as the one the D200 can display during picture review, typically looks like a curve with one or more slopes and peaks, depending on how many highlight, middle, and shadow tones are present in the image.

hot shoe A mount on top of a camera used to hold an electronic flash, while providing an electrical connection between the flash and the camera.

hyperfocal distance A point of focus where everything from half that distance to infinity appears to be acceptably sharp. For example, if your lens has a hyperfocal distance of 4 feet, everything from 2 feet to infinity will appear sharp. The hyperfocal distance varies by the lens and the aperture in use. If you know you'll be making a grab shot without warning, sometimes it's useful to turn off your camera's automatic focus, and set the lens to infinity, or, better yet, the hyperfocal distance. Then, you can snap off a quick picture without having to wait for the lag that occurs with most digital cameras as their autofocus locks in.

image rotation A feature that senses whether a picture was taken in horizontal or vertical orientation. That information is embedded in the picture file so that the camera and compatible software applications can automatically display the image in the correct orientation.

image stabilization A technology, called *vibration reduction* by Nikon, which compensates for camera shake, usually by adjusting the position of the camera sensor

or lens elements in response to movements of the camera.

incident light Light falling on a surface.

International Organization for Standardization (ISO) A governing body that provides standards used to represent film speed, or the equivalent sensitivity of a digital camera's sensor. Digital camera sensitivity is expressed in ISO settings.

interpolation A technique digital cameras, scanners, and image editors use to create new pixels required whenever you resize or change the resolution of an image based on the values of surrounding pixels. Devices such as scanners and digital cameras can also use interpolation to create pixels in addition to those actually captured, thereby increasing the apparent resolution or color information in an image.

ISO See International Organization for Standardization (ISO).

jaggies The staircasing effect of lines that are not perfectly horizontal or vertical, caused by pixels that are too large to represent the line accurately. See also *anti-alias*.

JPEG A file lossy format (short for *Joint Photographic Experts Group*) that supports 24-bit color and reduces file sizes by selectively discarding image data. Digital cameras generally use JPEG compression to pack more images onto memory cards. You can select how much compression is used (and, therefore, how much information is thrown away) by selecting from among the Standard, Fine, Super Fine, or other quality settings your camera offers. See also *RAW*.

Kelvin (K) A unit of measure based on the absolute temperature scale in which absolute zero is zero. It is used to describe

the color of continuous-spectrum light sources, and applied when setting white balance. For example, daylight has a color temperature of about 5500K, and a tungsten lamp has a temperature of about 3400K.

lag time The interval between when the shutter is pressed and when the picture is actually taken. During that span, the camera may be automatically focusing and calculating exposure. With digital SLRs such as the Nikon D200, lag time is generally very short; with non-dSLRs, the elapsed time easily can be 1 second or more.

latitude The range of camera exposures that produces acceptable images with a particular digital sensor or film.

lens flare A feature of conventional photography that is both a bane and a creative outlet. It is an effect produced by the reflection of light internally among elements of an optical lens. Bright light sources within or just outside the field of view cause lens flare. Flare can be reduced by the use of coatings on the lens elements or with the use of lens hoods. Photographers sometimes use the effect as a creative technique, and Photoshop includes a filter that lets you add lens flare at your whim.

lighting ratio The proportional relationship between the amount of light falling on the subject from the main light and other lights, expressed in a ratio, such as 3:1.

lossless compression An image-compression scheme, such as TIFF, that preserves all image detail. When the image is decompressed, it is identical to the original version.

lossy compression An image-compression scheme, such as JPEG, that creates smaller files by discarding image information, which can affect image quality.

macro lens A lens that provides continuous focusing from infinity to extreme close-ups, often to a reproduction ratio of 1:2 (half life-size) or 1:1 (life-size).

matrix metering A system of exposure calculation that looks at many different segments of an image to determine the brightest and darkest portions.

midtones Parts of an image with tones of an intermediate value, usually in the 25 percent to 75 percent range. Many image-editing features enable you to manipulate midtones independently from the highlights and shadows.

mirror lock-up The capability to retract the SLR's mirror to reduce vibration prior to taking the photo (with some cameras), or, with the Nikon D200, to allow access to the sensor for cleaning.

NEF (Nikon Electronic File) Nikon's name for its proprietary RAW format.

neutral color A color in which red, green, and blue are present in equal amounts, producing a gray.

neutral density filter A gray camera filter reduces the amount of light entering the camera without affecting the colors.

noise In an image, it is pixels with randomly distributed color values. Noise in digital photographs tends to be the product of low-light conditions and long exposures, particularly when you've set your camera to a higher ISO rating than normal.

noise reduction A technology used to cut down on the amount of random information in a digital picture, usually caused by long exposures at increased sensitivity ratings. In the Nikon D200, noise reduction

involves the camera automatically taking a second blank/dark exposure at the same settings that contains only noise, and then using the blank photo's information to cancel out the noise in the original picture. Although the process is very quick, it does double the amount of time required to take the photo.

normal lens A lens that makes the image in a photograph appear in a perspective that is like that of the original scene, typically with a field of view of roughly 45°.

overexposure A condition in which too much light reaches the film or sensor, producing a dense negative or a very bright/light print, slide, or digital image.

pincushion distortion A type of lens distortion, most often found at telephoto focal lengths, in which lines at the top and side edges of an image are bent inward, producing an effect that looks like a pincushion. See also *barrel distortion*.

polarizing filter A filter that forces light, which normally vibrates in all directions, to vibrate only in a single plane, reducing or removing the specular reflections from the surface of objects.

RAW An image file format, such as the NEF format in the Nikon D200, which includes all the unprocessed information the camera captures. RAW files are very large compared to JPEG files and must be processed by a special program such as Nikon Capture or Adobe's Camera RAW filter after being downloaded from the camera. See also *JPEG*.

rear-curtain sync An optional kind of electronic flash synchronization technique, originally associated with focal plane shutters, which consist of a traveling set of curtains,

including a front curtain (which opens to reveal the film or sensor) and a rear curtain (which follows at a distance determined by shutter speed to conceal the film or sensor at the conclusion of the exposure). For a flash picture to be taken, the entire sensor must be exposed at one time to the brief flash exposure, so the image is exposed after the front curtain has reached the other side of the focal plane, but before the rear curtain begins to move. Rear-curtain sync causes the flash to fire at the end of the exposure, an instant before the second or rear curtain of the focal plane shutter begins to move. With slow shutter speeds, this feature can create a blur effect from the ambient light, showing as patterns that follow a moving subject with the subject shown sharply frozen at the end of the blur trail. If you were shooting a photo of The Flash, the superhero would appear sharp, with a ghostly trail behind him. See also front-curtain sync.

red-eye An effect from flash photography that appears to make a person's eyes glow red, or an animal's yellow or green. It's caused by light bouncing from the retina of the eye and is most pronounced in dim illumination (when the irises are wide open), and when the electronic flash is close to the lens and, therefore, prone to reflect directly back. Image editors can fix red-eye by cloning other pixels over the offending red or orange ones.

RGB color model A color model that represents the three colors—red, green, and blue—used by devices such as scanners or monitors to reproduce color. Photoshop works in RGB mode by default, and even displays CMYK images by converting them to RGB.

saturation The purity of color; the amount by which a pure color is diluted with white or gray.

selective focus Choosing a lens opening that produces a shallow depth of field. Usually this is used to isolate a subject by causing most other elements in the scene to be blurred.

self-timer A mechanism that delays the opening of the shutter for some seconds after the release has been operated.

sensitivity A measure of the degree of response of a film or sensor to light, measured using the ISO setting.

shadow The darkest part of an image, represented on a digital image by pixels with low numeric values.

sharpening Increasing the apparent sharpness of an image by boosting the contrast between adjacent pixels that form an edge.

shutter In a conventional film camera, the shutter is a mechanism consisting of blades, a curtain, a plate, or some other movable cover that controls the time during which light reaches the film. Digital cameras, including the Nikon D200, use actual mechanical shutters for the slower shutter speeds (less than 1/250th second) and an electronic shutter for higher speeds.

Shutter Priority An exposure mode in which you set the shutter speed and the camera determines the appropriate f-stop. See also *Aperture Priority*.

sidelighting Applying illumination from the left or right sides of the camera. See also *backlighting* and *frontlighting*.

Single Autofocus An automatic focusing setting (AF-S) in which the camera locks in focus when you press the shutter release half way. This setting is usually the best choice for non-moving subjects. See also *Continuous Autofocus*.

slave unit An accessory flash unit that supplements the main flash, usually triggered electronically when the slave senses the light output by the main unit or through radio waves.

slow sync An electronic flash synchronizing method that uses a slow shutter speed so that ambient light is recorded by the camera in addition to the electronic flash illumination. This enables the background to receive more exposure for a more realistic effect.

specular highlight Bright spots in an image caused by reflection from light sources.

spot meter An exposure system that concentrates on a small area in the image. See also *averaging meter* and *center-weighted meter*.

subtractive primary colors Cyan, magenta, and yellow, which are the printing inks that theoretically absorb all color and produce black. In practice, however, they generate a muddy brown, so black is added to preserve detail (especially in shadows). The combination of the three colors and black is referred to as CMYK. (K represents black, to differentiate it from blue in the RGB model.)

TIFF (Tagged Image File Format) A standard graphics file format that can be used to store grayscale and color images, plus selection masks with lossless compression. See also *JPEG* and *RAW*.

time exposure A picture taken by leaving the shutter open for a long period, usually more than 1 second. The camera is generally locked down with a tripod to prevent blur during the long exposure.

time lapse A process by which a tripodmounted camera takes sequential pictures at intervals, allowing the viewing of events that take place over a long period of time, such as a sunrise or flower opening. With the D200, time-lapse photography is accomplished by connecting the camera to a computer with the USB cable and triggering the pictures with Nikon Capture.

through the lens (TTL) A system of providing viewing and exposure calculation through the actual lens taking the picture.

tungsten light Light from ordinary room lamps and ceiling fixtures, as opposed to fluorescent illumination.

underexposure A condition in which too little light reaches the film or sensor, producing a thin negative, a dark slide, a muddy-looking print, or a dark digital image.

unsharp masking The process for increasing the contrast between adjacent pixels in an image, increasing sharpness, especially around edges.

vignetting The dark corners of an image, often produced by using a lens hood that is too small for the field of view, using a lens that does not completely fill the image frame, or generating it artificially using image-editing techniques.

white balance The adjustment of a digital camera to the color temperature of the light source. Interior illumination is relatively red; outdoor light is relatively blue. Digital cameras often set correct white balance automatically or let you do it through menus. Image editors can often do some color correction of images that were exposed using the wrong white balance setting.

Index

A	animal photography
	framing animals in natural setting, 134
abstract photography	getting close, 134
color and form, 130	inspiration, 132
cropping and rotating, 130	overview, 130-131, 134
freezing and blending time, 130	practice, 132–133
inspiration, 127–128	anti-alias, 241
overview, 127, 130	anti-shake systems, 105
in post-processing, 130	aperture adjustment, 78-79
practice, 128–130	aperture lock, 18–19
AC power connector cover, 16	Aperture/other functions display, 29
action photography. See sports and action	Aperture Priority AE mode
photography	abstract pictures, 129
action-stopping capabilities, 118	auction photos, 186
Activate Autofocus button, 22	event pictures, 144
additive primary colors, 241	filter effects pictures, 152
Adobe Camera Raw, 222	flower and plant pictures, 160
taking abstract pictures, 129	indoor portraits, 167
taking filter effects pictures, 152	macro photos, 178
taking pictures at zoos, 133	still-life pictures, 199
taking waterfall pictures, 213	Aperture Priority mode, 2, 33, 45, 47-48, 68, 70
Adobe Photoshop Elements, 216, 220	72, 85, 95, 189, 241
Adobe RGB, 59	aperture ring, 18
AE & Flash bracketing, 41	architectural photography
AE/AF (autoexposure/autofocus) lock, 22, 241	inspiration, 135
AE-L/AF-L button, 49, 52–53, 68	lens distortion, 137
AE Lock feature, 68	overview, 134–135, 137
AE shutter priority mode, 146	permission to take photos, 138
AF (autofocus) activation, 67	perspective distortion, avoiding, 137
AF Area mode, 66	practice, 135–137
AF Area mode, 66	shooting wide, 137
AF lens feature, 96	artificial lights, 118
AF-area mode selector, 52	AS-15 Sync Terminal Adapter, 115, 117
AF-C mode priority, 66	aspect ratio, 242
AF-D letter code, 96 AF-I letter code, 96	auction photography. See online auction
AF-Hetter code, 96	photography
AF-ON button, 67	Auto Aperture mode, 111
	Auto BBKT Set menu, 71
AF-ON for MB-D200, 67	auto bracketing, 40, 71
AF-S letter code, 96 AF-S mode priority, 66	Auto Bracketing in Manual Exposure Mode
After Delete setting, 63	feature, 71
after-the-shot tool, 82	Auto Bracketing Selection Method, 71
	Auto Bracket Order option, 71
Al lens feature, 95	Auto FP mode, 70
Al letter code, 95–96	Auto Gain option, 60
AI-S letter code, 95–96	Auto Image Rotation option, 63, 64
ambient lighting, 112, 241 analog/digital converter, 241	Auto Meter-Off option, 69
anaios/digital Conventer, 241	

Index + A–C

auto timing function, 68	Bracketing/Flash submenu, of Custom Settings
autoexposure/focus lock feature, 68	menu, 70–71
Autoexposure lock, 25	broad lighting, 164
autoexposure system, 194	broad scope photos, 142
autofocus, 48–53	Built-in Flash menu, 70–71
Autofocus area selector control, 23–24	built-in slave unit, 166
Autofocus Assist Illuminator, 67	built-in time-lapse feature, 161
autofocus assist lamp, 242	bulb blower, 238
autofocusing, 13	Bulb exposure, 77
autofocus lens, 3	burst mode, 243
autofocus/manual switch (AF/M), 17	business-oriented photos, 138
Autofocus submenu, of Custom Settings menu,	business photography
66–67	backgrounds, keeping simple, 141
autofocus system, 194	direct flash in headshots, avoiding, 141
Autofocus zones, 25	inspiration, 138–139
automatic bracketing, 137	overview, 138, 141
automatic extension tubes, 176	photos to be used as series, 141
automatic focus/manual override (M/A), 14	practice, 139–141
automatic indexing feature, 95–96	- 1 000 0 000 0000
Automatic mode, 111	C
auxiliary lighting, 198	calibration, 243
AV connector cover, 16	Camera body focus mode selector, 14–16
averaging meter, 242	Camera Control Module, Nikon Capture, 224, 226
AV port output, 64	Camera Raw, 243
	camera shake, 243
В	camera-eye-level, 166
back lighting, 165	Capture Controls, 226
back panel, 21–24	Capture NX Browser, 227
background, 125, 138, 139–140, 164	catalog photographers, 185
backlight illuminator, on front panel, 14	center button, 71
backlighting, 242	center-weighted metering, 24–25, 33, 38, 68, 85, 24
Bank Select option, 66	Channel Mixer, Photoshop, 171
barrel distortion, 99, 134, 242	Charge Life scale, 65
batch operations, PhotoImpact, 228	charge-coupled device (CCD), 243
Battery indicator, 25	charge/discharge cycles, 234
Battery info option, 65	chromatic aberration, 243
Battery level option, 29	
Battery levels, 29	circle of confusion, 87, 243
beep, 69	circular polarizer, 174
Beep indicator, 29	Claass, Arnaud, 127
Bibble Pro, 228	clear spot filter, 150
3KT button, 40, 71	CL-Mode shooting speed, 69 Clock icon, 235
Black-and-white indicator, 25	
plooming, 81, 242	Clock not set indicator, 27
	close-focusing distance, 104
olown highlights, 146 Olur, 242	close-focusing macro lens, 79
00×00×00×00×00×00×00×00×00×00×00×00×00×	close-ups, 38, 104, 243
ookeh, 87–88, 242	CMYK color model, 243
porders, 127	Cokin Filter System, 152
pounce flash, 112	color correction, 244
pounce lighting, 243	Color keys, 36
pouncelight cards, 116	Color Mode, 53–54
pracketing, 28, 243	color rendering index (CRI), 120
Bracketing (BKT) button, 21	color saturation, 102
Bracketing display, 28	Color Space menu, 54
oracketing exposures, 40–41, 85–86	color temperature, 29, 54, 118, 119–120

color-correction filters, 121	custom curves, 42, 82
colored filters, 164, 206	Custom menu bank, 28, 66
colored gels, 130	Custom Menu Settings, 43
Commander mode, 70–71, 112, 116	Custom Settings Banks, 46
Commander Mode flash, 70	Custom Settings menu
command/sub-command dial functions, 72	Autofocus submenu, 66–67
communications	Bank Select, 66
Exposure 1 tab, 224	Bracketing/Flash submenu, 70–71
Exposure 2 tab, 224	Controls submenu, 71–72
Image Processing tab, 225–227	Menu Reset option, 66
Mechanical tab, 225	Metering/Exposure submenu, 67-68
Storage tab, 225	overview, 65–66
CompactFlash access lamp control, 24	Shooting/Display submenu, 69-70
CompactFlash card, 1, 6, 58, 62, 72, 237	Timers/AE&AF Lock submenu, 68-69
CompactFlash door release control, 24	Custom Settings menu (CSM), 39-40, 46, 57, 118
complementary metal-oxide semiconductor	customized exposure, 42
(CMOS), 244	-
composition, 124–127	D
conductors, 115	D letter code, 96
constant aperture lenses, 94	Dark Frame Subtraction, 45
continuous autofocus, 3, 14, 48, 66, 244	daylight, 119
continuous high speed position, 41	DC letter code, 96–97
continuous lighting	dead/live pixel, 238
color temperature, 119–120	dedicated flash, 244
overview, 118	default camera value, 5
types of, 118–119	defocus control, 96
white balance, 120–121	Delete button, 31
continuous low speed position, 41	Delete setting, 62
continuous shooting mode, 194, 196	Delete/Format #2 button, 21
Continuous-servo mode, 49-50	depth of field (DOF), 4-5, 78, 109
contrast, 42, 83-84, 102, 244	and aperture adjustment, 78
control/shutter release devices, 156	overview, 86–88
Controls submenu, of Custom Settings menu	and telephoto lenses, 102
center button option, 71	and wide-angle lenses, 98
Command Dials option, 72	Depth-of-field preview button, 4-5, 12, 131, 178
Disable Shutter If No Memory Card? option, 72	diameter thread, 153
Func button option, 72	diffraction, 79
Multi-Selector Press option, 71	diffuse lighting, 244
overview, 71	diffuser dome, 116
Photo Info Playback option, 71–72	digital interference, 44
setting method for buttons and dials, 72	digital processing chip, 244
cool white fluorescents, 121	digital single lens reflexes (dSLRs), 1, 11
Corel Painter, 229	digital SLR photography, 11
Corel Paint Shop Pro, 228	Digital Vari-Program (DVP) modes, 3
Corel PhotoPaint, 228	diopter, 244
Corel RAW Essentials, 222	Diopter adjustment control, 21
CorelDRAW Graphics suite, 228	Disable Shutter If No Memory Card? control, 72
Creative Lighting System, 112	discs, 88
cropping factor, 97	dispersion glass, 90
CSM e1 (flash sync speed setting), 112	Display mode, 62
CSM e2 (slowest speed when using flash), 112	distance, 124
CSM e3 (built-in flash mode), 112	Distance scale, 17
CSM e4 (modeling flash), 112, 116	distortions, 137
Curves palette, Photoshop, 82	DOF preview button, 5, 86

downloading/aditing in a sec	
downloading/editing images	exposure
Bibble Pro, 228	adjustments to, 77–81
Corel Painter, 229	conditions affecting, 76–77
Corel Plant Shop Pro, 228	correcting, 6–7
Corel PhotoPaint, 228	fine-tuning, 85–86
IrfanView, 227–228	overview, 76
Macromedia Fireworks, 228–229	Exposure compensation display, 25, 29
Nikon capture, 222–227	Exposure compensation indicator, 25
Nikon PictureProject, 216–221	Exposure compensation/Reset #1 button, 19-20
overview, 215	Exposure Delay mode, 69
Phase One Capture One Pro (C1 Pro), 228	Exposure display, 29
Photoshop CS/Photoshop Elements, 228	Exposure keys, 35
PictureCode Noise Ninja, 229	Exposure mode, 25, 27
Ulead PhotoImpact, 229	exposure value (EV)
DPOF (Digital Print Order Format), 62	bracketing exposures and other parameters,
Dust Off Ref Photo option, 65	40–41
DX letter code, 96	customized exposure and contrast tweaks, 42
Dynamic Area Autofocus mode, 52	overview, 39
Dynamic Area/Closest Subject mode, 52	using histograms, 39–40
,	exposure-lock feature, 193
E	Exposures remaining/other functions, 28–29
E letter code, 96	Exposures remaining/other functions, 28–29 Exposures remaining/other functions display,
Eclipse solution, 239	28–29
ED letter code, 96	extension tube, 129
ED-IF AF-S DX Zoom-Nikkor, 135	
Edit List, 227	external flash. See flash
editing images. See downloading/editing images	external light meter, 48
18–70mm f/3.5–4.5G ED-IF AF-S DX Zoom	F
Nikkor lens	
architectural exteriors, 136	f/3.5–f/4.5 optic, 79
business pictures, 141	factory default settings, 58
environmental portraits, 189	far infrared illumination, 169
sunset and sunrise pictures, 207	field of view for distant shots, 98
	50mm f/1.8D AF Nikkor lens
waterfall pictures, 213 18–200mm f/3.5–5.6 G ED-IF AF-S VR DX Zoom	abstract pictures, 129
Nikkor lens	indoor portraits, 167
	File Information option, 31
holiday lights photos, 163	file naming, 59
infrared pictures, 171	File Number Sequence option, 69–70
landscape and nature pictures, 174 electrical interference, 44	fill flash photography
	colored gels, 149
electronic rangefinder, 49	flash meters, 149
EN-EL3e battery, 233	inspiration, 146–147
Enter button, 31	lighting ratios, 149
evening photography. See night and evening	overview, 145–146, 149
photography	practice, 147–148
event photography	fill lighting, 164, 245
angles, 145	fill-in illumination, 144
arriving early, 145	filter effects photography, 149–153
changing light conditions, 145	Cokin Filter System, 153
inspiration, 142–143	inspiration, 150
overview, 141–142, 145	overview, 149–150, 153
permission to take photos, 145	polarizers, 153
practice, 143–145	practice, 151–152
EV Step setting, 68	step-up/step down ring, 153
exchangeable image file format (Exif), 244	filter plug-ins, 130

fireworks and light trail photography digital noise, 156–157	Focus keys, 35 focus lock button, 205
inspiration, 154	focus modes, 49–50
overview, 153–154, 156	focus ring, 4, 17
practice, 155–156	Focus selector lock, 23, 51
tripods, 156	focus tracking, 245
fish-eye lenses, 91, 93	Focus Tracking With Lock On option, 66-67
fixed-focal-length/prime lenses, 93, 94, 103	focus zones, 50–52
flash	focus-assist light, 115
coverage, 99–103	Folders option, 58–59
exposure compensation, 111–112	FOR (format) warning, 235
exposure modes, 110–111	Format feature, 64
external, 112–118	FPS Rate, 66
overview, 107–109	framing, 103
sync modes, 109–110	fringing, 245
Flash accessory shoe control, 14, 19	Front lamp, 13-14
Flash compensation display, on LCD display, 29	front lighting, 246
Flash compensation indicator, on viewfinder	front panel
display, 25	10-pin remote connector, 16
flash coverage, 102	AC power connector cover, 16
flash lighting ratio, 149	AV connector cover, 16
Flash lock release button, 14	Camera body focus mode selector, 14-16
Flash output, 118	Depth-of-field preview button, 12
Flash ready display, 25	Flash accessory shoe control, 14
flash shoe, 115	Flash lock release button, 14
Flash sync indicator, 25, 27	Flash sync mode/flash exposure compensation
Flash sync mode, 29	control, 14
Flash sync mode/flash exposure compensation	front lamp, 13-14
control, 14	Func button, 12
Flash Sync Speed, 70	handgrip, 12
flash triggering function, 115	lens release, 14
flash units, 110	on/off switch/Backlight illuminator, 14
Flash value lock	overview, 12
in LCD display, 29	PC/X flash connector, 16
in viewfinder display, 25	Shutter Release button, 14
Flexible program indicator, 27	sub-command dial, 12-13
flip-up flash, 233	USB port connector cover, 16
flower and plant photography	Front sync mode, 109
inspiration, 158	Front-curtain sync option, 32, 245–246
manual focus, 160	f-stop, 25, 76, 78, 157, 246
natural backlighting, 160	full frame/film camera, 134
overview, 157–158, 160	Func button, 5, 12, 52, 72
practice, 159-160	f-value, 79
saturation, boosting, 161	
time-lapse photography, 161	G
fluorescent lighting, 119	G letter code, 96
focal length, 79, 86, 97, 245	ghost streak, 110
focus	glass flash tube, 107
automatic, 3	Global Positioning Systems, 16
manual, 4	GPS connection display, 29
Focus area/Autofocus area mode, 28	GPS connection status indicator, 27
Focus Area Frame option, 66	GPS Data option, 31
Focus Area setting, 67	graduated filter, 246
focus frame function, 52	gray card, 246
Focus indicator, 25	grayscale brightness chart, 64

group dynamic autofocus option, 66	overview, 164–165, 167
Group Dynamic mode, 52	practice, 166–167
	reflections, 168
Н	infrared (IR) filter, 168-169
handgrip, 12	infrared photography
Harris shutter, 213	bracketing exposures, 171
head-and-shoulder portraits, 140	inspiration, 169–170
Help/Protect menu, 23	long exposures, 171
Hide Image feature, 62	overview, 168–169, 171
high contrast, 246	practice, 170–171
High ISO NR setting, 44–45, 60	swapping channels, 171
High noise reduction, 236	infrared remote commander, 114
high shutter speed, 130, 133	internal autoexposure system, 115
high-intensity desk lamps, 177	internal communications, 138
high-IR-reflecting subjects, 171	internal flash, 112
higher (colder) color temperature, 54	internal focusing, 96
Highlights option, 31	interpolation, 247
highspeed continuous shooting mode, 69	interpolation/demosaicing algorithm, 238
Histogram option, 31	interval shooting, 61
histograms, 31, 39-40, 82, 246	Interval timer indicator, 29
holiday lights photography	InTouch, PictureProject, 221
filters, 164	Intvl Timer submenu, of Shooting menu, 60-61
inspiration, 161–162	inverse square law, 108, 118
overview, 161, 164	IrfanView program, 227–228
practice, 162–163	ISO
tripod, 164	changing, 80–81
VR lens, 164	sensitivity, 34, 42–44
hot shoe, 115, 246	ISO auto indicator, 25
hyperfocal distance, 87, 246	ISO Auto option, 67
	ISO button, 19
I	ISO sensitivity option, 29
IF letter code, 96	ISO Sensitivity submenu, of Shooting menu, 60
Illumination option, 70	ISO setting, 25
Image Comment feature, 64	i-TTL flash exposure system, 47
Image comment indicator, 29	i-TTL mode, 110–111
image overlay, 60	IX letter code, 96
image parameters, 53–54	
Image quality display, 27–28	J
Image Quality menu, of Shooting menu, 59	jaggies, 247
lmage Quality/Reset #2 button, 19	JPEG compression, 59–60
Image Review option, 63	compression, 225
lmage size display, 27	
lmage Size submenu, Shooting menu, 59	L
mage stabilization, 246–247	lag time, 247
mage-splitting filters, 150	landscape and nature photography
maginary intersection points, 125	bracketing exposures, 175
mport button, 220	circular polarizer, 175
ncandescent lighting, 116, 119, 135	distant subjects, 175
ncident light, 247	inspiration, 173
ncident meter, 48	overview, 172, 175
ndoor illumination, 120	practice, 173–174
ndoor portrait photography	protective gear, 175
angles, 167	Language option, 64
inspiration, 165	latitude, 247
lighting, 167–168	LCD Brightness option 64

LCDtu-l 99	magra goom langag 02 120
LCD display 23, 27, 20	macro-zoom lenses, 92, 129 Macromedia Fireworks, 228–229
LCD display, 23, 27–29	magnification converters, 105
LCD monitor, 34	_
LCD status panel, 39, 55, 70, 79–80	main command dial, 22, 33, 56
LCH Editor, Nikon Capture, 223	main light, 164
left/right buttons, 71	Manual exposure mode, 12, 32, 34, 47–48
lens code, 95–97	Manual flash setting, 70
Lens hood bayonet/alignment guide, 17	Manual focus, 3, 14
lens release, 14	Manual mode, 2–3, 47–48, 72, 85
lens thread, 18	Mass Storage device mode, 65
lenses	matrix metering, 32, 36–37, 85, 110, 146, 183, 248
compatibility, 94–95	maximum aperture, 93
lens code, 95–97	Max. Sensitivity option, 43
normal, 103–104	MB-D200 batteries option, 70
overview, 89	MB-D200 grip/battery pack, 233
reducing vibration, 105	MB-D200 Multi-Power Battery Pack, 12
teleconverter for, 106	MC-30 wired remote control, 129
telephoto, 101–103	memory card warning, 25
wide-angle, 98–101	Menu button, 22
zoom vs. fixed-focal-length, 93-94	Menu Reset option
light spills, 154	in Custom Settings menu, 66
light trail photography. See fireworks and light	in Shooting menu, 58
trail photography	mercury vapor lights, 121
light writing, 107	Metered Exposure/Under Exposure/Over Exposure
light-sensing slave unit, 115	option, 40
lighting. See also continuous lighting	metering mode dial, 21
effect on exposure, 76–77	Metering Mode/Format #1 button, 19–20
sources of, 76, 120	metering modes
supplementing, 135	button, 85
lighting ratio, 145, 247	center-weighted, 33, 38
Limit switch, 18	dial, 21
locking focus, 52–53, 197	matrix, 32, 36–37
Lock Menu, 65	overview, 32–33
	spot, 33, 38
Long Exp. NR option, 45, 60	in viewfinder display, 25
long exposure, 163	
lossless compression, 247	metering selector dial, 32
lossy compression, 247	metering system, 47
low (warm) color temperature, 54	Metering/Exposure submenu, of Custom Settings,
low noise reduction, 236	67–68
low pressure sodium lamps, 121	Micro lens code, 96
low shutter speeds, 164	midtones, 248
low-speed continuous shooting mode, 69	Mirror Lock-Up option, 64, 238, 248
**	mirror prerelease feature, 69
M	mixed illumination, 135
M/A designation, 48	Mode button, 1
Macro focusing, 92	Mode dial, 19
macro lens, 129, 186, 248	Mode dial lock button, 6
macro photography	Modeling Flash option, 71
close-up photos, using LCD to review, 178	modeling lamps, 116
freezing focus with focus-lock control, 178	modeling light mode, 233
inspiration, 175–177	Monitor-Off option, 69
overview, 175	Monochrome LCD status panel, 19
practice, 177–178	monolights, 117
time required for long exposures, 178	monopods, 105, 131, 144, 183

mountain-range effect, 82 multi selector button, 23, 30, 60, 62, 82 Multi selector control, 23 multiple exposures, 29, 60 multiple flash units, 116–117	105mm f/2.8D AF Micro-Nikkor lens abstract pictures, 129 auction photos, 186 flower and plant pictures, 160 macro photos, 178
multiplier factor, 97 multipurpose lens, 89	1005 sensor cells, 36 On/Off Switch/Backlight illuminator, 14
N	On/Off Switch/LCD illuminator, 20 online auction photography
naming files, 59 nature photography. See landscape and nature	boosting saturation, 187 cropping tightly, 186
photography	higher-contrast lighting, 187
near infrared portion, 168	inspiration, 184–185
NEF (Nikon Electronic File), 248	overview, 183–184, 186
neutral density filter, 248	plain background, 187
neutral-color backgrounds, 141	practice, 185–186
new lens, 91–93	Optimal Quality choice, 60
night and evening photography	Optimize Image menu, 53
blur due to long exposure times, 183	Optimize Image submenu, of Shooting menu, 59
boosting ISO, 180	optional viewfinder reference grid, 99
bracketing exposures, 183	organizing pictures, 219–220
inspiration, 180–181	outdoor and environmental portrait photography
longest exposure time, 180	background, 190
overview, 179, 183	inspiration, 187–188
practice, 181–183	late-afternoon and dusk shoots, 190
shooting in twilight, 183	limiting environment in composition, 190
shooting with full moon, 183	overview, 187, 190
slow-sync mode flash, 183	practice, 188–189
tripods or monopods, 180	Over 1,000 exposures remain message, 25
night photography, 161	overexposure, 40, 248
Nikkor autofocus lens, 48 Nikon Capture	overlapping photos, 191
camera communications, 224–227	p
flower and plant pictures, 160	
image editing, 223	Paint Shop Pro, Corel, 228 Painter, Corel, 229
overview, 222	painting with light, 134, 136
transfer/RAW conversion, 222	panning, 195
Nikon PictureProject	panoramic photography
organizing and viewing pictures, 219–220	exposure, 193
overview, 216	inspiration, 191–192
retouching pictures, 220–221	overlapping, 193
sharing pictures, 221	overview, 190–191, 193
transferring pictures, 216–218	practice, 192–193
Nikon strobes, 70	software, 193
NikonNet, 217, 221	tripods, 193
noise reduction, 44–45, 80, 180, 248	PC/X flash connector, 16
No memory card warning, 25	Pec*Pad cloths, 239
Non-CPU Lens Data submenu, of Shooting	penlights, 154
menu, 61	perspective distortion, 91, 98
normal framing, 50	petroleum jelly, 150
normal lenses, 103–104, 248	Phase One Capture One Pro (C1 Pro) program, 228
0	Photo Info Playback control, 71–72
0	photo safaris, 131
off-camera electronic flash units, 140 onboard flash, 32	Photographic Solutions, 239

photography	Playback Zoom button, 23
abstract, 127–130	polarizing filters, 153, 161, 248
animal, 130–134	portable hard drive/CD-burner, 208
architectural, 134–138	portrait photography. See indoor portrait
business, 138-141	photography
event, 141–145	portraitures, 38
fill flash, 145–149	posing tips, 190
filter effects, 149–153	preflashes, 110
fireworks and light trail, 153–157	Preset capability, 171
flower and plant, 157–161	preview button, 102
holiday lights, 161–164	prime lens, 94
indoor portrait, 164–168	Print Set option, 62
infrared, 168–171	Program mode, 2, 33, 85
landscape and nature, 172-175	Programmed Auto mode, 45–46, 68, 70
macro, 175–178	Programmed mode, 86
night and evening, 179–183	protect button, 31
online auction, 183–187	PTP (Picture Transfer Protocol), 65
outdoor and environmental portrait, 187-190	-
panoramic, 190–193	Q
sports and action, 194–197	Qual button, 59
still life, 197–200	
street life, 200	R
sunset and sunrise, 204–207	random patterns, 127
travel, 207–210	RAW capture
waterfall, 211–214	auction photos, 186
PhotoImpact, Ulead, 229	holiday lights photos, 163
photojournalist-style images, 204	indoor portraits, 167
PhotoPaint, Corel, 228	landscape and nature pictures, 174
Photoshop blur filter, 150	macro photos, 178
Photoshop CS/Photoshop Elements, 228	night and evening pictures, 182
picture-taking mode, 1–3	panorama pictures, 193
PictureCode Noise Ninja, 229	pictures at zoos, 133
PictureProject, Nikon. See Nikon PictureProject	pictures of street life, 203
pincushion distortion, 99, 248	still-life pictures, 199
pivot point, 191	sunset and sunrise pictures, 207
pixel mapping, 238	travel pictures, 210
pixel resolutions, 190	RAW Compression option, 60
pixels, 83	RAW Essentials, Corel, 222
plant photography. See flower and plant	RAW file utilities, 227
photography	RAW format, 213
Playback button, 6, 22, 40	RAW mode, 233
Playback Folder option, 62	RAW/NEF images, 222
Playback Folder submenu, 62	Rear sync mode, 109–110
Playback Menu settings	rear-curtain sync, 32, 110, 248–249
After Delete option, 63	Recent Settings menu, 64–65
Delete option, 62	Red value, Red Channel, 171
Display Mode option, 62	red-eye, 14, 32, 110, 249
Hide Image option, 62	Reference grid display, 24
Image Review option, 63	reflections, 137
overview, 61	reflectors, 84, 129
Playback Folder option, 62	release priority, 66
Print Set option, 62	remaining exposures, 25
Rotate Tall option, 63	Remaining exposures/other functions display, 25
Slide Show option, 62	Rename option, 58, 66
playback mode, 30, 71	repeating flash, 70, 112, 117–118

retouching pictures, 220–221	High ISO NR, 60
retro-Speed Graphic look, 179	Image Overlay, 60
reviewing images, 6, 30–31	Image Quality, 59
RGB color model, 249	Image Size, 59
RGB Histogram option, 31	Intvl Timer Shooting, 60–61
Rotate Tall option, 63	ISO Sensitivity, 60
Rotate Tall playback option, 64	JPEG Compression, 59–60
Rule of Thirds, 125–126	Long Exp. NR, 60
	Menu Reset, 58
S	Multiple Exposure, 60
saturation, 137, 161, 249	Non-CPU Lens Data, 61
SB-800 Speedlight, 166	Optimize Image, 59
SC-28 cable, 115	overview, 58
SC-29 cable, 115	RAW Compression, 60
Sel button, 116	Shooting Menu Bank Option, 58
Select/Set screen, 62	White Balance, 60
selective focus, 249	short lighting, 165
self-timer, 5–6, 69, 249	short telephotos, 180
semi-automatic exposure mode, 33–34, 47	shots per second, 117
semi-fisheye lens, 136	Show Thumbnails button, 216
sensor arrays, 36	shutter button, 4
Sensor focal plane control, 19	Shutter Priority AE mode
sensor frame, 108	event pictures, 144
sensor noise, 81	landscape and nature pictures, 174
sensor, sensitivity of, 77	night and evening pictures, 182
Setting Method for Buttons and Dials option, 72	panorama pictures, 193
	pictures at zoos, 133
Setup menu options, 63–65	pictures at 2008, 133 pictures of street life, 203
Auto Image Rotation, 64 Battery Info, 65	sports and action pictures, 196
	•
Dust Off Ref Photo, 65	sunset and sunrise pictures, 207
Firmware Version, 65	travel pictures, 210
Format, 64	Shutter Priority focus, 237
Image Comment, 64	Shutter Priority mode, 2, 33, 47, 68, 72, 85, 137, 196
Language, 64	shutter release, 14, 72
LCD Brightness, 64	Shutter Release button, 1, 4, 14, 20, 68, 194, 197
Mirror Lock-Up, 64	Shutter Speed display, 102
overview, 63	Shutter speed/other functions display, 29
Recent Settings, 64–65	sidelighting, 165, 249
USB, 65	Sigma 170–500mm F5–7.3 APO Aspherical AutoFocus Telephoto Zoom Lens, 133, 196
Video Mode, 64	
World Time, 64	silver reflectors, 141
17–55mm f/2.8G EDIF AF-S DX Zoom-Nikkor lens, 90	silver umbrellas, 141
shadows, 81–82, 136, 249	Single area autofocus mode, 52
sharing pictures, 221	Single Autofocus, 3, 14, 48, 237, 249
sharpness, 79, 93, 249	Single-servo as autofocus mode, 49
Sharpness keys, 36	Single-servo mode, 49
Shooting bank display, 28	60mm f/2.8D AF Micro-Nikkor lens
shooting banks, 28, 235	abstract pictures, 129
Shooting Data 1 option, 31	still-life pictures, 199
Shooting Data 2 option, 31	skylight filter, 150
Shooting menu preferences	slave unit, 250
Color Space, 59	Slide Show option, 62
File Naming, 59	slow shutter speed, 130
Folders, 58–59	Slow sync mode, 32, 110

Slowest Shutter Speed When Using Flash option, 70 sneaker zoom, 91, 100	haze/fog, 102 isolating subject, 101
sodium-vapor illumination, 119, 120	macro photography, 101–102
soft boxes, 168, 199	overview, 101
specular highlight, 250	portraits, 101
Speedlight, 108, 111, 144	shutter speeds, 102
split neutral density filters, 150	telephoto macro lens, 101–102
sports and action photography	telephoto zoom, 203
	10-pin remote connector, 16
anticipating action, 197 inspiration, 194–195	10.5mm f/2.8G ED AF DX Fisheye-Nikkor lens, 136
manual focus/focus lock, 197	text entry screen, 64
overview, 194, 197	3D Color Matrix II, 36
peak action, 197	through-the-lens (TTL) flash, 110
practice, 195–196	thumbnails, 6, 23, 30, 31
shooting oncoming action, 197	TIFF (Tagged Image File Format), 250
spot metering, 85, 250	time lapse, 60, 226, 250
Spot mode, 33, 38	time-exposures, 136, 250
star filters, 150, 163	tonal range, 82–85
status panel LCD backlight illumination lamp, 14	tonal scales, 42
still life photography	tone compensation, 85
angles, 200	Tools menu, PictureProject, 216
inspiration, 198	Transfer dialog box, PictureProject, 216
overview, 197–198, 200	transferring images to computer, 7–8, 216–217
practice, 198–199	transparency film, 81
stratospheric ISO settings, 80	travel photography
street life photography	capturing cultural environment, 210
incorporating cities into pictures, 204	close-up shots, 210
inspiration, 201–202	inspiration, 208–209
overview, 200–201, 204	overview, 207–208, 210
practice, 202–203	practice, 209–210
telling story, 204	tripods, 129, 137, 156, 183
traveling light, 204	TTL flash, 70
wide-angle lenses, 204	TTL mode, 111
stuck pixel, 238	tungsten lighting, 119, 250
studio flash, 117	12–24mm f/4G ED-IF AF-S DX Zoom-Nikkor lens
Sub-command dial, 12–13, 55, 56, 78	panorama pictures, 193
subposition tables, 172	travel pictures, 210
subtractive primary colors, 250	28–200mm f/3.5–5.6G ED-IF AF Zoom-Nikkor lens
sunlight, 119	architectural exteriors, 136
sunset and sunrise photography	night and evening pictures, 182
filters, 207	pictures of fireworks, 156
inspiration, 205–206	pictures of street life, 203
overview, 204–205, 207	F
practice, 206–207	U
sync speed, 108	Ulead PhotoImpact, 229
cyne opeca, rec	underexposure, 40, 250
T	UnderExposure/Metered Exposure/Over Exposure
teleconverters, 79, 106	option, 40
telephoto lenses	unsharp masking, 250
compression, 103	up/down buttons, 6, 71
decreasing distance, 102	USB cable, 7, 216
depth of field (DOF), 102	USB option, 65
flare, 102	USB port connector cover, 16
flash coverage, 102–103	

getting closer to wildlife, 101

Index + T–Z

vertical grip/battery pack, 12 vibration reduction (VR), 89, 91, 96, 105, 144, 161, 164 Video Mode, 64 viewfinder display, 24–26 eyepiece, 21 Grid option, 69 info display, 52 Warning option, 69 viewing pictures, 219–220 vignetting, 152, 250 VisibleDust, 239	white cardboard reflectors, 141 white pixel, 238 white umbrellas, 141 wide framing, 50 wide-angle lenses angles, 98 avoiding unwanted perspective distortion depth of field (DOF), 98 distorting foreground, 98–99 emphasizing foreground, 98 field of view, 98 flash coverage, 99–100 getting whole scene in close quarters, 98 horizontal and vertical, 99 lens defects, 99
W warm lighting, 120, 121 waterfall photography adding wildlife, 214 backdrops, 214	overview, 98 slower shutter speeds, 100–101 sneaker zoom, 100 World Time option, 64 wrinkle-emphasizing shadows, 168
freezing time, 214 inspiration, 212 overview, 211–212, 214 practice, 212–213 WB button, 55	X/PC connection, 117 Z zoom lenses, 17, 79, 94, 134, 144, 186
Wein Safe Sync adapter, 115, 117 white balance, 19, 28, 34, 54–56, 60, 118–119, 120–121, 129, 189, 250	zoom ring, 17 zoom scale, 17, 103 zoom slider, 219